GRAND FINALES

ALSO BY SUSAN GUBAR

Late-Life Love: A Memoir

Reading and Writing Cancer: How Words Heal

Memoir of a Debulked Woman: Enduring Ovarian Cancer

Judas: A Biography

Lo largo y lo corto del verso Holocausto

Rooms of Our Own

Poetry After Auschwitz: Remembering What One Never Knew

Critical Condition: Feminism at the Turn of the Century

Racechanges: White Skin, Black Face in American Culture

Still Mad: American Women Writers and the Feminist Imagination (with Sandra M. Gilbert)

Masterpiece Theatre: An Academic Melodrama (with Sandra M. Gilbert)

No Man's Land: The Place of the Woman Writer in the Twentieth Century (with Sandra M. Gilbert)

Volume I: The War of the Words

Volume II: Sexchanges

Volume III: Letters from the Front

The Madwoman in the Attic: The Woman Writer and the Nineteenth-Century Literary Imagination (with Sandra M. Gilbert)

EDITOR

True Confessions: Feminist Professors Tell Stories Out of School

Feminist Literary Theory and Criticism (with Sandra M. Gilbert)

MotherSongs: Poems for, by, and about Mothers (with Sandra M. Gilbert and Diana O'Hehir)

English Inside and Out: The Places of Literary Criticism (with Jonathan Kamholtz)

For Adult Users Only: The Dilemma of Violent Pornography (with Joan Hoff)

The Norton Anthology of Literature by Women (with Sandra M. Gilbert)

Shakespeare's Sisters: Feminist Essays on Women Poets (with Sandra M. Gilbert)

SUSAN GUBAR

GRAND FINALES

The Creative Longevity of
Women Artists

W. W. Norton & Company
Independent Publishers Since 1923

Copyright © 2025 by Susan Gubar

All rights reserved
Printed in the United States of America
First Edition

For information about permission to reproduce selections from this book, write to
Permissions, W. W. Norton & Company, Inc., 500 Fifth Avenue, New York, NY 10110

For information about special discounts for bulk purchases, please contact
W. W. Norton Special Sales at specialsales@wwnorton.com or 800-233-4830

Manufacturing by Lake Book Manufacturing
Book design by Brooke Koven
Production manager: Julia Druskin

ISBN 978-1-324-06564-7

W. W. Norton & Company, Inc., 500 Fifth Avenue, New York, NY 10110
www.wwnorton.com

W. W. Norton & Company Ltd., 15 Carlisle Street, London W1D 3BS

1 2 3 4 5 6 7 8 9 0

*For all the elderly women we have loved
And those we can't believe we are becoming*

Contents

Preface — xi

Introduction / Creativity in Old Age — 1

Section I ～ Lovers — 27

 1. George Eliot — 29
 2. Colette — 55
 3. Georgia O'Keeffe — 83

Section II ～ Mavericks — 111

 4. Isak Dinesen — 113
 5. Marianne Moore — 139
 6. Louise Bourgeois — 165

Section III ～ Sages — 189

 7. Mary Lou Williams — 193
 8. Gwendolyn Brooks — 221
 9. Katherine Dunham — 249

Conclusion / Inventive Endgames in Our Times — 277

Acknowledgments	305
Notes	309
Illustration Credits	355
Index	357

Preface

ADVANCED AGING WAS a blessing I did not expect to receive, but also a curse for which I was unprepared. In 2008, at sixty-three years of age, I grappled with a diagnosis of terminal ovarian cancer. My trusted oncologist informed me that I had three to five years to live. That death sentence focused my attention on the boons of a longevity I would never experience. Yet Dr. Matei urged me to engage in treatments so I would not kick the bucket even sooner. And, she added, who knew what sort of research breakthrough might be coming down the pike? Pie in the sky, I thought.

I nevertheless submitted to a series of surgeries and chemotherapy that plunged me into decrepitude. Over and over again, needles and tubes and scalpels pierced my skin, internal organs were removed or rearranged, chemicals infused. Throughout treatments and recurrences, I needed a walker to get around or stayed in bed; I lost more than twenty-five pounds and all body hair; my only outings were hospital visits. My husband took care of me and all the chores, even though he is seventeen years my senior. Since I had been teaching and traveling before the diagnosis, it was as if I had entered a time machine that had hurtled me from my prime into infirmity. In my sixties, I felt ancient and yet I knew that I would be deprived of old age.

Then, in 2012, Dr. Matei encouraged me to enroll in a Phase I clinical trial with an experimental medication. Four daily pills were much easier to take than the earlier interventions. My retirement

from teaching was a done deal; however, I purchased a silver wig, resumed cooking and laundry routines, and began writing about living with cancer in a column for the online *New York Times*. My first *Times* essay was titled "I Am Not a Survivor," because both Dr. Matei and I assumed that the new medication would soon stop working, the cancer would recur, and I would be back on the miserable regimen that had failed to keep the disease at bay.

But slowly, by 2020, it started to dawn on me that regardless of what the future held, I was in fact a cancer survivor. Then the next year, with a great deal of trepidation, I heeded the advice of Dr. Matei, withdrew from the clinical trial, and went on a drug holiday. No one could tell me if discontinuing the medicine would lead to the cancer returning, but sustained use of the pills had the potential to cause leukemia. In my late seventies, I composed this book while still on that holiday.

A medical breakthrough delivered me into an old age I had not expected to inhabit. It sent me into research-drive to investigate how those women who were fortunate enough to live long lives dealt with the everyday challenges of aging. I was reading Laura Shapiro's engaging book *What She Ate*, when the title *How She Aged* popped into my head. The subject hooked me. Only with notable women would there be sufficient biographical information to study how individuals sustained their creativity as they negotiated the obstacles of old age.

After my esteemed editor encouraged me to dump what she deemed an unmarketable title, I became acutely aware of an entrenched aversion to aging. To underscore the fact that quite a few people have managed to transform the last stage of existence into a rousing conclusion, I came up with *Grand Finales*. I was drawn to the understudied aging of creative women by a slew of questions. Not the least of them was how I could enhance creativity in my own unanticipated old age. By what means did prominent women extend their careers as they started looking back on the failures or accomplishments of their midlives? Did the pace or nature of their work change during their final decades? How did they counteract the

indignities of aging or avoid the isolation that plagues many people in their last years? Did art-making help them cope with the process of aging, whether or not they tackled old age as a subject?

With a background in literary studies, I was well aware that the sedentary nature of writing makes it conducive to those depleted by the aging process. Activities like painting, sculpting, playing an instrument, and dancing require physical exertions that may be impaired in old age. It seemed important, for this reason, to cast a wide net, to consider how all sorts of artists negotiated deficits that impeded their efforts to continue practicing their disciplines. I began without any conscious presuppositions or theories. Groupings emerged, but there would be no overarching argument homogenizing my subjects' responses to the hurdles of aging, except for some speculations in the conclusion about what inventive artists can teach the rest of us about the environments, relationships, and attitudes that support creativity in old age.

As I began studying some of the most charismatic women artists, I determined there would be no airbrushing in my approach to the territory I affectionately dubbed Little-Old-Lady-Land—with thanks to Mel Brooks for the tap-dancing widows on walkers in one jubilant theatrical number of *The Producers*. Would it be possible to reclaim the derisive term "old lady" for elderly women, to drain it of scorn and infuse it with glamour, charm, or honor? Like Julia Louis-Dreyfus, whose podcast is called "Wiser Than Me," I wanted to learn from old ladies . . . but not just the living ones. Conveying each of their finales with all its bumps and blemishes might provide clues to help those of us facing a future sure to be bumpy and blemished.

Grand Finales is not entirely focused on elderly women artists: one of my subjects, George Eliot, did not reach old age, and quite a few others devised the lifestyles that would see them into old age decades before they were old. What particularly fascinated me is how aging affects creativity, and vice versa. The excursions, prizes, and deathbeds of my subjects riveted me less than where and how they directed their creative energies. What does a novelist produce when

she no longer has the energy to undertake a novel? When a dancer can no longer perform, must she take up choreography? Hopefully, aging artists' responses to these perplexities will inspire readers, as they have me.

Disabilities inflicted by past treatments, combined with the COVID pandemic, made it impossible for me to travel to archives and artworks. Because I found myself dependent on lending libraries and websites, there are many endnotes, some of them containing links to electronic troves where readers can see and hear a number of my subjects in documentaries and interviews.

As I learned the hard way, it is impossible to know how much aging one has left to do. The terminal diagnosis continues to function like the loaded gun aimed at the grandmother at the end of one of Flannery O'Connor's treasured stories. Remember her in "A Good Man Is Hard to Find"? She would have been a good woman, we are informed, if there had been someone there to shoot her every minute of her life.

Others do not need such a shock to come to their senses about the unmerited rewards of longevity. The individuals studied in the pages to come can teach us a good deal about paths we will all tread, if we are lucky. They bring mettle to a terra incognita that has too long remained shrouded in silence, shame, and denial. Through their eyes, we can view old age as a passage rife not only with challenges but also with opportunities. Creative activity, it turns out, furnishes an escape from the sorrows of aging, a method of grappling with the deficits accompanying old age, and a means of communicating its somewhat daunting terrain.

GRAND FINALES

INTRODUCTION

Creativity in Old Age

WELCOME TO a fresh perspective on Little-Old-Lady-Land. This book spotlights its resolute inhabitants from the distant and not-so-distant past. Three immigrants on its border pledge themselves to men young enough to be their sons. One solid citizen produces luminous paintings while partly blind. Others throw out the first ball in Yankee Stadium, export huge sculptures all around the world, conduct sacred concerts, and serve as advocates of militant political movements.

Yes, all these women were prodigiously gifted. But no, not all of them were little or ladylike. Nor are they singular anomalies. What is freakish is the common assumption that elderly women are so physically and mentally feeble, discountable, and unremarkable, that they often seem invisible or risible. To counter a toxic brew of gerontophobia and sexism, we need role models who furnish ingenious solutions to the challenges often attendant upon an extended lifespan. The more value we perceive in old people's lives, the less likely we will be to regard them as worthless or expendable.

Of course, old men also suffer from ageism, but women tend to be more stigmatized because of what Susan Sontag called "the double standard of aging": the sad truths that female bodies are judged to be

old sooner than male bodies and are also viewed as more repulsive. For too long, age studies scholars declare, the words *aging* and *women* have conjured images of decline. If disheartening albeit archaic stereotypes are to be offset by cheering or inspiring exemplars, they need to be grounded in the everyday losses of old age: frailty, disability, illness, pain, and grief over lost companions. Only through this realistic lens can we comprehend the existential and aesthetic survival skills of elderly women as well as their curious late-life decisions, all of which can help us conceptualize and attempt to lead a creative old age ourselves.

Why, for example, did the aging writers George Eliot, Colette, and Isak Dinesen commit themselves to much younger men? How did the visually impaired painter Georgia O'Keeffe continue working with oils? By what means did the experimental modernist Marianne Moore turn herself into a pop-culture icon at sporting events? What prompted the sculptor Louise Bourgeois to construct colossal Spiders as she neared ninety, or the jazz pianist Mary Lou Williams to score church masses in her sixties? Who inspired the poet Gwendolyn Brooks and the dancer Katherine Dunham to become social justice activists in late life? All these figures navigated the realities of loss and debility that often inflect the final chapter of existence.

Though oldsters are generally overlooked or slighted, old age has the potential to be the most inventive stage of existence. In infancy and childhood, we are controlled by our parents. In adolescence and young adulthood, education rules over most of our lives. In midlife, familial and/or professional duties often take precedence: responsibilities for offspring, work, rents or mortgages, dependent parents. Only at older ages can many of us turn our attention to creative pursuits. Long-lived artists who managed to sustain their creativity in old age provide insights into the strategies that can assist the rest of us to do so as well.

Old age tends to be closeted in our youth-oriented society. The aged reside tucked away in assisted living facilities, retirement villages, nursing homes, and houses or apartments where they often

cannot interact with younger people. Self-help books proliferate, advising us to cherish every golden moment or telling us not to do the stupid things our superannuated parents did. Some of them urge us to be creative. But, in fact, we read very few accounts of how longevity affects individuals and specifically how it affects women. *Grand Finales* focuses on especially inventive old women to see how they extended their creativity into their sixties, seventies, eighties, or nineties and also to understand how their artwork illuminates the lived realities of old age, for artists in old age sometimes take old age as their subject and in doing so provide nuanced insights into the aging process.

"Never trust people under seventy and over seven," the painter Leonora Carrington once advised. She was suggesting that the elderly gain unique access to the imaginative honesty, immediacy, and intensity that some children display. "Even if I could have done, when I was young, what I am doing now—and it is what I dreamed of then—I wouldn't have dared": Henri Matisse was speaking of the cutouts he produced in the final phase of his long career.

As the reception histories of Carrington and Matisse demonstrate, the late-life works of women have received less attention than those of men. Michelangelo painted frescoes in his eighties, Verdi composed operas in his seventies, and Frank Lloyd Wright completed the Guggenheim Museum in his nineties. Beethoven and Picasso have been lauded for their late styles. On his ninety-sixth birthday, the pianist Eubie Blake said, "If I had known I was going to live so long I would have taken better care of myself." How did women artists respond to longevity?

This introduction explores the characteristics of aging, who gets to undertake creative activities in old age, and why such pursuits are especially important in the last stage of life. It also analyzes key factors that foster creative activities. In subsequent chapters, I recount the pursuits of individuals who continued to be creative during their vibrant final decades. Lastly, the conclusion of *Grand Finales* glances at contemporary figures as we consider what their and their prede-

cessors' case histories tell us about how—when it is most needed—creativity can be sustained.

WHEN DOES OLD age begin? That the answer to this question differs markedly for different people proves something about the irrelevance of chronology. For many today, retirement and Social Security payments signal the start of old age, placing it at or about sixty-five years of age. But for those extending their professional services or taking on second jobs or launching second careers (mainly in knowledge-based jobs), old age may be deferred to seventy or eighty, an indication of how important paid and recognized work remains to our sense of identity. Our psychological age may be much younger than our chronological age.

However, the age we feel ourselves to be can also be much older than our chronological age. If old age can be delayed, it can also arrive quicker than expected. Persistent stress, a poor diet, and manual labor accelerate physiological aging. Before the celebration of a sixty-fifth birthday, any number of cataclysmic events—medical, familial, financial, spiritual, political—may convince a person that she has entered the last phase of her existence. Life expectancy, which varies over time and place and with different races and classes, also modifies an individual's sense of arriving at the final stage of life.

The intuition that one is entering old age often gets expressed with the verb "settle": we are "settling into old age" or "settling down in old age." Settling: the word comes from the Old English *setl*, meaning a chair. One piece of furniture—a wooden bench with arms, a high back, and a seat that consists of a box or chest—is called a settle. Old age is presumed to be a period of staying put, establishing a residence, coming to rest. Within early and later old age, of course, many seniors, not sitting down on a settle, become globetrotters. Whether mobile or stationary, however, seniority initiates oddly new experiences of temporality.

On the one hand, time speeds up in old age, for each year consists of a smaller fraction of one's overall lifespan. When I was a child, summers seemed endless, but these days they are over soon after they have begun. It feels like just yesterday that I retired, but by now it was about thirteen years ago. On the other hand, time slows down in old age, for there are fewer social obligations that need to be met, and everything—from making the bed to making the evening meal—takes longer to do. A day with nothing on the calendar but a visit to a doctor can seem interminable. There is more time at one's disposal—retirement guarantees it—and more time accruing in a lengthening past. Yet there is less time to look forward to. For this reason, most elderly people become cognizant of a looming sense of an ending.

The accessories of old age foreground the awareness of impending mortality that it can impose. Wigs, hearing aids, magnifying lenses, dentures, bridges, implants, orthopedic shoes, braces, absorbent underpants, toilet seat risers, bedside commodes, grab bars, shower benches, adaptive utensils, canes, walkers, rollators, wheelchairs, ostomy pouches, prostheses, catheters, blood monitors, insulin pumps, portable oxygen tanks: such accoutrements amplify the creaking that signals the unbolting of death's door. Then the body aches of manifold diseases and treatments, the heartaches of grief when contemporaries pass away: since the elderly often find themselves accompanied by the elderly, the creaking of the door may crescendo. Like besieged soldiers, "the old die many times in one long life," Charles Dickens observed, for they suffer "the pain of seeing others die around them."

"Old age is a battle," a widowed character in Philip Roth's novel *Everyman* (2006) says, "if not with this, then with that. It's an unrelenting battle, and just when you're at your weakest and least able to call up your old fight." Eventually, the book's glum protagonist decides, "Old age isn't a battle; old age is a massacre." Yet as in the frightful skirmishes described in Tim O'Brien's accounts of warfare, in old age "proximity to death brings with it a corresponding prox-

imity to life." Realizing that we will die—not someday far off but sooner—may paradoxically quicken and thicken reality. "Death is the shadow now, even with something joyful," Delia Ephron writes in a memoir about marrying a late-life lover in the midst of a devastating illness: "But that is normal now. That is old-age normal." Some aging people, closer to death than young people, discover that an awareness of transience intensifies their response to existence.

Or perhaps the nearness of death puts other ills in perspective. Lots of experience can furnish older people the resiliency that enables them to anticipate and cope with daily difficulties. George Eliot once noted that young people are apt to view each crisis as definitively catastrophic; in contrast, "the oldest inhabitants of Peru do not cease to be agitated by the earthquakes, but they probably see beyond each shock, and reflect that there are plenty more to come." Similarly, Margaret Atwood juxtaposes middle-aged people responding to someone with cancer by saying "*We don't want to deal with this*" over and against older people who know "this has happened before.... You're not afraid of it in the same way. And you order the flowers and send the note."

Quite a few psychologists take this line of thinking further than I would, given the deterioration of the body. One book about the U-shaped happiness curve—it posits that life satisfaction plummets in one's forties—has as its subtitle *Why Life Gets Better After Fifty*. Another social scientist is not atypical in arguing that "older people are actually happier and more satisfied with their lives than younger people; they experience more positive emotions and fewer negative ones."

Although physical ailments can put "positive emotions" to the test, it is true that the subjectivity of aging people can help defend against the threats of decrepitude and death. It does so by attending to the multiple selves that have accrued in the past and continue to pile up in memory. Older people house a larger number of earlier avatars of ourselves than do youngsters. I am the second-grader who spilled ink on the classroom floor, the teen who dated a pothead, the

mother bearing down on the delivery table, the divorcée of a man now dead, the professor at a lectern, the wife of a fellow seventeen years my senior, the cancer patient with an ileostomy, etc. The novelist Penelope Lively put it this way: "This old age self is just a top dressing, it seems; early selves are still mutinously present, getting a word in now and then."

Old people, to use Walt Whitman's phrase about himself, "contain multitudes"; we can each proclaim ourselves "a kosmos." Aging multiplies our identities. I have experienced all the ages of my children and grandchildren, though they have not experienced all of mine. Layer upon layer of the past envelopes us. "'Live in the layers, / not on the litter,'" the elderly poet Stanley Kunitz once advised himself. Maya Angelou hints at one psychological consequence of the layers in her poem "On Aging": "When you see me sitting quietly / Like a sack left on the shelf, / Don't think I need your chattering. / I'm listening to myself." A joking remark often attributed to Agatha Christie alludes to the accretion of these same strata of experience: "I married an archeologist," she purportedly said, "because the older I grow, the more he appreciates me."

Multilayered old age may be a time to settle down in a meditative state, to let the dust settle, or to settle with less. Yet it can also be a time of settling a new land or of settling an argument. In fact, though, many people cannot or refuse to settle into old age. May Sarton in *At Seventy* (1984) declared, "I do not feel old at all," because "I suppose real old age begins when one looks backward rather than forward." Simone de Beauvoir, at sixty-two years of age in 1970, published a monumental work, *La Vieillesse* (*Old Age*), that explains why old age is the only stage of life that is regularly disavowed, why quite a few people lie about their birthdate to pass as younger than they are.

A brilliant achievement, but a flawed one as well, *La Vieillesse* recycles assumptions still prevalent today about the decrepitude of the elderly. Also, the ways in which the old are marginalized, impoverished, and ignored. For the antique are rarely considered repositories of wisdom now—if they ever had been—but rather unsightly

reminders of degeneration that the able-bodied would rather ignore. Beauvoir argued that the term "old lady" emerges from an "alien eye" that cannot perceive in an older woman the younger woman she had been. When used by the elderly, she believed, it registers self-alienation. In general, the humiliations of the elderly are assumed to far outweigh their (or, I should write, *our*) joys. Old people are not only bored and lonely but also cranky and self-involved, Beauvoir alleged, and for good reason.

Discounted by socially distant young and midlife people, old people decline into weakened and ailing shut-ins, according to Beauvoir. Because of various disabilities, she assumes, they (*we*) cannot ground their (*our*) existence on the two cornerstones that many thinkers consider crucial for healthy, contented human beings: work and love. Before I contest this foundational supposition, I'm struck by my tendency to vacillate between *they* and *we*—another mark of aging. For while children know themselves to be children and people in their prime know themselves to be in their prime, the elderly harbor so many different stages of life within themselves (*ourselves*) that it becomes difficult to know oneself as simply and fundamentally old. *They/we* also expresses the self-alienation involved in aging.

The face in the mirror or the age on the hospital bracelet can dispense a jolt. No wonder the poet Louise Glück refers to old age as "that time of life / people prefer to allude to in others / but not in themselves." A scholar of aging, Kathleen Woodward, puts the self-alienation of old age this way: "*We* are not old; it is the Other, the stranger within us who is old" or again, "Our bodies are old, we are not." Still, awareness of one's own aging can strike at any time of life. One day Simone de Beauvoir said to herself, "I'm forty!" By the time she "recovered from the shock of that discovery," she explained, "I had reached fifty. The stupor that seized me then has not left me yet. I can't get around to believing it."

To the memoirist Vivian Gornick, "Turning sixty was like being told I had six months to live." In one novel, Erica Jong equates "the Faustian wish of all Faustian wishes" with "the wish to grow

younger." The poet Donald Hall titled an essay collection on aging *A Carnival of Losses* (2018). "I do not myself find it agreeable to be ninety," the author Rebecca West confided toward the end of her life. "It is not that you have any fears about your own death, it is that your upholstery is already dead around you." Few people want to identify with old age.

However, more and more of us are getting to be old during the graying of America, a phrase that marks a population increasingly dominated by old people. And emphasizing only the negatives of old age further debilitates individuals debilitated by the ravages of time. Despite the foundational supposition recycled in Beauvoir's book, the two cornerstones of a healthy, contented life—(unpaid) work and love—continue to ground and invigorate the everyday routines of a large number of oldsters today, as they did the subjects of this book. Indeed, once we recognize unpaid work as work and not-necessarily-sexual-love as love, it becomes immediately evident how many elders engage themselves daily with both. Nor are work and love always distinguishable, for unpaid work is often undertaken as an act of love. Hale and hearty seniors defy prevailing stereotypes, but so do the impaired.

Given the physical and mental deficits associated with the "battles" or "massacres" of old age, such cheeky contestations involve determination, defiance, even braggadocio. Precisely because old age is accompanied by multiple losses that can feel like a shellacking, it requires more stamina than do the other stages of life. A heightened awareness of the precariousness of life, as well as the fearfulness that awareness can instill, necessitates a spirited response. It is a good thing that persistency is a character trait that actually increases with age, or so one thinker postulates.

Grit or the passion to persevere, according to the psychologist Angela Duckworth, surges in people sixty-five and over: "we get grittier as we get older." Associated with enduring enthusiasm, goal-oriented practices, and sustained determination, "grit grows as we figure out our life philosophy, learn to dust ourselves off after rejec-

tion and disappointment," and discover "the difference between low-level goals that should be abandoned quickly and higher-level goals that demand more tenacity." The fortitude of seniors, or what some call obstinacy, can stand us in good stead.

While dealing with a range of impairments, the creative artists whom I study in this book resisted the frightful gravity of physical deterioration, its tendency to pull the elderly into the orbit of stagnation or depression. Devoted to lifelong labors of love, all of my subjects confirm an adage of my now deceased mother: "Old age is not for sissies." Noting the "fine fighting material" in elders, one of Agatha Christie's characters declares, "You show me anyone who's lived to over seventy and you show me a fighter—someone who's got the will to live." John Halliday, in his introduction to an anthology of poetry on aging, simply states, "We need to be tough to age well." Contra Beauvoir, the term "old lady," when used by elderly women, can put a tough spin on the self-alienation it would impose. Although for some the rubric has been so thoroughly besmirched that it is beyond recuperation, lots of slurs against despised groups have been recast as badges of honor. For others, then, it might seem auspicious that the acronym for "little old ladies" is LOL.

How did the valiant old ladies in this book age? With pizzazz, with chutzpah, with mojo, with panache, with bravura performances of geezer machismo. This last phrase, a coinage etymologically associated with men but a preening accessible to anyone, is encapsulated in a brickmaker's boastful motto in one of Anthony Trollope's last novels: "It's dogged as does it." At eighty, Penelope Lively observed: "A positive attitude is not going to cure the arthritis or the macular degeneration or whatever but a spot of bravado makes endurance more possible," though "bravado comes a great deal easier to those cushioned by financial security." An amen to her caveat resounds throughout this book.

At any age, for quite a few centuries, creative women had to tap into a rebellious determination to devote themselves not to family but to artistry. In later life, this sort of defiant resolve may be

easier to act on. Although menopause can accelerate aging, by disentangling sexual intercourse from the fear of pregnancy and freeing women from reproduction it liberates one half of the species to take pride in a humanity historically conferred on men. Children, if they have been begotten, no longer require rearing, and therefore the anguish that often results from the conflicting demands of creativity and maternity drops away. The androgynous look of many oldsters—as secondary sex characteristics fade—highlights the possibility that gender plays a transmuted role in the final stage of life, that the imperatives of masculinity and femininity become more malleable, a fact that may boost aging women's confidence in a male-dominated society.

It is only in old age, my mentor Carolyn Heilbrun claimed, "that women can stop being female impersonators, can grasp the opportunity to reverse their most cherished principles of 'femininity.'" She attributed the idea that younger women are female impersonators to Gloria Steinem. By the time Steinem reached eighty-one, she felt liberated from the "demands of gender." As in latency, Steinem thought, after sixty "you're free again" and "can do what you want." She was articulating a perspective earlier expressed by Elizabeth Cady Stanton; namely, that with flirtation, courtship, marriage, and maternity behind them, older women can pursue more expansive forms of expression. The novelist Isabel Allende verbalized the belief of many when she argued that women escape the servitude of objectification only "with age, when we become invisible and are no longer objects of desire."

But like Allende, the elderly women in *Grand Finales* never succumbed to invisibility and were often the objects of all sorts of desires. They escaped objectification by putting on display their sometimes playful, sometimes perverse, sometimes prayerful but always gritty efforts to transform the last stage of existence into a grand finale. Aging, they prove, need not be equated with decline and loss and contraction, nor should old age be imagined as merely a postscript to the real deal. Women artists from George Eliot to

Katherine Dunham often settled down in one physical location, but they did not settle for less.

―❦―

ALL BUT ONE of the subjects in *Grand Finales* managed to beat the odds, for many of the most famous women artists did not live into old age. Historically, the tension between being a woman and being an artist took a terrible toll—even in the realm of writing, which was the easiest of the male-monopolized arts for women to crack because it was cheap and could be undertaken privately. The superstars of women's literature tend to be the early fated.

Dead by suicide at thirty, Sylvia Plath never witnessed the celebrity that *Ariel* (1965) would bring her for poems protesting her confinement within patriarchal structures that threatened to deform her aesthetic ambition. So compelling was Plath's suicide that the poet Anne Sexton admitted to feeling envy at being bested by her rival, before she killed herself at forty-five. Both of their careers bolstered the myth of the early-doomed creative genius. Until relatively recently, being a woman and an artist made for contradictions that could be deadly.

Growing old as a female writer was blocked by a number of impediments beyond the friction between domestic roles and aesthetic ambition, including the mortality rates of reproduction and chance disasters as well as economic and racial barriers. As a young woman, the feminist polemicist Mary Wollstonecraft attempted to kill herself by throwing herself off a bridge into the Thames, but she survived and married happily, only to end up dead within a year at the age of thirty-eight. A few days after she gave birth to the future author of *Frankenstein* (1818), Wollstonecraft suffered puerperal fever, possibly caused by blood poisoning when physicians removed the placenta. They could counteract the painful symptoms of lactation only with puppies brought in to draw the milk from her breasts.

A more grotesque death is hard to imagine; however, her American counterpart suffered an untimely end almost as disturbing. Mar-

garet Fuller felt miserably deprived of emotional fulfillment as she established her intellectual reputation in New England among the Transcendentalists. After she found a compatible lover in Italy and decided to bring him and their daughter back to America, their ship smashed into a sandbar during a storm, just outside of New York's harbor. Fuller was dead at forty years of age.

Some of the most notable nineteenth- and twentieth-century women writers—Jane Austen, Emily and Charlotte Brontë, Elizabeth Barrett Browning, Emily Dickinson, Kate Chopin, Katherine Mansfield, Virginia Woolf, Lorraine Hansberry—did not grow old, even if by "old" we take into consideration the contracted life expectancies of their times. Others with lauded careers stopped producing new work. Still others, like Nella Larsen and Zora Neale Hurston, bore their senior days in obscurity and/or poverty. The fates of these last two serve as a reminder of the critical role played by material conditions and social justice in extending creativity in old age.

Nella Larsen gave up the difficult task of trying to earn a living by writing and returned to a nursing job at the end of her life. By the time she died at seventy-two in her downtown New York apartment, most people did not remember Larsen as a vanguard figure in the Harlem Renaissance. In Alice Walker's essay "In Search of Zora Neale Hurston" (1974), the contemporary author describes buying a gravestone to mark the unmarked grave of another forgotten luminary in the Harlem Renaissance. In her sixties, Hurston barely made ends meet by working as a substitute teacher and a maid before having to enter a welfare home.

The barriers sex poses to artistry multiply when compounded with those imposed by race. Although Larsen and Hurston lived relatively long lives, neither reaped the benefits of their earlier productivity. Their now canonical novels—Larsen's *Quicksand* (1928) and *Passing* (1929), Hurston's *Their Eyes Were Watching God* (1937)—went out of print. The literary trajectories of other ethnic traditions are fairly recent. The generation of Chicana artists who started publishing with Gloria Anzaldúa is beginning to enter old age, but Anzaldúa

herself died at sixty-one after struggling from youth onward with the physical and psychological pain she brilliantly diagnosed. Still other non-White American artists (with Asian and African backgrounds) have only recently begun to make their mark, often in their youth or middle age.

Many of the Anglo-American literary women who survived into a creative old age were White and economically privileged. In contrast to the racial and financial barriers that impeded Larsen and Hurston, consider the material advantages that granted very long careers to such figures as Dorothy Richardson, Rebecca West, Edith Wharton, Dorothy Parker, M. F. K. Fisher, H.D., Penelope Fitzgerald, Agatha Christie, Mary McCarthy, Denise Levertov, Doris Lessing, Grace Paley, Maxine Kumin, Mary Oliver, Ursula K. Le Guin, Ruth Stone, Joan Didion, and Adrienne Rich. A long career empowered each to overcome shame or anxiety over their aesthetic ambition, even as it undercut the myth of the early-doomed creative genius.

Any one of these authors could have been included in *Grand Finales*, as could May Sarton, who made it her end-of-life mission to stress the importance of sustaining creativity in old age. A poet and novelist, Sarton used the titles of her late-life journals to emphasize her absorption with the subject: *After the Stroke* (1988), *Endgame* (1992), *Encore* (1993), and *At Eighty-Two* (1996).

If one widens the scope to other artistic venues and other countries, still more names spring to mind: the pianists and composers Clara Schumann and Amy Beach; the novelist Nélida Piñon; the painters Leonora Carrington, Alice Neel, Carmen Herrera, and Faith Ringgold; the filmmaker Agnès Varda; entertainers from Josephine Baker to Aretha Franklin and Chita Rivera; the cooking guru Julia Child; the Catholic social justice advocate Dorothy Day; sculptors from Augusta Savage to Louise Nevelson and Barbara Hepworth; the modern dancer and choreographer Martha Graham; the conductor Nadia Boulanger; the landscape architect Cornelia Han Oberland; the ballet dancer and artistic director Beryl Grey.

To all these figures, one could add a slew of living women writers whose productive late lives should be studied: Cynthia Ozick, Joyce Carol Oates, Marilynne Robinson, Annie Ernaux, Margaret Atwood, Erica Jong, Alice Walker, Maxine Hong Kingston, Penelope Lively, Isabel Allende, Leslie Marmon Silko, Adrienne Kennedy, Sharon Olds, Fleur Adcock, Julia Alvarez, Amy Tan, and Joy Harjo.

In other fields, too, elders abound: the choreographer Twyla Tharp; painters like Luchita Hurtado, Judy Baca, and Joan Semmel; the assemblage artists Betye Saar and Judy Chicago; such sculptors as Lynda Benglis, Michelle Stuart, and Yayoi Kusama; and performers like Patti Smith, Barbra Streisand, and Lily Tomlin, as well as the photographer Annie Lebovitz, the classical pianist Mitsuko Uchida, performance artists like Marina Abramović and Joan Jonas, the textile artists Olga de Amaral and Isabella Ducrot, the architect Yasmeen Lari, and the primatologist-author Jane Goodall. Many of our favorite actresses are over sixty. No, the figures in *Grand Finales* are not anomalous. Nor are they representative, for all these creative elders deserve our attention as individuals.

Not all long-lived writers change their tunes, and sometimes we would not want them to. In the sixty-six whodunits that Agatha Christie published, her plots feature red-herring suspects brushed aside at the end by detectives who reveal how they nabbed the unlikely but decidedly guilty party. Joyce Carol Oates's 2024 novel *Butcher* is as frightfully unnerving as the fiction she began publishing in the 1960s. Neither inventiveness nor productivity declined as Agatha Christie and Joyce Carol Oates aged. In 2022, Adrienne Kennedy had her Broadway debut at ninety-one, but she had seen her surrealistic plays staged in theaters since 1964, at the age of thirty-two.

On a quite different trajectory, one undertaken by late bloomers, Laura Ingalls Wilder published the first book in her famous series, *Little House in the Big Woods* (1932), when she was sixty-five. Grandma Moses (Anna Mary Robertson Moses) started painting in her seventies and published her autobiography in her nineties. Penelope

Fitzgerald produced her most prized novel, *The Blue Flower* (1995), when she was seventy-nine. One art historian calls the assemblage sculptor Louise Nevelson "the patron saint of late bloomers." I would give that encomium to the Cuban American abstractionist Carmen Herrera, who gained critical attention when she was one hundred. Late bloomers serve as dramatic proof that, as scientific studies tell us, "the cognitive abilities we lose as we age are offset by abilities we acquire up until the end of our lives." The more we know about aging the less we accept depressing assumptions about its miserable incapacities.

Just as important, the more we know about old age the less we accept normative notions about what constitutes a good old age. It is generally assumed that a good life forms a coherent, integrated storyline or arc, one that its subject narrates as she lives it. In this paradigm, it is also generally assumed that the storyline or arc peaks in the prime of life—hence its name—before declining in a retrospectively self-satisfied old age. The case histories in *Grand Finales* do not merely complicate this idea: they topple it.

Few of the artists I study view their own lateness as a hard-earned resolution of issues that had baffled them earlier. Many, instead, question their earlier assumptions. For some, old age becomes a last-ditch effort to attain joy after passages of sorrow or upheaval. For a number of these, old age emerges in an elongated state of heightened creativity that ends only when older old age dictates less strenuous undertakings. Old age does involve retrospection, but rarely self-satisfied retrospection, as earlier projects are critiqued or reconfigured. Judging from my subjects, many aged people digress from their earlier storyline, branching out into different directions. Quite a few old dogs do learn new tricks.

The English word *senescence* is based on the Latin word *senex*, "old man," as is the word *senility*. Showcasing creative elderly women shatters ingrained assumptions about the superannuated, a word that conflates the old with the obsolete who have inexplicably (and perhaps toxically) survived beyond their expiration dates.

SINCE *Grand Finales* examines the lives and art of aging women, each chapter consists of a biographical account interlaced with extended interpretations of the artworks created in the years during which each individual felt herself to be inhabiting the last stage of her existence. I will be appraising how that work reconfigures earlier achievements or veers away from them, and also how late-life work comments upon aspects of the aging process. Because it can be difficult to describe a person's old age without references to her earlier life, some of my case histories truncate those earlier periods before they explore the final decades.

The classifications that contain women artists here—Lovers, Mavericks, and Sages—are meant to be very porous. Quite a few of the women featured in *Grand Finales* could be characterized as lovers, mavericks, and sages, all rolled into one. Yet these section titles gesture toward resourceful roles that provide antidotes to the multiple pangs of aging. Such roles resist historically prevalent (if happily crumbling) stereotypes. The late-life lover who used to be called Lady Wishfort—a lascivious widow in William Congreve's *The Way of the World* (1700)—is today (just as unfortunately) called a MILF (mother I'd like to fuck) or a cougar; the late-life maverick was demonized as a witch, crone, or harpy; late-life sages were labeled and libeled as schoolmarms, viragos, hags, bags, or battle-axes. The denouements of the women who subverted these stereotypes provide captivating testaments to the longevity of aesthetic ambition.

In the first section of *Grand Finales*, "Lovers," I consider artists whose unions with younger men empowered them to cope with grief over dead or unfaithful partners, the logistics required to ensure the circulation and value of artistic productions, and physical incapacity. Section II, "Mavericks," centers on artists whose quirky costumes and artworks suggest that the elderly engage in altered perceptions and performances of gender and sexuality. In Section III, "Sages," I

turn to artists who swerved from their earlier careers and embarked on pedagogic ventures to promote racial justice.

Finally, the conclusion addresses the visionary old age of contemporary artists who, along with their predecessors, enable me to speculate on the living arrangements and attitudes that can sustain a creative old age in us humbler creatures. Because many of the elderly women discussed in these pages limited their social interactions to preserve the energy that they needed to produce their artwork, I keep the artwork front and center as a window into my old ladies' sense of themselves.

The lives of these artists illuminate the aging process, but in ways that do not always align. Some testify to the powerful sexual agency that aging can confer, whereas others discover in aging a freedom from sexuality more thrilling than orgasm. Quite a few believe that seniority empowers them to mentor the young, but one concedes that mentoring can end up manipulating younger people as pawns. Some view themselves as relics of a dying generation, while others see themselves as bridging generations. In their artworks, too, they present startlingly different perspectives on longevity.

Often, they suggest, eccentricity can be a cherished license furnished by old age. Many elders feel that they can reap the benefits of having paid their dues to conventionality. "One of the advantages of being seventy," Agatha Christie observed, "is that you really don't care any longer what anyone says about you." There is a long tradition of portraying the antique as wild, wise oddballs: wanderers, hermits, scamps, and pranksters. In the popular poem "Warning," the British writer Jenny Joseph wants a flamboyant old age to make up for the temperance of midlife. She will wear outrageous colors, gobble samples in shops, and learn how to spit. The last stage of life will release her from the staid customs that govern a middle age in which she needs to set a good example for the children.

Quite a few of my subjects cultivated an aura of singularity to attract attention to themselves and their creative endeavors: they trademarked their old age with distinctive hairdos or shoes, capes

or caftans, hats or turbans. Besides contesting the invisibility of old ladies, their costumes offset the body dysmorphia that can accompany aging. Although physicians mostly diagnosis body-image anxieties in adolescents, plenty of seniors avoid mirrors and cameras, negatively compare their bodies to younger versions of themselves, undertake successive diets, sign up for cosmetic surgeries, or try to hide the wrinkles, sags, or disabilities of aging. Body dysmorphia, intensified by a youth-oriented culture, can breed agoraphobia. The fear of being seen in public, especially if coupled with mobility issues, quarantines some of the aged. But even when my old ladies suffered from these sorts of disorders, they flaunted the markings of age.

Not only were the artists in *Grand Finales* eccentric, the loose grouping of Lovers, Mavericks, and Sages also fails to register a major factor in the lives of creative elderly people, one that unites them all: namely, their profound sense of connectedness to something other than and outside the self. Indeed, a sense of connectedness appears to be one of the keys to a creative old age. All of my subjects felt deeply committed to other human beings or to the past or to a place or to a religious, racial, political, or artistic community, or to the future of the planet. This sense of being conjoined and dedicated (to something other than the self) generates desire and hope: a desire to continue working for whatever it is that one has been committed to and the hope that doing so will gain immortality for the work itself and its sponsor.

Unexpectedly, that sense of connection rarely pivots on children or grandchildren. More than half of my subjects had children, stepchildren, or adopted nieces and nephews, about whom they cared and sometimes cared deeply. Yet functioning as a mother or grandmother or aunt seems to play a subordinate role in a creative old age, whether one is married, divorced, widowed, or single. Nor (until recently) do children, stepchildren, nieces, nephews, or grandchildren surface as significant facilitators of (or topics in) most of their artwork. The sense of connection crucial for a creative old age, in other words, is rarely familial.

An awareness of being connected (to a personal past or an impersonal future, a particular place or community) motivates artists, for the process of engaging in artwork functions as glue or adhesive: a means of securing the attachment. Predictably, many of the inhabitants of Little-Old-Lady-Land exhibit a profound feeling of connectedness to the art form they practiced in the past and seek to continue reinventing in the present. A project related to that art form provides a rationale for ongoing existence: one needs to continue living in order to complete it. Regardless of its medium or scale, the artwork becomes a raison d'être.

If, as Leonora Carrington hinted, people under seven and over seventy share traits in common, it could be argued that the artwork functions like a security blanket or a stuffed animal. Engaged and daily involvement in the process of producing the aesthetic project alleviates loneliness, even as it stimulates curiosity and playfulness. A very old woman writer in Alice Elliott Dark's novel *Fellowship Point* (2022), who "was never lonely when she was in a book," believes that her memoir has become "my transitional object into the grave."

Positing the equivalence of the artwork and the security blanket or stuffed animal might strike some as disturbing. Throughout its long history, old age has been conflated with "second childishness." The analogizing of old age with infancy can be demeaning and demoralizing. Sans teeth, sans hair, sometimes unable to dress or feed ourselves, old people have no desire to be infantilized. Actually, we have every reason to resist infantilization with all its trimmings: dependency, speechlessness, incontinence.

However, comparing the artwork to a toddler's beloved transitional object—it can be picked up, put down, and then picked up again—illuminates the fundamental usefulness of creativity in old age. The work-in-progress becomes an always available companion in an alternative reality, and an inspiration for fun and games. Residing within the alternative reality of the controllable work-in-progress cocoons its creator from an uncontrollable here-and-now.

"The minute I sat in front of a canvas," Alice Neel said, "I was happy. Because it was a world, and I could do as I liked." She was eighty when she painted *Self-Portrait* (1980), a picture of herself seated naked in a striped upholstered chair—with white hair, sagging breasts, a distended belly, and a paintbrush in one hand. The pleasure of painting the picture distanced Neel from her aging body. The creative project comes from the artist, but also from inspiring forces often not consciously understood or regulated, as it takes on a reality of its own.

When formal constraints become an inspiration, the artwork elicits responses from the artist and a different conceptualization of their relationship surfaces. The aesthetic project becomes a "not-me" strongly attached to "me" even when we view the artwork as a resource not in re-creating but in de-creating the artist by providing a release from the self's prison house. The materials out of which the artwork is composed, as well as the process involved in working with those materials, require attentiveness. The materials—words and pens/keyboards, paints and brushes, rocks and chisels, notes and instruments, motions and the human body, needles and fabric—are governed by their own implacable laws and complex techniques. The practice of executing those laws and of applying or modifying those techniques elicits undivided concentration.

In *The Sovereignty of Good* (1970), the philosopher and novelist Iris Murdoch argued that the intractability of materials and the attention they require in the process of working with them pertain to their value:

> If I am learning, for instance, Russian, I am confronted by an authoritative structure which commands my respect.... My work is a progressive revelation of something which exists independently of me. Attention is rewarded by a knowledge of reality. Love of Russian leads me away from myself towards something alien to me, something which my consciousness cannot take over, swallow up, deny or make unreal.

Murdoch identifies language acquisition as "an occasion for 'unselfing'" sorely needed in order to liberate ourselves from His Majesty, the ego.

Since "Our minds are continually active, fabricating an anxious, usually self-preoccupied, often falsifying *veil* which partially conceals the world," Murdoch believed, unselfing is virtuous: "anything which alters consciousness in the direction of unselfishness, objectivity and realism is to be connected with virtue." For a number of my subjects, their art form functions like a second language and their art-making is motivated by a love of learning more about their art form that "leads me away from myself."

Virtue is an honored goal, but utility speaks in a louder voice. Whether we conceive of the artwork as re-creating or de-creating the artist, the artist and the artwork remain intimately connected and the work-in-progress elicits rapt concentration that involves setting aside worries about a hand or tooth or bladder that seems to be going kaput. The enchantment of discovering how to begin, engage in, or complete the project-in-progress sidelines nagging frets about shambolic deterioration, when any organ of world-wearied flesh can malfunction and often does.

The aesthetic project alleviates vulnerabilities resulting from physical and emotional losses—as well as anxieties about vulnerabilities—no matter what form or medium it takes. From George Eliot and Katherine Dunham to contemporaries like Yayoi Kusama and Margaret Atwood, aging women artists had to deal with often painful disabilities and with grief resulting from the deaths of intimates. In this state, undertaking an artistic project assuages or deflects apprehensions about fearful helplessness and frightful loneliness. It stimulates absorption, inquisitiveness, experimentation, a sense of accomplishment, and, we will see, it promotes all sorts of friendships and social networks.

The proliferation of arts-related therapy programs today is one index of growing empirical research into the beneficial effects of sustained creativity on stress, infections, injuries, and chronic condi-

tions. Participation in arts and crafts may function therapeutically earlier in life too, but the slings and arrows of old age make it much more precious. Like Grandma Moses, who asked for paints in the health facility where she lay dying, some of the elderly women in this book reached for a pen or a brush or a musical instrument when they knew they were close to death.

"I AM NOT sure that anybody has invented old women yet, but it might be worth trying," the wonderful fabulist Ursula K. Le Guin once wrote. There is a modicum of truth in her joke. For the most part, the lives of elderly women have dropped out of public awareness. The question that Harriet Beecher Stowe posed back in 1852 still pertains today: "Why don't somebody wake up to the beauty of old women?" In Betty Friedan's 1993 book on aging, one interviewed woman expressed the complaints of many: "We have no role models." Quite a few of Le Guin's contemporaries set out to prove, as she did, that beauty and creativity can flourish in the last decades of life.

The elderly artists inventing old women these days are not saints. Nor were their precursors, the aged women of the past whose efforts to invent themselves have gone largely ignored. Some of the subjects in subsequent chapters shamelessly promoted or isolated themselves, overate or starved themselves, or suffered from manic or depressive episodes. A few were imperious, others irascible. Paradoxically, they are role models precisely because they were not paragons. Nor were their passages into old age always exemplary. "Wisdom is a virtue of old age," the political philosopher Hannah Arendt once observed, "and it seems to come only to those who, when young, were neither wise nor prudent."

Different as they are, the old women in the chapters that follow share an in-your-face audacity that bespeaks a drive to keep on realizing one's own potential, a wonderful antidote to incipient geezer

catatonia. Ongoing creative work suffuses their last years with a sense of meaning. They know who they are and what they are doing with their lives by means of their projects-in-progress. A truncated future infuses their days with intensity and integrity: there simply isn't enough time left to dither about what one wants to do, to lie to oneself about what one desires, to pretend to be other than who one is.

Recognition of a foreshortened future ignites and fuels a determination to blaze in the present of old age. The German word *Torschlusspanik*—"last-minute panic"—conveys the fear of time running out that can act like adrenaline, sending one into overdrive. Despite the renown of my subjects, they may not be atypical in this regard. The director of the Stanford Center on Longevity, Laura L. Carstensen, argues that as most people age, "we sense the clock winding down and our attention shifts to savoring the time that is left" and to "a smaller set of goals." Though I like to believe that my old ladies' intensity about their goals will be inspiring, the inventive endgames of women artists are fascinating in their own right, for each one searches out unique ways to enhance the last stage of existence.

For many of them, old age did not devolve into a (generally assumed) dimming and drooping, but rather it involved a ratcheting up of personal, political, spiritual, or aesthetic zeal. Creative activity accelerates when some of the subverting insecurities, self-censorship, and ventriloquizing of youth dissipate, during a period of time when public recognition may also boost confidence. The subjects of this book prove the veracity of Yogi Berra's truism: "It ain't over till it's over." Taken together, they suggest that the last stage of life can become a passage of renovation and reinvention, if not rejuvenation. This is the case for even the most anomalous artist in this book, George Eliot, who did not really make it into old age but who is included here because her last publication and decision have puzzled so many of her devoted readers.

Georgia O'Keeffe's youthful companion said of her what can be

said of each of the women in *Grand Finales*: "She didn't want anyone to be pitying her. She wanted to continue her work. And if she couldn't paint, well then she was going to write. And if she couldn't write, she was going to walk. And if she couldn't walk, she was going to swim." Like a concluding moment in the memoir of ninety-six-year-old Martha Graham, their life stories seem to issue in a question that is also a boast: "But what is there for me but to go on?" Toni Morrison's words about aged Black women in the rural South also pertain to my cast of characters: "They were old enough to be irritable when and where they chose, tired enough to look forward to death, disinterested enough to accept the idea of pain while ignoring the presence of pain. They were, in fact and at last, free."

Free to steer by their own lights. No longer conforming to the conventions governing their upbringing and no longer embroiled in youthful rebellions against those conventions, the artists in *Grand Finales* teeter on the cusp of existence, emblazoning a message about creativity's capacity to deliver new wine into old bottles. A willingness and ability to change in response to the losses of aging turns out to be another key factor in establishing a creative old age, as we will see. Needless to say, the luck of not experiencing a massive stroke or heart attack, a malignancy or the onset of dementia, cannot be discounted. But it is not the sturdiest who survive and thrive, or the most intelligent or the happiest, but the ones most responsive to change. Increasingly, the odds of devising a creative old age are good, though the goods are odd.

Section I
LOVERS

For centuries, old ladies were supposed to be ladylike, whereas the lusty appetites of old men have generally been taken for granted. Transgenerational liaisons have always been a highly visible way for older men to gain validation. They are still sexually potent enough, physically attractive enough, economically or intellectually powerful enough to entrance a girl. Yet older women paired with boys have generally elicited derision or disapproval. Consider Mrs. Robinson Syndrome, which types the older woman as a seductive but predatory cradle-snatcher—or, worse yet, the fates of Jocasta and Phaedra, both of whom hanged themselves (one after discovering that the younger man she loved was literally her son).

By the time George Eliot, Colette, and Georgia O'Keeffe established relationships with younger men, they had attained the magnetism that accompanies growing fame: Eliot and Colette as novelists, O'Keeffe as a painter. Banking on that celebrity, all three were proving that they were sexually potent enough, physically attractive enough, economically or intellectually powerful enough to entrance a young man. Their late-life partnerships manifest their common desire for intimacy and companionship in old age. Yet the decision to act on their wants was inflected differently by the earnest Victorian, the outrageous Francophile, and the staunch American.

Eliot embarked on a late-life marriage to a much younger man in an attempt to weather a series of crises that threatened to undermine her faith in humanity. Colette sought to disengage from the submissive sexuality of her youth, to become not the subordinated but the dominating partner. O'Keeffe also toppled the debilitating sexual politics at play at the start of her career. All three turned to much younger men after prior relationships had dissolved. Taken together, their case histories suggest that the last stage of existence can release women from the heartaches of grief or sexual abjection.

While Eliot's story clarifies the despair that aging can activate and the gumption needed to counteract it, Colette's suggests that old age furnishes women an emancipation from a range of unsatisfying sexualities. However, O'Keeffe did not need a younger man to get over the loss of an older man. She freed herself from a draining marriage by relocating alone to a place of her own. Indeed, O'Keeffe's trajectory clarifies the transporting ecstasies that can surpass the pleasures of human companionship in late life. After replacing a beloved husband with a beloved place, she forged an alliance with a young man only in much older old age.

Still, in different ways, the late lives of all three illustrate the longevity of love during "the downswing of time." These words, from Charlie Smith's poem "The Meaning of Birds," characterize the physical decline experienced by Eliot, Colette, and O'Keeffe in an aging process that nevertheless led them to exemplify what it means to take the sort of advice Smith advances at the conclusion of his poem: "Perhaps it isn't too late / to make a fool of yourself again," to express "one more cracked rendition of your singular, aspirant song."

Although one can only speculate about the writing George Eliot might have produced in the happy old age she tried to invent for herself, both Colette and Georgia O'Keeffe—with the support of the younger men who helped make their last years a delight—kept on producing renditions of their singular perspectives in artworks that testified to their ongoing capacity to appreciate the wonders of the world.

CHAPTER I
George Eliot

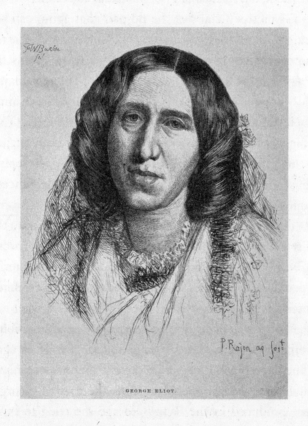

GEORGE ELIOT.

A LESS AUSPICIOUS honeymoon is inconceivable. Sixty-year-old George Eliot celebrated her wedding to forty-year-old John Cross with a sojourn on the Continent that included a stay in Venice. On the morning of June 16, 1880, while she discussed his weight loss with a physician, Cross hurled himself off their hotel balcony into the Grand Canal. For a woman whose ears were finely attuned to minute shifts in tone, mood, and consciousness, the splash must have been deafening. Yet neither George Eliot's letters nor her journal entries mention the event. After gondoliers fished Cross out of the water and returned him back to their rooms, the couple summoned his brother and traveled with him through Germany before returning to England, where Eliot would die of natural causes seven months later.

The "sniggering explanation" that circulated in the gentlemen's clubs of Victorian London insinuated "that Cross was so overwhelmed by having to make physical love to an ugly old woman that he preferred death to intercourse." Long afterward, too, academics smirked when telling this story in classroom discussions that might seem unimaginable today. Given the twenty-year age gap in the Eliot–Cross partnership, scholars of nineteenth-century literature—mostly men until recently—were apt to suggest that the aged bride must have been mortified by the groom's sexual fright. With more than a smidgen of misogyny, they assumed that John Cross was repulsed by George Eliot's decrepitude.

However, such a retrograde response obscures the sense we get from both George Eliot and John Cross that their marriage, albeit brief, was a remarkable success. What if we ditch the historical baggage that led to the maligning of the romantic or erotic desires of older women and instead factor in the acuity of George Eliot, who had by this time established her reputation as one of England's greatest novelists? On the spot in Venice, it seems, Eliot determined to

help her younger husband get on with their partnership. "What do we live for," she had asked in her most esteemed novel, "if it is not to make life less difficult to each other?"

The union nevertheless raises many questions. Why did Eliot entertain a marriage proposal less than a year after the death of George Henry Lewes, the beloved mate who enlivened the decades in which she produced some of the greatest novels in English, from *Adam Bede* (1859) and *The Mill on the Floss* (1860) to *Middlemarch* (1871–72) and *Daniel Deronda* (1876)? What was her mindset before the wedding, or her motivation? Eliot's decision to marry is interpreted in contradictory ways by the biographers, critics, and novelists who have written about it. Most imply that it issued from a vulnerable woman aware of her need for a protective man, though a few lone voices argue that it came from a powerful authority who steered by her own lights.

But why choose one explanation over and against the other, given an author talented in depicting the entangled motives of her heroes and heroines? If we grant George Eliot the same complexity that she gave her characters, there is quite a bit of evidence to suggest that the conjugal decision grew out of the despondency she suffered in the years before she made it, when she was in her late fifties. While living with Lewes, dealing with a host of health problems, and writing her last book, Eliot grappled with despair about the culture she inhabited: a breakdown of faith in the humanism that had anchored all her previous publications. Her final publication, *Impressions of Theophrastus Such* (1879), expresses the profound disillusionment of its ailing author. Then the death of George Henry Lewes catapulted Eliot into a desolate life-in-death. Aware of her extreme vulnerability, she soon risked embarking on a new identity with the couple's friend John Cross.

George Eliot knew all about the risks of new identities. The multiplicity of her names manifests that fact as she evolved over time: Mary Ann Evans, Marian Evans, Marian Lewes or Mrs. Lewes, her male pseudonym, and finally (after the wedding) Mary Ann Cross. In

her last years, she also signed letters as Mutter or Madre or Mother (to Lewes's children); as M.E.L. and Polly (to intimates); as Aunt (to Cross) and later as Beatrice, the beatific power who guides Dante toward salvation. This last signature hints that far from being a distressed damsel in need of a rescuing prince, George Eliot realized her own power.

George Eliot's late-life marriage to the man she had earlier called "Nephew" illuminates two impulses within the aging artist: the need for love as well as the equally urgent desire for authority. At the end of her life, after experiencing an intellectual crisis of faith and then an emotional crisis of grief, George Eliot gained sovereignty by acknowledging her neediness as she embarked on a daring story that she would never publicly tell. Indeed, she was so tight-lipped about it that one must shut the biographies and open more imaginative accounts of her life in order to glimpse the happily-ever-after George Eliot tried to construct for an old age she would not attain.

FIVE YEARS BEFORE the marriage to John Cross, George Eliot was ensconced in a loving but unsanctioned union with George Henry Lewes. By 1875, they had been residing together in a scandalous partnership for over twenty years. Lewes had been unable to obtain a divorce from his wife, Agnes Jervis. According to the law, he had implicitly condoned his wife's adultery by continuing to support her as well as her legitimate and illegitimate children. Although Marian Evans and George Lewes were exceptionally compatible, it must have taken extraordinary courage to embark on their cohabitation in rule-bound Victorian society.

The unconventionality of her decision inflected Marian Evans's contemptuous view of a novel composed by her contemporary Charlotte Brontë. Whereas Jane Eyre decided to relinquish Mr. Rochester upon learning about his mad wife in the attic, Marian Evans believed that acts of renunciation should serve a nobler cause than

"a diabolical law which chains a man soul and body to a putrefying carcase." She intimates that she would have shipped Bertha Mason Rochester off to an institution and moved into Thornfield Hall.

Condemned by family and acquaintances, Marian Evans knew she would suffer social ostracism. Before the fame attending the publication of her first novels, most respectable people would not visit. Their absence, she claimed, worked on her behalf. The snubs gained her time alone to do the work she had begun with Lewes's support. Quite a bit earlier in life, she had rejected traditional Christianity, believing (to the shock of her father) that the idea of God in the Bible should be understood figuratively as the personification of a fully human ideal of goodness. Out of devotion to her father she agreed to attend services with him, but her radical rejection of Christianity may have prepared the groundwork for her bohemian alliance with Lewes.

Never one to flout polite society, however, Marian Evans asked those brave enough to visit to call her Marian Lewes or Mrs. Lewes. Her temperament teetered on melancholy and self-doubt, his on buoyancy and hilarity. She preferred soulful one-on-one dialogues, while he cracked jokes and recounted risqué stories to larger groups. He was said to look like an ape, she like a horse, but they got on swimmingly. Given the couple's robust commitment to productivity and to each other, the biographer Phyllis Rose pronounced them "the perfect married couple. Only—they weren't married." Marian Evans's brother immediately cut her off.

Unfazed, the two thrived in part because George Lewes encouraged his partner's creative efforts. She had already made a name for herself as a translator and editor. But with Lewes's encouragement, she began composing the stories in *Scenes from Clerical Life* (1857) and then the succession of novels. Her gratitude embeds itself in her pseudonym. George: after George Henry Lewes; Eliot: to L—— I owe it. She was protected from criticism and from tedious paperwork by Lewes, who kept back unfavorable reviews that would have troubled her, suggested ideas for novels, and negotiated print

runs, formats, and payments with her publishers. Her insecurity about her talents—not unlike her distress over what she perceived as her ugliness—would be countered by his protective cheer and keen admiration.

By 1876, the incognito of the pseudonym had long been dispelled. Everyone knew that George Eliot was Marian Evans and that Marian Evans was Mrs. Lewes. *Middlemarch* and *Daniel Deronda* had made her a celebrity whom people of the highest rank wanted to meet. In that year, the son of the couple's friend Anna Cross, Johnny Cross, found Lewes and Eliot an ivy-covered country home, the Heights in Surrey, a one-hour train trip from London and close to the Cross family home. Either there or in the Priory, their city place, Lewes and Eliot led social lives: theater outings, musical parties, museum visits, readings, concerts, Sundays at home attended by the likes of Alfred Tennyson, Robert Browning, Anthony Trollope, Ivan Turgenev, and Richard Wagner, whose wife's father, Franz Liszt, had played the piano for them many years earlier.

If Lewes's gout or piles and her headaches or pains from kidney disease did not interfere, "Nephew Johnny" engaged them in lawn tennis in the country or badminton in the city. After John Cross hosted a dinner, Henry James wrote that he found Lewes "personally repulsive; (as Mrs. Kemble says, 'He looked like he had been gnawed by the rats'—& left), but most clever and entertaining."

During what turned out to be their last summer together, Lewes sang through the tenor part of *Barber of Seville*—accompanied by George Eliot on the piano—though at this point he might have guessed that he was dying. Within the newly refurbished Heights, George Eliot was working on *Impressions of Theophrastus Such*, whenever her attendance on Lewes allowed. Back in London, his last letter to her publisher, John Blackwood, explained that the enclosed manuscript by George Eliot was "*not* a story." It was, rather, an essay collection supposedly authored by one Theophrastus Such, who has generally been interpreted as George Eliot's persona or mask.

Certainly, the odd name puts a distance between George Eliot

and what is written in the book, just as her pseudonym did at the start of her career. She wanted that removal. As her celebrity grew so did her desire for privacy, her dislike of biographies, her suspicion of fans, and her fear that letters might be used after her death to sully her reputation. As for the unusual first and last name of her narrator, Theophrastus of antiquity wrote character sketches of various types of people. Each begins with the phrase "such a type who..." And so it is supposed that this Victorian Theophrastus is "such a type who" lives as an erudite bachelor in London with one publication to his name and a disposition that makes him extremely sensitive to his own and others' failings.

Except for its astonishing last two essays, *Impressions of Theophrastus* is an unpleasant book that I would not recommend to readers, but it provides insight into Eliot's late-life intellectual crisis. Her final book stands in marked contrast to her earlier work not only because it consists of essays instead of fiction but also because it expresses a startling disenchantment with her earlier ideals.

Impressions of Theophrastus Such consists of a series of recondite pieces in which the scholar Theophrastus Such serves only intermittently as George Eliot's mouthpiece. Adorned with many fantastic conceits and caustic jibes, the essays are populated by human figures wadded with the stupidity she had decried in earlier novels, but here unable to break out of the solipsism such padding promotes. Unlike those novels, *Theophrastus Such* expresses her estrangement from her own society and hopelessness about its future. By her late fifties, George Eliot's congenital melancholy seemed to be plunging her into a funk.

In one letter to her "dearest Nephew," John Cross, Eliot intimates that she may have started to write essays because novel writing was taxing her health. Would John Cross have his aunt healthy on the tennis court, she asks him, or "an aunt who remained sickly and

beckoned death by writing more books?" If he chooses the former, she realizes, he will seem not to care about her writing; if the latter, he will seem to have no affection for her. "It is impossible to satisfy an author," she concedes. Did Eliot undertake an essay collection because her last novel, *Daniel Deronda*, had taken too much of a toll? Perhaps she was drawn to satire because she wanted to let off steam about criticism of that novel's Jewish plot.

In any case, Theophrastus mocks the delusional self-mythologizing of his contemporaries in prose that puts on display his own (somewhat pedantic) knowledge: elliptical sentences, arcane scientific terms, and untranslated foreign idioms abound. Here's the view of the book's most recent editor: "the difficulty of the cultural allusions," "its elusiveness," its "contorted sentences, ambiguous quotations, incessant puns," and "the mysteriousness of names, the sense that arcane jokes are being made" add up to an atmosphere "of exclusivity and elitism." Not unlike the nitpicker Casaubon in *Middlemarch*, Theophrastus/Eliot sounds like a learned but testy grump.

Although George Eliot was not really old by the lights of her day, in *Impressions of Theophrastus Such* the sarcasm of a crank produces a hyper-scholastic complaint that society is going to hell in a handbasket. Given her trademarked product—novels about everyday mishaps, thwarted ambitions, and reversals of fortune that evoke sympathy from narrators, characters, and readers alike—*Impressions of Theophrastus Such* took courage to compose. Its short (if not short enough) sketches are peopled not by compassionately rendered characters but by debunked caricatures.

The first two essays of the volume might strike readers as coherent with her fiction. But starting with the third chapter, "How We Encourage Research," Theophrastus censures the pettiness, folly, competition, complacency, and professional one-upmanship of his acquaintances in a despoiled cultural marketplace. "How We Encourage Research" intimates that some "research" should be discouraged since it has nothing to do with real intellectual inquiry and everything to do with jockeying to establish a reputation. The

journalist Proteus Merman (a name alluding to a god who changes shape and a male mermaid) gets some cockamamie idea that the preeminent scholar Grampus "is all wrong about the Magicodumbras and the Zuzumotzis" (whatever those terms mean) and that he can set the intellectual establishment straight. Obsessed with disproving Grampus, Merman publishes his speculations and finds himself the butt of jokes.

Merman remains wedded to his countertheory; however, academics and preachers slander him, turning him into a figure of fun. Convinced of the rightness of his idea, he suffers when his brain becomes "a registry of the foolish and ignorant objections made against him" and his loyal wife has trouble paying the bills. By the end of this sendup of a maligned monomaniac obsessed with arcane disputes, Merman seems to have "gone through a disease which alters what we call the constitution."

That this is one of the more amusing character sketches in *Impressions of Theophrastus Such* speaks volumes. A curmudgeon, Theophrastus picks up the disease imagery later in the volume in an essay reminiscent of George Eliot's much earlier "Silly Novels by Lady Novelists" (1856). Theophrastus diagnoses the "chronic ailments that come of small authorship" in a case study of one ridiculous lady author, Vorticella (a name alluding to a single-celled organism). Her illness turns out to be a magnified sense of self-importance that oppresses all her acquaintances. Vorticella's entire being is fixated on the single issue of her (puny) fame.

Vorticella has a bound book of all the reviews of her one published magnum opus that she thrusts into the hands of her visitors and insists on discussing ad nauseam until like Theophrastus they flee her oppressive presence. He likens the narcissism of minor authors to a "fungous disfiguration, which makes Self disagreeably larger." And while he had supposed this sort of bloated ego was "most common to the female sex," he concludes that it blights both sexes: "A man cannot show his vanity in a tight skirt which forces him to walk sideways down the staircase; but let the match be between the

respective vanities of largest beard and tightest skirt, and here too the battle would be to the strong."

The novelist lauded for generously attentive depictions of fallen, flawed, or injured creatures produced in *Impressions* send-ups of one man who sneers at the greatest poets and philosophers while producing no poetry or philosophy of his own and another man who listens with rapt attention to commonplaces as if they were being issued by the Delphic oracle. A company of more knaves and fools follows, including a man who appropriates other people's philosophic or scientific ideas with his "non-acknowledgment of indebtedness." Theophrastus opines about an aging dandy who fancies himself still young, and prolix writers who resemble excessive talking heads, and stupid Melissa who thinks a man moral because he has a reputation as a fine family man when his business involves swindling his customers.

Eliot's character sketches are finicky, convoluted, not worth all the translation work and footnote checking that they require, chockablock with zany zoological references to wasps, badgers, bears, bees, apes, skunks, muskrats, and pelicans—critters that sometimes come off as superior to humankind. Here resides a clue to why the book may have been worth her precious time to write, or so the last two chapters suggest. They represent a sort of philosophical breakthrough for George Eliot, albeit a vertiginous one. The pessimistic insights of the last two essays demonstrate that her prized sense of compassion for errant humanity had worn itself thin. Eliot was beginning to entertain suspicions about the capacity of human beings to improve themselves and the worlds they inhabited. Cynicism was in the process of unraveling her famed humanism.

PUT ANOTHER WAY, Eliot was developing a critique of anthropocentrism. "Shadows of the Race," the penultimate essay in *Impressions of Theophrastus Such*, presents a dialogue between Theophrastus

and an interlocutor about the advancing sophistication of machines. His debater optimistically argues that sophisticated machines will serve the human race to promote progress, whereas Theophrastus thinks instead that "steely organisms" will supplant and supersede human beings.

Machines will evolve to repair and reproduce themselves as they do the work on the planet "better than we could do it, but with the immense advantage of banishing from the earth's atmosphere screaming consciousnesses which, in our comparatively clumsy race, make an intolerable noise and fuss to each other about every petty ant-like performance." In the future envisioned by Theophrastus, mechanical automata will communicate better without the "fussy accompaniment of that consciousness to which our prejudice gives a supreme governing rank, when in truth it is an idle parasite on the grand sequence of things." Human beings, who pride themselves on their superiority, remain deluded about their minuscule role in the cosmos. With prescience, Eliot was envisioning what we now call AI: intelligent machines with astonishing computational capacities that dwarf the brains of pesky human beings.

In an apocalyptic posthuman world, survival of the fittest means the end of parasitic flesh-and-blood humans who foolishly endow themselves with preeminence, the beginning of a "more powerful unconscious race." That this posthuman era is heralded by a thinker who had earlier found divinity in acts of human kindness is shocking. After a midlife celebrating humanity's capacity for restoration, a disheartened Eliot seems to be saying that maybe the earth would be better off without the human of the species. Just as she had earlier questioned the existence of God, the older Eliot questions the humanistic faith she had put in religion's place.

If the next-to-the-last essay of *Impressions* demonstrates that George Eliot was witnessing the dissolution of her former beliefs, the last chapter expresses her anger at her countrymen—"the prejudiced, the puerile, the spiteful, and the abysmally ignorant"—who continue promoting injustice and cruelty. Possibly miffed at read-

ers who had disparaged the Jewish plotline in *Daniel Deronda*, Eliot returned to the issue of anti-Semitism with a more scornful conviction about its staying power.

Before composing *Daniel Deronda*, Eliot had immersed herself in the Hebrew language and in historical studies of Judaism. A non-Jew, indeed a nonbeliever, she had befriended Jewish scholars and countered anti-Semitic stereotypes in her last novel. However, her increasingly dismal view of the human species cast in doubt any viable solution for Jews living in the diaspora. Extending her critique of endemic prejudice against the Jews, Eliot knew about her Christian compatriots that "we are a colonising people, and it is we who have punished others."

"The Modern Hep! Hep! Hep!" denounces Christians who should but rarely do realize that Jesus was Jewish or that their every "Amen" manifests the indebtedness of Christianity to Judaism. Its title alludes to the anti-Semitic cry of Crusaders recycled in the anti-Jewish riots of 1819 Germany. Like the curse on Ham, used by slaveholders to justify slavery,

> the curse on the Jews was counted a justification for hindering them from pursuing agriculture and handicrafts; for marking them out as execrable figures by a peculiar dress; for torturing them to make them part with their gains, or for more gratuitously spitting at them and pelting them; for taking it as certain that they killed and ate babies, poisoned the wells, and took pains to spread the plague; . . . for hounding them tens by tens on tens of thousands from the homes where they had found shelter for centuries, and inflicting on them the horrors of a new exile and a new dispersion.

Given the righteous rage of this powerful denunciation, why does the last essay of *Impressions* remain unsettling?

Because Eliot emphasizes how exile has damaged the moral character of Jews. Quite a few Jews "have a bad pre-eminence in evil,

an unrivalled superfluity of naughtiness." The assimilation of immigrants horrifies her: "Let it be admitted that it is a calamity to the English ... to undergo a premature fusion with immigrants of alien blood." The "marring of our speech" with mispronunciations is a "minor evil compared with what must follow from the predominance of wealth-acquiring immigrants, whose appreciation of our political and social life must often be as approximative or fatally erroneous as their delivery of our language."

With its argument based on the boons of a spirited patriotism denied Jews for centuries, this high-minded essay teeters on the brink of fatalism. Throughout, love of country is said to nourish basic virtues in Germans, Italians, and the British. But national pride is precisely what history had robbed the Jews of. Which is why George Eliot became a Zionist before Theodor Herzl published his "Jewish State" pamphlet in 1896 and created the World Zionist Organization in 1897. Expatriated, the Jews—lacking the nobility of nationalism—"may be in danger of lapsing into a cosmopolitan indifference equivalent to cynicism." Eliot therefore calls for "some new Ezras, some modern Maccabees" to make "their people once more one among the nations."

In *Daniela Deronda*, the character Mordecai articulated a passionate yearning to establish a Jewish homeland in Palestine, a project Daniel adopts as he marries his dying mentor's sister, Mirah. But the novel also questions the patriarchal nature of Judaism. First, a benefactor of Mirah's wonders why Jewish women in the synagogue must be seated in a separate section. Then Daniel's Jewish mother explains that she gave him up for adoption as a rebellion against her autocratic father, who thought it "beautiful that men should bind the *tephillin* on them, and women not." Daniel's mother rebelled against her lot—having "a man's force of genius" while suffering "the slavery of being a girl"—in part because her father "cared more about a grandson to come than he did about me: I counted as nothing." Just as important, the character of the pianist Klesmer suggests an alternative to the separatism of Zionism. Intermarriage remains a via-

ble possibility for a musician who enriches British culture with his cosmopolitan roots.

In Eliot's last publication, however, she remains resistant to the idea of assimilation and blind to the misogyny of Jewish orthodoxy. Hers has become a separatist vision only: Jews (who are male) need to go back to where they came from. There is no hope for justice in England and no realization that some Indigenous inhabitants of Palestine might object to the establishment of a Jewish homeland. Without a nation of their own, Jews will always be in danger of occupying an outsider status that can never be fully ameliorated.

And yet... and yet... how amazing that this passionate (if pessimistic) statement issued toward the end of George Eliot's life. What a testament to her intellectual daring, not to mention the ongoing fervor of her ideas. What other Victorian thinker was tackling this deeply inbred societal problem, one very much still alive today both in her own country and throughout the world?

Impressions of Theophrastus Such gives us a window into Eliot's bleak mindset: the floundering of her belief that compassion can puncture myopic parochialism. Maybe she was worn down by physical ailments. Before and after the book's publication, her letters contain references to face ache, irritation of the gums, diarrhea, draughts and chills, swelled eyelids, hip pain, toothache, and bilious influenza. Of these disorders, the renal disease must have been the most excruciating. Kidney pains, sore throats, and headaches distressed her, as did Lewes's rheumatic gout and intestinal cramps.

On November 18, 1878, Eliot wrote, "I am unhappy about my husband, who is grievously ailing. This anxiety spoils all joy, which would otherwise be abundant with me in spite of the world's calamities." A week later, she has "a deep sense of change within, and of a permanently closer companionship with death." On November 29, John Cross left his mother's deathbed to join her and Lewes's son

Charles to discuss investments with the dying man. The death of Lewes the following day shook George Eliot profoundly. She was heard howling in their London house, too devastated to attend the funeral in Highgate Cemetery. Condolence letters went unanswered.

For quite a few months, Eliot would allow visits only from her "son" Charles Lewes and would focus on editing George Henry Lewes's last works and establishing a "studentship" in his name. She signs a letter to her friend Barbara Bodichon "Your loving but half dead Marian." Since Lewes had wanted *Impressions of Theophrastus Such* printed, she decides to have a notice affixed explaining that the book was delayed by the author's domestic afflictions. To John Cross, she writes, "what used to be joy is joy no longer, and what is pain is easier because he has not to bear it." Her "everlasting winter has set in," and she cannot leave their house: "I could not bear to go out of sight of the things he used and looked on." "Each day seems a new beginning—a new acquaintance with grief." While her weight plummets to 103 pounds, she must live "without happiness": "My appetite for life is gone."

In the journal entry on January 1, 1879, the Shakespeare quotation "Here I and Sorrow sit" is followed by other utterances of grief: "For I am sorrow and sorrow is I" (Chaucer) and "wie tot die Welt ihm erscheint! [how dead the world seems!]" (Goethe). Throughout February, severe attacks of "Renal colic" and nausea contribute to her feeling "deeply depressed" or "Ailing and in constant pain," though she begins to accept visits from John Cross, who supplies records of her investments. Between trips to the dentist and to the Highgate Cemetery, she reads proofs of *Impressions*, starts to receive visits from her bevy of women friends, and concerns herself with the fate of a "daughter-in-law" (the widow of another of Lewes's sons) and with Lewes's grandchildren.

Four months after Lewes's death, George Eliot expresses her anger and grief in a letter to Harriet Beecher Stowe: "I am still rebellious—not yet resigned to the cutting short of a full life, while so many half empty lives go on in vigorous uselessness. Submis-

sion will come—but it comes slowly." After an enigmatic entry in her journal on May 16, "Crisis," she relocates to the country, where throughout June she is "Ill and in bed all day."

Still, the sales of *Impressions*—the only book that George Eliot saw through production on her own—proved better than she or Blackwood might have predicted, and she attends with him to reprintings and translations. In July, she accepts the doctors' prescription with alacrity: "Fancy! I am ordered to drink Champagne and am wasting my substance in riotous living at the rate of a pint bottle daily." Amid her lists of the classics she is reading or rereading and the letters she is reading or writing, another cryptic journal entry on August 21, "Decisive conversation," is followed by yet another on October 8: "Joy came in the evening."

Given the obscurity of these references, it is startling to come across the October 16, 1879, love letter to John Cross: "Best loved and loving one—the sun it shines so cold, so cold, when there are no eyes to look love on me. I cannot bear to sadden one moment when we are together, but wenn Du bist nicht da [when you are not here] I have often a bad time." Composed on the black-bordered paper of the widowed, the letter goes on to balance John Cross's lack of erudition against his goodness: "Thou dost not know anything of verbs in Hiphil and Hophal or the history of metaphysics or the position of Kepler in science, but thou knowest best things of another sort such as belong to the manly heart—secrets of lovingness and rectitude. O I am flattering. Consider what thou wast a little time ago in pantaloons and back hair."

Eliot concludes by asking, "Why should I compliment myself at the end of my letter and say that I am faithful, loving, more anxious for thy life than mine? I will run no risks of being 'inexact'—so I will only say 'varium et mutabile, semper' but at this particular moment thy tender, / Beatrice." The archaic "thou dost" and "thou wast" phrasing oddly jars with Virgil's Latin, which in the original means "woman is ever a fickle and changeable thing." The next day, a journal entry—"Meditation on difficulties"—hints at cold feet.

In the biography John Cross produced after George Eliot's death, he explains that throughout that summer and fall he was visiting and encouraging her to play the piano. While he mourned his mother's death and she mourned Lewes's, she served as Cross's teacher; they embarked on a line-by-line translation of Dante's *Inferno* and *Purgatorio*: "The divine poet took us into a new world. It was a renovation of life." Yet Eliot's journal remains oblique. Dental appointments, notices of checks sent to employees and dependents, and visits from the sisters of John Cross are recorded, but she does not disclose what he tells us: that back in the city house in November, they began studying Chaucer, Shakespeare, and Wordsworth together.

The day before the one-year anniversary of George Lewes's death, Eliot reread his letters and packed them away to be buried with her. The day before Christmas, she wrote a second letter to her "Bester Mann!," explaining who was visiting, gossiping about shared acquaintances, and signing off with a joke about his financial dealings. Equally unforthcoming, the journal from January through March 1880 lists checks, visitors, trips to galleries, and dental appointments until April 9: "Sir James Paget [her doctor] came to see me. My marriage decided." The next day there is a reference to looking at a house on Cheyne Walk in Chelsea, the one John Cross would refurbish as their new town house.

On April 13, writing to one of Cross's sisters, Eliot notes that the "*wonderful renewal*" of her life depends not only on John Cross but also on the rest of his family: "now I cherish the thought that the family life will be the richer and not the poorer through your Brother's great gift of love to me." Although the news of her engagement will inevitably surprise or distress some of her friends, "The *springs of affection are reopened in me, and it will make me better to be among you—more loving and trustful*" (emphases mine). To her most intimate women friends, Eliot delayed communications on her decision and mislaid one of the missives.

When, in the last minute, she finally disclosed her wedding plans

to a few in her adoring circle of women friends, Eliot stressed that John Cross was especially trusted by George Lewes, the marriage would not affect the disposition of her property, Cross had his own fortune, and he wished to dedicate his life to her happiness. To Georgiana Burne-Jones, she writes of "a great momentous change" taking place, "a sort of miracle in which I could never have believed, and under which I still sit amazed."

The marriage took place on May 6, 1880, in an Anglican church. Eliot's friend Barbara Bodichon dashed off a gallant note: "Tell Johnny Cross I should have done exactly what he has done if you would have let me and I had been a man." Then, insisting that the marriage was not an act of infidelity, Bodichon added: "If I knew Mr. Lewes he would be glad as I am that you have [a] new friend." It was an inspired response, for Eliot had copied Emily Brontë's poem "Remembrance" during the worst winter of her life. In it, the speaker asks her sweet love to "forgive, if I forget thee / While the world's tide is bearing me along." Brontë's speaker is clearly anxious about dishonoring the dead by moving forward with her life.

FROM THE WEDDING to Eliot's death seven months later, the letters and journal entries furnish quite a few attestations of gladness. At the start of the honeymoon journey, Eliot recounts having "had a delicious six days' happiness" and describes her "delight" at witnessing "Johnnie's rapture at the sight of La Sainte Chapelle." In Lyons, she finds herself "wonderfully well and able to take a great deal of exercise without fatigue." In his biography Cross agrees about her vigor: "During the eleven years of our acquaintance I had never seen her so strong in health." From Grenoble, she exults that "marriage has seemed *to restore me to my old self. I was getting hard, and if I had decided differently I think I should have become very selfish*" (emphasis mine). In Milan, to the Cross family, she describes the honeymoon as "a chapter of delights," though "Johnnie has taken cold" and "is thinner": "we

seem to love each other better than we did when we set out, which seemed then hardly possible."

It was a "great joy" to receive congratulations on the marriage from her brother, who had excommunicated her after her union with Lewes. To one correspondent, Eliot reiterates her earlier comment that "the springs of affection are reopened," intimating that the marriage rescued her from the cynicism underpinning *Impressions of Theophrastus Such* and the solipsism of the grieving process: "The whole history is something like a miracle-legend. But instead of any former affection being displaced in my mind, *I seem to have recovered the loving sympathy that I was in danger of losing.* I mean that I had been conscious of a certain *drying-up of tenderness in me, and that now the spring seems to have arisen again*" (emphases mine).

The names of the towns at which the couple stopped and of some of the paintings they admired appear in the journal, prefacing a note in Venice about the appearance of a Dr. Ricchetti, the arrival of Cross's brother Willie, and a "Quiet night, without chloral," a sedative. That's all the information Eliot puts down about the leap into the Grand Canal, although a number of Italian newspapers covered the event.

In his biography, Cross attributes his malady to "bad air, and the complete and sudden deprivation of all bodily exercise." At Innsbruck, Eliot also credits her husband's "attack of illness" to "the climate and to the lack of muscular exercise." Throughout their travels in Germany, she feels strong and he gains weight and vitality. After their arrival back in England and their viewing of the new Chelsea house, John Cross often goes to town to oversee its renovations, and like a good suburban wife Eliot greets him at the train station upon his return to the country. Because of her health problems, there is a trip to Brighton, when she assures a relative that she is "being cared for in every way with a miraculous tenderness."

This last word resounds in other letters to friends: "Think of me as if I were under the charge of angels, for I have more tenderness given to me than could belong to *one* angel. It takes a strong man

to be perfectly tender—a strong man who has known what it is to suffer." She reframes this sentiment more than once: "Mr. Cross has nursed me as if he had been a wife nursing a husband." On November 30, 1880, the second anniversary of George Henry Lewes's death, the couple checked into a London hotel. On December 3, they moved into their London house and began unpacking.

After Cross recovered from "a feverish cold" or "a bilious attack," Eliot died on December 22, much to his shock: "I cannot believe it. It has all been so terribly sudden." He is "left alone in this new House we meant to be so happy in." On the gravestone in the section of the Highgate Cemetery for dissenters and atheists, under the inscription "George Eliot," her remains are marked by the name Mary Ann Cross, but she is buried next to George Henry Lewes. The stone marks her birthdate as 1820, as she herself often alleged, but she was actually born in 1819: one last sign of her efforts to gain control over her own narrative.

THERE ARE MORE biographies of George Eliot than the number of novels she produced, but biographers must stick to the facts; and with the facts so scant, they often gloss over the marriage as an embarrassing addendum. In contrast, scant facts tantalize fiction writers, who have a license to brazen riskier suppositions that clarify the significance of George Eliot's late-life marriage.

Dinitia Smith's novel *The Honeymoon* (2016), which cuts back and forth between the Venice honeymoon and chronological scenes from George Eliot's earlier life, proves that the judgment of her foundational biographer, Gordon Haight, continues to hold sway: "She was not fitted to stand alone." From her childhood devotion to her father and older brother on, according to *The Honeymoon*, the love-starved George Eliot longed for male protection. All of her youthful relationships—explicitly sexual in this novel—involve unavailable men. At first, George Lewes, himself married and reputed to be a

rake, looks to be another mistake, until she realizes that "he would never leave her."

Spliced into this fictional biography, the Venice scenes reiterate the pattern of a desirous woman yoked to an unavailable man. In a sex-changed version of Thomas Mann's *Death in Venice*, Smith depicts an amorous woman, taken to be the mother of the man she wedded. But while Thomas Mann condemns his antique protagonist, Dinitia Smith blames the younger man. As Johnny becomes restless, irritable, and rude, Marian remembers asking George Lewes if single Johnny Cross was "a Nancy boy." In Venice, a hungover Cross, smelling of vomit, has returned from a night out on the town with the gondolier Corradini. The leap into the Canal seems to be overdetermined: Smith's Johnny Cross was closeted and conflicted, he may have been earlier institutionalized, there were mentally ill relatives in his family, and the sirocco is also to blame.

No matter how one judges its vaguely homophobic interpretation of John Cross's leap, *The Honeymoon* has the virtue of presenting a desirous George Eliot. Many of Eliot's heroines struggle with the hunger of the heart or the want of some demonstrative affection. The actress-filmmaker Lena Dunham appeared to agree with Dinitia Smith when, after reading a Wikipedia entry on George Eliot, she tweeted, "she was ugly AND horny!" While Dinitia Smith emphasizes Eliot's erotic cravings, Cynthia Ozick stresses her intellectual appetites in a novella that makes a cautionary point about the misuses to which biography can be put. Obliquely, it also sheds new light on Eliot's late-life union.

Ozick's story "Puttermesser Paired" (1990) focuses on a woman who wants to recapture George Eliot's relationship with George Lewes in an American society that has devolved into the mediocrity and deceit mocked by Theophrastus Such. Ozick's fifty-something lawyer, Ruth Puttermesser, dreams of "the marriage of true minds": "George Eliot and George Lewes, penmen both, sat side by side every evening reading aloud to each other." Estranged from the conceit everywhere evident in her Manhattan neighborhood, the ideal-

istic Ruth wants "a time machine." It arrives, she thinks, in the figure of an artist, Rupert, who paints copies of masterpieces in museums.

Although Ruth believes that she has found George Lewes, the twenty-year "moat of age" between her and Rupert suggests that she has landed with John Cross. As the couple reads accounts of George Eliot's life and Rupert proposes marriage, he posits a Johnny Cross who wanted to be like Lewes, a "reasonable facsimile." Sitting in Lewes's chair at the Priory, Rupert's Johnny Cross asks Eliot to play the music she had played for Lewes. Though Ruth objects to the idea of making Johnny "into a copyist," she agrees to Rupert's marriage proposal and they go on to study Eliot's honeymoon.

In Venice, Rupert's George Eliot remains obsessed by the fact that "they had not yet lain as husband and wife." While Rupert's Eliot lies down close to Johnny, fearing he is unwell, recalling a mad relative, and wondering if he was "not normal," she senses a projectile hurtling out of the window: "He was having his swim in the Grand Canal." Ruth suffers over this part of the story; however, Rupert decides they must get witnesses for their wedding, and she revives: "Lewes! Lewes after all! Lewes had inspired him to it."

Ruth trusts that Rupert will stop distributing the postcards he reproduces from the paintings he has copied from masterpieces. He had "never explained why a reenactment had to be a dwindling. If it was a dwindling, how could you call it a reenactment?" A quick ceremony in a rabbi's study is followed by the bride and groom's return to her apartment, where she feels her heart swelling "like a spiraled loaf of hot new bread." Rupert runs to the window and raises it; but then reverses course and walks out the door: "It was pointless to call down to him as George Eliot had called down into the Grand Canal, but anyhow she called and called," while snow whitens her hair and she knows him to be "a copyist, a copyist!"

Rupert is a con artist, who has hoodwinked Ruth into staging a reenactment that (as he claims of his paintings) "isn't a version. It's a different thing altogether." Within a debased cultural marketplace that proves how prophetic *Impressions of Theophrastus Such* had been,

Rupert is such a man who appropriates the great art of the past to circulate his forgeries not only in his paintings and postcards but also in his punitive and inaccurate reenactment of Eliot's marriage, for the real John Cross remained loyally wedded to George Eliot until her death and loyal to her memory until his own. Unlike Cross, Rupert is destructive, not self-destructive, when he absconds to drive home the point that the knockoffs he produces on canvases and then in postcards have a ghastly power of their own. Since Rupert's copyist John Cross is merely a projection of himself, Ozick implicitly questions our capacity to glimpse the alterity of the past.

More significantly, in terms of George Eliot's evolution, Cynthia Ozick's tale illuminates the radicality of her precursor's venture in the last year of her life—because Rupert's self-serving theory about John Cross wanting to be like George Lewes reminds us how *unlike* George Lewes and John Cross were. In late life, different wants made George Eliot choose a very different sort of mate.

Lewes was a public intellectual who studied psychology and the natural sciences as well as literature, whereas Cross was a banker. Lewes, like Eliot, was multilingual, while Cross was not. At leisure, Lewes was an actor and raconteur, Cross an athlete. The mercurial Lewes was odd-looking, whereas the respectable Cross was conventionally handsome. Lewes was married to another woman; Cross was a bachelor. Cross offered not a bohemian arrangement but a legal one, sanctified by the church. Lewes started his relationship with Mary Ann Evans when she was a lonely journalist, whereas Cross sealed his relationship with George Eliot after she had become a living legend. Lewes's brash confidence contrasts with Cross's nervous wish to please. Lewes was two years older than George Eliot, whereas Cross was two decades younger.

What the fictional and factual biographies tend to leave out is how much George Eliot stood to gain from a marriage that was *not* a reenactment and *not* a dwindling of her partnership with Lewes but an entirely unprecedented venture. She sought a union not with a surrogate for the beloved dead man, but with an entirely dissimilar individual, one who

offered a new sort of companionship. The union signaled her reborn trust—in a human being quite unlike Lewes and in the future, for all weddings bespeak faith in the prospect of an unfolding marriage.

George Eliot took the risk of a cross-generational attachment at the end of her life with sound reasoning. Over the course of a decade, Cross had exhibited his trustworthiness and enlivened her life. At its close, she could count on him remembering George Lewes and honoring her memories of him as well. Moreover, Cross provided her assistance with her considerable investments, aid in dealing with many dependents, consolation from a fellow-mourner, a family with supportive brothers and sisters, and a reconciliation with her own brother. As one critic who discusses the benefits of the union, Rosemarie Bodenheimer, points out, "Marrying John Cross... was the most practical step she could have taken." But it wasn't merely practical.

For the very first time with a man, Eliot assumed the role of adored mentor that she had earlier adopted with a number of smitten women friends. She took Cross not as a soulmate but instead as a consort who ratified her authority. With such an acolyte, Eliot knew, she would be prized for the stature she had attained as a Victorian sage. She gained a tender caregiver when she needed one, a man who nursed her like an angelic wife. And posthumously, she acquired a biographer dedicated to protecting her cherished privacy. Cross destroyed large portions of her journals and "pruned" the letters "of everything that I thought my wife would have wished to be omitted." His reverential *George Eliot's Life as Related in Her Letters and Journals* was a massive curatorial undertaking, even though its uxorious piety turned off a generation of readers.

Yet it required the same bravery for George Eliot to embark on the marriage with Cross as it had taken for her to travel with Lewes to Germany in 1854. Acquaintances were scandalized by her decision to live out of wedlock and they were later appalled by her decision to wed a much younger man. A deeply private person, she kept her own counsel. Both types of unconventional partnerships, neither of which appears in her fiction, bespeak the courage with which she lived.

Factoring in "the drying-up of tenderness" marked by the essays in *Impressions of Theophrastus Such* and the life-in-death grief after Lewes's death, it is possible to view the marriage as a sign of Eliot's firm decision to confound her own depression and replenish her depleted spirits. Its benefits were ineffable as she extricated herself from the "hard" and "selfish" creature who she feared she was becoming. She regained the precious feeling of "loving sympathy" that she had been in danger of losing.

A letter to Barbara Bodichon describes the marriage as a "wonderful blessing falling to me beyond my share after I had thought my life was ended and that, so to speak, my coffin was ready for me in the next room." Though "there is a hidden river of sadness," Eliot explains, "I am able to enjoy my newly reopened life. I shall be a better more loving creature than I could have been in solitude. To be constantly lovingly grateful for the gift of perfect love is the best illumination of one's mind to all the possible good there may be in store for man on this troublous little planet." The stress here, as in most of Eliot's comments about the marriage, places the love in John Cross's heart; she is the beneficiary. He is Dante worshipping a Beatrice resurrected into "a better more loving creature."

In the midst of her earlier gloom about the vanity of human wishes, amid grievous mourning of a lifelong partner as well as physical reminders of her own impending mortality, George Eliot welcomed a "wonderful renewal." The shock in Venice may have led her to fear that her marriage was a misstep. Whether or not that trepidation persisted, however, the decision was taken by an imperious woman unafraid to reach for the intimacy she needed to keep the "springs of affection" flowing. In her final months, Eliot's heroism consisted in making something of her marriage to John Cross that reproduces the grand restorative possibilities of her novels, but in a plot too audacious to be contained within any one of them.

CHAPTER 2
Colette

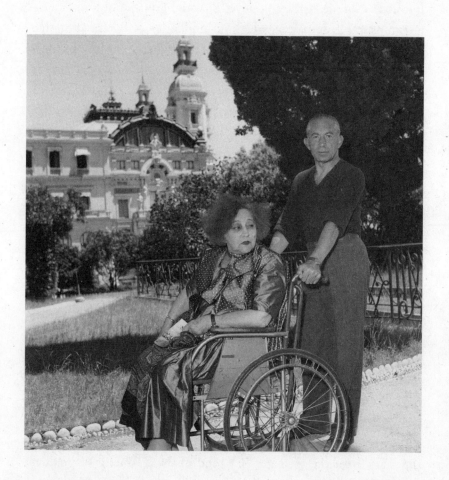

A T FORTY-SEVEN years of age, Colette embarked on an affair with her sixteen-year-old stepson, Bertrand de Jouvenel, that was shocking even in the louche Paris of the 1920s. Growing suspicion of it horrified his Jewish mother, who did what she could to put distance between the lovers. One of Colette's friends, the lesbian luminary Natalie Barney, believed that the French novelist seduced her stepson to retaliate against the infidelities of Bertrand's father, her second husband. Yet the affair catapulted Colette into a magisterial old age, a fact underlined by the weird circumstance that she described it in fiction before it became a reality—providing evidence that, as Oscar Wilde put it, "Life imitates art far more than Art imitates life."

Throughout her prime, Colette was famously hedonistic, relishing butter and fish, gardening and exercising, and the theater and animals of every species, as well as the bodies of men and women. The gratifications of the senses, grounded in her Burgundy childhood, persisted and she wrote sensuously about avidity throughout her indentured labor for her first husband in fin-de-siècle Paris; her vagabond years before the Great War, spent touring as a mime and an actress; her second marriage, during which she became a war correspondent; and the satisfying third marriage that lasted until she died at eighty-one. Colette knew that pleasures could be fleeting: "What more can one be sure of than that which one holds in one's arms, at the moment one holds it in one's arms?" The flagrant extramarital flings of her first two husbands proved that devotion could not keep them in her arms.

In an excellent biography, Judith Thurman has pointed out that the affair with the teenager Bertrand enabled Colette to graduate from submission to dominance in her erotic relationships: "from being the slave of love to the master, and from the child to the parent." By means of the affair, begun in 1920 and concluded in 1925, Colette

also pivoted toward the lasting third marriage in which she finally attained the confidence she needed to transition from an apprentice to a master worker. When the child Sidonie-Gabrielle Colette, the youthful and married Colette Willy, and the remarried Colette de Jouvenel receded into the past, Colette emerged like a rock star with one name. She was in her fifties, with a notorious history behind her, as she began to settle into the final stage of her career.

Professionally, Colette's second husband was very different from the infamous first husband, Henry Gauthier-Villars or Willy, who purportedly locked her in a room until she produced the titillating *Claudine* novels that he marketed under his own name. He also photographed her for smutty postcards and sold Claudine lotions, perfumes, cigars, collars, and ice cream. Unlike Willy, a publicity hound, Henri de Jouvenel was a journalist and statesman. Yet Colette found herself serving the needs of both men and recurrently tortured by jealousy over their hectic philandering. In between these two marriages, she lived with the cross-dresser Mathilde de Morny, the marquise de Belbeuf, who was known as Missy or Max and whose performance with a half-naked Colette at the Moulin Rouge outraged respectable Parisians. In this relationship, too, she was the junior partner who needed to be coddled, housed, and diverted by a wealthier, older, and mannish mate.

Although the affair with her stepson was blatantly outrageous, it empowered Colette to finally establish her erotic and aesthetic primacy. Not only had she imagined the liaison before she initiated it, Colette also fictionalized it while she was living it and again while it concluded. How did those portraits of her mastery in some of her finest novels—*Chéri* (1920), *Green Wheat* (1923), and *The Last of Chéri* (1926)—propel her into a pioneering investigation into eroticism that blurs the categories of normalcy and deviancy into which people are still pigeonholed today? With *The Pure and the Impure* (1941; first published as *Those Pleasures*, 1932), Colette took a holiday from lucrative journalism, memoirs, and fiction to undermine prevailing taxonomies of carnality.

In the book she considered her finest achievement, a writer indifferent to politics and hostile to the women's movement addressed sexual politics. Was Colette a pro-sex feminist before that term arose? Certainly, she opposed the policing of desire. But no: she was decidedly not a feminist, since she doubted that gender inequality could be altered and never assumed that sexual freedom would generate personal or societal liberation.

The Pure and the Impure marks Colette's entrance into old age: her disenchantment with the sexual mores that had characterized her earlier life. Reviewing her own ribald past, she found herself relieved to be done with it. In her only treatise on desire, Colette—whose name had become synonymous with risqué performances and lusty passions—explored unsatisfying erotic relationships, especially those of women . . . regardless of the gender of their partners. Old age liberated her from those sexual relations.

But how in the world did such a bleak view issue in one of her last stories, *Gigi* (1944), the frothy rom-com that solidified Colette's fame in America, or, for that matter, how did it undergird the iconic setting she staged for her old age and the amusing memoirs she composed about it? As she aged, Colette upended the rules of a sexual arena stacked against women and later positioned herself outside it, but she never lost interest in the love stories that had made her name.

THAT IN *Chéri* Colette conceived of an affair between the aging courtesan Léa and her best friend's son *before* the affair with Bertrand de Jouvenel suggests that she needed to come to terms imaginatively with her own aging. It was one of several novels in which Colette pictures herself as the older woman. At the start of *Chéri*, the survival of the affair is challenged by the news that twenty-four-year-old Chéri's mother has arranged a marriage of convenience for him with a young woman. The prospect of that union endangers the pleasure the forty-nine-year-old Léa takes in responding

to her own body, "endowed with the long legs and straight back of a naiad on an Italian fountain," with his "naked in the morning on her ermine rug."

Léa had been "happy and maternal" in a six-year liaison she sometimes called "an adoption." When Chéri was a boy, she was "a sort of doting godmother." She remembers his first demand for a kiss and how after it "he babbled indeterminate words—a whole animal chant of desire" in "a song to which she listened solicitous, leaning over him, as if unwittingly she had hurt him to the quick." Léa revels in the sort of sexual power that for generations had been accorded only men, as her author explores what one fan of her fiction calls "gerontophilic devotion—the feeling of a young person for someone definitely not young."

Once Chéri's marital plans have been announced, looking at aging women becomes a source of torment for Léa. She is especially dismayed by a seventy-year-old acquaintance who "walked with difficulty on round swollen feet, tightly swaddled in high-heeled laced boots with paste buckles on the ankle straps." A silver fox cannot conceal a neck "the shape of a flower-pot and the size of a belly." Must aging women always try to pass as youthful and sexy in grotesque charades? Colette addresses the unfortunate fact that maturity consolidates the authority of men while devaluing the worth of women. By embarking on a trip, proud Léa defends herself against being humiliated by Chéri's future wife.

However, Colette revises a Continental tradition in which an older woman inducts a younger man into the rites of eroticism so he can then happily bed a bride closer to his own age. Although Chéri does take a young woman as his wife, he never extricates himself from the allure of his older mistress—possibly because her powers derive from the maternal role she plays. Far from being merely instrumental, the maternal–filial bond in *Chéri* inaugurates a blissful paradise. Once lost, it cannot be regained. Colette seems to be thinking of the incest taboo: the alluring prohibition against a woman taking a son surrogate as her lover, the frisson of the illicit. Paradox-

ically, it is the maternal role that grants Léa the pleasures of (traditionally male) ascendancy.

When Chéri and Léa reunite—his marriage has proved to be a disaster—they collapse on her bed. Their bodies "joined together like the two living halves of an animal that has been cut through," while she anticipates "with a sort of terror the moment of her own undoing" —which arrives in the morning, when the clear light falls on the "soft flabby skin" on her hands and wrists "like crisscrossings on a clay soil when heavy rain is followed by a dry spell." Aware that her lover has returned to "find an old woman," she determines that Chéri must free himself "from perverted mother love." As she had done throughout the affair, Léa takes charge at its conclusion, relinquishing a young man twenty-four years her junior. She also takes moral responsibility for failing to put her lover's psychological well-being first: "I should have made a man of you, and not thought only of the pleasures of your body, and my own happiness," she admits. "I am to blame for everything you lack." With this admission, Léa concedes that her behavior could be considered greedy and destructive.

In the brilliant closing scene of the novel, after Léa has sent the young man away, she thinks he might return and cries out, raising her arms: "An old woman, out of breath, repeated her movements in the long pier-glass, and Léa wondered what she could have in common with that crazy woman." Through the mirrored madwoman, Colette depicts the self-alienation of aging.

The son of Colette's second husband received a copy of *Chéri*, inscribed to "my CHERIshed son Bertrand de Jouvenel," the year it came out: "This was unexpected. I wasn't her son, I barely knew her, but she already had me in her thrall." His "primary impression" of her was "of power, and a power whose shock was sweet to me. With my first glance, I do believe that I surrendered to that protective influence." Colette's affair with Bertrand widened the age gap between her fictional characters considerably; and although she and

her stepson were not blood relatives, it also flirted more outrageously with the incest taboo.

At the villa in Brittany given to her by her lover Missy/Max, Colette taught her stepson how to swim, plumped him up with lobsters and cream, and decided that she or visiting friends should bed him. When one of them "failed to deflower him," as Thurman puts it, Colette took the matter into her own hands, an act that might be considered actionable today. Over the next few years, Colette reveled in the pleasures of pampering and mentoring her charge—a behavior that may have startled her daughter, whom she generally kept at arm's length. During another summer with Bertrand, Colette's letters make her "leopard cub" or "great greyhound of a boy" sound like a pet: "I give him a rubdown, stuff him with food, rub him with sand and let him go brown in the sun." Knowing how damaging such "perverted mother love" could be, she nevertheless seems to have savored it. As for him, he found her a "demanding, voracious, expert, and rewarding" instructor.

Bertrand was studying in Paris when Colette performed the role of Léa in the one hundredth performance of the dramatization of *Chéri*. Later, they traveled together to her childhood home in Saint-Sauveur and then toured Algeria. Embarrassed at her weight gain— she was nearly 180 pounds—Colette kept her body under wraps and thought she was pregnant, but a doctor informed her that she was undergoing menopause. She had her first facelift, booked daily massages, tried "rejuvenating" blood transfusions from an adolescent girl (with adverse results), and started perming her hair into the aureole of hennaed frizz that became a sort of trademark.

In 1923, Colette published *Le Blé en herbe*, translated as *Green Wheat* or *The Ripening Seed*, which the biographer Joanna Richardson calls "the fictionalized account of her initiation of Bertrand." Installments of its chapters in her husband's newspaper, *Le Matin*, had met with readers' protests and been abruptly discontinued. What is remarkable about this lyrical novel is the change in point of view from the

perspective of the older woman to that of the adolescent boy. Indeed, the novel begins and ends with a sixteen-year-old boy's infatuation with a fifteen-year-old girl, based on a chaste relationship with a contemporary that Bernard had confided to Colette.

In *Green Wheat*, Philippe and Vinca are two friends who have shared summer holidays with their parents in a house on the Breton coast since childhood, and their sense of themselves as twins is gradually giving way to an awareness that they will soon become lovers. Amid sandy grasses adjacent to sloping beaches, sibling affections and conspiracies advance into longings of a more mature nature, but then regress back in a bucolic depiction of the in-between psychology of teenagers, neither children nor adults.

With a self-consciousness about predation that is breathtaking, Colette presents her fictional surrogate as an intruder who brings about Philippe's and Vinca's fall from innocence to experience. The name of the older woman, Madame Dalleray, alludes to the rue d'Alleray, where Bertrand would sometimes stay in the apartment of one of Colette's friends. In stark contrast to the sunlit seaside scenes, the red, black, and gold tapestries in Madame Dalleray's house evoke "the sensation of a sumptuous nightmare, an arbitrary custody, an equivocal kidnapping that swept away all of Philippe's composure." After he erects a smokescreen for Vinca about what happened in the house—"I was ambushed going around a bed, held prisoner in a cave, dosed with powerful drugs, tied naked to a post, whipped, interrogated"—he thinks to himself, "*if she only knew how true that really is.*"

When Philippe returns from a night in Madame Dalleray's strong arms to study his face in the mirror, he looks subjugated: with languid eyes and lipstick on his mouth, he resembles "less a man than a bruised girl." No wonder that he later considers Madame Dalleray a "commanding she-devil." *Green Wheat* ends with the inscrutable Madame Dalleray driving away as unexpectedly as she had arrived and with the fallout from her seduction visited not only on Philippe but on Vinca as well.

Vinca cycles through all the gears of jealousy: secret suspicions and investigations, tears and complaints, anger and self-pity, competition with her rival, and, finally, reconciliation with Philippe through lovemaking. Yet Colette bestowed on Vinca some of her own rooted pragmatism. A keen observer of the sounds, sights, and smells around her, she remains grounded in reality and matures by means of her sexual initiation, whereas Philippe remains haunted by the absent woman whom he calls "*my master.*" On the one hand, Colette understands how dangerous cross-generational desire can be; on the other, she sees it as a catalyst in erotic awakenings.

IN THE SAME year in which the sexual mastery of an older woman was portrayed in *Green Wheat*—the first book signed with Colette's singular name—Henri de Juvenel announced that he was sending his son to Prague. Colette protested, and then went on to reveal the affair to her husband. Outraged, he moved out, talking of divorce. Soon after, she and her stepson went on a skiing and sledding holiday in the Swiss Alps. Unlike Léa, Colette intervened to break up Bertrand's engagement to a woman chosen by his parents. They were irate.

The letters Colette wrote while she was going on tour with the dramatization of *Chéri* indicate that she was spending a good deal of time with the Jewish businessman Maurice Goudeket, and perhaps her growing attachment to him led her to fulminate to a correspondent: "*La Fin de Chéri!* I wish he'd kick the bucket!" Goudeket explains that *The Last of Chéri* was "the first book which Colette wrote under my eyes." She got rid of Chéri in the 1926 sequel, which explains why Colette ditched the affair. The reason is not merely because her aging led to a realistic acceptance of the affair's conclusion or because she had found a new lover.

As in the account of the damage done to Philippe in *Green Wheat*, in *The Last of Chéri* Colette emphasizes the harm done to its antihero

as she tells the tale from his perspective, not Léa's. Having been petted and pampered in an extended dependency on an older woman, he lacks a sense of autonomy or ambition. Apathetic, her mollycoddled central character has been depleted by too much mothering and cannot become his own person.

Colette portrays Chéri's shock when he reconnects with Léa: "She was not monstrous, but huge, and loaded with exuberant buttresses of fat in every part of her body." But Chéri suspects that Léa has made peace with an aging process that has liberated her from gender: "when she stopped smiling or laughing, she ceased to belong to any assignable sex." By approaching her aging body from a young man's point of view, Colette conveys a weird paradox about aging: its visible signs of thickening can revolt younger onlookers, but they do not register the same way for the old. "Despite her enormous breasts and crushing backside," Chéri intuits, "she seemed by virtue of age altogether virile and happy in that state."

Of course, Colette was describing not how she looked but how she might come to look. In any case, though, the "unsexed" Léa is "virile" and "happy," she has not degenerated into a self-alienated character. In their final scene together, Léa insists that she is neither ashamed nor regretful about their affair, for she had been in love. The person who suffers the horrors of aging is Chéri. She endures, whereas he goes off to commit suicide. Given Colette's years on the stage, she knew that she was detonating the plot of Jean Racine's *Phèdre* (1677), in which the guilty heroine kills herself after her passionate desire for her husband's son goes unrequited. Léa is no Phèdre.

The composing of *Chéri*, *Green Wheat*, and *The Last of Chéri* may have served up a monitory tale to Colette, a warning that she had to renounce Bertrand or she would blight his existence. She clearly understood, as she once explained, that "when a woman of a certain age enters into a relationship with a much younger man, she risks less than he. His character is still in a formative stage, and therefore the more likely to be spoiled by their love, deformed by the failure of it. After they have parted he may be haunted by her, held back by

her, forever." Did she bring Maurice Goudeket to the final meeting with her stepson in order to assure both of them that they would each end up with a more suitable mate? Soon after Colette and Bertrand agreed to part, he married one of his parents' candidates and she took Maurice Goudeket as her last and lasting partner.

Sixteen years younger than Colette, Maurice Goudeket had been entranced by reading her works in his youth and had informed his parents that he was "going to marry that woman" one day. She remained the master-teacher in this less scandalous permutation of her ascendancy with Bertrand. Though she would never be called Madame Goudeket, her acolyte and husband would become known as "Monsieur Colette." Toward the end of her life, he would help negotiate book and film contracts and compile a complete edition of her voluminous works. When they met, he was thirty-five and she was fifty-two. With rising fame and Goudeket's steady support, Colette liberated herself from her earlier subservience to Bertrand's father and to his father's predecessors.

In the 1928 autobiographical novel *The Break of Day*, Colette again bids farewell to a youthful admirer. Here, too, she suggests that seniority involves a detachment from romance and eroticism. Yet the lovers' age disparity is not the issue. Instead, her rejection has to do with new wants: "An age comes for a woman when ... the only thing that is left for her is to enrich her own self." For "the first time since I was sixteen," the character Colette believes, "I'm going to have to live—and even die—without my life or death depending on love. It's so extraordinary." At fifty-five, Colette was disengaging from the sexual exploits of her youth and adulthood.

To be sure, Colette's autobiographical fiction cannot supply an accurate account of her personal life. Yet in *The Break of Day*, Colette anticipates a "prodigious" future in which "my sadness, if I'm sad, and my gaiety, if I'm gay, must exist without the motive which has been all they needed for thirty years: love." The happily-ever-after union with her third husband helped Colette "enrich her own self," as none of the previous marriages had.

Throughout the unmarried stage of her relationship with Maurice Goudeket—they kept separate addresses—Colette was lecturing, acting, producing novels and drama criticism as well as stage adaptations, changing Paris apartments, setting up a new house in the south of France, caring for her dogs and cats, and providing highly paid advertising texts for luxury products. She had clearly grasped the polarities of domination and submission from both sides of the dialectic and was poised to make a summary statement about the nature of desire. After her death, in an otherwise glowing homage, Bertrand de Jouvenel summed up "her most vital days": endowed with "a deep understanding and appreciation of the lovable and a petulant willfulness to seize it," she "eagerly picked the fruits of the earth without discriminating those which were forbidden."

BECAUSE COLETTE HAD the temerity to seize the lovable, she could use her newfound authority to examine the remarkable range of sexualities she had witnessed at the start of the twentieth century. An autobiographical meditation, *The Pure and the Impure* suggests that Colette had come to feel skeptical about women finding erotic fulfillment. Having experienced both abject submission and masterful domination, she became convinced that these polarities characterize most sexual relationships. She was ready to air her heretical view that at least for women, normative sexuality could be downright unpleasant and alternatives to it faintly ridiculous.

The Pure and the Impure consists of a series of inconclusive conversations with, or portraits of, companions from the underworld of Colette's racy past. Composed in the first person, it describes her encounters with a series of individuals discussing their quite varied sexual exploits. A retrospective Colette began assembling her gallery of aged (or dead) sexual adventurers in the 1930s by publishing a series of essays in a journal, but the installments were abruptly aborted. Ten years later, amid Nazi persecution of Jews and homo-

sexual, she revised them and *The Pure and the Impure* appeared in 1941, when she was sixty-eight.

By this time, the Depression had created hardships that motivated her and Maurice Goudeket to take on numerous journalism assignments, including a trip to New York City that persuaded them to marry so they could lodge together in American hotels. The couple, moving between Paris and summer stays in Saint Tropez, had started a short-lived beauty business in which she undertook celebrity makeovers. But Colette suffered a fall and began dealing with the rheumatoid arthritis that would eventually land her on canes or on the divan-bed in her Palais-Royal apartment. Not a moneymaker, *The Pure and the Impure*, which remains eccentric in her oeuvre and also in literary history, registers Colette's growing distance from sexual behavior she could now examine with a somewhat rueful eye.

At the start, Colette states that she "will treat *sadly* of sexual pleasure" (emphasis mine)—an understatement, for the book begins and ends with accounts suggesting that heterosexuality is a decidedly queer and unsatisfactory practice. Especially in its opening vignettes, Colette's encounters prove that in a period of history noted for its profligacy, most people did not or could not say what they wanted and generally engaged in frustrating sexual activities. Colette's treatise begins by exploring the deceits and dissatisfactions of heterosexuals and then goes on to suggest that an entrenched heterosexual model of love nevertheless shapes the partnerships of many lesbians.

The Pure and the Impure may be the first (or only!) publication on sexuality to begin with a faked orgasm. In the opening, which takes place in an opium den, Colette—who does not imbibe or smoke much of anything—encounters a plump, older woman who couples with her boyish and sickly lover on an unseen balcony. Colette hears Charlotte pouring out her notes like a nightingale "in a flood of arpeggios," which are "contrived to give a weak and sensitive boy the very highest concept of himself that a man can have." If this scene is a comment on the *Chéri* plot, what does it mean that the public dis-

play Charlotte makes of her pleasure turns out to be "a melodious and merciful lie"?

The faked orgasm serves neither partner well. The boy, possibly aware of the fakery, flies into rages and physically abuses Charlotte. She believes that his love would be wonderful, "if only I didn't have to pretend..." (ellipses hers). Her heart is devoted to him, but the body is "something else again!": "It has a cultivated taste... it knows what it wants." Yet when Colette seeks to discover what Charlotte really wants, she shuts down: "I'd be more ashamed of the truth than the lie." Given that Charlotte has much in common with Colette in looks and temperament, this opening episode suggests that more than one woman, experiencing unspeakable wants, takes a compensatory gratification in artful performances of desire that flatter men into a sense of their (fragile) manhood.

The next section of *The Pure and the Impure*, possibly undertaken to comprehend the philandering of Colette's first two husbands, is just as skeptical about the pleasures of heterosexual men. The older Colette, looking back at the libertines of her past, sees them not as women-lovers but as women-haters. A series of Don Juan figures, who think of "servicing" a succession of "bitches" or "she-devils," voice the suspicion that they are the ones being used in the sexual exchange. Colette remains dumbfounded "at the monotony" of the maneuvers used by philanderers to lure women to their "fall, one misstep after another."

A roué named Damien offers final words of advice, "Give nothing—take nothing," that shock her. Damien never offers gifts, aid, comfort, or support to his mistresses, because he believes that what he bestows as a gift are (and here he gestures toward) "his chest, his mouth, his genitals, his thighs." A narcissist and lone wolf, Don Juan turns out to be "a man utterly dedicated to conquest, solitude, and vain flight."

Although the machinations and frustrations of the heterosexual characters who open *The Pure and the Impure* detach erotic activity from pleasure, Colette explores the tenacity of the gender

roles underpinning heterosexuality when she turns to the lesbian circles she inhabited. While she appeared on the stage "trying to look like a boy" but feeling very "feminine," Colette observed the "mannish women" she encountered in various social settings. They formed a clique circumventing laws against women cross-dressing in public—by hosting private parties, donning trousers and dinner jackets in darkened bars, but covering up with an opera cloak on the street. Wearing their aristocratic garb, the "ladies in male attire" adopted clever working-class girls. That these protégées could be rude and grasping did not surprise Colette, because the aristocrats had met their intimate needs in childhood not with their upstairs families but with the downstairs domestics.

Class hierarchies reinforce the masculine role-playing undertaken by the aristocrats in men's suits. But with their monocles, their excitement at the scent of stables, and their taste for working-class girls, the aristocrats seem a tad passé or, worse, fake: "The thing women in men's clothes imitate worst is a man's stride." Whether they want to rival men by gaining male privileges or become men, success remains dubious, or so Colette hints in an account of Lucienne de _____, a cross-dressed woman who adopted the role of a Don Juan. Lucienne's girlfriend rejected her because "when you and I go out together, everyone takes you for a man, that's understood. But for my part, I feel humiliated to be with a man who can't do *pipi* against a wall." A friend of Colette's considers Lucienne a "pseudo-man": "What is more ridiculous, what is sadder, than a woman pretending to be a man?"

Differentiated from all the rest, the figure modeled on Missy/Max, La Chevalière, "had all the ease and good manners of a man, the restrained gestures, the virile poise of a man." Yet even in a tribute to her former lover, Colette suggests that sex gets in the way of pleasure. For forty years, "this woman with the bearing of a handsome boy" could not establish "a lasting affair with a woman," possibly because "the salacious expectations of women shocked her very natural platonic tendencies, which resembled more the suppressed

excitement, the diffuse emotion of an adolescent, than a woman's explicit need."

Featured at the center of *The Pure and the Impure* as the antithesis of the charismatic La Chevalière, the Decadent poet Renée Vivien (Pauline Tarn) conformed not to stereotypical masculine but to stereotypical feminine behavior. The Anglo-American heiress, who died at thirty years of age, is presented as an anorexic drunk. Most of the conversations Colette had with her onetime neighbor took place in Vivien's gloomy apartment with its nailed-down windows and odor of incense mixed with rotten fruit. The lugubrious setting seems as unhealthy as Vivien's ruinous lifestyle. She served exotic foods that "come from too far away" and strong cocktails that she downed in one gulp.

Worse than Vivien's crude boasting about "the pleasure she took with a woman," to Colette's mind, was her masochistic thralldom. Captivated by a "master," who "was never referred to by the name of a woman," Vivien received "invisible messages laden with jades, enamels, lacquers, fabrics . . ." (ellipsis hers). Whenever this preemptory female "master" required her presence, Vivien immediately abandoned her guests. On other occasions, she felt physically endangered: "*She* will kill me." Maybe, Colette surmises, "the exhausting Lesbian lover never existed." Perhaps this ghoul was invented by an imagination sickened by a "habit of obtaining sexual satisfaction [that] is less tyrannical than the tobacco habit, but it gains on one."

AS IF COLETTE's jibes at lesbian mimicry and degeneracy weren't bad enough from any anti-homophobic perspective, the rest of *The Pure and the Impure* goes on to contrast the deficiency of lesbians with the sufficiency of male homosexuals. In another textual moment that undoubtedly distresses many readers today, Colette takes issue with the novelist Marcel Proust when he assembled "a Gomorrah of inscrutable and depraved young girls." "There is no such thing as

Gomorrah," she proclaims: "Intact, enormous, eternal Sodom looks down from its heights upon its puny counterfeit."

By using Proust's terms, Colette signals that she, too, believes that from biblical times to her own, homosexuality has been punished as an abomination, whether practiced by women (Gomorrah) or men (Sodom). In the second half of *The Pure and the Impure*, male homosexuals teach Colette "not only that *a man can be amorously satisfied with a man but that one sex can suppress, by forgetting it, the other sex. This I had not learned from the ladies in men's clothes*, who were preoccupied with men, who were always, with suspect bitterness, finding fault with men" (emphasis mine). "There is no such thing as Gomorrah," Colette believed, because in a patriarchal society, men could "suppress, by forgetting," women, whereas women could never "suppress, by forgetting," men. For as long as women remain the second sex, Gomorrah, like the clitoris imagined by Freud, remains a "puny counterfeit."

Throughout the rest of *The Pure and the Impure*, Colette posits companionate unions, male homosexuality, and friendship as her ideals. She approaches companionate unions—"two twin bodies that have similar afflictions, are subject to the same cares, the same predictable periods of chastity"—in the long ago rural past by retelling the story of the Ladies of Llangollen, who lived cloistered lives in Wales toward the end of the eighteenth century. Here Colette meditates on a quieter sense of kinship, similarity, resemblance in the "delicious and exquisite retirement" of Lady Eleanor Butler and Miss Sarah Ponsonby. A sensuality "less concentrated than the orgasm" promotes "happiness in an exchange of glances, an arm laid on a shoulder, and is thrilled by the odor of sun-warmed wheat caught in a head of hair."

The tranquil devotion of the "double person called 'we'" absorbs Colette until she begins wondering if the protective, older Eleanor became "the masculine element." The suspicious author would have liked to read "the diary that *the victim*" Sarah might have kept (emphasis mine). And in her own milieu, she emphasizes, their pasto-

ral idyll would be impossible. Sarah might not know "how to remain silent," and "Eleanor Butler would curse as she jacked up the car, and would have her breasts amputated." To the aging Colette, romance for women-loving women in the twentieth century seems ill-fated, though not for men-loving men.

In their bravery confronting stigmatization, male homosexuals emerge as admirable lovers when Colette goes on to discuss "eternal Sodom" from the perspective she gained in Willy's "writers' workshop." Many of her fellow ghost writers were homosexuals, who ought not be confused with "effeminate men," for "a human being with a man's face is virile by the very fact that he contracts a dangerous way of life and the certainty of an exceptional death." Her courageous companions speak to her of deaths, blackmailers, and lawsuits, all "the perils of their chosen way of life." They do so with "tartness, theatrical cynicism, affectation, [and] nonsensical jesting," even when their partners were "supposed to have strangled a Turkish-bath attendant."

A woman whose man seeks another man is lost, for he has found an equal, we are informed, whereas a man who sends his woman to another woman expects her to be returned polished. Although there are instances of men dressing up as women in *The Pure and the Impure*, they are rare, deadly, and often involve working-class men. Two men living in rustic seclusion allow Colette to celebrate the "dignity" of the "male couple." Their poignant fate leads her "to see in homosexuality a kind of legitimacy and to acknowledge its eternal character." The doughty inhabitants of Sodom contrast with the mimics of Gomorrah.

Colette concludes *The Pure and the Impure* by describing the ways in which aging estranges her from erotic unions. The dissimulation that must be practiced by homosexuals and that links them to the theatrical world is "only possible for the young." In her current state, she finds herself comforted by "extrahuman" beings: in asexual relationships with animals and children as well as camaraderie with equals who share "the etiquette of survivors" in friendships. She

illustrates this last point with the painter-engraver D., whose lover had been imprisoned for cutting up his grandmother and raping a little girl; but once released the young man cannot be brought to visit Madame Colette, because he is "shy." What she appreciates about D. is his respect for her conception of his lover's character. D. and she "come from the distant past" and prefer "passion to goodness."

Jealousy is another casualty of aging. In bygone days, Colette descended "to the very depths of jealousy," which she compared to "a sojourn in hell" but now sees as "a kind of gymnast's purgatory." The mutual hatred that jealous women share can transport them into a loving union. Even though the man might look upon himself as "the prize over which we fought," in fact "we lacked nothing, those women and I: we had every kind of trouble." When wife and mistress cease being rivals and instead become intimates, the one betrayed "is the patriarch *in camera*, the clandestine Mormon," or the "small-scale *pasha*": "Women pair off like this oftener than one might think," she states with a final potshot at heterosexual men.

The Pure and the Impure represents Colette's farewell to the erotic experimentation of her earlier days. Paradoxically, its passages on an idealized male homosexuality are littered with murders, suicides, and rapes. While she recounts the erotic behavior of her dead or dying friends, she never reveals her own sexual history. "Mental hermaphroditism" is as close as she gets to approaching her bisexuality. Reticence, with its long history of stultifying lovers, emerges as a startling virtue. And though Colette discusses cross-class sexual relationships, she never confronts how exploitative they can be.

In the wake of gender studies and queer theory, *The Pure and the Impure* would be decried as homophobic and transphobic or hailed as a pioneering text. It subscribes to the all-too-common idea that lesbians and transgender people are impostors or victims of arrested development. Yet it thoroughly invalidates heterosexuality and illuminates homosexual subcultures. And despite Colette's jaundiced take on Gomorrah, she refrained from generalizing about eroticism. Not all female cross-dressers are alike: one feels feminine

(Colette), but some aspire to masculine privileges (the aristocrats), one remains anomalous (La Chevalière), and one acts like a Don Juan (Lucienne).

Because the mutable inflections of desire keep on evolving, identity categories cannot describe the often-inarticulate cravings of women and men. In the belle epoque, sexual freedom did not lead to personal or societal emancipation, according to Colette. Instead, it manifested the pervasiveness of intractable power relations, those imposed by gender and by class. Filtered through sorrowful affection for her bygone days, *The Pure and the Impure* is an older woman's edgy elegy for erotic urgencies she had outgrown.

ONE MONTH AFTER the publication of *The Pure and the Impure*, Maurice Goudeket was arrested in one of many roundups of Jews and transported to the detention camp at Compiègne. Colette pulled as many strings as she could, for she had been circulating her work in pro-fascist newspapers and publishing houses. In the newspaper *Gringoire*, the page with an announcement of her last full-length novel, *Julie de Carneilhan* (1941), included a caricature of the Statue of Liberty brandishing a menorah; when the novel appeared as a book, its back cover announced the forthcoming appearance of *Mein Kampf*.

But an emaciated Goudeket did not return to her for seven weeks. Once he and "the twelve hundred in that batch" were taken to the detention camp, Colette explained, "they immediately became like the nameless dead. Nor a word, not a letter, no longer anything to tell us that they were still alive." At her husband's return, "I had never before seen in a man such non-human coloring, the greenish-white of cheeks and forehead, the orange of the edges of the eyelids, the grey of the lips . . ." (ellipsis hers).

Colette was now a celebrity, whose radio talks and magazine articles received widespread attention, as did photographs of her receiv-

ing literary prizes while wearing sandals with her red-lacquered toenails on display. However, she and Goudeket remained rationally fearful of his fate. He would hide out in the garrets of the Palais-Royal or with friends in Saint-Tropez, while she remained increasingly housebound in the Paris apartment. With her maid of many years, Pauline Verine, serving as nurse, shopper, messenger, and companion, Colette stitched tapestries, foraged food supplies, and began composing a series of memoirs.

Immobilized and corpulent, Colette made the setting of her old age legendary during and then after the war. With assistance, she could occasionally be moved in a wheelchair to a restaurant for a fine meal or flown to Monte Carlo for a stint at a luxury hotel or driven to a spa for yet another futile treatment of her arthritis. Mainly, though, she floated on the raft of her divan-bed in a red-wallpapered room, near a blue-shaded lamp and a movable desk. Surrounded by vases of flowers and a collection of crystal paperweights, she presented herself in the late memoirs as constantly attended by her solicitous "best friend," Maurice Goudeket, and cheerful about her sedentary condition.

"If we are to be shaped by misfortune," the seventy-three-year-old Colette advised at the start of her memoir *The Evening Star* (1946), "it's as well to accept it." Her conviction that "We do well to adapt misfortune to our requirements and even to our convenience" helped her view "near-immobility" as a "gift." It consisted of the life review she conducted of friendships with long-gone journalists, actresses, and animal companions; of savory meals, like her wedding breakfast with Goudeket. She plans

> to live a little longer yet, to continue to suffer in honourable fashion, that is without complaint or rancor, . . . to laugh quietly to myself and also to laugh openly when there's cause, to love those who love me, to put in order what I shall leave behind me, the bank deposit as well as the drawer of old photographs, a little linen, the few letters.

Colette "cannot entirely condemn" even the "torment" of her leg and hip, for "there is, in the pain that comes in bursts or waves, an element of rhythm" or "a flux and reflux whose autonomy grips the attention. What I call honourable suffering is my dialogue with the presence of this evil." As proof, she mentions "the absence from my bed-table of any analgesic or hypnotic drug." She suffers "in very bearable fashion, in a rhythm of twinges and waves that I can capitalize musically, as one does the pistons of a train."

The "inability to get about, and the years, make it impossible for me to sin by fabrication any longer, and exclude me from any chance of romantic encounters," so Colette takes possession of "the images which unfold on the screen of my window, only the light of a sky or an eye, a constellation, the marvels enlarged by my magnifying-glass." Waking to an empty apartment, she finds the "silence and hermit-like existence... far from unpleasant, and where nowadays could I find reasons for being miserable? This leg... Yes, we know. Enough about this leg. We'll do without that. I am a normal old person, that is, one who is easily amused" (second ellipsis hers). In a late letter, Colette admitted that she would "prefer not to suffer, or to suffer less," but she added, "my window faces south, over the Garden, toward the sun, have I the right to complain? And then I've married a saint."

Though Colette neither actively resisted nor actively collaborated with the Nazis, she survived and at seventy-one years of age created *Gigi*. Both the scene of its composition and the charming story itself would become symbols of stubborn French endurance. Once again, she considers gender and class disparities, in this case to imagine a teenage girl's unlikely victory against great odds. A shrewd professional, she was capitalizing on nostalgia for the pleasures of prewar Paris. Colette shaped her romance to suggest that if young women cannot change a sexist sexual marketplace, they can survive and thrive by negotiating successfully within it, just as she had.

Colette's quarrel with feminists had never been based on a dis-

agreement about gender inequity but was grounded on her conviction that nothing could be done about it. The trick, as with pain or the Nazis, was "to adapt misfortune to our requirements and even to our convenience": "If we are to be shaped by misfortune, it's as well to accept it." When resistance is futile, one needs to maneuver within vicissitudes. *C'est la vie.*

Using a generational age gap to dramatize inequality again, Colette revisited the belle epoque to depict her adolescent heroine's maturation within a predatory sexual economy. Movie lovers put off by Maurice Chevalier's rendition of "Thank Heavens for Little Girls" in Vincente Minnelli's 1958 film of *Gigi* should go back to the more bracing novella. Unfortunately, there is no film of the 1951 Broadway production with Audrey Hepburn, whom Colette had spotted in Monte Carlo as "our Gigi for America."

Based on an anecdote Colette heard in 1926 and set even earlier, *Gigi* opens with its heroine getting her hair curled by her grandmother. She is being groomed to become a cocotte or a kept woman. Her claustrophobic situation is emphasized by the two interiors in which the action takes place: her grandmother's dilapidated apartment, where Gigi resides, and her aunt's more sumptuous rooms. Fifteen years old, with a large mouth, high cheekbones, "heron-like legs," and masses of hair, "at times she looked like Robin Hood, at others like a carved angel, or again like a boy in skirts." Neither a child nor an adult, Gigi is a creature coming into her maturity under the tutelage of two panderers.

Because Gigi remains childlike or, as her groomers see it, backward, her grandmother, Madame Alvarez, schools her in deportment, while her Aunt Alicia inspects her jaw, skin, and breath as one would a prized racehorse. Both have their eyes on a rich family friend, the thirty-three-year-old playboy Gaston Lachaille, whose last mistress cuckolded him in an event widely circulated in the gossip pages. "Tonton," as an affectionate Gigi calls him, has been her pal for years. Much of the humor in the first act revolves about newspaper reports of his mistress having committed suicide, a charade

she has performed with laudanum in the past, whenever one of her lovers absconded.

Therefore, in the second act, when Gaston proposes to take Gigi as his next mistress, she "doesn't want to" accede. She knows that his promise to make her rich means "that I should sleep in your bed," but it also means that "when eternal spring is over Monsieur Lachaille will go off with another lady" and she will end up in tabloid accounts of laudanum. Gaston tells her guardians that "she doesn't want to" accept his offer and they echo the phrase as he bangs out the door. Disappointed, her grandmother guilt-trips Gigi into thinking she has endangered the economic security of the family; her aunt recounts the material delights she has rashly forfeited. Late at night, at home, Gigi has the sorrowful example of her mother: an exhausted singer in a theatrical profession on which her two guardians look down.

Upon Gaston's return, Colette's conclusion leaves Gigi's mental state unclear. Sadder and wiser, has she taken her relatives' insistence into account when she tells him that she agrees to his proposition? Though she thereby prompts his marriage proposal, it is impossible to grasp her motives. If family pressure does not overwhelm her, perhaps she has fallen in love, or is she strategizing to turn his proposition into the proposal she needs? In any case, the happily-ever-after ending suggests that she had nowhere else to turn. The curtain drops as Gaston asks Madame Alvarez for Gigi's hand in matrimony.

Within the constraints of the world in which Gigi must operate, she will become a wife, not a kept mistress: a better fate, quantitatively if not qualitatively. Aware that husbands can also "go off with another lady," Colette knew that the eighteen-year age gap between her lovers was more palatable to audiences when the man was the senior partner. She was writing with an eye on the stage and the screen. Whereas Anita Loos's Broadway staging of *Gigi* emphasizes the heroine's vulnerability as an object of exchange between her guardians and Gaston, the movie downplays her outwitting all of them and instead accentuates the budding infatuation.

Even in this seemingly lighthearted piece, Colette raised diffi-

cult issues not only about the commodification of girls but also about female sexuality. Curiously, Gigi's groomers remain remarkably puritanical. When she wants longer skirts so she does not have to twist herself "in a Z every time I sit down" and worry about "my you-know-what," Madame Alvarez says, "Aren't you ashamed to call it your you-know-what?" and then refuses to supply another name: "There is no other name," she says. Who else in the 1940s was thinking about girls having been robbed of the words they need?

By the time Simone de Beauvoir met Colette in 1948, the seventy-five-year-old writer had received Europe's most prestigious literary awards. Although she had tried various medical interventions to deal with crippling arthritis, she continued to refuse painkillers on the grounds that they would dull her sensibilities. Beauvoir, who considered Colette "the only really great woman writer in France," explained to her American partner Nelson Algren why "I was in love with her": "She danced in music-halls, slept with a lot of men, wrote pornographic novels and then good novels." Accompanied by her neighbor Jean Cocteau, Colette "has still the most fascinating eyes and a nice triangular cat face; she is very fat, impotent, a little deaf, but she can tell stories and smile and laugh in such a way nobody would think of looking at younger, finer women."

Colette remained true to her preference for passion over goodness, much to the delight of her growing international audience. When *Green Wheat* premiered as a film, she stressed her ongoing curiosity about earthly pleasures: "Everything that surprised me when I was young surprises me much more today.... The world is new to me when I wake each morning, and I shall only cease to flower when I cease to live." When Anita Loos's adaptation of *Gigi* was televised, Colette said, "Love has never been a question of age. I shall never be old enough to forget love, and to stop thinking about it, and talking about it."

One funny passage in *The Evening Star* typifies Colette's delight in the oddities of her sedentary existence. About an unknown man who calls her regularly on the phone at two or four o'clock in the

morning to say "'I shit on you' and hangs up," she writes, "I should like to question him about his mysterious ailment, the motives for his insomnia, to discover whether, having nocturnally shat on me, he can fall back on his bed to sleep there, at last happy and released."

In *The Blue Lantern* (1949), Colette relishes the hilariously impertinent fan mail that she receives from strangers: one correspondent inquires if the author knows *"anyone who would let us have for nothing a motor-car"*; another feels the need to confess *"the fact that we find your stories of days gone by a little fatiguing"*; a third leaves a blank page between the title and the text of a manuscript and asks Colette to supply a preface: *"P.S. Please make the preface as long as possible."* Elsewhere, whether flirting with a doctor or jockeying with an overly inquisitive journalist or hiding a disability, she mocks "my old woman's wiles."

Colette died on Maurice Goudeket's birthday and much later he died on hers. He had set out to prove to her "that fidelity was not an empty word. Year by year she grew more persuaded of this, and her last books bear witness to a serenity that she would not otherwise have acquired." Though she knew that he had sexual relations with "very feminine" women, Colette trusted that he was bound to her because of what she called "my virility." With her blue eye makeup, her permed hair and painted toenails, the elderly Colette looked very feminine. But like Léa at the end of *The Last of Chéri*, she "seemed by virtue of age altogether virile and happy."

When close friends asked in amazement why Goudeket and Colette were often found together laughing, she explained, "We could well reply: 'No joke at all. But I was here with him, and he was here with me.'" Though she enjoyed needlework, her goal of relinquishing the pen had not been reached: "I don't yet know when I shall succeed in not writing; the obsession, the obligation are half a century old." After admitting that "I'm still going to write," she ends her last memoir with the words "'To be continued...'" The ellipsis is hers, a fitting final statement for a writer who never stopped writing.

A professional from start to finish, Colette "made her living by her pen," Erica Jong observed. Jong's poem "Dear Colette" explains

what the French writer's lust for life and letters has meant to many of her readers. In a literary history littered with "Suicides and spinsters," Colette managed to

>*endure & marry,*
>*go on writing*
>............
>*sing & tap dance*
>*& you go on writing,*
>............
>*love a woman, love a man*
>*& go on writing.*

Jong concludes by thanking her muse: "Dear Colette / You hold me / to this life."

CHAPTER 3
Georgia O'Keeffe

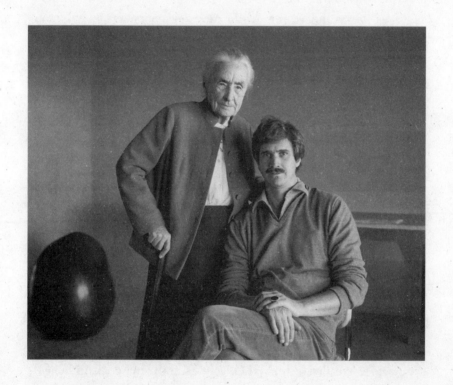

The final photograph inside Georgia O'Keeffe's 1976 memoir, *Georgia O'Keeffe*, depicts the wizened artist holding a pot. In the text, she admits that even though a protégé helped her roll and coil the clay, "I cannot yet make the clay speak—so I must keep on." She did keep on until the age of ninety-eight, but she never replaced painting with ceramics. Astonishingly, some of her most luminous canvases were undertaken while macular degeneration was robbing her of her eyesight. Throughout her old age, Georgia O'Keeffe relied on the resolve she had honed much earlier, when she needed to extricate herself from the forceful man who initially promoted her creative enterprises.

The stark contrast between New York City and New Mexico dramatizes the divergence between Georgia O'Keeffe's coupled youth and the single old age that she fashioned for herself in midlife. Celebrity photographers made her image iconic when they arrived at her desert homes to depict the elderly painter often alone. But O'Keeffe pursued the first part of her career in Manhattan with the aid of the influential photographer Alfred Stieglitz. From the start, their passionate partnership exhibited tensions that would escalate until O'Keeffe knew that though she owed her growing reputation to her mate, she had to escape his presence in order to preserve her sanity and her artistry.

That Alfred Stieglitz, not *a* but *the* pioneering photographer of the period, had first exhibited O'Keeffe's early charcoals in his gallery, 291, without her knowledge or consent illustrates the presumption with which he approached their relationship. She had produced the abstract drawings during one of several rural teaching stints that punctuated her training in a series of art schools. The drawings landed in his hands after she mailed them to a friend who then delivered them to Stieglitz. "Finally," he famously said, "a woman on paper!"

Soon, Stieglitz wrangled O'Keeffe's appearance in New York City, found her an apartment, and then moved in. A married man with enormous influence in the art world and twenty-four years her senior, he immediately recognized and nurtured her talent. "Women can only create babies, say the scientists," Stieglitz declared at the 1923 show he organized for her, "but I say they can produce art—and Georgia O'Keeffe is the proof of it." Treasuring her as an innovative co-creator, Stieglitz arranged a loan that granted O'Keeffe a year's break from teaching. She would never return to the classroom.

While O'Keeffe went on to create her paintings of magnified flowers and Manhattan skyscrapers, Stieglitz was shooting hundreds of photographs of her in the city and at his mother's country house at Lake George in upstate New York. He also served as her publicist and agent, negotiating with buyers so skillfully that she became the best-paid painter in his entourage. Before that happened, when he obtained a divorce and persuaded her to marry in 1924, the thirty-seven-year-old bride determined to hang on to her last name "with my teeth" and he agreed: "She's a person in her own right." They often sported matching black capes and in different mediums tackled the same landscapes.

For all their camaraderie, however, in temperament Stieglitz and O'Keeffe were like oil and water. He was a self-dramatizing German American Jew, but she was closemouthed about her youth on a Wisconsin dairy farm run by her Catholic father and Protestant mother. The families of Stieglitz and his first wife were wealthy; O'Keeffe's parents had sunk into poverty. When they met, he was a wheeler-dealer but a stick-in-the-mud who rarely left the state of New York, while she was a solitary traveler. Gregarious, he was a hypochondriac, whereas she was a loner and a stoic. Old enough to be her father, Stieglitz was incompetent at the everyday chores of housekeeping, but O'Keeffe was all too able to cook and clean and mend, although at least in Manhattan they often dwelled in kitchen-less apartments that sent them nightly to cheap restaurants.

Despite his voluble devotion and guidance, Stieglitz must have

exhausted O'Keeffe with the tumult he perpetually ignited: around his estranged first wife and ailing daughter and the sibling rivalries of the acolytes he adopted as his disciples. Then there were the contentious relatives who congregated at the Lake George house, his fierce debates with critics and curators, his objections to many of her projects, and finally the public display of his affair with a younger woman whose maternal allure—she and her husband had one child, and another would soon be on the way—underscored the childlessness he had imposed on his wife.

The story of how Georgia O'Keeffe remained loyal to Alfred Stieglitz while detaching herself from his needs and demands would not be told by the circumspect artist. Yet she hinted at it in a series of publications issued during her senior years. The retrospective essays, as well as the evolution of her paintings once she relocated to New Mexico, illuminate her determination to dedicate her old age to the American ideal of self-reliance. Toward the end of her life, an ardent relationship with a young ceramicist whom she could mentor offered Georgia O'Keeffe the opportunity to turn topsy-turvy her early dependency on Stieglitz. Even when partially blind, O'Keeffe fashioned herself into an icon of a resilient old age as she continued to envision and paint the light she could no longer see.

NEAR HER NINETIETH birthday, Georgia O'Keeffe produced an introduction for the New York Metropolitan Museum of Art's book of Stieglitz's photographs of her, *Georgia O'Keeffe* (1978). The volume contains fifty-one plates—a small fraction of the photographs he began taking of her in 1917, with the last one dated 1930. In them, one can see her evolving from her early thirties into her mid-forties. Sixty years after Stieglitz began photographing her, O'Keeffe's prose displays the laconic but pointed candor for which she would become known. While working on the essay, she informed a caregiver, "If you live with a husband for thirty years, and you left, and

you are talking about why you leave, and you are telling the truth, it is sharp."

At the start of her introduction, O'Keeffe mentions the several times she visited 291 only to retreat from the "quite violent" talk of Stieglitz with her male colleagues and from the overly "personal questions" he put to her girlfriends. At another visit, after he told her about the painter John Marin's need for money, she got the idea that she might be able to sell her own work. Back at her teaching job, she then explains, she showed the first of Stieglitz's photographs to the students in her Texas classroom. These opening paragraphs display her youthful artistic ambition as well as her clear-eyed understanding that she would have to finance it herself.

O'Keeffe sets out to depict her younger self as a teacher, with colleagues and students and economic objectives, in order to counteract the emphasis in the photographs on her role as Stieglitz's muse. Close-ups of her delicate hands abound: fingers curled inward or stretched out, cupped around a button or the areola of her nipple, open and upraised as if in supplication, extended with a thimble covering one nail. None of the hands is engaged in producing a product; not one holds a brush or a stick of charcoal.

Stieglitz's photographs catalogue the fleshly attributes of its subject in a pictorial analogue of the blazon, the list of virtues that poets attribute to the beauties—eyes, neck, shoulders—inspiring their verse. As in those catalogues, Stieglitz's camera fractures the female figure into often decapitated body parts. In one torso, from the breasts to the knees. In another seated torso, from the breasts to the open thighs, where a dark thatch of pubic hair dominates the lower central third of the picture. Sometimes, within a draped robe, only the breasts appear, brushed by a hand. In one, the lens crops the head above the lips, turned in profile, as well as the breasts below to foreground the taut tendons of the neck and the clavicle bones.

When, shortly after the 1921 exhibition of some of the photographs, the faux-naïf painter Florine Stettheimer met Georgia O'Keeffe, she confessed that she was "pleased to see her whole, as so

far I only knew her in sections." Like the arts patron Mabel Dodge Luhan, Stettheimer suspected that the then-married (to another woman) Stieglitz was exploiting O'Keeffe to incite gossip that would publicize both their names. Because of the steamy show, viewed by some 3,000 spectators, O'Keeffe became "a newspaper personality."

As if to resist such objectification, the elderly author of the introduction emphasizes the professionalism required of models and the difficulty of sustaining required poses. After discussing the glass plates and parchment paper Stieglitz used, she explains that she had "to be still for three or four minutes": "That is hard—you blink when you shouldn't—your mouth twitches—your ear itches or some other spot itches. Your arms and hands get tired, and you can't stay still." O'Keeffe juxtaposes the stoical model with "a great deal of fuss" made by the artist if she couldn't help moving.

While the photographs were exhibited in the Anderson Galleries, O'Keeffe recalls in the introduction, some men asked Stieglitz if he would photograph their partners. He laughed, because "if they had known what a close relationship he would have needed to have to photograph their wives or girlfriends the way he photographed me—I think they wouldn't have been interested." Her comment is a tactful way of expressing the erotic charge that the images capture. It was decidedly not coming only from the photographer. In the twenties, the youthful O'Keeffe's letters to Stieglitz attest to the power of her desire: "I wonder if your body wants mine the way mine wants yours—the kisses—the hotness—the wetness—all melting together—the being held so tight that it hurts—the strangle and struggle—the release that moans and groans and the quickly drawn breath— . . ."

Soon after the exhibit, critics praised O'Keeffe's artworks as "gloriously female" or as "great painful and ecstatic climaxes" and portrayed her as "the Sphinxian sniffer at the value of a secret." The model's reputation was coloring the painter's reception. Privately, she reviled the critics' stereotyping. Two years after the photography show, however, some of these same comments were reprinted

in catalogue copy... presumably with Stieglitz's and O'Keeffe's approval. Both understood that in the highly competitive art marketplace, name recognition—even if it came at a price—jacked up prices. Stieglitz promoted O'Keeffe's art "as an expression of her sexuality," the curator Sarah Greenough has explained, "(and also, to some extent, his virility)."

In her introduction, the aged O'Keeffe continues to believe that Stieglitz's work provides "the most beautiful photographic document of our times." Instead of ending on this note of acclaim, though, she goes on to concede that when she looks at the model in the photographs taken decades ago, "I wonder who that person is." The opinionated photographer who took them had the "power to destroy" and the "power to build" up the people in his circle, she admits—and then she adds, "the extremes went together. I have experienced both and survived, but *I think I only crossed him when I had to—to survive*" (emphasis mine).

O'Keeffe likens Stieglitz's "power" to the constant grinding of the ocean, though her subsequent words make him sound more like a constantly erupting volcano: "It was as if something hot, dark, destructive was hitched to the highest, brightest star." In her final sentence, she draws a conclusion from the fact that Stieglitz never traveled anywhere to photograph but instead shot "anything nearby": "Maybe that way he was always photographing himself." A reviewer in the *New Yorker* agreed: "The portrait is a self-portrait." As the book's title and subtitle, *Georgia O'Keeffe: A Portrait of Alfred Stieglitz*, indicate, in midlife O'Keeffe was in danger of becoming a creature of Stieglitz's creation.

TOWARD THE END of the Metropolitan Museum's volume, five pictures locate O'Keeffe beside or inside an automobile, poised to escape Stieglitz and the New York art scene. While he continued to establish a succession of galleries, while the couple shuttled

between a Shelton Hotel apartment and summers at Lake George, O'Keeffe periodically fled her husband and the crowds that invariably thronged around him. She traveled to Maine, Wisconsin, New Mexico, Canada, and back again to New Mexico, where she bought a Model A Ford to drive around the land that began to emblematize her freedom. It must have been a confusing period, despite her extraordinary productivity. A series of tribulations—as well as flights from them—led to O'Keeffe's breakdown and hospitalization in 1933.

Midlife frustrations put a strain on O'Keeffe that resulted in bouts of despondency and weight loss. By the time she married the sixty-year-old Alfred Stieglitz, she knew that she was not going to become the mother she had wanted to be. His anxieties about relatives harmed by childbearing and about O'Keeffe's capacity to combine artistic creation with biological procreation coalesced to convince her that it was he who required her caregiving, especially when kidney stones and angina attacks began to incapacitate him, and she took on the duties of a nurse.

With her own medical issues to deal with—the surgical removal of two benign growths in her breasts—O'Keeffe also had to contend with Stieglitz's objections to most of her aesthetic innovations, for he initially derided her large-scale flowers, as well as the Manhattan skyscraper paintings. At the same time, the women showing up at her exhibitions convinced quite a few critics that her mass appeal was evidence of the decorative pandering of her work. Sexual interpretations of her imagery simply infuriated her.

Georgia O'Keeffe was horrified by Freudian readings of her paintings and later with feminists who also praised the female genitalia evoked in the flower and clamshell portraits associated with her output in the late 1920s and early 1930s: *Open Clam Shell* (1926), *Closed Black Iris* (1926), *Red Poppy* (1927), *Jack in the Pulpit III* (1930), and many more. "Nobody sees a flower—really—it is so small—we haven't time," O'Keeffe often explained, so she decided to "paint it big and they will be surprised into taking time to look at it." However,

she informs her spectators, "When you took time to really notice my flower you hung all your own associations with flowers on my flower and you write about my flower as if I think and see what you think and see of the flower—and I don't."

This flat denial of the sexual nature of her imagery issued from a woman who always espoused feminist values. The friend who originally delivered her charcoals to Stieglitz, Anita Pollitzer, worked with Alice Paul and the National Women's Party, to which O'Keeffe also belonged. Back in 1915, O'Keeffe had subscribed to *The Forerunner*, Charlotte Perkins Gilman's publication. In 1925, when invited by Pollitzer to address the National Women's Party, O'Keeffe spoke of "the responsibility of self-realization." Many feminists at this time, including Gilman, objected to the Freudians' propensity to sexualize everything, including the content of art.

In 1930, when the Marxist-oriented author Michael Gold criticized O'Keeffe for not using her art to depict the struggles of the working class, O'Keeffe argued that women of all classes were oppressed. In the 1940s, she wrote a letter urging Eleanor Roosevelt to stop opposing the Equal Rights Amendment. Yet when Gloria Steinem appeared with a bouquet of roses in New Mexico in the 1970s, the aged O'Keeffe refused to see her. Antagonistic to feminists who championed women artists, she found the topic "silly": "Write about women. Or write about artists. I don't see how they're connected. Personally, the only people who ever helped me were men."

It was a community of women, however, that temporarily freed O'Keeffe from the frustrations she was encountering in New York, troubles exasperated by the oppressive presence of a worshipful new acolyte, Dorothy Norman, in Stieglitz's gallery. Stieglitz, O'Keeffe knew, adored being adored. To her distress, he had been briefly idolized by the wife of his disciple Paul Strand, Rebecca, and taken many nude pictures of her. By 1928, the year Dorothy Norman's infatuation with Stieglitz turned into a sexual affair, the smitten twenty-three-year-old intuited that O'Keeffe was looking at her "as if I were some queer species of animal who had strayed in... and

wouldn't I please remove my superfluous presence far enough away so as to be out of her sight."

With the wealthy and beautiful Dorothy Norman always hanging on Stieglitz's every word, it is no wonder that O'Keeffe removed herself from the city. A neighbor's account of New Mexico led her to counter Stieglitz's objections to her departure by explaining that Rebecca Strand would accompany her. The neighbor, the painter Dorothy Brett, had spoken about D. H. Lawrence's wealthy patron Mabel Dodge Luhan. In 1929, at Luhan's twelve-acre compound Los Gallos, near Taos, Rebecca Strand and Georgia O'Keeffe hiked, painted, sunbathed, undertook a horseback trip to visit Dorothy Brett, camped out, witnessed Indigenous ceremonies, and dressed up to emphasize their uncanny physical resemblance to each other.

In enthusiastic letters home to their husbands, both women attested to their joy at the limitless landscape, especially after Strand taught O'Keeffe to drive the car they called "Hello." Rebecca Strand exulted at her companion's healthy appetite for food, drinking, dancing, and adventuring. Their bonding—whether sexual or not—opened vistas for O'Keeffe. Alone for successive summers, she would continue to return to the region, where she painted the Spanish churches, wooden crosses, and bleached animal bones that began to surface at her New York shows.

During the 1929 trip to New Mexico, O'Keeffe received Stieglitz's hyperbolic complaints about her absence, in one of which he used their shared code to recount a dream of them naked in the bathroom: "You turned around stooped down & with your hands pulled Fluffy open—I had a terrific erection—Fluffy looked like the big *Black Iris*... as I took hold of you—& rammed my Little Man into you... you said... you must leave him... And I saw Fluffy—I saw him wet & shiny ramming into Fluffy & felt like God must feel." After elaborating on this fantasy, Stieglitz upbraided her for supposing that he would share her letters with "Mrs. Norman" and pleaded for attention. "Without you," he wrote, "I am nothing. Without me you go right ahead—will be Georgia O'Keeffe." Was he

a tad threatened by her independence? Operatic in his self-pity, he pictures her having "lived this summer," while "I have been dying by inches—I want you to live & laugh—enjoy people—I'm willing to die alone[.]"

Yet Stieglitz was rarely alone. When O'Keeffe's 1931 exhibit of her New Mexico work went up at An American Place, she associated the gallery with the oppressive presence of Dorothy Norman, who was taking on all sorts of managerial roles. O'Keeffe learned how obsessively the lovers communicated, but she may not have known that Norman's pet name for Stieglitz was "God"; his code name for her was "Y.L." (for Young Lady), while his code name for O'Keeffe was "S.W." (for Southwest).

Wanting to be "kind" to Stieglitz, O'Keeffe explained to him, "there is nothing to be kind to you if I cannot be me." Rather than indulge in jealousy that would be destructive not only to his well-being but to her own, she repeatedly lit out for the territories. In doing so, she needed to balance her allegiance to her husband with her increasingly intense desire to absent herself from him. "I am divided between my man and a life with him," she wrote a Texan correspondent, "and some thing of the outdoors—of your world—that is in my blood—and that I know I will never get rid of." Despite growing evidence of Stieglitz's passion for Norman, O'Keeffe struggled with guilt. She sought to *not* let guilt—at her desire for separation—stymie her.

To Mabel Dodge Luhan, O'Keeffe explained that "I feel I have two jobs—my own work—and helping him to function in his way." Given Stieglitz's charisma but also the neediness inflicted by his aging, it was never easy to extricate herself, she often admitted. To Dorothy Brett, she articulated the advice that she herself would take: "You must not let the things you cannot help destroy you.... I am so sure that Work is the thing in life.... Do save your strength and energy for creating—dont spend it on problems and situations you cant help."

While O'Keeffe relished her summer trips to New Mexico, Stieglitz, nearing seventy, grieved over her absence, worried about the

health of the twenty-seven-year-old Dorothy Norman during her second pregnancy, shot more than a hundred portraits of Norman, taught her photography, bought her a camera, and encouraged her to take pictures (of himself). O'Keeffe, fleeing the city for Maine or Lake George, put as much distance between herself and the lovers as possible, but on one return to the Shelton in 1931, she encountered them in the apartment. A furious Stieglitz told her never to appear unannounced again. It would not have been lost on O'Keeffe that his first wife had blundered upon her and Stieglitz in the married couple's apartment, an event that led to their divorce.

At a Stieglitz retrospective in 1932, O'Keeffe would see on the walls not only images of herself but also portraits of Dorothy Norman. "When I make a picture," Stieglitz famously said in his assisted monologues with gallery visitors, "I make love." At the exhibition, as the biographer Benita Eisler puts it, "in cruel contrast to Dorothy's dewy youthfulness, Georgia, looking older than her forty-five years, was publicly displayed in the role of superseded wife." By the time O'Keeffe disregarded Stieglitz's vehement objections and began working on a mural for the powder room in Radio City Music Hall, construction was delayed, then the canvas did not adhere to the wet plaster, and she became ill. In brief letters from Lake George to Stieglitz, she mentions feeling "quite empty" or "vacant." When she was admitted to Doctors Hospital, his visitations were curtailed during her two-month stay.

THE FORTY-FIVE-YEAR-OLD WAS experiencing headaches, shortness of breath, chest pains, difficulty speaking and eating, agoraphobia, insomnia, and weepiness. Little is known about the therapy Georgia O'Keeffe underwent, though it might have involved the so-called rest cure to which Charlotte Perkins Gilman had vigorously objected: restrictions put on creative activities like writing or painting.

During the hospitalization, O'Keeffe received a letter from Frida Kahlo—they had met earlier at a retrospective of Diego Rivera's work—in which the younger artist explained that she wanted to confide her troubles to the older, but "you mustn't know sad things now": she would, Kahlo promised, "never forget your wonderful hands and the color of your eyes. I will see you soon... I like you very much Georgia." After O'Keeffe's release, Kahlo, who had her own problems with a philandering husband, wrote to another correspondent that O'Keeffe had previously made love to her, but did not then "on account of her weakness." Though the remark might have exaggerated their intimacy, Kahlo's letters, which came as an enormous surprise to me, give us a glimpse into how much of this turbulent period the guarded artist concealed.

In any case, avoiding the city and Stieglitz was crucial. O'Keeffe convalesced during two trips to Bermuda and then alone at Lake George, where she invited the grieving Jean Toomer to join her in December. The author of *Cane* (1923), now considered a classic of the Harlem Renaissance, had recently suffered the death of his wife in childbirth and had obtained some of her letters from O'Keeffe. Exceptionally handsome, Toomer did not want to be confined within a racial category, just as she did not want to be confined within a gender category. They tramped in the snow, dug out her frozen car, played with the cats, listened to jazz, talked into the early hours about race, and celebrated Christmas (she gave him a red scarf), and she read *Cane*. After he left, she wrote him fourteen passionate letters in January and February 1934 that clarify how he midwifed her recovery.

On January 3, O'Keeffe told Toomer that he had given her "a strangely beautiful feeling of balance": "I seem to have come to life in such a quiet surprising fashion—as tho I am not sick any more—Everything in me begins to move and I feel like a really positive thing again[.]" Then she admits, "I miss you. We had duck for dinner today... even the duck missed you." Other passages are more fervent: "I wish so hotly to feel you hold me very very tight—.... All

your being here was very perfect for me—I like it that it stands as it is."

One letter recounts a dream of his sleeping with another woman and she was "neither surprised nor hurt." In another, she explains that "What you give me makes me more able to stand up alone": "I want you—sometimes terribly—but I like it that I am quite apart from you like the snow on the mountain—for now I need it that way." The relationship with Toomer enabled O'Keeffe to experience loving alone and apart: precisely the protocol she would quickly establish with Alfred Stieglitz, as she rearranged the rest of their marriage. The heavy tome that reprints a selection of their letters is titled *My Faraway One*.

From this point until Stieglitz's death, O'Keeffe spent the spring making the Lake George house habitable, but summer and fall would find her in New Mexico, while in a wintry Manhattan she supervised his living conditions, stipulating with the housekeeper that Dorothy Norman was not to enter the penthouse apartment in which she installed him. Shuttling between New Mexico and New York, O'Keeffe became the primary breadwinner in the family.

The reason she objected to the Freudians and feminists—even though the erotic code she shared with Stieglitz clearly associated flowers with genitalia—had everything to do with the herculean effort it took for O'Keeffe to extricate herself from the muse/model/wife roles that Stieglitz had so tenaciously fashioned for her. An unwelcomed Gloria Steinem would be the first person to understand why women of O'Keeffe's generation refused to be considered "women artists": "Whoever is in power takes over the noun—and the norm—while the less powerful get an adjective," Steinem once observed. In the last, long chapter of O'Keeffe's married and then widowed life, she took power over the noun and the norm.

"I don't like being second or third or fourth," she had known for quite some time; "I like being first." Mary Cassatt notwithstanding, O'Keeffe went on to become the first American woman painter to devise her own visual vocabulary, one that included lexicons

deployed by surrealists and abstract expressionists but mined to express her singular perspective.

THE PAINTING *Summer Days* (1936, 36⅛ × 30⅛ in.) announces that the desert is in O'Keeffe's bones. In her late forties, she settled into the stark landscape that would serve as the backdrop of her old age. Like the earlier, horizontal painting *Ram's Head with Hollyhock and Little Hills* (1935, 30 × 36 in.), the vertical *Summer Days* sets at the base of the canvas small hills softened by centuries of erosion from wind and rain. Above the hills in both, a suspended animal's skull is separated from the earth by a swath of sky. Above the antlers more sky appears. Flowers float near the skulls: in *Summer Days* a red and a yellow bouquet, in *Ram's Head* a white bloom.

O'Keeffe's skull-and-antler paintings issue a declaration of independence from Stieglitz and the New York art scene. On her first trip to New Mexico, O'Keeffe had shipped a barrel of bones back to Lake George and painted horse and cow skulls while thinking of "the city men" who droned on about the Great American Novel without any knowledge of America beyond New York City. But "I knew the cattle country—... and I knew that at that time almost any one of those great minds would have been living in Europe if it had been possible for them." The implication is clear: O'Keeffe settled in New Mexico in order to produce Great American Paintings, so she brushed red, white, and blue stripes down both sides of her painting *Cow's Skull— Red, White and Blue* (1931, 40 × 36 in.).

In *Summer Days* and *Ram's Head*, the magnified flowers of O'Keeffe's earlier career have been miniaturized. Rootless, stemless, they hover where they could never grow or exist: in the air. Decidedly out of place, the flowers have been reduced to decorative traces from bygone days, maybe a farewell tribute to the receding self she had once been. A later deer skull painting, *From the Far Away Nearby* (1937, 36 × 40⅛ in.), dispenses with the flowers altogether. Of

course, animal skulls could not levitate in the clouds either. To this extent, the paintings can be considered surrealistic like René Magritte's *Time Transfixed* (1938), in which a train zooms out of a fireplace, although the antlered skulls seem less intellectually contrived, more viscerally transplanted.

Whether derived from legends or dreams, O'Keeffe's floating animal skulls signify death. Each is a momento mori. Like a skull-and-crossbones and unlike the taxidermized heads mounted on the walls of hunting lodges, the animal skulls with their empty eye sockets and mouth- and ear-cavities testify to the loss of sight, breath, taste, sound, flesh, desire. In a Southwest novel, *St. Mawr* (1925), D. H. Lawrence, whom O'Keeffe celebrated in paintings of trees near his New Mexico dwelling, associated the desert with "Bones of horses struck by lightning, bones of dead cattle, skulls of goats with little horns: bleached, unburied bones."

Yet the antlered skulls are literally "remains," relics levitating overhead like blimps, except, unlike blimps, they are an emblem of nature's handiwork. Transcendent, they represent the spirit of the place where O'Keeffe satisfied her "feeling of aloneness": "*I even get a kind of ecstasy from the vast space—feeling like death—that is close kin to what the male can give me*," she tried to explain to the faraway Stieglitz (emphasis mine). Lawrence's heroine, alienated from sex, wants "to be by myself, really" and finds "something more to me than men" in "a wild spirit" accessible in the desert. The shape of O'Keeffe's skull with antlers resembles nothing so much as a uterus with fallopian tubes. Is the artist elegizing her erotic past, welcoming the "wild spirit" of her seniority? If so, *Summer Days* constitutes the first representation of menopause in the history of art.

Oddly, then, the skulls also signify ecstatic survival, during a period of time when love of a place eclipses love of a person. Skulls do not experience headaches, shortness of breath, chest pains, difficulty speaking and eating, agoraphobia, insomnia, or weepiness. Bristling with antlers that can function as weapons, the skulls reflect O'Keeffe's efforts to keep others at bay so as to get down to the bare

bones of existence. O'Keeffe shows us that these bones are going to rise again.

In a 1944 exhibition catalogue, the painter suggests that some of her Southwest works are assemblages, not unlike collages. She remembers picking up the bones in the desert, plucking the flowers where she had planted them in her vegetable garden. Scale and perspective also remind viewers that the paintings are constructions, for the skulls loom larger than life over the diminished landscape below. A collage is about as far removed from Stieglitz's photographic realism as one could get. Never shy, Stieglitz was quite willing to express his reaction to *Summer Days*: "I hate it," he told a reporter. *Summer Days* is the work O'Keeffe selected for the cover of her 1976 memoir.

In this signature piece, O'Keeffe has Americanized the Vanitas still life, which generally displays flowers and glassware, often on a tabletop, along with a human skull positioned near other symbols of ephemerality: a half-spent candle, a watch or hourglass. In an outdoor, not a domestic, setting, nothing man-made or cultural appears in *Summer Days*. By replacing the human skull with an animal skull, O'Keeffe dispenses with humanity altogether. Human figures rarely found a place in her output. But the landscape in *Summer Days* is decidedly indifferent to human life, which shrinks into insignificance. Not the transience of human life or the futility of human pleasure, but the inconsequentiality of humanity comes into view.

Yet O'Keeffe's assembled still life manifests the resourcefulness of the person hardy enough to gather flowers or cultivate them in arid ground, hale enough to wander on rocky paths collecting bones, to camp out in freezing cold or burning heat. O'Keeffe often described how she got her canvases into her car, and painted inside it. Sometimes the only way to evade the intense heat was to lie down beneath the car. Her accounts of the difficulty of keeping herself safe on camping/painting trips—the fierce winds and storms; threatening bears, coyotes, and insects; venison cooked over a cedar fire—make her sound like a pioneer woman or like Ernest Hemingway, turning

the act of painting into a courageous act of grace under pressure. By her fiftieth birthday, O'Keeffe and her skulls were home, home on the range.

Vibrant colors return with later bone portraits that feature the pelvis, which contains holes, and in *Pelvis with Moon* (1943, 30 × 24 in.), as well as *Pelvis with Distance* (1943, 23⅞ × 29¾ in.), the intense blue of the sky shines through them. The pelvis bone portraits enabled O'Keeffe to return to the abstracts she had produced in her earliest charcoal and watercolor drawings. Indeed, without the title *75 Pelvis Series, Red with Yellow* (1945, 36 × 48 in.), it would be impossible to know that the oval yellow at the painting's center, almost completely surrounded by red, has anything to do with anatomy at all. Such abstract paintings could not easily be gender stereotyped.

Quite a few of O'Keeffe's pelvis bone paintings were produced after she had been proclaimed "America's most famous and successful woman artist" in a 1938 *Life* article. She had earned large sums from paintings, as well as a substantial commission from Elizabeth Arden for the sort of mural she had earlier been unable to complete. She realized that Dorothy Norman reigned over Stieglitz's gallery, where he held forth "all day, everyday, including weekends, from morning until night." While Stieglitz busied himself publishing Norman's poetry, Norman was collecting laudatory essays about Stieglitz. In 1940, O'Keeffe bought Rancho de los Burros, the adobe house at Ghost Ranch that she had been renting: "I am about 100 miles from the railroad—68 from Santa Fe—95 from Taos—40 miles from town—18 miles from a post office and it is good," she told Florine Stettheimer's sister, Ettie.

IN A NUMBER of ways, the 1939 commission from the Hawaiian Pineapple Company epitomizes the old age Georgia O'Keeffe devised for herself during her midlife, for with the luck of a strong constitution and healthy habits, her midlife gradually unfolded into her later life.

First, the company's request for an image to use in their advertising reflects her growing renown. Especially after she spent two months painting on the islands, she received an astonishing number of retrospective exhibits at prominent museums and many honorary degrees and national medals of honor.

Second, like the honorary ceremonies to which she traveled, the Hawaii trip manifests O'Keeffe's wanderlust. After the death of Alfred Stieglitz in 1946—she flew back to be at his hospital bedside—and after three years devoted to cataloguing and distributing his enormous collection of letters and art, O'Keeffe lived year-round in New Mexico, spending summers at the remote Ghost Ranch and winters in a second property: the Abiquiu house, a dilapidated hacienda that she had bought in 1945 and rebuilt with the help of a devoted admirer, Maria Chabot. But she also embarked on numerous camping expeditions and in the 1950s and '60s took plane trips to almost every continent. She became more of a globe-trotter in old age than did my other subjects.

In a less palpable way, the pineapple commission reflects O'Keeffe's evolving temperament. She returned from Hawaii with paintings and painting ideas, not one of which included a pineapple! Only after the company air-shipped a pineapple plant did she comply, a fact that signals a high-handed posture that she cultivated through her garb, interior decorating, and paintings. Roughing it in the wilderness—albeit with skylights, picture windows, stereo systems, an extensive library, Calder mobiles, Navajo rugs, and designer chairs, and often garbed in (black or white) silk kimonos—she promoted an image of herself as a remote, autonomous trailblazer.

Produced in her fifties, the paintings of the arroyos, mesas, canyons, and cliffs of New Mexico convey O'Keeffe's continued interest in merging representational images with abstract forms. *From the White Place* (1942, 30 × 24 in.), *Cliffs Beyond Abiquiu* (1943, 30 × 24 in.), *Black Place III* (1944, 36 × 40 in.), and *Red Hills and Sky* (1945, 30 × 40 in.) present monumental earth formations that seem primeval and

elemental, strong and obdurate, unchanging and eternal. *Red Hills and Sky*, O'Keeffe explained, portrays "the arms of two red hills reaching out to the sky and holding it."

But this painting, which depicts the subtle changes in one area of color (blue) reverberating against another (tan), could as easily be seen as legs opening onto the sky or, for that matter, sand dunes adjacent to water. At some moments, the Black Place looked to O'Keeffe "like a mile of elephants." One art historian sees in the hills "the bodies of recumbent giants slowly rising in an attempt to extricate themselves from their shell." By erasing details and abstracting her representations, O'Keeffe adds mystery to what no longer register as landscapes. Whether the cliffs and hills resemble arms or elephants or recumbent giants, they signify the "unexplainable thing in nature that makes me feel the world is big far beyond my understanding." To this extent, O'Keeffe seeks to stimulate in viewers not fearful awe at the sublimity of destructive nature but rather calm wonder at its enduring majesty.

The curves of the hills disappear, replaced by the squares and rectangles of the Abiquiu house, in a series executed after Stieglitz's death: *In the Patio I* (1946, 30 × 24), *In the Patio IV* (1948, 14 × 30 in.), *Patio with Black Door* (1955, 40 × 30 in.), and *White Patio with Red Door* (1960, 48 × 84 in.). The Abiquiu house gave O'Keeffe the pleasures of ordering seeds, weeding, and composting. An admirer of the healthful cooking guru Adele Davis, she prided herself on growing the vegetables, fruits, and herbs that she ate daily, or canned, or dried, and on teaching her housekeepers how to make whole-grain breads. Without the titles, once again, representations of the patio door look abstract in their geometric symmetry.

On canvas, the patio appears as empty as the cliffs it overlooks, but in fact many people were visiting the celebrity, and many others— cooks, secretaries, gardeners, handymen—were keeping her houses running. Like her sisters, who visited recurrently, famous guests arrived to wine, dine, or buy: Cary Grant (not allowed in because of a cold), the Harlem Renaissance patron Carl Van Vechten, Chris-

topher Isherwood, Ansel Adams, Andy Warhol, Pete Seeger, Allen Ginsberg, and Thomas Merton. Intimate friends who were also helpers moved in for longer stays: Maria Chabot, who ran the house and accompanied O'Keeffe on camping trips; Doris Bry, who had taken over the drudge work of the Stieglitz allocations and then served as O'Keeffe's dealer; Anita Pollitzer, who received permission to write a biography about O'Keeffe. That O'Keeffe ended up alienating each of these close associates suggests just how powerfully the myth of self-reliance would eventually have her in its grip.

But aging compromises most people's sense of self-reliance. In her early seventies, O'Keeffe painted *Ladder to the Moon* (1958, 40 × 30 in.). When she first lived at the Ghost Ranch house, she explains, she climbed a ladder several times a day so as to stand on the roof and look all around: at the "strong handmade ladder" with "the dark Pedernal and the high white moon—all ready to be put down the next day." Yet the painting is not realistically "put down," for the ladder is suspended in the sky, poised in midair between the narrow strip of earth below and the half moon above.

Ladder to the Moon can be read as a meditation on transitions, as the biographer Roxana Robinson has suggested, specifically the transition into old age, a period in which most people avoid ladders. The sky, still holding light, will be darkening soon. The moon is half eclipsed, while the earthly landscape appears very far away. In the greenish-blue sky, the tilted ladder floats in the ether. The painting therefore swerves from the story it invokes, the biblical tale of Jacob's ladder, a bridge between heaven and earth on which the angels descend and ascend (Genesis 28:10–19). In the spiritual, too, "every rung goes higher, higher" for "Soldiers of the Cross."

Yet O'Keeffe seems to echo Jacob's words when he awakes from his dream: "How awesome is this place." If *Ladder to the Moon* is viewed as a self-portrait, the unattached artist is holding steady, alone and apart, equipoised in the winds of time. The image shields her from the infirmities of aging. In a 1977 television documentary directed by Perry Miller Adato, O'Keeffe climbed the ladder to the

roof of her house so as to enjoy the view, but the scene was staged: she no longer saw well enough to climb alone or to glimpse the flat-topped mesa.

Wishing to appear fully capable, O'Keeffe did not want the public to know about her mastectomy or her loss of vision and hearing. Instead, she sought to propagate an image of her physical strength and rugged individualism. When glossy magazines featured pictures of her—wearing a black gaucho hat, posing with a skull in a black wrap dress—photographers collaborated with her in promoting a myth of "Saint Georgia of the Desert... that eventually captured the national imagination."

In four pages toward the end of her memoir, O'Keeffe emphasizes the arduous manual labor of preparing the canvas for *Sky Above Clouds IV* (1965, 96 × 288 in.), a work too big to fit into her house: screwing the stretcher together, dealing with a rough and unwieldy bundle of canvas, applying the grommets, lacing the canvas to the stretcher, wetting the canvas to shrink it, screwing steel strips to hold the stretchers together, painting it with glue water and two coats of primer while standing on a table, "and every time I sat down on the floor I was afraid that the rattlesnakes would come in behind me as I worked."

Up at 6 a.m. and working seven days a week, O'Keeffe explains, at seventy-nine years of age she produced an op art rendition of the sky: white lozenges of clouds floating amid the blue and extending into the distance until blurred into a pink sunset at the horizon. With its stylized, almost cartoonish cottony cloud puffs, *Sky Above Clouds IV* has a scale that dwarfs Stieglitz's photographs of cloudscapes. The strenuous task of transporting the gigantic painting and hanging it comprises the rest of her description. "If we had taken it to San Francisco," she mentions with a note of pride, "it couldn't have gotten through any door—so it still hangs in Chicago." In keeping with her sense of scale, books about O'Keeffe tend to be massive, with Barbara Buhler Lyne's two-volume *Catalogue Raisonné* weighing in at almost twenty pounds.

IN 1973, AS older old age was descending upon the eighty-six-year old Georgia O'Keeffe, a handsome twenty-six-year-old ceramicist named John Hamilton knocked on her door, asking for work. Fully acquainted with her standing in the art world, he provided her the opportunity to take on the masterful role that Stieglitz had played in the past. She had admired her husband's capacity to continue innovating his ideas in old age and, like him, she drew on the energies and talents of younger people. Juan, as she called him and as he became known, would work productively for and with O'Keeffe until she died in 1986.

Hamilton became O'Keeffe's handyman, driver, secretary, walking and dinner companion, fellow international traveler, and disciple. She bought him a kiln, encouraged his efforts, and arranged exhibits as well as sales of his work. Nightly they listened to Sviatoslav Richter's recordings of Beethoven's piano sonatas. He teased her and she flirted with him. Yet the lasting friendship was complicated by the vulnerabilities inflicted by later late life, including the loss of her central vision in 1971. As O'Keeffe grew frailer, he also began functioning as her agent, as her caregiver, and (more disturbingly at the end of her life) as though he was her designated heir. Still, in her only memoir, *Georgia O'Keeffe*, she credits Hamilton for a three-year stint of arranging the layout of her memoir's large format.

In this summarizing text, O'Keeffe stresses that she was self-taught. From her earliest visual attempts to her formal training, the painter asserts, she has no idea where she got her desire to be an artist or her aesthetic goals. Certainly not from her instructors, who are presented as "hot and stuffy" or "too old" or "a hunchback." In an anatomy class, "I don't remember learning anything except that I finally became accustomed to the idea of the nude model." In a composition class, "I didn't think much of the compositions put up for criticism and I wasn't interested in what was said about them."

Producing the early abstract charcoals and watercolors, "I was alone and singularly free, working into my own unknown—no one to satisfy but myself." School and instructors "even keep me from painting as I want to," she reiterates: "I decided I was a very stupid fool not to at least paint as I wanted to and say what I wanted to when I painted as that seemed to be the only thing I could do that didn't concern anybody but myself—that was nobody's business but my own."

In O'Keeffe's memoir, there is no discussion of Alfred Stieglitz's work and influence, no allusion to the marriage or her breakdown or, for that matter, the important roles played by friends or facilitators from Rebecca Strand to Maria Chabot, Doris Bry, and Anita Pollitzer, quite a few of whom O'Keeffe turned against. She fired Maria Chabot, who had remodeled the Abiquiu house. She initiated a lawsuit against Doris Bry after years of meticulous work involving the sales of her paintings. And she denied Anita Pollitzer permission to publish the completed (adulatory) biography that she had previously sanctioned. After Pollitzer's death, the artist added insult to injury by asking that the painting she had given her lifelong friend be returned by her survivors.

Stories about O'Keeffe's putting herself first abounded. She had squelched the painterly ambition of one of her sisters, when she felt it might challenge her preeminence. In an exhibition of Stieglitz's photographs after his death, she excised pictures of Dorothy Norman, who believed that she had been made his executrix until, at O'Keeffe's insistence, he had changed his will. An assistant who helped O'Keeffe paint in old age was likened to "a palette knife" so as to deny him the credit he felt that he deserved. In 1977, a caregiver attested, "She walks, does rolfing exercises, stays informed, and creates and eats carefully. She goes into a rage if anyone pampers her. It is as if she fights such conditioning to make her dependent or weak or less than she is."

In the photograph on the back of her memoir, O'Keeffe stands at a great distance from the camera, looking out over the hills with

her back decidedly set at the observer; her chow also has his back to the photographer, Juan Hamilton. She was still walking a mile a day and she liked chows because they kept people away. Did Hamilton enrich O'Keeffe's old age, or was he an opportunist who exploited the sixty-year age gap between them?

Most biographers answer *yes* to both questions. He encouraged her creative efforts, accompanied her on numerous jaunts, negotiated financial as well as aesthetic matters with museum administrators, held her hand, and made her laugh. Photographs and Adato's documentary attest to the supportive role he played. "For every person who believed him to be manipulative and ungracious," the biographer Hunter Drohojowska-Philp explains, "there was another who thought that Hamilton enhanced the artist's last years immeasurably."

The worst (unproven) allegation against Hamilton involves a scene in 1984 when O'Keeffe signed a codicil that bequeathed her enormous assets to him. They had already arranged for him to receive a substantial number of paintings and properties. But in the midst of mental confusion, she dressed in white and told one of her nurses that she was getting married to Juan that day. Did she think it was a wedding ceremony, even though several years earlier she had encouraged and had later acknowledged his marriage to someone else? In her nineties, O'Keeffe moved with Hamilton and his family into a house in Santa Fe, to be closer to medical assistance. He did receive the huge O'Keeffe estate; however, he relinquished much of it after her relatives sued and he settled out of court.

Even if Hamilton harbored mercenary motives, for more than a decade his quirky humor, respect for her artistry, and personal dedication made it possible for her to continue producing many watercolors, charcoals, and clay pots. At ninety, O'Keeffe uncharacteristically named a series of oil paintings for her companion: *A Day with Juan* (1976–77). Their central feature, a solid trapezoid against a blue background, abstracts a section of the George Washington Monument they had seen on a trip to Washington, D.C. It seems to signify stability, perhaps the sense of equilibrium Hamilton supplied.

"He is my eyes and my ears," she would often tell people. The work expressed, he thought, "an upward bound feeling."

Although O'Keeffe ended her memoir with an intimation that she had moved on to work with clay, she continued painting in order to capture the sense of infinity toward which her aerial views of roads and rivers—seen from afar and portrayed through large-scale calligraphy—pointed. While she suffered numerous impairments, O'Keeffe often found watercolor, pastel, and graphite easier to use than oils. But four paintings in particular constitute a late-life achievement. In them, she provides spiritual insights into the sensation of what one might call dissolving into the light or what the art critic Barbara Rose calls "fading away."

Sky with Flat White Cloud (1962, 60 × 80 in.) highlights a large white block in the lower half of the picture with a faint green horizon and above it a pale and then deepening blue. *Sky with Moon* (1966, 48 × 84 in.) contains bands of gradations of gray with elements of pink toward the top of the canvas. *The Beyond* (1972, 30 × 40 in.) features strata of dark horizontal bands below with lighter blues above a white streak at the horizon. And *Sky Above Clouds/Yellow Horizon and Clouds* (1976–77, 48 × 84 in.), executed with the help of assistants, contrasts a grayish-white large rectangle in the lower half with a yellow horizon modulating into whitish bands of blues in the distance. Layers on top of layers of horizonal striations imperceptibly blur into each other.

The translucent colors of these late works contrast with the bold reds and saturated greens of O'Keeffe's earlier fruit and flower portraits. Now, everything is bleached, melted away, seen from a very remote distance, awash in a pale radiance. "What one sees from the air," O'Keeffe once wrote Maria Chabot, "is so simple and so beautiful that I cannot help feeling that it would do something for the human race—rid it of much smallness and pettiness if more people flew." What one sees from old age, it seems, can also be so elemental that it cleanses the doors of perception. O'Keeffe's ethereal skyscapes promote a consciousness beyond "smallness and pettiness." Throughout her mature work, she had been fascinated by gravity (mountains,

hills, rock formations) and levitation (skulls, flowers, clouds, ladders). In the late paintings, O'Keeffe envisions freeing herself from gravity, floating and dissolving into levitating light, evaporating into the void.

There is nothing to see in these upward-bound paintings except gradations of pellucid colors extending in space. Gone are flowers, buildings, skulls, hills, cliffs, doors, ladders, and roads. Gone, too, the cotton puffs of the cloudscape in Chicago, replaced by reflections and refractions of ever-changing, multicolored bands of shimmering pastels. Light-infused, the paintings position the viewer in a transcendent place, an airplane view but also a posthumous or otherworldly perspective. The catalogue copy in a book that reprints the mystic *Sky Above Clouds/Yellow Horizon and Clouds* explains: it was "painted when O'Keeffe was ninety with the help of assistants. Almost blind, she painted from memory: 'I can see what I want to paint. The thing that makes you want to create is still there.'"

O'Keeffe had admired Mark Rothko's works of three broad and stacked bands of color, and informed one of her caregivers "that she would have liked to see the Rothko Chapel in Houston." What a counterpoint the large, dark canvases in that chapel would make to a collection of O'Keeffe's last paintings. Such an exhibit, though clearly impossible, might be called Night and Day. Like Rothko's, O'Keeffe's paintings feature subtle color modulations. Without representing anything, both artists envision the beyond in quite large works with quite limited palettes. In the process, paradoxically, they question the possibility of a monochromatic cosmos. Whereas Rothko evokes a spectrum of shadowy colors emerging out of the black darkness, O'Keeffe's washes of pigments play with limpid whites and grays dissolving into the ghosts of pinks, yellows, and blues. Both hint at spectral forms of consciousness. If his vision is tragic, hers remains serene.

Spiritual in their emptiness, the late great works of Georgia O'Keeffe leave sunny imaginations free to wonder at the buoyancy and beauty of the air. Wouldn't it be grand to have an O'Keeffe Chapel, in which one could meditate on the longevity of her aesthetic courage?

Section II
MAVERICKS

In a book titled *Long Life* (2004), the poet Mary Oliver expressed her belief that "along with the differences that abide in each of us, there is also in each of us the maverick, the darling stubborn one who won't listen, who insists, who chooses preference or the spirited guess over yardsticks or even history. I suspect this maverick is somewhat what the soul is, or at least that the soul lives close by and companionably with its agitating and inquiring force."

For good or for ill, do some of us get closer to the quirky nub of ourselves in old age? Like simmering, does the process of aging render a concentrated version of who we are? The food writer M. F. K. Fisher believed that "as I get rid of the protective covering of the middle years, I am openly amused and incautious and less careful socially," which "makes for increasingly pleasant contacts with the world." After reaching the age of sixty, the storyteller Isak Dinesen, the poet Marianne Moore, and the sculptor Louise Bourgeois cultivated a roguish old age in which they flaunted their deeply eccentric spirits.

Different as all mavericks must be from each other, Dinesen, Moore, and Bourgeois produced their idiosyncratic late-life work at a phenomenal pace. All three were preoccupied with the past and in particular with their dead parents: Dinesen with her father, Moore

with her mother, and Bourgeois with the effort to replace her father with her mother as a model of creativity. Their long pasts inflected their perspectives on the last chapter of existence. Dinesen took old age to be an afterlife; Moore saw it as an opportunity to preserve and transmit obsolete values; Bourgeois viewed her eighties and nineties as a stage haunted by memories.

Dinesen, Moore, and Bourgeois enhanced their fame through odd outfits, reflecting their engagement with self-mythologizing. Their showy self-presentations put sly old ladies on the cultural map. In doing so, the storyteller, poet, and sculptor suggested that elderly people pursue varied involvements with sexuality and gender. Dinesen used her stories to explore her post-sexual existence. Moore morphed into a civic poet by stressing her nonconforming gender identity and also her celibate nature. Bourgeois escaped the sexual politics that had traumatized her youth by pondering formative pre-gendered moments.

All three viewed themselves as anachronisms, holdovers from a prior historical period. The single Moore dramatized her survival in a comic mode, whereas the divorced Dinesen and widowed Bourgeois mined more somber veins. Yet the final artworks of all three testify to their glee at having transfigured a complicated past. Mischievous playfulness helped them escape pain, boredom, and isolation. It also enabled them to plumb the authority conferred by their seniority.

In a poem about longevity, "Lapis Lazuli" (1938), William Butler Yeats imagines that the ancient eyes of even tragic figures are gay: "All things fall and are built again / And those who build them again are gay." At the end of their lives, not only Marianne Moore but also Isak Dinesen and Louise Bourgeois reveled in a gaiety based on having seen things fall apart and having built them up again.

CHAPTER 4
Isak Dinesen

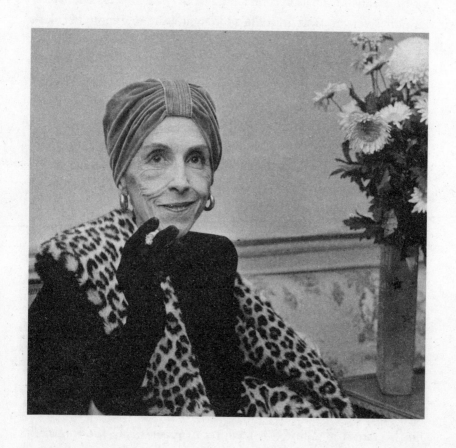

ISAK DINESEN, or Karen Blixen as she was called in her native Denmark, often claimed that she was three thousand years old. When she finally managed to visit America, the seventy-four-year-old looked so desiccated that she seemed poised in the liminal zone between life and death. In publicity photographs, her pallor, wrinkles, and emaciation contributed to an eerie impression that the gossamer veneer of flesh would soon melt away to expose her skull and bones. Rather than diminishing this effect, white powder and black kohl around her eyes theatricalized it. While others feasted at the dinner parties in New York, it seemed appropriate that the celebrated storyteller fasted. Three years later, Dinesen would be dead.

It was not the first ending of her life. Like Emily Dickinson, whose "life closed twice before its close," Dinesen's life closed twice before her death. The first time was the central tragedy of her childhood, near her tenth birthday: the suicide by hanging of her father, Wilhelm Dinesen, possibly because of fear of progressive syphilis. His favorite child mourned the man whose aristocratic escapades she idealized. He had soldiered in Europe, traveled among Indigenous people as far away from Denmark as Wisconsin, and published a successful book, *Letters from the Hunt* (1887).

The second closing of Dinesen's life occurred in 1931, when her adventures in the wilds of Africa were over. By the age of forty-six, she had lost her husband, her lover, and the coffee plantation she tried to cultivate at an unfavorable altitude. These injuries recycled the first, for on the 6,000-acre farm above Nairobi, Dinesen's marriage to Bror von Blixen-Finecke and her love affair with Denys Finch Hatton manifested her efforts to reconstitute the tragically terminated attachment to her dashing father. Both partnerships ended in disaster.

A model for Ernest Hemingway's great White hunter, Bror von Blixen-Finecke was hopeless at running the coffee plantation, but

expert at leading safaris and a dissolute existence. Soon after the wedding, the Baroness von Blixen-Finecke's fever, headaches, and insomnia led a doctor to inform her that she had a case of syphilis as "bad as a trooper's." Dinesen suffered from her husband's infidelities, but she was devastated when he obtained a divorce. She would keep secret the syphilis, as she did the mercury- and arsenic-based treatments administered by doctors. Still, a late letter states that "it was worth while having syphilis in order to become a Baroness." Dinesen adored playing the role of Mem Sahib, who acted as ruler, judge, teacher, and healer of the Africans on her farm.

The ardent affair with Denys Finch Hatton, an English daredevil who personified Dinesen's ideal, illuminates her estrangement from her mother's side of the family, relatives she associated with a bourgeois respectability at odds with her father's patrician license. Finch Hatton came from a titled family and was a big game hunter during the period when she acquired her African nickname, the Lioness. His Old French motto, "Je responderay" (I will answer), signaled a determination not to let societal commitments or moral duties hamper his spontaneity. Like Bror Blixen, then, he was devoted to his own autonomy and often absent from her life. He also encouraged Dinesen to abort the baby she wanted but could not physically bring to term.

As the biographer Judith Thurman has shown, few of these facts appear in Dinesen's elegiac *Out of Africa* (1937), which was composed after the failure of the coffee plantation, Finch Hatton's death in an airplane crash, and a sorry return to her mother's estate, Rungstedlund, "one of the oldest houses—perhaps the oldest house—between Copenhagen and Elsinore," where Dinesen resided for the rest of her life. When, like Lucifer or the Devil, a figure to whom she recurrently referred, she was cast out of heaven, her life split in two. The second half was an afterlife punctuated by bouts of depression. A thrilling quest in Africa would be replaced by a writerly career in Denmark.

To buffer herself against the loss of the liberty she associated with

Africa, Dinesen again resorted to her paternal role model. In midlife she adopted his patronymic and a (male) pseudonymous first name to publish her first book, *Seven Gothic Tales* (1934). In the Bible, baby Isaac, "the one who laughs," is God's joke on the ancient couple Abraham and Sarah. The volume was instantly successful in America and, like *Out of Africa*, became a Book-of-the-Month Club selection.

World War II prefaced Isak Dinesen's passage into old age. After her mother's death, her response to the rise of fascism was equivocal. On a journalism assignment in Berlin, she glamorized the Third Reich when, for example, she compared the Nazi bureaucracy to the Catholic priesthood and *Mein Kampf* to the Qu'ran. Yet during the German occupation, her house was used by the Danish resistance to hide Jews bound for safety in Sweden. To make money, Dinesen produced *Winter's Tales* (1942), a collection valued for its evocative depictions of Scandinavian landscapes and, with a different pseudonym, the potboiler *Angelic Avengers* (1944).

Clara Svendsen's name as translator of the potboiler marks the onset of Dinesen's old age. In fact, Svendsen—a well-educated and devoted servant—transcribed the translation that Dinesen dictated while lying on the floor in agony. By her early sixties, the degeneration of Dinesen's spinal cord led to cramps, gastric crises, and medical interventions that incapacitated her. Despite paralyzing attacks of pain, the aristocratic Baroness and fearless Lioness became a literary lion reigning over a salon populated by the intelligentsia of Denmark. Later surgeries rendered her physically weak—her weight hovered around seventy or eighty pounds—and the tempestuous artist grew irascible about her dependency on the all-suffering Clara Svendsen, who served first as maid and secretary and eventually as sounding board, companion, and literary executor.

One of Dinesen's earliest interpreters points out that "there is a long hiatus of fifteen years" between the first acclaimed books and those she published in her seventies, if one does not count the potboiler (which she did not). In some ways, the late-life books—*Last Tales* (1957), *Anecdotes of Destiny* (1958), and the posthumously published

Ehrengard (1963)—extend the work of Dinesen's midlife. Fantastically unrealistic fiction worked like a magic carpet transporting her highborn characters to long-ago adventures in faraway lands. Throughout her career, Dinesen likened herself to Scheherazade, who nightly defends herself against the sultan's death sentence by keeping him hanging on her every word.

But a number of Isak Dinesen's late publications derived from a curious affair with a younger poet during the "long hiatus" of her sixties. A Romantic identification with the Devil led her to create fiction analyzing the diabolical machinations of the elderly and the ungovernability of female eroticism. It may have also propelled the emaciation that led to her death. Anorexia manifested the loneliness that accompanied her aging. Life is what Dinesen had led in Africa, whereas storytelling is what she did in Denmark: many of her late-life works ponder this exchange of life for art, and some found storytelling a poor recompense. Yet throughout her old age, Dinesen enacted the part of a cavalier grande dame, a wrecked but gallant relic from a more exhilarating era, as she used her tales to confront, escape, and mythologize a post-sexual existence.

IN HER SIXTIES, Dinesen held forth, painted, and dressed to play the part of a bewitching storyteller. Off and on, she applied belladonna to make her eyes shine and kohl to outline them, used turbans and powder to cover the thinning hair and wrinkles that resulted from her syphilis or her incessant smoking, and relied on amphetamines for bursts of energy. Because of radio broadcasts and prizes, she had become a public personality. Dinesen gave names to her chic gowns and suits: Sappho, Eminence Grise, Bôhème, Sober Truth. A favorite getup was a Pierrot clown outfit. One black dress with a black hood was called Little Devil.

Though Dinesen occasionally sounded a feminist note, she generally emphasized the sorts of traditional powers women could wield

by means of tale-telling, erotic allure, and social standing. She used these ploys to charm a number of young men in her salon, an all-male club populated by poets, literary critics, journalists, and philosophers. While they ate the elegant meals provided by her cook at dinner symposia and debates in Rungstedlund, Dinesen presided as the world-weary but demanding *magister ludi*, the master of intellectual games. There is no term for a female in this role. Maybe doyenne comes closest. In Denmark, the doyenne role recaptured—in an anemic register—the power that Dinesen as Mem Sahib had relished exercising over her household servants and their families on her African farm.

Do we possess language for the grande dame or doyenne who acts as not only an overbearing but also a seductive impresario? Vamp, diva, siren: these words barely capture the erotic patina Dinesen cast on her mentorship, especially with the younger poet Thorkild Bjørnvig, a portentous alliance that he described in a memoir, *The Pact* (1983), published after her death. When it was dramatized in a play, Thor Bjørn Krebs's *The Baroness* (2011), reviewers likened the story to *Sunset Boulevard* (1950). Both the memoir and the play zero in on a contract Dinesen sought to make and keep with Bjørnvig, who survived to become a major Danish author.

In 1948, during the long gap between her mid- and late-life works—and in part explaining it—the sixty-four-year-old Dinesen associated herself with the Devil and his pact with Faust: if Bjørnvig, thirty years her junior, put himself under her tutelage, she would empower him to become a consummate, cosmopolitan artist. The pact involved him serving her with "trust of a mystic sort which nothing could touch or shake," he explains. In return, she would, in words that Bjørnvig attributes to her, "cast my mantle upon you as Elijah did on Elisha, as a sign that one day I shall let three-fourths of my spirit remain with you." With a good dash of grandiosity, she viewed herself as an inspirational figure who would induct her protégé into visionary artistry.

"I promised the Devil my soul," Dinesen privately informed

Bjørnvig (and a number of other young men whom she wanted to take into her confidence), "and he promised me in return that everything I experienced thereafter would become a story." According to Bjørnvig, Dinesen's pact with the Devil occurred when syphilis "had separated her from life, first and foremost the sexual part of it, at an early age." Expelled from paradise, Dinesen was drawn to the Romantic outlaw Satan—and like one of her heroes, Lord Byron, she wanted to join what William Blake called "the Devil's party." She had loved rebellious men whose daring ambitions defied conventional pieties. She too would rebel, defy conventional pieties, and glamorize herself.

Under Satan's aegis, Dinesen promised to author Thorkild Bjørnvig's life story by inducting him into her demonic wisdom. She did so by "incessantly alternating between motherly, sisterly, and erotic love": "the childless woman who wanted an heir, the lonely woman who wanted a lover." While instructing him on philosophical and literary matters or nursing him in times of stress or poor health, Dinesen provided Bjørnvig a study in her house, meals, and space away from his wife and their son. She encouraged him to travel, fall in love with another woman, and commit "a crime of sublime intent and motive."

When Bjørnvig did fall in love with another woman, however, "It was not just ordinary feminine jealousy that asserted itself; it was the annihilating radical zeal of the Old Testament. I should have no other gods before her. And according to our pact I was hers and nobody's else's." If he smarted under her control, Dinesen would propose a blood rite: "Blood was the strongest and most powerful bond between people, she said, and a pact confirmed by blood would constitute an unbreakable covenant." He equivocated.

The pact Dinesen made with Satan and later with Bjørnvig did not morph her into the Promethean heroes imagined by Blake and Byron. Instead, it turned her into a fairy-tale witch. "Won't you get up on the broomstick with me?" she sometimes asked Bjørnvig. Once, when Dinesen was particularly pleased with his literary output, she

chided him for having fooled her: "It is as in the tale of Hansel and Gretel. Here I have kept you securely locked up and every time I have come to see if you have gained weight and become fat enough for a feast, like Hansel you have struck a gnawed bone out between the bars instead of your finger. Now I can finally feel how fit and plump you have become."

During the four years in which Dinesen was involved with Bjørnvig, she published remarks she had made on the radio that touch on the topic of the single woman. Most people assume "that a woman who can exist without a man certainly also can exist without God, or that a woman who does not want to be possessed by a man necessarily must be possessed by the devil." She seems to have made that assumption herself. After asking Bjørnvig to tell her if he noted any sign of "megalomania" in her—she viewed it as a symptom of advancing syphilis—Dinesen "sincerely felt" that a concussion he suffered when he was far away occurred because in a moment of frustration she had hexed him. Banging a table, she had exclaimed, "May this blow strike the Magister on his head!"

Dinesen used Circe-like wiles to enchant her disciple: music (especially Schubert and Tchaikovsky), drink (wine and "a piglet-shaped bottle of cognac"), and the storytelling that had entranced Denys Finch Hatton. Was she trying to make him play Finch Hatton's role? Not exactly, for she insisted that Bjørnvig do her bidding in what she considered whimsical, public acts of obeisance—sporting flowers she entwined in his hair, carving their initials on a tree—injunctions that he "hated to carry out." Yet sometimes when Bjørnvig and she were together, Dinesen told him, "I think it is like an echo of that time, frailer but the same, the same." Enamored, he nevertheless grew increasingly tormented by his thralldom.

If he resisted or defected, she "would stamp her foot and hiss at me, 'I can feel the white heat of your cowardice!'" Deference or homage was what she wanted, as she attempted to separate Bjørnvig from his family and friends. When he showed her a divine aphorism—about God saying "You shall belong only to *me* in this world"—she crossed

out the word "God," replaced it with "I," and then signed the piece of paper, turning it "into yet another formula for our pact." During one incident in their tug-of-war, Dinesen aimed a gun at him. Bjørnvig dealt with the event amiably, partly because he was tipsy.

The movie of *The Pact*, directed by Bille August and released in America in 2022, bases its perspective on Bjørnvig's. Though he exults at finding an intoxicating mentor, he finds himself mortified by her efforts to stage-manage his life, especially when he witnesses the havoc she wreaks, with his complicity: the suicidal reaction of his wife, the flight of his mistress, his own mental anguish. In the film, unfortunately, Dinesen seems tiresomely demanding. When she offers to bequeath Bjørnvig her estate, Rungstedlund, she sounds pathetic.

It is one thing for a woman to make a pact with the Devil, quite another for her to attain his charisma. Meanwhile, Dinesen kept on revising the stories that would appear in *Last Tales*, many of which explain why women—even women in "the Devil's party"—rarely acquire his satanic powers. A few years after Bjørnvig absconded, according to Clara Svendsen, it became "a problem for Karen Blixen to take nourishment." At seventy, Dinesen underwent a chordotomy to sever pain-conducting tracts in the spinal cord, and then part of her stomach was removed to deal with her ulcers. Dinesen's surgeries in 1955–56 delivered a "deathblow" that "no one expected her to live through."

SINCE STORYTELLING WAS less successful in life than in art, Dinesen reinvented herself and Bjørnvig as characters within plots illuminating that very point. "Echoes," which represents Dinesen's perspective on the affair, startlingly whitewashes the pact. By portraying her protégé as a young boy, she evades the relationship's erotic frisson. The story recycles a fictional surrogate, Pellegrina Leoni, an aging diva "who had lost her voice" and who the world

thinks died in an opera house fire. When Bjørnvig met Dinesen, in fact, he was shocked because he had thought she had been long dead. Pellegrina hears the boy Emanuele singing with a prepubescent voice that recalls her own youthful voice, so she determines to make him a great artist who will reincarnate and resurrect her past glory.

Pellegrina wants to toughen her prodigy, just as Dinesen wanted to strengthen Bjørnvig's courage, so she pricks his fingertips with a needle to draw blood, wipes the blood off with her handkerchief, and lifts it to her lips. After this blood pact, the boy flees, as Bjørnvig repeatedly did, and when Pellegrina tracks him down, he calls her a witch, a vampire. Emanuele is too immature to realize that "the mingling of blood" does not mean "the drinking of it." Bjørnvig was too unsophisticated to comprehend the depth of Dinesen's selfless devotion to the lofty calling that bound them together. Authorial self-pity shapes the fate of her heroine, who ends up realizing that "the voice of Pellegrina Leoni . . . will not be heard again."

During a singing lesson in "Echoes," however, Dinesen does acknowledge the voracity of her and her heroine's cravings:

> She felt her own lungs drawing breath in his body and his tongue in her own mouth. A little later she made him talk and made his eyes meet hers, and she sensed, as she had often done before, the power of her beauty and her mind over a young male being, her heart cried out in triumph: "I've got my talons in him. He will not escape me."

This passage is quite explicit about the desire of an aging woman to capture a young prey in order to feed off his vitality, confirm the rejuvenation of her powers, and experience a faint echo of youthful passions in the far distant past.

A more convoluted fictionalization of the pact, "The Immortal Story" (1953), manifests a keener awareness of its dangers, for here Dinesen projects herself into a proud capitalist who manipulates people like puppets. In old age, Charles Clay reduces individuals

to characters in a plot meant to exhibit his own genius. As Orson Welles's movie adaptation makes plain through its close-ups of Welles-as-Clay sitting alone, surrounded by mirrors, "The Immortal Story" signals Isak Dinesen's isolation, possibly caused by a belief that syphilis had prevented her from having a sex life. Like "Echoes," it depicts a temptation that loneliness, disability, or illness can present to the elderly: the effort to live one's late life vicariously through younger proxies, a stratagem that generally boomerangs.

A meta-story, "The Immortal Story" centers on old, sick Clay, a merchant who knows his account ledgers inside out but only one story that he takes to be literally true: the story of a sailor offered five guineas by an old gentleman who wants his young wife impregnated. Clay's clerk Elishama immediately informs his boss that this story "never has happened, and it never will happen, and that is why it is told." Sailors tell it because they wish it would happen. Still, Clay vows to make it happen: his clerk engages the aging actress Virginie to play the part of wife; Clay gets the youthful sailor Paul to accept his gold and informs them both that they "are, in reality, two young, strong and lusty jumping-jacks within this old hand of mine."

Though the night of lovemaking entrances Paul, Virginie—terrified that he will see her aging face in the daylight—reminds him that he has accepted the gold with a promise to leave: "Remember that I am seventeen," she says. "Remember that I have never loved anybody till I met you." She is, of course, telling him a story, but once he remembers that he was paid, will he realize that she was as well?

More ironies accrue at the tale's conclusion. First, Clay does not live through the night to learn its outcome. The omnipotent puppeteer has been bested by a higher power and "looked like a jumping-jack when the hand which has pulled the strings has suddenly let them go." Second, when Elishama instructs the sailor that he can tell the story, the boy refuses. Upon leaving the house, he hands the clerk a polished pink shell, with instructions to give it to Virginie. Listening to a "deep, low surge in it, like the distant roar of great breakers," Elishama hears "a new voice in the house."

A survivor of a Polish pogrom, Elishama believed that "desire, in any form, had been washed, bleached and burnt out of him"; yet when he hears the voice in nature's artwork, it stirs memories of his having heard it before, "long ago. But where?" He knew from the start that stories express not facts but primordial desires. The story that is immortal is desire, which is what the traumatized clerk vaguely recalls from the period before the pogrom. Stories are immortal because desire is immortal. One immortal story is the immoral story of elderly people whose inability to participate in the sexual part of life leads them to manipulate younger people who can do so for them and thereby keep their presence alive—another desirous plot that, Dinesen knew, rarely pans out.

UNABLE TO LIVE a life of immortal desire, Dinesen could nevertheless hone her art to celebrate it. The men in her youth had provided her an ideal of Romantic energy and excess, but circumstances had alienated her from their alienation. Unlike them, she did not have the prerogative to take Satan as a role model, because "the devil is masculine," as she dryly observed, and also the Prince of Darkness was not stuck at home. Yet though her devilish pact failed, she could dedicate her storytelling to demonic ends.

Was there some residual anger at the desertion of her father, husband, lover, and protégé in turn? If Dinesen could not live a sexual life, she could nevertheless tell stories about women whose eroticism subverted the authority of men. Although the heroines of her tales are invariably subordinated in a masculinist social order, their stories express Dinesen's gleeful conviction that such patriarchal structures would never succeed in controlling women's bodies. Hinged on unruly female desire, her convoluted plots challenge the paternal privileges accorded God's representatives on earth, the sons of Adam. Because of these stories, the sometime snobbish and sometimes dictatorial Dinesen became one of my favorite literary old ladies.

Told by a series of antiquated gentlemen, aged priests, crones, and old hags, many of the fables in *Last Tales* meditate on women's lawless desires, which undermine the basic rule of patriarchy: namely, the father's ownership of the child. When the baroque plots of *Last Tales* are whittled down to the secrets they sometimes divulge, they often address the question "Who are you?"—the query posed by a lady to her confessor at the start of the volume. In this opening story in a book about the fictionality of paternity, it is answered by a cardinal with a story-within-the-story recounting the impossibility of his knowing his parentage and therefore the difficulty of knowing who he is.

The Cardinal in "The Cardinal's First Tale" begins with an aging prince who wants "to have his name live on." But his young wife finds herself transported by music, and in an opera house, she falls in love with a castrato whose voice uplifts and transforms her: "It was a birth, the pangs of which were beyond words, [and] . . . she triumphantly became her whole self." Months after this orgasmic immaculate conception, the Princess gives birth to identical twins: her husband's son, named Atanasio for a church father, and her son (mystically conceived with the castrato), named Dionysio for the Greek god associated with his ecstatic female followers.

When a fire incinerates one of the twins, the father brings up the surviving boy as Atanasio, while the mother nurtures him as Dionysio, with the result that the young man becomes self-divided between asceticism and aesthetics, renunciation and pleasure. Whether the surviving child was his father's or his mother's son remains unknowable. The Cardinal's confession to the Lady (who had come to him for confession) pertains to his dual nature and to the split allegiances that continue to divide him. Because he has become a cardinal, we may presume that the Prince triumphed and Atanasio survived the fire. But in the process of telling his fable of identity, the Cardinal has explained that "the divine art is the story. In the beginning was the story"—not the Word but the ironic, multivalent story. Like the Princess and like Dinesen (whose name derives from Dionysos), the

Cardinal remains captivated by the Dionysian intoxication attributed not to God but to the Devil.

To argue that "The Cardinal's First Story" propounds the idea that women cannot be reduced to incubators would be to deprive the narrative of its ornate details. But the tale does insist that a mother is more than a passive vessel enabling the father "to have his name live on." Before DNA tests, how did any father know that the baby was really his? In "A Country Tale," a peasant's newborn has been exchanged for a nobleman's, but only the wet nurse who effected the switch knows for sure which baby is which. A similar point is made in "The Caryatids." Its title, alluding to sculpted female figures used to support the horizontal beam resting on their heads, reminds us of the supportive role played by women in a social structure that would topple without them.

"The Caryatids" includes three female characters whose insubordinate desires cannot be controlled by men. Its heroine begins to suspect that her mother had an extramarital affair with her husband's father: are she and her husband really brother and sister? She glimpses her mother's illicit affair through the magic of a gypsy-witch, who is not "made out of stone, a caryatid." Finally, when the enraptured heroine leaves the witch with the promise of returning, reality seems "pale and cold in comparison with the world of witchcraft." "The Caryatids" concludes in medias res, but it fully conveys female powers that jeopardize patriarchal control. Dinesen's witchy outlaw inducts her heroine into an illicit and intoxicating vision of her mother's and her own anarchic desires.

Dinesen most brilliantly approaches the idea that exceptional women may be unownable in "The Blank Page," a parable about a Carmelite order of nuns who grow flax to manufacture fine linen for the bridal sheets of all the neighboring royal families. After the wedding night, the sheet is displayed to attest to the virginity of the princess and then reclaimed by the convent, where the central, stained piece is mounted, framed, and hung in a long gallery with a plate identifying the name of the bride. The "markings" are of spe-

cial interest to female pilgrims who journey to the remote country convent. But pilgrims and sisters alike are especially fascinated by the framed canvas over the one nameless plate that displays a snow-white sheet that gives the story its title.

Conveyed by an old woman who learned the art of storytelling from her wrinkled grandmother, "The Blank Page" celebrates matrilineal storytelling: "'Be loyal to the story,' the old hag would say to me," for "'Where the story-teller is loyal, ... there, in the end, silence will speak.'" The blood of the hymen that the storytellers study declares the bride to have been a virgin. Unlike menstrual blood, which defiles like a curse, or the blood of childbirth, also taboo, the blood on the royal sheets is holy, for it certifies the integrity of the patrilineage.

The single and singular blank sheet seems radically subversive, the result of one woman's defiant refusal to acquiesce in the patriarchal order, which may have cost either her life or her honor. Not an emblem of innocence or purity or passivity, the white page is a mysterious but potent sign of resistance. And the showing of the sheet proves that the anonymous princess has forced some sort of accommodation in the public realm. Its enigma silences not only the Carmelite nuns, who are dedicated to silence, but even the storytellers.

On a literal level, the blank sheet may invoke a number of alternative scripts. Was this anonymous princess not a virgin on her wedding night? Or did she, perhaps, flee the marriage bed and thereby retain her virginity? Or again, maybe the snow-white sheet tells the story of a young woman who met up with an impotent husband, or who learned other erotic arts, or who consecrated herself to the nuns' vow of chastity but within marriage. Did she, like Scheherazade, spend her time in bed telling stories so to escape the fate of her predecessors? Perhaps she migrated to Africa and became a Lioness. The meaning of the sheet seems as mystic as the anonymous princess herself, but it clearly signifies a woman who got away with something. Dinesen's ancient storyteller urges her audience to

"look at this page, and recognize the wisdom of my grandmother and of all storytelling women!"

"Tales of Two Old Gentlemen" summarizes an idea running throughout *Last Tales*: that the ironies on which storytelling depends can best be grasped by women who have survived for centuries as objects for men but subjects in their own right. In one of a succession of stories told by two codgers setting out to "prove in what good understanding a young girl is with ... paradox," a husband hands over to his bride his property, money, and jewels, but "there is in my house one object which I am keeping to myself, and to the ownership of which you must never make any claim." He takes her into the bedroom, where he unclothes her and places her before a mirror: "'There,' he said, 'is the one thing of my estate solely reserved for me myself.'" The husband's ownership of this "one object" that owns all his earthly possessions depletes the wife of all the power he has bestowed. Yet on their twentieth wedding anniversary, she says that without his final caveat, she would have "been lost," for she knows there is no legitimate social space for an autonomous woman.

A concluding tale by the codgers underscores the erotic potency available to the otherwise powerless wife. It involves a nobleman who decides to marry one of several "blanks": daughters born before the son and heir was produced. He chooses the one who must have been the most disappointing to her parents, the youngest, since she has "an ambition kindred to his own," an extraordinary "energy to satisfy longing." After three years, when "a change" occurs and he thinks he has "spoilt her," he warns her that he can send her back to her lowly origins. The wife takes her time to answer: "Surely you will realize that to an ambitious woman it comes hard, in entering a ballroom, to know that she is entering it on the arm of a cuckold.'" He sits wondering, "as till now he had never done, at the complexity of the Universe." The fables in Dinesen's *Last Tales* resound with the gallows humor associated with the first name of her pseudonym.

WHEREAS MANY OF Dinesen's stories celebrate mutinous female eroticism, her real late-life relationships revolved around the staff she assembled at Rungstedlund, her siblings, and the titled friends, interviewers, and would-be biographers she entertained or visited on brief sojourns to London, Paris, and Rome. Visiting and hosting, bicycling and gardening, if not flower arranging, were thwarted by recurrent attacks of pain, and she never managed to return to her beloved Africa, though she put together a series of nostalgic portraits of her servants. Weak and at times in need of blood transfusions, she had worked on *Last Tales*, she explained, "with a leg and a half in the grave."

Dinesen's frailty may have been exacerbated by heavy metal poisoning (produced by syphilis treatments) as well as by surgeries. One expert on Dinesen's history of abdominal pain, Linda Donelson, argues that "Karen Blixen did not suffer late in life from syphilis," but rather had panic attacks, which she might have found "too bourgeois an explanation." Syphilis seemed more "aristocratic": "she succeeded in fooling herself and her public." Along with Dinesen's possibly unsupported conviction about her late-life syphilis, consider a lifelong pattern of taking laxatives and amphetamines, recurrent diets and statements about her ideal of thinness, and her legendary subsistence on asparagus, oysters, grapes, and champagne: all contributed to malnutrition. Although many people remarked on her extreme thinness, one must go back to the late fiction to tease out the significance of her odd diet.

At a pivotal moment in Dinesen's story "Tempests," the heroine reads a passage in Isaiah that describes a hungry man dreaming that he has eaten but awakening empty, a thirsty man dreaming that he drank but awakening faint. Realizing that she has mistaken dreams for actualities, Dinesen's fictional surrogate cuts herself off from a life of love and dedicates herself to the lonely demands of her art. She

becomes a famished, parched hunger artist who—comprehending the difference between imaginary and real nourishment—resolves to renounce the latter and subsist on the former.

"Tempests" illuminates Dinesen's eating disorder as well as her conviction that she was condemned to a post-sexual existence. It recounts its heroine Malli's decision to dedicate herself to art over and against life with its sensual, sexual satisfactions. Haunted in childhood, as Dinesen was, by an absent but powerful father, Malli evolves into "a lioness." Like Dinesen, who found substitutes for her dead father, Malli is given the opportunity to perform her artistry by a man of the world, in Malli's case the director of a theatrical company who will take the part of the magus Prospero. In this production of Shakespeare's *The Tempest* (1611), Herr Soerensen, whose name in Danish evokes the Devil, controls the epicene spirit Ariel.

Shakespeare's Ariel sings, casts spells, and transforms appearances, even his own when he disappears into thin air. Dinesen's Malli, believing herself to actually be Ariel, rescues the crew on a shipwrecked steamer and the act leads to two diametrically opposed consequences. First, it delivers her into the arms of her husband-to-be and she morphs into an adoring Miranda. But second, it results in the death of another man, Ferdinand, who assisted her in the storm. Guilt about that death, though unfounded, convinces Malli that she should forsake her fiancé and return to the role of the ambiguously gendered Ariel. Given that "mal" means "bad," her very name speaks of guilt. At the end of "Tempests," Dinesen's heroine goes off to be an actress, pondering why "things go so disastrously" for artists and wondering what they get in return. In return, the director tells her, "we get the world's distrust—and our dire loneliness." Stagecraft has replaced living and loving.

Because desire had brought intense suffering, perhaps Dinesen believed that she deserved the pain. Groundless guilt may have convinced the storyteller that she, like the men in her life, would hurt those she loved. Telling replaced living and loving, just as the syphilis treatments set off warning alarms about living and loving. Story-

telling, a reparation after the curse of syphilis, licensed Dinesen to write about immortal desire but not to experience it. A sense of guilt informs the conviction that she had given her soul to the Devil in exchange for the power of storytelling, for in this scenario, her artistry condemns her to eternal perdition.

The account of the pact with the Devil expresses Dinesen's sense that she was doomed to inhabit words instead of worlds. Though she assured Bjørnvig that her disease was harmless except to herself, the disgrace attached to syphilis may have convinced her that she was contagious. Abundant references to vampirism and gobbling witches bespeak anxieties about her appetites. Anorexia was one way to punish the wicked self and to manifest her anomalous isolation. In a hunger strike, not-eating sloughs off markers of womanliness. Loss of body fat can occasion the loss of libido. Malnutrition turned her into a mordantly asexual creature. Emaciated, Dinesen looked like she could vanish into thin air, like Ariel.

The historical precedent for fasting women (rather than girls) derives from the medieval period, when female saints refrained from eating and drinking. In the case of anorexia mirabilis, not anorexia nervosa, the ability to survive without sustenance was taken as a sign of God's or the Devil's handiwork. Abstinence set these women apart from the common horde. Legends about such figures persisted, and fasting became a mark of a physical being permeated by powerful spiritual forces. An extreme form of asceticism, fasting in a religious context starves the body to feed the soul—but starvation can also feed an imagination bingeing on hallucinations and visions.

Here, anorexia becomes a rigorous art of losing: specifically, the art of losing weight to manifest a life forfeited for art. Dinesen's frightful fragility functioned like a badge of honor, displaying the exorbitant price she paid for an estranged existence. If, like Lucifer, Dinesen was a loser, she could damn well exhibit what losing looked like and do it so it felt and looked like hell, but a stylish and classy hell.

Not-eating in old age has not received the sort of attention it has gained in studies of adolescence. But when agency in the world is thwarted by disabilities, not-eating can offer a modicum of control. By renouncing food and telling tales, Dinesen announced that she was not merely the passive victim of troubles that had fallen on her: she was authoring them herself. She had been rudely awakened from her storybook adventures as Mem Sahib and Lioness in Africa. After the fiasco with Bjørnvig, she would revel only in fantasy. Idiosyncratic though it might seem, Dinesen's old age illuminates the sense of some elderly people that their adventures are over and done with; they must make do with mythologizing the past.

Yet the larger-than-life self-mythologizing in which Dinesen engaged amplified her stature on the world stage. Decades after her death, in a one-woman show called *Lucifer's Child* (1991), the actress Julie Harris played the septuagenarian before and after her lecture tour in the States. Throughout both acts, Harris's Dinesen recalls her love affairs with Africa, Bror, and Denys: "for a moment, you made me forget the awful, the inescapable truth—that God had cast me from Heaven." And Dinesen remained paradoxical till the end. Although she prided herself on her paltry diet, although the cause of her death was attributed to emaciation, she composed one of the greatest paeans to food in "Babette's Feast" (1950). And though she flirted with the Devil in many old wives' tales, the last publication that Dinesen revised for publication features a woman warrior who defeats the satanic force arrayed against her to live happily ever after.

THE MYSTIC COOK in "Babette's Feast" personifies the starving artist's mature view of her alchemical artistry. Like Dinesen, Babette has survived grievous loses in a magnificent past. "Almost mad with grief and fear," she arrived in a small town in Norway after her husband and son had been shot as Communards and she herself had been arrested as a Pétroleuse. An arsonist, a rebel, and an outlaw,

Babette lands in a cold country far away from her warmer homeland. Once engaged by the Lutheran sisters Philippa and Martine, Babette displays her magical potency.

While preparing the feast, for which Babette pays with the money she has won in a lottery, she looks "like the bottled demon of the fairy tale," for she "swelled . . . to such dimensions that her mistresses felt small before her." As cartloads of ingredients appear, the pious sisters are shocked by "a greenish-black stone" that "shot out a snake-like head and moved it slightly from side to side." Martine worries that the feast in honor of her dead father's birthday will be "a witches' sabbath"—and she may be right, for unbeknownst to the congregants, their asceticism will be transformed by the hedonistic sensuality of Babette's culinary craft.

The sisters' histories are steeped in ascetic renunciations. Martine's suitor, Lorens Loewenhielm, was so daunted by the household's spirituality that he fled. In an echo of "Echoes," Philippa's suitor, a singer-teacher, believed that making her a great diva would counteract his own aging, but after an intoxicating duet, Philippa cut off the relationship. No wonder, then, that the sisters, alarmed at a lavish extravagance, warn their neighbors. Out of devotion to the sisters, the congregants promise that nothing served "would wring a word from their lips."

The stage has been set, the characters assembled and joined by General Loewenhielm, who has returned to visit his aunt, when the meal becomes a comic triumph. An opening hymn—"*Wouldst thou gave a stone, a reptile / to thy pleading child for food?*"—establishes a jovial mood for the turtle soup. As one sophisticated course follows another, the humble congregants eat silently, as if this were their ordinary fare, while the cosmopolitan General cannot help exclaiming in wonder. Like the congregants, whose aging produced squabbles, the General had been quarreling with himself. But the communal feast heals all rifts, even as it leads the General to recall great meals in his past.

While most of the diners assume that the sparkling liquid they

have been given "must be some kind of lemonade," the General marvels over the rare Veuve Cliquot and remembers a Parisian chef capable of "turning a dinner ... into a kind of love affair ... in which one no longer distinguishes between bodily and spiritual appetite or satiety!" The feast does become "a kind of love affair," as the guests transcend their differences in a communion of body and soul: "They only knew that the rooms had been filled with a heavenly light, as if a number of small halos had blended into one glorious radiance. Taciturn old people received the gift of tongues; ears that for years had been almost deaf were opened to it. Time itself had merged into eternity."

By returning at the end of the tale to the depleted cook, the only one who did not partake of the sacramental meal, Dinesen approaches her exclusion from love affairs and satiety: her conviction that her artworks celebrated precisely the pleasures that she could not herself enjoy—or could enjoy only in the world of make-believe. Babette, declaring that she is not returning to Paris, explains why: the aristocracy whom she used to serve are gone. Philippa comforts the artist without an audience—"In Paradise you will be the great artist that God meant you to be!"—but we recognize Dinesen's profound feelings of exile.

Not so in *Ehrengard*, a story that could grace a sparkling Mozart opera. Here, in a tale told by "an old lady," Dinesen makes herself fully at home in a fantasy of female heroism undertaken against a demonic artist. Its eponymous heroine, "a young Walkyrie" who rides a steed named Wotan, serves as maid of honor to a Princess in a delicate situation: she and her Prince have conceived a baby who will be born two months too early. They must hide away in a pastoral retreat until they can present the baby publicly at a baptism. Loyal and brave Ehrengard, brought up "in the sternest military virtues," will serve like a "white-hot young angel with a flaming sword to stand sentinel before our lovers' paradise!"

The great painter who casts Ehrengard in the role of maid of honor has an ulterior motive. An "irresistible Don Juan of his age,"

Cazotte wants to make the virgin blush: "I shall in time be drawing my young Amazon's blood ... upwards from the deepest, most secret and sacred wells of her being, making it cover her all over like a transparent crimson veil." His schemes are motivated not by fleshly desires but by a willful ambition to conquer. In front of a fountain of Leda and the Swan, Cazotte begins conceiving of a "full surrender without any physical touch whatsoever" in which Ehrengard will feel herself to be "fallen, broken and lost."

When Cazotte comes upon Ehrengard disrobing for a bath in the lake, he decides that painting "The Bath of Diana" will get the results he wants when he exhibits it. Since he will depict Ehrengard facing away, only the two of them will know what he had witnessed, with the result that she will become "for all eternity, a Cazotte": his painted and vanquished possession. Her belated recognition of the male gaze on her naked body, he believes, will cause her to blush "in consent and surrender!" But the artist-seducer has not counted on the stratagems of the heroine and her author. Cazotte's plan starts to go awry when Ehrengard meets him again at the Leda statue. Having learned that he wishes to paint her, she proposes that he do so at her daily bath, thereby deflating his sense of himself as a transgressive voyeur. The imperial swan will have to find someone else to rape by the close of the tale.

Of course, the royal baby is kidnapped one day before the baptism and both Ehrengard and Cazotte go in search of the villain, whom she soundly pummels. When her fiancé pops up to stop the fight, he wants to know who the baby is. To safeguard the honor of the Princess, Ehrengard claims the child as her own. After being asked about the baby's father, she exacts her revenge: by pointing at Cazotte, whose "blood was drawn upwards, as from the profoundest wells of his being, till it colored him all over like a transparent crimson veil." Not the woman warrior but the Don Juan, who always wants to be a seducer and never a husband or father, feels "fallen, broken and lost" at being put to use in a story. With its blushing philanderer, the conclusion of Dinesen's last publication issues a boisterous rebuke to the

father who did not stay to father her, the husband who did not stay to husband her, the lover who did not stay to love her.

According to Judith Thurman, when Clara Svendsen deemed *Ehrengard* "too light," "the Baroness flew into a rage, and Clara went to live in Copenhagen." It is light and bright, like the chivalric romances of Don Quixote. Dinesen often referred to Clara Svendsen as her Sancho Panza. By the time the quixotic Dinesen arrived in America, she was too frail to walk, so Clara Svendsen sometimes had to support her. Yet she clearly relished hobnobbing with Marilyn Monroe, Arthur Miller, and Carson McCullers.

One witness of the septuagenarian's storytelling at the 92nd Street Y recounted that Dinesen recited to packed houses, often with encores, "without ever once referring to a page of paper or a book." To the political philosopher Hannah Arendt, she looked "very very old, terribly fragile, beautifully dressed": "She was like an apparition from god knows where or when." After her return to Denmark, Dinesen was informed by her doctor "that I have all the symptoms of a concentration camp prisoner." Characteristically, she went on to explain that one of her symptoms consisted of her legs swelling "so they look like thick poles and feel like cannon balls. This last thing is terribly unbecoming and for some reason very vulgar. Altogether I look like the most horrid old witch, a real Memento Mori."

Still, "until the very end," Clara Svendsen tells us, Dinesen worked daily in Ewald's room—the celebrated eighteenth-century poet Johannes Ewald had lived in Rungstedlund—which she also visited nightly before retiring for sleep. Dinesen told Svendsen that in Ewald's room she could look toward Africa and at a map of her farm, though she refrained from mentioning that it contained a portrait of Denys Finch Hatton. Despite nagging economic insecurities and worries about taxes on royalties, Dinesen had financed the non-profit Rungstedlund Foundation—to maintain the house as a cultural center, its grounds as a bird sanctuary—by means of a radio address in which she asked the Danish people to contribute one

krone each because in that way she could ascertain the number of her readers.

During an evening with the poet Marianne Moore, according to the novelist and essayist Glenway Wescott, Dinesen alluded to her arduous process of composition. "'It taught me a lesson,'" she explained. "'When you have a great and difficult task, something perhaps almost impossible, if you only work a little at a time, every day a little, *without faith and without hope*'—and she underlined the words with her spooky, strong, but insubstantial voice—'suddenly the work will finish itself.'"

A spellbinder, Isak Dinesen never fully relinquished the idea that "women... when they are old enough to have done with the business of being women, and can let loose their strength, may be the most powerful creatures in the whole world." According to Hannah Arendt, Dinesen's significance can be encapsulated in one of her sayings: "All sorrows can be borne if you put them into a story or tell a story about them."

CHAPTER 5
Marianne Moore

When the poet Elizabeth Bishop asked her mentor to "please come flying" over the Brooklyn Bridge, she imagined Marianne Moore airborne in a black cape, a black hat, and pointy black shoes, an outfit resembling the George Washington getup often sported by the elderly bard. In "Invitation to Miss Marianne Moore" (1955), Bishop wants her friend to accompany her to the 42nd Street library or to shop and play a series of esoteric word games. The magic of Marianne Moore issues not from a wicked witch but from a fairy godmother whose beneficence graces the skyline of the city she would love and laud in her old age.

For a journalist, however, the seventy-nine-year-old poet produced a funnier portrait of herself as a madcap old lady. It exemplifies the endearing way Moore would lean into her eccentricity—to leave behind her career as an elite experimentalist and turn her elderly self into an unlikely pop-culture icon at sporting events, on magazine covers, and in television ads:

"I'm good-natured but hideous as an old hop toad. I look like a scarecrow. I'm just like a lizard, like Lazarus awakening. I look permanently alarmed, like a frog. I *aspire* to be neat, I try to do my hair with a lot of thought to avoid those explosive sunbursts, but when one hairpin goes in, another seems to come out.

"Look at these hands: they look as if I'd died of an adder bite. A crocodile couldn't look worse. My physiognomy isn't classic at all, it's like a banana-nosed monkey." She stops for a second thought. "Well, I do seem at least to be awake, don't I?"

Taking self-deprecation to a hilarious extreme, Moore emphasized her antiquity and also her resemblance to the animals that had captivated her at circuses and zoos, in her midlife verse, and in her earlier life. Within her family, she was affectionately called Rat, after

the poetry-murmuring River Rat in Kenneth Grahame's *The Wind in the Willows* (1908), while her mother and brother were Mole and Badger. The affectionate bonds of Grahame's creatures characterize the tender allegiances of the close-knit family.

Growing up in a single-parent household—her mentally ill father was institutionalized before her birth—Moore remained firmly attached to her mother, Mary Warner Moore, and her brother, John Warner Moore, known in the family as Warner. After the three moved from her grandfather's house in Missouri to Carlisle, Pennsylvania, where Mary Warner Moore taught high school English, Marianne and Warner referred to each other as "brothers." In letters, the poet often called herself "it" and her mother called Marianne "he." Moore would go on to lead a single and celibate life.

At the age of twelve, according to the biographer Linda Leavell, a second parental figure materialized. For a decade, her mother's lover, Mary Norcross, became part of the family. Moore followed Norcross's lead by enrolling in Bryn Mawr, where the homesick student suffered her only prolonged separation from her mother. Indeed, she would reside with her mother—in Carlisle, in Greenwich Village, and in Brooklyn—until her mother's death in 1947, when Moore was about to turn sixty. That event marks the onset of her old age, for it severed the intense companionship that launched her career.

While the youthful Marianne Moore helped pay the bills by working as a secretary or teacher or librarian, she and her mother wrote, read, and discussed an enormous number of letters in exchanges with the friends they began making as Moore's verse started to appear in vanguard magazines. Her pious, frugal mother was the first reader and editor of the verse. The idiosyncratic poems—bristling with arcane words, typographical oddities, and extensive quotations—attracted the admiration of figures who soon became leaders in modernist experimentation: Ezra Pound, William Carlos Williams, H.D., and H.D.'s sometime lover and lifelong mainstay, Bryher.

Such friendships deepened after the move in 1918 to 14 St. Luke's Place, which must have intensified the intimacy of Moore and her

mother, for the apartment had only one room—with a hot plate in the bathroom where meals were sometimes served, which may have contributed to the poet's "delicate appetite." Mother and daughter grudgingly reconciled themselves to Warner's marriage and continued to share with each other the books Moore reviewed. Yet when H.D. and Bryher published Moore's first collection of poems, she was distressed—because of modesty or insecurity—though her next collection, *Observations* (1924), earned her the *Dial* award as well as the editorship of Harriet Monroe's prestigious *Dial* magazine.

The 1929 relocation to a larger apartment in Fort Greene, arranged by Warner so his sister and mother could attend the Sunday services he conducted as a chaplain at the Brooklyn Navy Yard, put some space between the poet and the poetry scene but not between the poet and her mother. There were two bedrooms, but one was designated for the absent Warner so mother and daughter continued to share a bed. Though some of Moore's friends praised her mother, others worried about her controlling influence.

In 1935, Moore's *Selected Poems* appeared with a laudatory introduction by T. S. Eliot, who became another lifelong supporter. Despite a spate of illnesses, Moore weathered the Depression by meeting requests for poems and reviews, attending lectures, giving talks herself, and reading aloud daily from the Bible. While dealing with a spastic colon or scoliosis and her mother's neuralgia or throat problems, she worked on a novel (rejected) and submitted poems to the *New Yorker* and the *Atlantic Monthly* (also rejected), buoyed by a number of female benefactors who supplemented Warner's financial aid with generous gifts: money as well as groceries and hand-me-downs.

Mary Warner Moore's 1947 death accelerated a major shift in Moore's oeuvre as well as her life, a transition from being the poets' poet to becoming the people's poet. Her midlife obscurity and reticence contrast with her late-life volubility and visibility. Many critics discount the verse of her last decades as a decline from her modernist publications. Yet Moore was drawn to appreciative and topical modes of address that led to her becoming the unofficial laureate of

New York City. Entranced by her adopted hometown, she took evident delight in her late-life celebrity. By producing what she called "straight writing" and by publicly playing the role of the wonky old lady, Moore widened her audience. During an old age characterized not by contraction but by expansion, she established a place for the elderly woman and the civic poet on the national stage. In a phrase by her younger friend W. H. Auden that she quoted, Moore used her old age to "show an affirming flame."

EVEN AT THE start of her career, Marianne Moore had touted "plain American which cats and dogs can read." Three poems published during World War II illustrate her emergent involvement with civic matters. They hark back to the abstruse complexity of her modernist verse even as they forecast her growing engagement with moral instruction. Shaped by her Presbyterian and Republican upbringing, these transitional works reflect Moore's effort to buttress, in a fraught historical moment, the old-fashioned virtues of humility, patience, and fortitude often advocated by her mother.

"The Paper Nautilus" (1940), a gift thanking Moore's friends for the gift of a tangible paper nautilus, gestures toward the symbiosis of Moore and her mother and of the poet and her poem. By describing an anomaly in the cephalopod world, the text adds another specimen to the unusual creatures—anteaters, pangolins, desert rats—found in her earlier works. Its opening is incomprehensible until the reader unscrambles the grammar, and its mythic allusions are difficult to comprehend. Yet by focusing on a shell, Moore considers a protective edifice within which vulnerability can thrive. In an unusually autobiographical meditation, the shell of the paper nautilus becomes a brood chamber in which new conceptions hatch.

Whether interpreted as an analysis of the creative or of the procreative process, "The Paper Nautilus" suggests that generativity requires a high degree of guardedness. During the period of ges-

tation, the nautilus waits and watches the shell she creates, scarcely eating until the eggs are ready to emerge. With her multiple arms, she must bury the eggs in her brittle nest without crushing them and then protect the shell. The poet or the mother creates this delicate but strong enclosure to cradle the poem or the embryo before it issues out into the world. When the poem or the baby is released, it releases the poet or mother from her protective caregiving, but in doing so depletes her.

Moore uses the myth of Hercules to capture the violence involved in the process of detaching the poetic utterance from the poet, the baby from the womb, and thereby gives us a glimpse into her aesthetic and daughterly struggle. She did exhibit problems letting go of her poems (which she revised incessantly) and separating from her mother (something she never fully did). "The Paper Nautilus" emphasizes the patience, devotion, tenacity, even the heroism involved in creative and procreative labors. To this extent, Marianne Moore celebrates her mother as well as her own artistry, but guardedly, given the poem's tortured syntax, complex allusions, and mollusk subject. "The Paper Nautilus" concludes with a moral maxim—"love / is the only fortress / strong enough to trust to"—reflecting Moore's belief that in hard times, the poet must take seriously her ethical responsibilities.

A motto serves that purpose again toward the end of "Nevertheless" (1943), another reassuring poem about vulnerability: "The weak overcomes its / menace, the strong over- / comes itself." With only glancing references to global violence, Moore attends to the idea "that weakness is power, that handicap is proficiency." Here the poet muses on a strawberry plant struggling to establish its seeds and then considers a succession of other plants that look frail but gain vigor through sometimes visible, sometimes invisible growth that enables them to surmount menacing circumstances. The title of this tribute to persistence takes for granted the horrors of the war waged overseas, insisting that signs of quiet resilience nevertheless abide as icons of strength grounded in weakness.

The longer poem "In Distrust of Merits" (1943), which directly articulates Moore's response to World War II, was roundly applauded when it appeared, but it has been just as roundly dismissed by later critics and by the poet herself. It shouldn't be called a poem, she often exclaimed before admitting, "I do like it; it is sincere . . . ; it is testimony—to the fact that war is intolerable and unjust." As testimony, "In Distrust of Merits" exhibits Moore's intensified engagement with current events. In a letter to her brother, who was serving as a naval chaplain, Moore decried "intolerance[, which] is at work in us all, *in all* countries;—that we ourselves 'persecute' Jews & Negroes & submit to wrongful tyranny. Or at least feel 'superior' in sundry ways."

A missive from the home front, "In Distrust of Merits" emphasizes civilian distance from the war through the phrase "they're fighting," which echoes throughout its eight stanzas. Moore's ability to articulate self-correcting thoughts in verse helps her negotiate the difficult minefield of a just war. Her title questions the idea of living and dying for medals and merits. And throughout the poem, the peace-loving poet mourns those lost at sea or battling in caves. War makes the world an orphanage, she laments toward the end of the poem. What could be worth all the agony and bloodshed?

Moore's answer has nothing to do with nationalism or the barbarism of the enemy and everything to do with the root problem of the self: "they're fighting that I / may yet recover from the disease, My / Self." Here she identifies the arrogance that sickens humankind, warmongers and war protesters alike. For this reason, she moves to the pronoun "we" when she makes a vow to those fighting: "'We'll / never hate black, white, red, yellow, Jew, / Gentile, Untouchable.'" For this reason, too, she knows "We are not competent to / make our vows." The authentic struggle involves purging ourselves of conceit, pride, vanity, a presumption of superiority. Without belaboring the point, Moore suggests that racism and anti-Semitism in America recapitulate the dynamic at work in the fascists whom Americans were fighting overseas.

An inveterate clipper of articles, Marianne Moore once explained that a printed photograph of a slain soldier inspired her. In the poem, she sees a "quiet form upon the dust" and admits, "I cannot / look and yet I must." This sort of confession of vacillation punctuates a pro-war poem decrying war, a patriotic poem critical of Americans. "In Distrust of Merits" praises the merits of distrust. It seeks to promote skepticism in the rightness of one's self and one's personal, racial, or national preeminence. The bravery of the soldiers "cures me," Moore states—but then, true to her self-suspicion, she worries, "or am I what / I can't believe in?"

According to Moore, fighting must infiltrate the subjective front so as to batter the "Hate-hardened" hearts of civilians, for "There never was a war that was / not inward." She makes another vow to "fight till I have conquered in myself what / causes war," and again questions her ability to keep her word. Peppered with allusions to the scriptures, "In Distrust of Merits" announces that the war to end all wars should evolve into a spiritual struggle, a war within the self of each individual. Its repetitions remain idiosyncratic in Moore's oeuvre, but its censure of hubris became the bedrock of her faith. Increasingly, Moore would underscore her distrust of an elitism she associated with arrogance and prejudice.

AT MIDCENTURY, MARIANNE Moore emerged as a public personage, but not before a painful period of loss. Prefaced by a host of personal disasters—the death of her mother's onetime partner Mary Norcross, her own hospitalization for digestive problems, her mother's painful shingles and neuralgia—the decade of the '40s brought sorrow. Moore had to deal with the rejection of her only attempt at a novel and the news that her *Selected Poems* had been remaindered at thirty cents a copy. Bouts of bursitis and bronchitis prompted her to hire a succession of nurses and helpers, one of whom—Gladys Berry—would work for Moore into her old age.

The busy rounds of teaching, conference going, and verse or letter writing were interrupted by her mother's "battle to eat; or rather to swallow," Moore explained to Pound: "I cannot write letters or even receive them." To Bryher, she listed the ingredients—"dehydrated goat-milk, vegetable iron, brewers' yeast"—she used to nourish her mother. After one visit, Bryher described being "terrified" about the poet: "she could not eat if Mother could not eat, and thus got rashes and kidney trouble and pains." Caregiving confined Moore to the Brooklyn apartment, where she started juicing vegetables.

Money from the Guggenheim Foundation enabled Moore to sign a contract for a translation of all twelve books of Jean de La Fontaine's *Fables* (1668–94) without accepting an advance, but her mother's death intervened and then the publisher reneged on the contract. Biographers uncover very few records revealing Marianne Moore's personal response to her mother's death, probably because she and her brother had begun destroying their papers. Was it a wrenching loss of a lifelong intimate or a release from a claustrophobic codependency or some combination of both? In any case, Leavell describes how after the death, Moore "dropped things, lost things, and broke things. Her hair whitened. Her skin sagged. Crying made her eyes puffy. She looked exhausted and beyond her sixty years."

Completing a work undertaken while her mother was alive may have furnished some solace. She probably found comfort, too, in her collaborative companionship with La Fontaine. Moore credited her translation work to W. H. Auden and Pound, and to her mother's "verbal decorum" and "impatience with imprecision." The *Fables* engaged Moore in capturing the rhythms, rhyme schemes, and whimsical tones of the original French. La Fontaine's focus on animals and penchant for moral maxims must have immediately attracted her. Some of his wry lines sound like they could be Moore's mottos: "Animals enact my universal theme"; "I bend and do not break"; "Everyone is self-deceived"; "One's skin creeps when poets persevere."

Given the miseries of the 1940s, the start of the '50s must have seemed miraculous. Moore's *Collected Poems* (1951), dedicated to her

mother's memory, won the National Book Award, the Pulitzer Prize, and the Bollingen Prize, and subsequent honors poured in, along with speaking and writing invitations. In her mid-sixties, Marianne Moore started to become a household name. To the extent that her *Collected Poems* retained the ordering of her *Selected Poems* along with a gathering of new verse, it looked quite conventional. But true to the spirit of self-criticism Moore had been pondering, she omitted many of her early poems from *Collected Poems*. And several celebrated works were reprinted with entire stanzas missing.

Moore did not revise her earlier poems so much as she slashed them, much to the distress of quite a few friends and later scholars. Her self-critical editing generated a great deal of confusion. A text in *Collected Poems* could look quite different from earlier versions. The question about what might have motivated Moore's editorial excisions in *Collected Poems* is worth considering, because she later rigorously expunged work in the misnamed *Complete Poems* (1967), which appeared on her eightieth birthday. Since, as she famously stated in the epigraph to that volume, "omissions are not accidents," one can search for clues about her motivation in the essays Moore composed.

In "Feeling and Precision," Moore argued that the deepest feelings tend "to be inarticulate" or they will "seem overcondensed." Because we associate intensity with minimalized language, "expanded explanation tends to spoil the lion's leap." In "Humility, Concentration, and Gusto," she admits, "I myself... would rather be told too little than too much." In another essay, she repeats "a master axiom" from Confucius: "When you have done justice to the meaning, stop." The discipline of restraint remains an ideal: "It is a commonplace that we are the most eloquent by reason of the not said." The titles of two essays—"Compactness Compacted" and "Reticent Candor"— express her admiration of "the not said."

Despite Moore's tendency to shrink her poems, she reprinted an expansive version of one of her most admired texts, "Poetry" (1919), which anticipates her late-life efforts to widen her audience. She had

earlier subtracted the piece down to one stanza, but she reinstated its original five stanzas in *Collected Poems*. Even readers who object to her long lines and erratic sentences relish the longer "Poetry," possibly because its conversational opening—"I, too, dislike it"—goes on to provide an unpretentious defense of poetry. By sympathetically addressing those who speak with "a perfect contempt" of poetry as incomprehensible "fiddle," Moore refuses to preach to the choir.

We need to hunt for the value of poetry, Moore suggests, because bad verse obscures our appreciation. Understanding those who dismiss poetry, the speaker is not defending unintelligible work. Instead, she searches for instances of "the genuine"—"Hands that can grasp, eyes / that can dilate / hair that can rise"—which are important "not because a / / high-sounding interpretation can be put upon them but because they are / useful." Hands grasp, eyes dilate, and hair rises while we are reading what moves us, and each motion involves an emotion related to fear or enchantment or absorption. We are then given a mini-catalogue of phenomena that we admire but may not fully understand.

This list includes a bat hanging upside down, elephants pushing, even an "immovable critic" whose skin is twitching (a nice jab at professional readers), and then the baseball fan and statistician. All these "are important," Moore declares; "nor is it valid" to dismiss "'business documents and school-books'" as prosaic. The subject matter of poetry need not be poetical: it can, does, and should deal with the quotidian. After this assertion, Moore contrasts "half-poets" with true poets who create "'imaginary gardens with real toads in them.'"

Readers often interpret Moore's most famous line as a definition of poetry: the synthesis of reality ("real toads") with imagination ("imaginary gardens"). Given the fairy-tale template, a warty, earthbound toad is less likely than a frog to turn into a Prince Charming when transplanted into an arcadian garden of verse. A casual phrase, "In the meantime," concludes "Poetry" with the concession that poetry may not yet have fully attained its goal, but

> *if you demand on the one hand,*
> *the raw material of poetry in*
> *all its rawness and*
> *that which is on the other hand*
> *genuine, then you are interested in poetry.*

In a 1951 essay, Moore explained that she felt "estranged from [poetry] by much that passes for virtuosity—that is affectation or exhibitionism—and then talent comes to the rescue, and we forget about what we think and automatically we are helplessly interested." In such cases "instinct outdoes intellect, for the rhythm is the person." She went on to praise the "verbal bravura" in Auden's verse—the same bravura exhibited in the colloquial rhythms of "Poetry." No wonder he admitted stealing from her.

Throughout late life, Marianne Moore exercised her imagination on a wide range of real activities, institutions, sites, and people—including baseball fans. Why, then, did she exclude this engaging statement of her aesthetic aims from the 1961 *Marianne Moore Reader?* And why did she cut "Poetry" down to three lines when she reinstated it in the 1967 *Complete Poems?*

IF "'OMISSIONS are not accidents,'" Moore's interpreter Bonnie Costello speculates, "the corollary may be 'inclusions are intentions.'" Although "Poetry" was omitted from *A Marianne Moore Reader*, the poet did include her 1955 correspondence with representatives of the Ford Motor Company in which they asked her to name a car in production. She floated a series of proposals including The Impeccable, The Resilient Bullet, Mongoose Civique, and Utopian Turtletop. The last of these playful suggestions brought her a bouquet of roses and a eucalyptus. A year later, she must have been surprised on learning that the car would be named after Henry Ford's son, Edsel.

By 1967, after the dangerous conditions in her Brooklyn neighborhood persuaded the eighty-year-old Marianne Moore to return to Greenwich Village, she was telling *Life* magazine, "I'm a happy hack as a writer." Two years later, she appeared in a televised Braniff airlines commercial with the crime novelist Mickey Spillane and recited Braniff's slogan: "When you got it—flaunt it." As the Ford request for her services and the television ad indicate, she had become, in the words of the *Life* headline, the "Leading Lady of U.S. Verse." From her sixties on, Moore turned her attention to American culture and in particular to the pleasures she had enjoyed for decades in New York City. To use one of her favorite words, Moore lived her last decades with gusto as she celebrated the city's horse-racing tracks, baseball fields, concert halls, museums, parks, and bridges.

Upon first visiting Manhattan back in 1915, Moore had credited the editors of the little magazines and her experience at Alfred Stieglitz's gallery, 291, with instilling in her the desire to move. While she and her mother lived on St. Luke's Place, the library down the street furnished a home away from home. Later, in Fort Greene, she profited from lectures, readings, concerts, films, and exhibits at the Brooklyn Academy of Music and the Brooklyn Institute of Arts and Sciences, where she encountered W. B. Yeats, Robert Frost, Gertrude Stein, and Edna St. Vincent Millay. Moore kept a bowl of coins for her visitors' subway rides home. After her mother's death, she continued to visit the 42nd Street Library, the Museum of Modern Art, and the Pierpont Morgan Library.

Just as she sent off gift-poems in return for material gifts, Moore devoted her creative energies in her final decades to poems thanking New York. One of the first, "Tom Fool at Jamaica," was her first acceptance by the *New Yorker* when it appeared in 1953. Like her earlier verse, it is chockablock with quotations, but now from lowbrow sources, for it recounts Moore's reaction to a particular horse, Tom Fool, racing at the Jamaica Race Course in Queens. Tom Fool is admired by his jockey, Ted Atkinson, and by the sports announcer Frederic Capossela. Awe at physical prowess in large and small crea-

tures opens the poem with its references to Jonah "deterred / by the whale" and a picture of "a mule and jockey / who had pulled up for a snail." These images are linked by a characteristically cautionary maxim: "Be infallible at your peril, for your system will fail."

"Tom Fool at Jamaica" fools around with the racehorse's "left white hind foot—an unconformity; though judging / by results, a kind of cottontail to give him confidence." That the announcer "keeps his head"—"why shouldn't I? / I'm relaxed, I'm confident, and I don't bet"—lets Marianne Moore off the hook, since, she explains in the notes, "I had just received an award from Youth United for a Better Tomorrow" and "I deplore gambling." The last section of the poem directly addresses the thoroughbred ("You've the beat of a dancer . . . of a porpoise") and turns into a rhapsodic list of other rhythmic "champions": the musicians Fats Waller, Ozzie Smith, and Eubie Blake, the jockey Ted Atkinson "cat-loping along," and "a monkey on a greyhound." It concludes with an interrupted but animated exclamation suggesting that none can compare with Tom Fool.

Although the association of Black people with animals can surface in troubling discourses used in demeaning ways, here it appears as an homage. Moore believed that animals and athletes of all colors furnish "subjects for art and [are] exemplars of it" by "minding their own business": they "do not pry or prey—or prolong the conversation; do not make us self-conscious; look their best when caring least."

Just as her early poems valued biodiversity, quite a few of Moore's late poems celebrate racial diversity. Unlike the earlier poems, the late poems are populated by throngs of named human subjects. In "Hometown Piece for Messrs. Alston and Reece," which appeared on the front page of the *New York Herald Tribune* on October 3, 1956, Moore catalogues the names of the Dodgers who won the World Series the year before and urges them to go out and do it again. Composed in rhymed couplets suitable to her heroic subject, the opening riffs off a *New York Times* column declaring that "the millennium and pandemonium arrived at approximately the same time in the Brook-

lyn Dodgers' clubhouse." Roy Campanella opens Moore's roll call of players and closes it along with his two other Black teammates, Jackie Robinson and Don Newcombe.

A 1960 interviewer in *Sports Illustrated* emphasized that Moore, on the Jack Paar talk show, attributed her interest in sports to the Indigenous athletes she had known while teaching in the Carlisle Indian School. Perhaps she was attracted by the teamwork at play on the field, a confirmation of her belief that "egomania is not a duty," as she dryly put it in "Blessed Is the Man." "Baseball and Writing," a poem that appeared in the *New Yorker* in 1961, considers the artful maneuvers of Elston Howard, the first Black player on the Yankees. The only non-Yankee player mentioned is Manny Montejo, a Cuban pitcher for the Detroit Tigers. Luis Arroyo, a Puerto Rican player, and Héctor López, a Panamanian, appear in the last stanza. Clearly, Marianne Moore celebrated the demographics of the baseball games she watched on television with her African American housekeeper, Gladys Berry, and avidly discussed with her brother before she was chosen to throw out the first pitch at Yankee Stadium in 1968.

"Rescue with Yul Brynner" (1961), about the Broadway star's work on behalf of refugee children, and "Arthur Mitchell" (1962), about the first African American dancer in the New York City Ballet, reflect Moore's ongoing efforts to laud diversity, artistic agility, and courage in civic endeavors. The pleasure she took in Gotham's cultural treasures is also expressed in her letters, which attest to Moore's gratification in visiting college campuses, meeting younger poets, and traveling with close friends, but return recurrently to the elation of hearing Billie Holiday sing at one of the "Coffee Concerts" at the Museum of Modern Art, dining in Manhattan with Isak Dinesen or the Sitwells, attending the ballet or theater with Lincoln Kirstein, and going to see a fight at Madison Square Garden with George Plimpton and afterward to a reception at Toots Shor's, where she recognized Norman Mailer.

After Cassius Clay (later Muhammad Ali) expressed his desire to collaborate with Moore on a sonnet about his upcoming fight with

Ernie Terrell, she provided the title: "A Poem on the Annihilation of Ernie Terrell." On the record jacket of Clay's *I Am the Greatest!* Moore calls the fighter "A knight, a king of the ring, a mimic, a satirist" as well as a "master of hyperbole" with "a fondness for antithesis." She concludes with his sort of rhymes: "He fights and he writes. Is there something I have missed? He is a smiling pugilist."

A fan addressing other fans, Moore exercised her genius at networking in a sphere larger than the company of poets, a fact italicized by the popular magazines in which she placed her late essays. "Brooklyn from Clinton Hill," published in *Vogue*, describes the historic landmarks in her borough. Even closer to home, "My Crow, Pluto—A Fantasy," which appeared in *Harper's Bazaar*, describes her apartment as well as her pet: "I could not induce him to say, 'Nevermore.' If I inquired, 'what was the refrain in Poe's 'Raven,' Pluto?' he invariably would croak, 'Evermore.'" "Profit Is a Dead Weight," in *Seventeen*, reiterates one of her favorite adages from Confucius—"If there be a knife of resentment in the heart, the mind fails to attain precision"—before it goes on to detail how a book by the fighter Floyd Patterson and the playing of the Spanish guitarist Andrés Segovia "fired my imagination with gratitude."

When on the brink of her eightieth birthday Moore received an award from the Poetry Society of America, Mayor John Lindsay called her "truly the poet laureate of New York City" and a tongue-in-cheek Langston Hughes alluded to her demographic and democratic vistas by praising her as "the most famous Negro woman poet in America." In the *New York Times*, she finishes an essay with the bravura of an enthusiast: "I like Santa Barbara, British Columbia; have an incurable fondness for London. But of any cities I have seen, I like New York best."

AS IN "THE LIBRARY Down the Street in the Village" (1968), an essay describing citizens banding together to save a Greenwich Village

branch of the New York Public Library, urban preservation became a civic passion for the elderly Marianne Moore. Even though she discouraged Elizabeth Bishop from uttering Walt Whitman's name, she worked to save the Walt Whitman building from demolition. She also used her verse to raise consciousness about conservation.

"Old Amusement Park" (1964) describes the Ferris wheel and carousel displaced by the building of LaGuardia Airport. "Carnegie Hall: Rescued" (1960) praises the preservation of the majestic music hall "At the fifty-ninth minute / of the eleventh hour" and credits the violinist Isaac Stern for the building's escape from "the 'cannibal / of real estate.'" Moore put her poem urging New Yorkers to save a tree in Prospect Park in the place of honor: at the very end of her verse selection in *Complete Poems*.

"The Camperdown Elm" (1967), about an ailing tree gifted to the park in 1872, begins by mentioning a Hudson River School landscape called *Kindred Spirits* (1849): Asher Brown Durand's oil painting of the painter Thomas Cole and the poet William Cullen Bryant. The two gentlemen, one holding a portfolio, are conversing on an outcropping of rock, a cliff over a river gorge. Moore sees Cole and Bryant framed "under the filigree of an elm overhead." All three men—Durand, Cole, and Bryant—associated nature with sacred space in which human beings could find community and communion. Especially needed in a city, natural settings, they believed, fostered kindred spirits. In the second stanza, Moore concedes that they must have "seen other trees," but "imagine / their rapture, had they come on the camperdown elm's / massiveness."

The poem goes on to state that a tree-cavity specialist thrust his arm into the tree in Prospect Park to find more cavities, though Moore omits mentioning that rats and ants had infiltrated its holes. The horizontal growth of this unusually gnarled tree also escapes her attention; however, in her essay "Crossing Brooklyn Bridge at Twilight," she explains that "It has eighteen cavities, is in need of cleaning and bracing under its heavy horizontal limbs," and "Funds could make it serve as an outdoor classroom, demonstrating techniques of

tree care," so she includes an address to which money can be sent. In the poem, Moore concludes with an urgent message about the "weeping" tree: "Props are needed and tree-food. / It is still leafing; / still there; *mortal* though. We must save it. It is / our crowning curio."

Moore herself was a gnarled curio but still leafing when at seventy-nine she created this image of old age. Attuned to the mortality of buildings and of natural habitats, Moore's preservation efforts worked effectively to save the Camperdown Elm and to repeal the demolition of the 1904 Boat House near it. She became president of the Greensward Foundation and helped found Friends of Prospect Park.

"Granite and Steel" (1966), a poem about the Brooklyn Bridge, elaborates on the poet's commitment to the city. It begins with the line "Enfranchising cable, silvered by the sea" to stress the contrast between American enfranchisement and a history of "Tyranny." The word "sea" sets up all the subsequent end rhymes: from "Tyranny" and "priority" to "perspicacity" and "actuality." In its first stanza, the poem locates the bridge in the bay where the Statue of Liberty steps "on shattered chains."

Moore's America depends on immigrants and foreigners. The construction of the bridge profited from "German ingenuity," while the Statue of Liberty was a gift of the newly enfranchised French. The attraction of the bridge, likened to Circe's, arises from its freely floating cables, which are juxtaposed against the shattered chains of Tyranny. A "spellbound" young reporter who climbed to the top of one of the cables testifies to Circe's allure; his cries for help were not heeded till the next morning. Moore deems the hanging cables an "implacable enemy" to societal problems associated with "the mind's deformity": "the crass love of crass" that obstructs those entering cities where mercenary motives overrule moral convictions or, as she puts it, "probity."

After this critique of materialism, the final stanza of "Granite and Steel" stresses the dogged ingenuity needed by engineers: "Untried, expedient, untried; then tried." Moore's poem serves as a tribute to

the tenacity and creativity of its designer, the German immigrant John H. Roebling. In an essay, Moore argues that the bridge is "synonymous with endurance—and sacrifice": by Roebling, who died "from a foot crushed by an incoming ferry when he was surveying for the bridge"; by his son, "who suffered caisson bends; and with heroism on the part of Mrs. Washington Roebling, who mastered calculus and engineering" to help complete it.

Finally, with its "fixed arcs of filament united by stress," the Brooklyn Bridge emerges in "Granite and Steel" as a "romantic passageway" that inspires awe—"O steel! O stone!"—because Roebling translated what he saw first in his mind's eye into "an actuality." Its "composite span" bridges steel and stone, cables and towers, material matter and imagined design, strength and grace, engineering and art, Brooklyn and Manhattan. With civic poems such as this one, Moore distinguished her later from her earlier works even as she linked herself to the statue's and the bridge's previous bards: Walt Whitman, Emma Lazarus, and Hart Crane, as well as Elizabeth Bishop's evocation of Moore's own spanning abilities.

That Moore weighted her *Reader* with later texts and omitted earlier ones like "Poetry" makes sense in terms of any aging writer's wanting not to rest on her laurels, wanting instead to emphasize recent achievements that register the ongoing imaginative impulses that continue to propel her. The book testified to her extraordinary poetic output in later life, much of it consisting of praise songs demonstrating precisely the usefulness of verse that she had stressed in "Poetry."

As for the cutting down of "Poetry" to a single, three-line stanza in the *Complete Poems*, Moore had started to realize that her books were functioning as advertisements for herself. She concludes "The Arctic Ox (or Goat)," a poem about the virtues of the underwool of the arctic ox, by explaining, "If you fear that you are / reading an advertisement, / you are. If we can't be cordial / to these creatures' fleece, / I think that we deserve to freeze." The tongue-in-cheek

doggerel intimates that devoted readers might want to consider the abbreviated version of "Poetry"—

> I, too, dislike it.
> Reading it, however, with a perfect contempt for it, one
> discovers in
> it, after all, a place for the genuine.

—as an ad for the longer version that can, after all, be found reprinted in its entirety within the *Complete Poem*'s notes. The three-line version of "Poetry" would be a great candidate for Poetry in Motion, a program (launched in 1992) that put verse into New York City's public transit system and that would have charmed Moore, an inveterate subway passenger whose picture appeared in train cars in 1967 to celebrate her as an exemplary citizen.

THE SAGACIOUS CRITIC Helen Vendler was not alone in judging Marianne Moore's late publications a falling off from her modernist achievements. Hilton Kramer argued that the media turned Moore into "the very archetype of the quaint literary spinster. She may very well have been the last spinster type created by the communications industry before the women's movement radically altered the terms of media mythmaking." But such a view accords too much power to the media, not enough to the poet. Even before the media blitz, my collaborator Sandra Gilbert has shown, Moore's modernist texts manipulated the spinster image to express her alienation from conventional gender roles.

Periodically during the last decades of her life, the wily poet parodied the role of the daft but spry old lady or the spirited but addlepated poetess. The persona enabled Moore to maintain the guardedness she had always admired. The remarkable opening of the foreword to *A Marianne Moore Reader*, for instance, puts on display

an oldster dithering over the messy remnants of her long-forgotten work, fumbling over her papers, not remembering her own titles or where she published what, making oddball allusions:

> Published: it is enough. The magazine was discontinued. The edition was small. One paragraph needs restating. Newspaper cuts on the fold or disintegrates. When was it published, and where? "The title was 'Words and...' something else. Could you say what it was? I have forgotten. Happened upon years later, it seems to have been "Words and Modes of Expression." What became of "Tedium and Integrity," the unfinished manuscript of which there was no duplicate? A housekeeper is needed to assort the untidiness. For whom? A curioso or just for the author? In that case "as safe at the publisher's as if chained to the shelves of Bodley," Lamb said smiling.

Some critics might call this salvo a case of the "senile sublime," a barely intelligible performance by a brilliant old person. But Marianne Moore was happily never senile. After a stroke in 1961, she worried that she was "mentally defective," so her trusted doctor took her to a neurologist who noticed that Moore dropped the final letters of words; but "it's all right," he assured her, "since you are aware of doing it." Perhaps, then, we should consider the *Reader*'s opening a self-caricaturing performance of geezer machismo.

In 1961, Moore composed a ditsy foreword to *The Absentee*, a play she had written a decade earlier. Based on a nineteenth-century novel by Maria Edgeworth, it had been rejected in the '50s. Once again, she emphasizes her own indecisiveness: "A play written in the time of gold-laced hats and long dresses?" Whether drawn to Maria Edgeworth's story by her Irish ancestry or her attraction to obsolescence, Moore shilly-shallies at the close of her introduction: "Does it hold the attention? Does any of it apply?" Her inconclusiveness left her open to the response of the scholar Charles Molesworth, who rightly sensed that "many readers may well answer with a reluc-

tant 'no'"; however, she was beginning to realize that her name was becoming a brand that would license anything she wrote.

In her Brooklyn apartment, Marianne Moore was known "for a certain recklessness" in the "dizzying monologues" she recited for visitors. A label on a bottle would lead her to a discussion of grocery stores that carry wine, and then to her "grudge against people who try to make me drink coffee," and to a friend who "grinds her own coffee," and onward to the grandfather of that friend's husband who (Moore goes on to explain)

> was a close friend of Wallace Stevens, who wrote "The Necessary Angel." He reprinted an anecdote about Goethe wearing black woolen stockings on a packet boat. I like Goethe. My favorite language is German. I like the periodic structure of the sentences. "And Shakespeare inspires me, too. He has so many good quotations. And Dante. He has a few, too." That's from Ruth Draper. At Monroe Wheeler's once, we played a game called "Who would you rather be except Shakespeare?"

The torrent of catawampus associations effectively warded off astonished journalists and preserved her privacy.

As for her signature costume—a black tricorn hat and cape (fastened with a silver-dollar pin)—the George Washington performance marketed her brand, even as it enabled her to revel in a permit granted by old age: the license to dress as one pleases. While partying with Truman Capote or Yevgeny Yevtushenko, Moore was evoking a president revered by her brother, one who never resided in Washington and who signed the first copyright law, issued the first Thanksgiving proclamation, delivered an address on religious tolerance at a synagogue, and visited his militia in Carlisle, Pennsylvania, where he attended the First Presbyterian Church. That George Washington established the precedent for term limits and delivered the shortest inaugural address ever given might have also endeared him to Marianne Moore.

The cape and tricorn hat first appeared at one of the many celebrations for the national awards at the start of the 1950s. Moore obtained the hat herself, but the cape was a gift from the mother of her friend Hildegarde Watson. The outfit signaled the indeterminacy or fluidity of her gender identifications, as did her mother's earlier habit of calling her daughter "he."

In midlife, Moore, who was also known in the family as Gater, indicated that the quirky nicknames and pronouns signaled her alienation from traditional identity categories: "Some feel their own sex to be more inane than the other, some the other to be more inane than their own. Some find both inane. It is not possible to differentiate in favor of either, according to Professor Papez' collection of brains at Cornell. They are, as it were, alligators." Speculating that "One may wish to let love alone," she provides "instances of impersonalism" in a list of famous bachelors. According to the scholar Elizabeth Gregory, Moore's "founding-father garb" expressed "the non-binary self-view she'd held all along." While becoming a celebrity, she legitimated celibacy.

Trotting from an award ceremony to a reading, Moore often wore the tricorn hat over her signature crown of braids, attire that made Elizabeth Bishop think of "a feminine, luminescent, delicate re-incarnation of Paul Revere" but made most of her audiences think of George Washington crossing the Delaware. While Emanuel Leutze put George Washington in a rowboat, Moore headlined him on stages, screens, and magazines with a fragility and decorum that fostered admiration, affection, and some awe. The poet Donald Hall, who met Moore at Harvard University amid a group of literary titans, witnessed a degree of trepidation in that awe: "She is five foot three and a half inches tall, weighs less than a hundred pounds, talks in a low mumble while looking at the floor, continually disparages herself while praising others—and they are all terrified of her."

The George Washington outfit accentuated Moore's singularity and patriotism as well as her acknowledgment that the values inculcated by her mother were decidedly outdated. When she com-

mended the three-cent postage stamp "Washington Saves His Army at Brooklyn," Moore was unaware that she would be commemorated on a twenty-five-cent postage stamp released in 1990 (looking suitably youthful and feminine). The bemused Moore exaggerated her little-old-lady eccentricity. She sometimes wore a fur coat that seemed to weigh more than she did. In interviews, she described the bric-a-brac she collected—a mechanical bird and elephant, a stuffed alligator, a fly in amber—contrasting her rooms cluttered with tchotchkes, books, and watercolors with an austere kitchen in which she had never baked a pie.

When Donald Hall arrived to interview the poet, who had broken her dentures, Moore could not take him to the usual nearby restaurant and instead served him lunch: "My tray held several little paper cups, the pleated kind used for cupcakes, which she employed as receptacles." They contained seven raisins and a few peanuts, accompanied by a half-full cheese glass (from a Kraft processed spread) of tomato juice, and (since he was still hungry) some Fritos that she could not herself eat. "'I like Fritos,' she croaked, covering her mouth. 'They're so nutritious.'"

In *Women's Wear Daily*, Moore's comments seem to issue from a throwback: "Most women's leg-below-the-knee looks better than the leg-above-the knee as currently on display in the subway" or "To repair lipstick in company is not quite like fastening a garter on the street but is in the same category." She offered not only urban etiquette but also loopy fashion tips: "Having afforded us counsel, snakes—perhaps a lizard—could have an influence on what we wear."

The elderly Moore was spotted in a garden behind an East Village bookstore singing old songs with the songwriter Lou Reed. With "happy hack" bravado, she accepted a commission from the Pencil Manufacturers Association:

> *Velvet mat*
> *is my cat.*
> *Beaver fur*

makes my hat.
Our best pencils
write like that.

She had always enjoyed the nonsense verse of Edward Lear, Lewis Carroll, Ogden Nash, and T. S. Eliot, and she treasured the odd sounds of outré words and the half rhymes she hid inside her lines. Startling her interlocutors must have been wonderfully amusing. As she grew older, she laughed at her own foibles or ineptitude, as she refused to be reified in the high seriousness of the modernist canon she had helped establish.

Taking on the difficult task of composing "poetry of praise in an age of anxiety," as Molesworth puts it, Moore continued to emphasize the usefulness of poetry as she relied upon and anticipated civically engaged forms of verse. She was drawing on a nineteenth-century lineage of municipal poets, though in the "tranquilized Fifties" civic activism was a good deal tamer. Moore, who supported President Eisenhower and later the Vietnam War, nevertheless engaged in the local issues of her day while participating in the emerging mass media that were gearing up to produce the celebrity culture we now inhabit. In this respect, she was an anomaly in the modernist poetry scene. None of her poet-friends aspired to (or were asked to) celebrate their native land on television or in mass-marketed print venues.

Moore's conservatism and her quaint propriety as she participated in popular culture made her an "unknockable," the term *Esquire* used to describe people whom nobody hates. She was pictured on a 1966 cover with Jimmy Durante, Kate Smith, and Joe Louis. The conservatism could issue in harsh judgments when, for example, she censured Sylvia Plath's verse for "gruesome detail, worms and germs and spiritual flatness." The propriety could verge on prudery when Moore took Allen Ginsberg to task for his line "I wandered off in search of the toilet." As she admonished him in a letter that might have cracked him up, "And I go with you, remember. Do I have to?"

Ginsberg's manuscript "dejected" her, Moore confessed, because she believed that poetry should put "a weapon in our hands; we are the better able to deal with injustice and with a sense of 'God's injustice.'" Yet she added that his "trials" affected her, and he must not feel obliged to respond back: "I write too many letters, then am too tired to do my work. I don't want to make *you* too tired to work." She did devote enormous amounts of her dwindling energies to penning encouraging letters to her astonishing number of friends and to apprentice writers. After Moore was confined by a series of strokes to a hospital bed in her apartment on West 9th Street in 1969 and then died in her sleep at the age of eighty-four, the *New York Times* informed the public of her wishes. She asked that contributions should be sent to the Camperdown Foundation for the planting and care of trees in Prospect Park and Central Park.

By fortifying the prominence of the civic poet on the public platform, Marianne Moore laid the groundwork for Allen Ginsberg, who went on television and appeared in the pages of magazines to discuss poems that functioned as "a weapon" to make us "better able to deal with injustice and with a sense of 'God's injustice.'" In better tune with her sensibilities, Robert Frost recited at John F. Kennedy's inauguration, to be followed at subsequent ceremonies by Maya Angelou, Elizabeth Alexander, Richard Blanco, and Amanda Gorman.

Marianne Moore's evolution suggests that we become more like our parents when we age, but we can improvise on their antediluvian morals and manners. While she clearly relished thinking of herself as an anachronism, holding out for her mother's quasi-Victorian virtues of courtesy, humility, propriety, reticence, precision, and gusto, she inflected those values with her idiosyncratic wit. Age freed her from the cruder conventions governing a younger generation, freed her to celebrate the love of her life, the city that fostered her aesthetic evolution. Longevity honed her advocacy of a "hackneyed truism" that she expressed to Allen Ginsberg and exemplified: "affirm or die."

CHAPTER 6
Louise Bourgeois

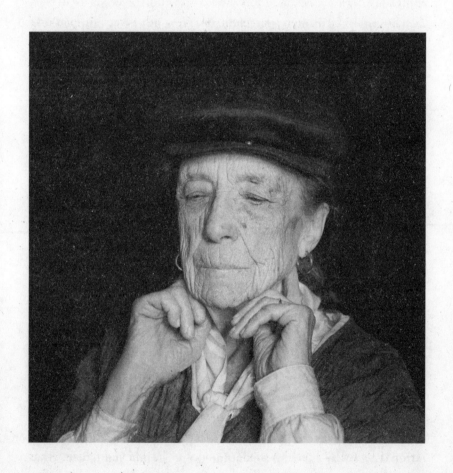

LOUISE BOURGEOIS brought her artwork *Fillette* (*Little Girl*, 1968), a plaster and latex penis with testicles, to a session with Robert Mapplethorpe because he liked to photograph men with large sex organs. His picture captures the grinning artist carrying the phallus under her right arm like a pet or a package. In the Museum of Modern Art's 1982 *Louise Bourgeois* exhibition catalogue, the portrait serves as a frontispiece, though *Fillette* has been cropped. On its back cover, another photo displays the artist posed in a smock bristling with more than twenty latex protuberances. Whether they represent trophies the sculptor assembled from symbolic victims or a wry statement about her prickly nature, the outfit might have reminded viewers of the latex garment she had worn for a *Vogue* photoshoot. Bourgeois had become, in the words of one *New Yorker* critic, "the art world's favorite naughty old lady."

Wildly inventive, the sculptor was entering her seventies at her retrospective. Yet it served less as a finale and more as an overture. During the next three decades, she worked at a hectic pace as she moved beyond human-scale projects to produce architectural installations and grandiose sculptures that would materialize all over the globe. The MoMA show, curated by Deborah Wye, was long in coming because of the historical exclusion of women from the art marketplace and also because of the artist's traumatic past.

Although she attained fame in New York, Bourgeois grew up and lived in France until she married the American art historian Robert Goldwater. Throughout her life, she retained indelible memories of a youth steeped in patterns and hurts. Her parents owned a tapestry workshop, where she learned to repair frayed antique textiles. After World War I and the 1918 influenza pandemic, her father began philandering and her mother's health declined. In the year of the MoMA exhibit, Bourgeois publicly attributed her wounded youth to her father's ten-year affair with her English nanny, which her mother

tolerated. In a photo essay and an audiovisual presentation, the artist considered it a form of "child abuse": "Everything I do," she stated, "was inspired by my early life."

At the Sorbonne, Bourgeois was drawn to the predictability and stability of mathematics, but the grievous death of her mother in 1932 led to suicide attempts. She decided to enroll in art classes that turned her toward the three-dimensional medium of sculpture. While the art student was glad to leave Paris as the bride of a college professor well-connected in the New York art scene, she missed friends like Colette.

After emigrating to join Robert Goldwater in 1938, Louise Bourgeois negotiated the twin demands of family and career. Living in New York, she brought up her three sons while beginning to produce sculptures of tall, thin wooden poles. During World War II, she organized an exhibition of the art and literature of the French Underground and networked with many artist-immigrants, especially the surrealists. In 1949, she debuted with installations of the totemic poles that spoke to gallery visitors of human isolation. However, the death of her father in 1951 plunged the sculptor into a depression that resulted in her disappearance from public view.

A series of drawings called *Femme Maison* (*Woman House*) anticipate the midlife crisis Bourgeois would suffer in her forties. They depict women from the neck or waist down whose heads are replaced by houses. Any one of these "housewives" would be a fine illustration of the malaise analyzed by Betty Friedan in *The Feminine Mystique* (1963). From 1953 until 1964, there were no shows. During this hiatus, Bourgeois embarked on an extensive course of psychoanalysis and familiarized herself with the writings of thinkers from Sigmund Freud to Jacques Lacan, a "con man" who (she believed) "gargled" with words.

In 1962, Bourgeois, Goldwater, and their sons moved to 347 West 20th Street, where she would reside for the rest of her life, and the sculptor began experimenting with bronze, marble, and plastic to produce works about the body that she called Lairs. Long after the death of her husband in 1973, Bourgeois expressed affection for

him. The marriage had been, she said, a "mutual wonderment," a "small miracle."

At least in part, the feminist movement rescued the artist from obscurity. The art critic Lucy Lippard included her in a 1966 exhibition of organic abstract forms and later published an essay about the "'crowds' of breast-phallus protrusions, fingerlike growths, [and] rounded cylinders" produced by Bourgeois as well as the 1974 cave-like installation called *Le Repas du Soir* (*The Evening Meal*, which was later renamed *The Destruction of the Father*), a work centered on a gruesome fantasy of devouring the oppressive patriarch. *Fillette* became "an underground icon of the growing women's movement," according to the biographer Robert Storr. Its creator was quite a bit older than activist-artists like Judy Chicago and Faith Ringgold. At the time of the MoMA exhibit, no one could have guessed that another retrospective would be needed in 2017—to account for the aesthetic breakthroughs of old age.

Increasingly agoraphobic in the last decades of her life, exceptionally literate and driven, Louise Bourgeois often said that she traveled not in space but in time. Except for an influx of prestigious awards, as well as a series of losses, nothing much happened in her old age: she spent virtually all her time making artworks. Until she died at ninety-eight in 2010, Bourgeois mined her fraught past through the paraphernalia of horror stories: frightful dolls, haunted rooms, claustrophobic cages, creepy-crawly critters, and mirrors reflecting evidence of violence or neglect. Although she started using these nightmarish motifs to explore the harms inflicted by the family romance at the core of classic psychoanalysis, the elderly Bourgeois became not only a critic of Sigmund Freud but also a phenomenologist of the aging process: she would focus on how it feels to be haunted by the memories accruing in old age.

Louise Bourgeois's late-life artworks transitioned in scale and subject matter. In size, they grew humongous until, toward the very end of her life, they shrank into small proportions that could be handled at a table in a wheelchair. In terms of subject matter, the sculp-

tor exchanged punitive representations of sexual violence that she associated with her father for restorative meditations on maternal creativity. Anger at her traumatic past continued to infuse the work she produced in her seventies, but by her eighties Bourgeois was fashioning monuments to grief that issued in astonishing artifacts of repair and recompense. That fear and pain were the emotions she concretized and that she dared to address private subjects in public projects explain why Louise Bourgeois's prodigious late-life artworks continue to stimulate awe at her bravery.

IN A 2008 documentary film about Louise Bourgeois, the elderly artist re-creates the first figure that captured her imagination. At the end of dinner, she explains, her father would regularly sculpt a tangerine, while his wife and children watched. Sitting at a table, the nonagenarian proceeds to cut the orange peel from the pulp. At the navel, she then pulls out the pith or core and holds up the humanoid rind with a white stub sticking out between its legs. Her father would then marvel at the penis and lament, "Well, I am sorry that my daughter does not exhibit such a beauty. The little creature was just a girl." After describing the mockery of her long-dead father, the aged artist weeps, and moves out of the camera's range.

If the anguish were not so very evident, one might be tempted to joke that Louise Bourgeois's upbringing sounds like a chapter from a book titled "Sigmund Freud for Dummies." She was named Louise by her mother to please her father, Louis, who had wanted a son after the birth of his first two daughters. His last child would be a boy; however, by that time Louise had become his favorite . . . because she resembled him.

The carving of the tangerine figure, an instruction in female castration, suggests, as Freud did, that the anatomy of the little girl signifies lack. This deficiency infects her with penis envy that can be assuaged if and when she accepts a baby—or a doll substitute

for a baby—as recompense for the missing phallus or as a symbolic replacement for it. Fear of being cut, of being incomplete or inadequate, mixes with anger at being told that one is cut, incomplete, or inadequate and with jealousy of those uncut, complete, adequate adults who do the telling.

Bourgeois tended to identify her sculpting as an act of retaliation against her father. She recalled an early response to his humiliating teasing: "I took white bread, mixed it with spit and molded a figure of my father. When the figure was done, I started cutting off the limbs with a knife." When discussing the sculpting of marble or bronze, she emphasized the violence involved in the process. Employing drills, files, mallets, knives, or chisels on resistant stone allayed her anxieties. "The resilience of stone ... challenges me," she explained in a 1987 interview. "It takes care of my aggression, my need to be violent and physical." At the start of old age, Bourgeois used resistant stone to re-create what she called "*poupées de pain*": she was punning in her two languages on "dolls of bread/pain." In later old age, however, she could have populated a penal colony with the multitude of figures she crafted out of variously colored fabrics.

The pink marble sculpture *Femme Couteau* (*Knife Woman*, 1969/70), which appears in the MoMA catalogue, lies prone, a narrow scalpel, twenty-six inches long, headless with the hint of breasts or pudenda. Its creator associates it with the destructive seduction of a hatchet woman. "In *Femme Couteau*," she explained, "the woman turns into a blade, she is defensive. She identifies with the penis to defend herself. A girl can be terrified by the world. She feels vulnerable because she can be wounded by the penis. So she tries to take on the weapon of the aggressor."

If Bourgeois did not have the penis, *Femme Couteau* suggests, she could nevertheless create and own one or more than one. As she said of *Fillette*, the "little girl" who looks like an outsized sex organ, "you can carry it around like a baby, have it as a doll." Some of Bourgeois's late sculptures tap into the anger evident not only in the "Child Abuse" essay but also in the cannibalistic fantasy of *The Destruction of*

the Father: she blamed her father, her English nanny, and her mother for her rage. In part because of her ongoing struggle with her painful past, Bourgeois claimed, "My religion is psychoanalysis." The stone figures Bourgeois produced after her first MoMA retrospective have been defaced or decapitated by the artist. They address the Freudian notion that headless bodies signify castration as well as outrage at the deficiency Freud's theory attributes to the female of the species, although psycho-biographical interpretations cannot fully account for their disturbing effects.

In *Spiral Woman* (1984, 12 in.), a gleaming bronze figurine is suspended from the ceiling. Dangling in midair, she has small arms and legs. Her neck and head have been engulfed in coiling spirals: a serpent or her own hair or a monstrous malignancy. Bourgeois had wanted to twist or wring the neck of the English nanny who was her father's mistress. Yet the piece transcends its biographical origins. Whatever it is that coils around the head of swiveling *Spiral Woman* exhibits a gleaming circularity with its own brand of sinister beauty, like a cocoon or a spinning top or a lamia. Turning to the left, then to the right, the female figure has perfected "the art of hanging in there" and so exhibits an equipoise of her own.

The massive black bronze *She-Fox* (1985, 30 × 19 × 15 in.) squats on her pedestal. Headless but multibreasted, she looks half animal, half human. Associating the piece with her mother, Bourgeois stated that "the appellation 'fox' means I considered my mother to be a very intelligent, patient and enduring if not calculating person," so "I did not measure up" and exasperation "pushed me to violence": "I cut her head off. I slit her throat." But the impact of the fox-woman also exceeds its personal significance, evoking the prophetic role played by the Sphinx in the Oedipus myth. Still, both *Spiral Woman* and *She-Fox* have been wounded by the woman artist who has exacted that revenge in works that set out to disturb or repel the viewer by exhibiting vindictive aggression generally prohibited women.

A later version of *Femme Couteau* (2002, 9 × 27½ × 6 in.) renders the knife woman not in stone but in overlapping pieces of canvas. The

decapitated female nude lies supine, with one lower leg amputated at the knee. The blade of a jackknife is stuck in her chest. Its other blade hovers over her swelling belly. With no possibility of defending herself, the figure emblematizes vulnerability. Whether violated or violent, both knife women remain enmeshed in sadomasochistic sexual politics. Yet many of Bourgeois's other stuffed cloth-figures prove that her furious preoccupation with the phallus was in the process of dissipating. She would still set out to shock, but sorrow nudged aside rage in the massive number of mutilated fabric-figures she produced in old age.

THE MOVE FROM rigid stone to pliable or floppy forms often in flimsy or threadbare fabric would be one of several shifts away from the artistry Bourgeois associated with her father to the creativity she associated with her mother, who was the master craftsperson in the family's tapestry business. A multitude of Bourgeois's fabric-dolls address male as well as female suffering, as she used the transitional objects of children to focus less on gendered violence and more on the helplessness of all embodied creatures.

Disfigurements, wounds, amputations, sutures, scars, prosthetic limbs, crutches, and braces abound. On the one hand, the "skins" of terry cloth, cotton, canvas, or wool on Bourgeois's male and female fabric-forms can look worn, fuzzy, inviting. On the other, the figures' postures, settings, and evident agony set them off as untouchables. The resulting *poupées de pain* testify less to the aggression of the artist and more to her identification with the sufferers. The squishy-looking and sometimes life-sized figures speak about pathos, not retaliation.

Probably the construction of the mutilated fabric-dolls was informed by the experience of visiting her wounded father in a war hospital and seeing many amputated veterans, as well as by long stints of nursing her dying mother during a terminal lung disease. Possibly these "dolls of loss and mortality," as the novelist Siri Hustvedt calls

them, derive from the artist's own inner torment. The young man who facilitated her artistry, Jerry Gorovoy, believed that hers "was a body under siege, a body that's going to break apart. She had to stop the tension or she was going to kill someone, or kill herself."

The fabric *poupées de pain* exemplify the wordlessness of besieged bodies. A professional seamstress, Mercedes Katz, helped stitch together many of the cloth creatures, according to Bourgeois's instructions. The sheer number of raggedy and patched fabric-dolls is stunning, as is the evident suffering they have endured, agony shaped by the artist's traumas but clearly meant to signify a host of ills that flesh is heir to.

Bourgeois's soft, stuffed fabric-figures communicate the incommunicability of pain. Headless gray or black pliable male forms are hung up on hooks or suspended in midair, pulled down by the force of gravity like meat in butcher shops (both 1996). Others are horizontal to signal defenselessness. A headless, armless, legless blue-and-pink torso with breasts lies on its back, prone like a pincushion (1996). Face down, a beige infant lies between the breasts of another headless and legless female torso (2002). On each breast and on the belly of the torso, a bull's-eye target has been stitched in red. Body parts in vitrines look like trophies of some ghastly medical experiment or torture procedure. A leg in a metal and plastic cast is displayed inside a wood-framed glass cabinet (1997), conjuring anatomical specimens.

On the steel shelving of a utility table, a misshapen pink baby-form lies below a larger pink girl-form, which lies below a still larger pink female-form, the three layered like cadavers in a morgue (*Three Horizontals*, 1998). "Together," the art historian Linda Nochlin points out, "they evoke the victims of some mass misogynist atrocity of our time." Also composed of pink patchworked fabric and pink thread, Bourgeois's male fabric-heads—her most disturbing fabric works—underscore loss by means of missing eyes or ears as well as gaping but empty mouths. A title affixed to a fabric-infant still attached to the umbilical cord of its fabric-mother, *Do Not Abandon Me* (1999), expresses either the mother's plea or the baby's or both.

Prominent stitching—rough, clumsy basting—produces sutures, especially when the pink "skin" has eroded, leaving visible the white batting beneath, looking like leprosy or infection from botched surgery. Many of the artist's creations look freakishly surreal. A headless and legless but clothed man and woman are displayed making love (*Couple*, 1996). A tan body-stocking figure features prominent breasts and testicles—or are they emerging fetal heads? (*Single III*, 1996). A blue fabric-woman's breasts perch on a large blue-stitched globe, a monstrous belly that replaces her torso and legs (*Endless Pursuit*, 2000).

The fabric-figures, even when executed on a small scale, diverge from the stuffed toys of children. Traditionally, stuffed cloth dolls were designed with proportions meant to stimulate affection in girls who would be socialized to nurture them. Such cuddly dolls consist of dead material made to look lifelike enough to stimulate caregiving, whereas Bourgeois's dolls are made to look lifelike in killed, damaged, or deformed states. Dolls have frequently brought out sadistic streaks in kids. With a fixed smile on her face, Raggedy Ann was marketed as able to survive "being thrown, boiled, wrung out, skinned and hanged" in the rough play to which she was sometimes subjected. Blind, deaf, dumb, immobile replicants, dolls have always figured as stock props in horror movies. Bourgeois's fabric-figures ask us to consider our own capacity for compassion and cruelty.

When the *poupées de pain* are put on display, spectators are apt to think of them as silent but incriminating casualties of national disasters or individual catastrophes. "It takes a kind of fearlessness in your art-making to cut your parents up into little pieces and put them down the drain. It is in a world of fantasy," Bourgeois once explained. "But then you wake up, you are afraid of what you've done. But then comes the reparation and exorcism."

The artist's tender care is apparent in the sewing, clothing, arranging, naming, dating, storing, and displaying of the fabric-dolls. Most of them address body dysmorphia and a dread of violation that can afflict both sexes. Why did the aging Bourgeois keep

on creating malformed fabric-figures in her last decades? "Artists repeat themselves," she said in her ever-emphatic way, "because they have no access to a cure." Old age freed Bourgeois from familial and social duties. It gave her the opportunity to concentrate all her energies on transmitting the overpowering emotions that beset her from childhood on and that, she realized, persist in the recollections of many older people. She would use her final decades to examine the effect of formative experiences on obsessive but fragmented memories in old age.

WHILE BOURGEOIS WAS producing her fabric-dolls, she was also constructing the unpeopled rooms of inhospitable and outsized dollhouses. They enabled her to reassess traumas in the past, by exploring how it feels to be haunted by such painful events in much later life. Phenomenology, rather than psychoanalysis, preoccupied the artist in the 1990s, when she began producing architectural structures called Cells, chambers generally devoid of human figures but filled with jumbles of memorabilia. Whereas stone work entailed aggression, furnishing these rooms involved "assemblage[, which] is a nurturing thing" and "not an attack," she said: "it is much less tiring to be loving than to be fighting."

As her work became less vindictive, Bourgeois was convinced that a community of younger people kept her creativity percolating: students and curators, filmmaker friends and art historians, as well as her adult sons. She had led a bohemian life in Chelsea and counted it a "piece of luck" that her senior years were populated by "people of a certain age, less than thirty-five or forty." A self-defined "loner," Bourgeois once confessed (in what she called "a very, very sad statement") that "I truly like only the people who help me." She meant the people who helped her with her work.

Bourgeois met the most important of these companions, Jerry Gorovoy, two years before the MoMA retrospective. At sixty-eight,

she was miffed at the placement of her art in a SoHo gallery and aired her ire with the twenty-six-year-old curator in charge. When she tripped and fell on the street, Gorovoy assisted her and intuited the source of her anger: she had been afraid to show her work. It was the beginning of an enduring collaboration. He began working several days a week for the artist and then served as her daily companion, chauffeur, sounding board, model, editor, and agent for thirty years.

Because Gorovoy could soothe her spirits, Bourgeois called him "the pacifier." He cleared the decks by dealing with logistical matters so she could concentrate on her art. Convinced that the process of working calmed her down, Gorovoy sensed that her efforts to translate emotions into visual forms would alter the course of art history. Given Bourgeois's mounting avoidance of public places, he would often be the one to travel to remote locations and oversee her installations. He also served as a mediator between Bourgeois and the artisans on whom she increasingly depended.

From 1980 until 1991, Gorovoy drove the artist to her Brooklyn studio, which had been a sewing factory, where she generally labored every day except Sundays. "Bloody Sundays" was the nickname for the salon that she conducted in the dilapidated Chelsea rowhouse until her death, so named because cosmopolitan and witty Bourgeois could be quite caustic in her response to the artwork that students brought her for critique. In a room described as "cramped," with "threadbare covers on the chairs, worn-out wooden floors, and shelves bellying under the weight of grey-beige documents," the setting of the Sunday salons felt to one young attendee like a "smackdown shack" because each session "ends in tears."

One visitor to the salon was struck by "those penetrating eyes that made you wish the floor would devour you to avoid her stealing all your secrets at once. With her sharp tongue and tiny body, she seemed old and young, strong and fragile, all at the same time." The artist "by turns needled, cajoled, seduced, and played hard-to-get with a cavalcade of mostly self-selected, self-involved interlocutors,"

Robert Storr (himself a participant) observed. Instead of a stove, the kitchen featured a two-burner gas hot plate, indicating that the petite Bourgeois—she was just a tad above five feet tall—did not spend a great deal of time on meal preparation. The town house was crammed with discarded furniture, hand-me-down clothing, and artworks.

"When I began building the Cells," Bourgeois said, "I wanted to constitute a real space which you enter and walk around in." Given museum regulations, one generally could not enter the exhibited Cells, but one could walk around them and peer inside. Rooms inside rooms inside museums, they are an expression of agoraphobia, a condition directly linked to aging since elderly people—especially those with compromised mobility—are often afflicted by a fear of entering public places that pose threats to their safety while also subjecting them to the gaze of the able-bodied. The Cells constitute Bourgeois's major statement on the aging process.

Referring to the cells of the body or brain or of a prison or cloister, the Cells engaged Bourgeois in displaying objects within doored, windowed, fenced, walled, or caged enclosures. Freeing her from the aggression that she associated with sculpting, these enclosures inspired her interior decorating. The Cells exhibit her bricolage in theatrical settings from life stories to which we have little or no access. To some extent, the staged tableaux within the Cells can be interpreted as flashbacks from the artist's childhood traumas.

However, the Cells also suggest that the older we get, the more inundated we become by often enigmatic images of the past. Filled with worn, damaged, partly concealed, and corroded things, the chambers of the Cells position the spectator as a spy who can glimpse only part of a scene that cannot be incorporated into a coherent narrative. In this way, the Cells imply that old age is a Gothic passage haunted by incomprehensible visions of earlier times and populated by the dearly departed. In late life, the Cells propose, receding montages from long ago function like the flashbacks of trauma: they cannot be understood or assimilated into the present.

Bourgeois reminds us how many symptoms some aged people share with victims of PTSD, or post-traumatic stress disorder: flashbacks but also hypervigilance, the inability to concentrate, and sleep disorders as well as a sense of a foreshortened future, of physical helplessness, of missing intimates who are gone or the prior person one had been. The vacant but incriminating sets in the Cells often make palpable the presence of an absent person.

A representation of solitary confinement, *Cell I* (1991, 83 × 96 × 108 in.) consists of decrepit, hinged-together doors without handles, one with dusty windows. Inside, most of the furniture—a chair frame, a narrow bed, an end table, a dilapidated lamp—is metal. The flat pillow at the head of the bed sports a crude bull's-eye target. In half-open drawers under the bed, the word "rage" has been stitched on a piece of fabric. The insubstantial mattress, pillow, and coverlet do not conceal the springs of the bed. Dingy and empty, the room looks decidedly uninviting. Was its inhabitant a displaced, undocumented person? Grubby and forlorn, it speaks of loneliness, poverty, transience.

The only remedies for the desolate mise-en-scène appear in the words stitched in red thread on the shabby coverlets made from French postal bags: "I need / my memories / they are / my documents" and (at the base of the bed) "Art / is the / guarantee / of / sanity" as well as "Pain is the / ransom / of formalism." The maxims intimate that constructing *Cell I* helped defend the artist against the threats of mental illness and institutionalization. Bourgeois's younger brother had been institutionalized as a schizophrenic after World War II and died in 1960 at forty-seven. She had to deal with that memory and with angry eruptions that continued to buffet her in old age. Especially during periods of stress, she might be driven to wreck a relationship or a work of art. "I always knew the rage would pass," Gorovoy explained after her death. "I don't think most people understood how psychologically fragile she was." A volatile workaholic, Bourgeois knew that art secured her sanity. Was pain, then, the price of her formalism?

From her eighties on, Bourgeois constructed sixty-two Cells. *Red Room (Parents)* and *Red Room (Child)*, both dated 1994, epitomize the mysteries generated by many of her uninhabited habitats for humanity. Dominated by a double bed, the larger parents' room is enclosed by aged wooden doors (97½ × 168 × 167 in.). On the base of the bed, a toy train and a piece of track as well as a battered black (xylophone) case appear. Between the two red pillows, a white, smaller pillow has been embroidered with the words "Je t'aime." The entire setting can be only partly glimpsed, even by means of the large oval mirror that stands in one corner.

With its red bedcover, red twin pillows, and white "I love you" child's pillow, *Red Room (Parents)* speaks of undivulged secrets related to the primal scene. What is inside the battered black case? A train in a tunnel has often been used as an image of intercourse, but it seems sinister that the counterpane is rubber and the color of blood. The mirror informs us less about the Lacanian mirror stage than about ourselves as museum habitués, viewing our own voyeurism as we peek into Bourgeois's past or into our own parents' always unknowable sexual congress. The carnal knowledge of our origins that we seek cannot be found and the quest for it makes us feel queasy.

It is still harder to peer through the mesh enclosing *Red Room (Child)*, which appears cluttered in comparison to the parents' chamber (83 × 139 × 108 in.). On pedestals and racks, spindles and spools of mostly red thread are chaotically displayed, some with threads hanging down or connected to each other. On shelves, red sculptures of clasped hands appear along with a closed, red metal box mounted on the wall. A closed suitcase rests on the floor. The words "Moi" and "Toi" barely legible on a pair of mittens, a closed canister: what does this jumble signify? A storehouse of attachments (threads, hands) and containers (generally closed) reveals the central project of the child: attaching to others ("Toi") and containing oneself ("Moi"), negotiating between you and me, self and Other.

Like *Cell I*, the two bloody chambers conjure missing persons, in both senses of that phrase—people whom the artist misses and peo-

ple who have gone missing: her parents, her childhood self. In 1990, Bourgeois had to deal with the death of her oldest son. Afterward, she kept the house she had bought for him on Staten Island empty, just as she had vacated her marital bedroom in the Chelsea house after the death of her husband and slept in another room. A deserted house or chamber "has been abandoned by life itself," she said. "The soul is gone," and "so it represents a mourning, whether mourning for the mother, the father, or just a friend."

Deserted spaces were consecrated to grief in many Cells. Inside the unoccupied interior of *Precious Liquids* (1992), within an open door of a wooden water tower, one can espy a metal contraption holding glass phials, carafes, and flasks, as well as a hung-up raincoat with a dress inside it and a bed that looks wet. In *Cell (Choisy)* (1990–93), a scale model of Bourgeois's family home appears inside a cage, over which a guillotine hangs down with a sharply angled blade. The miniaturized image of the past is about to be severed from the present. When human forms emerge in other Cells, they are lynched bodies. The polished bronze male figure in *Arch of Hysteria* (1992) hangs headless from a wire, its arched body forming a near-circle. *Cell XXVI* (2003) houses a fabric Spiral Woman, dangling before a mirror.

Bourgeois's mirrors often instruct viewers on the limits of their vision: how much is unseeable. The fact that we perceive only the remains of people inside many Cells turns the installations into elegiac testaments to lost lives. "I'm a prisoner of my memories," Bourgeois said about her cages and rooms. Through them, she suggests that the elderly inhabit only partly comprehensible scenes from a yesteryear that cannot be resurrected. In old age, according to Bourgeois, we are *ghosted* in both the traditional and the more recent meaning of that word. The older we get, the more we feel abandoned by the living while we are visited by lingering but absent and troubling presences evoked by the remnants left by them.

According to the Cells, aged people are housebound not only literally (within physical rooms) but also imaginatively (within recalled rooms). Old age, the Cells tell us, is a time of grieving. After our

beloveds are gone—Bourgeois had lost her mother, father, brother, husband, and one of her sons—we have only furniture, clothing, possessions, mementos whose meaning has begun to evaporate. In this sense, the Cells are cryptic reliquaries—of the imperfectly recalled layers of the past that accrue in the memories of the elderly. They hint that the rooms in which we dwell dwindle in reality compared to the rooms that dwell within us.

AS HER EIGHTIES advanced, Bourgeois constructed more interactive artworks. Her absorption with cages and with bull's-eye targets helps explain why she was drawn to spiders with their cage of legs and their concentric webs. In 1994, the year after she was chosen to represent the United States at the Venice Biennale, her first supersized Spider sculpture appeared at the Brooklyn Museum. Like her earlier work, the mammoth Spiders draw on but transcend their autobiographical source.

The spider emerged as a symbol of Bourgeois's mother in the 1995 illustrated book *Ode à la Mère* and then reappeared in a 1997 Cell called *Spider*. Bourgeois named her Spiders *Maman* to indicate that like her mother, spiders were clever, industrious, and patient repairers of webs. Bourgeois, who had used the word "Maman" as a code for menstrual cycles in her diary, accentuated her Spiders' gender by having them carry a wire-mesh sac of (marble) eggs. Though some large real spiders can be measured in inches, the largest of Bourgeois's Spiders—at the Tate Modern (2000)—looms thirty feet high. Its scale makes it seem both monstrous and grand, just as the delicacy of its tapered, articulated legs coexists with the cage made by all eight of them. Displayed throughout the world, Bourgeois's towering Spiders cast shadows that could be both thrilling and chilling.

For Bourgeois, the "neat and useful" spider serves "as a guardian" or "a defense against evil." Yet there is something furtive about spiders—"A spider sewed at night," Emily Dickinson wrote—which

are associated with dust, decay, and entropy. Bourgeois's mother had used her to keep track of her father's affairs. Spiders entrap insects in their webs, as they themselves seem attracted to the cramped corners and dirty crevasses in which they spin their sticky snares. For anyone dealing with arachnophobia, they prompt the sort of reaction that frightens Miss Muffet away, though the mega-magnification of a tiny insect can also seem funny. The enormous popularity of Bourgeois's "Spider Women" hinges on precisely this amalgamation of a frightful and filthy predator, an assiduous spinner of webs, a defense against noxious bugs, and a seismic joke.

One story about the origins of the spider strengthens the impression that Bourgeois's Spiders constitute a portrait of the woman artist. After Arachne challenged Athena to a weaving contest, Ovid records, Arachne created a tapestry depicting Jove's many seductions of women and the predatory acts of other gods as well. The goddess became outraged, presumably not at her rival's choice of content but by her flawless artistry, and beat her with a shuttle. In shame, Arachne fixed a noose around her throat; however, Athena saved her life with a stipulation imposed by a metamorphosis: "Though you will hang, / you must indeed live on, you wicked child." Given all the artist's hung and dismembered creatures, it seems telling that the peerless artist Arachne lost her nose, ears, and arms, as her head shrank and she morphed into a spider hanging by a thread.

In another grislier tale told by Ovid, a mythic weaver applies herself to crafty tapestry after great pain. Philomel weaves a garment to reveal that her brother-in-law raped her and then cut off her tongue. Philomel's sister takes revenge by serving her killed and cooked son to his father, who "begins to feed and shortly stuffs his gut / with flesh and blood that he himself begot." Bourgeois had reinvented this culinary revenge fantasy in *The Destruction of the Father*, just as she fabricated cloth-heads with gaping but tongueless mouths.

Does the monstrous Spider represent an eerie portrait of the artist as an old lady? Spiders are physically frail and small in size, as Bourgeois was. They can inflict venomous bites, as she could. When

constructed in steel, bronze, and marble, they seem indestructible. A spider's sticky but silvery webs ensnare those caught by its geometric threads. The eight legs of the gigantic Spiders form a circular cage like those constructed in many of Bourgeois's Cells, but in her *Spider* Cell, a spider perches *over* the caged box. An uncontainable container (of eggs), Bourgeois's Spiders constitute a refutation of Freud's definition of femininity.

Freud described weaving as the only invention women added to Western civilization. He associated it with shame at the lack of a penis and the resulting need to conceal that lack. Weaving makes "threads adhere to one another," he explained, whereas nature's forms of concealment, pubic hairs, "are only matted." With their sac of eggs and multitude of legs, however, there is nothing lacking about Louise Bourgeois's Spiders. Nor are they hanging by a string. Bourgeois's Spiders—by virtue of their towering size—have achieved a sublime recompense. Like the black widow spider, who got her name because of a decided proclivity for eating her mate in an act of sexual cannibalism, the artist's Spiders inspire respect—not shame.

A cagey widow, the fierce but fragile Bourgeois used her mother as a camouflage for a self-portrait that reflects both her sense of empowerment and her sense of diminishment. The magnification of the arachnid registers her burgeoning international reputation, while its tiny dimensions in nature acknowledge her declining physical strength. Her work would continue to loom large in the Western imagination as multiple prizes arrived, but her body was dwindling as she suffered from arthritis, insomnia, and hearing loss. Like Walt Whitman's noiseless, patient spider, Bourgeois's Spiders emblematize her creativity as she tirelessly launched filaments out of herself in a seemingly endless stream of drawings. To the question "What is a drawing?" she once answered, "It is a secretion, like a thread in a spider's web."

Ironically, Bourgeois, who had dedicated her work to materializing fear, was picked to fill the huge space in the Tate Modern Museum because "an artist without fear is what the Turbine

Hall needs." Along with a Spider, she exhibited another large-scale work—*I Do, I Undo, I Redo* (1999–2000)—that at first glance looks quite different from her previous creations. The three phrases of the title refer to its three thirty-foot-high towers: spiraling staircases lead to (fenced) platforms with large mirrors affixed at the top of the first column, *I Do,* and the third column, *I Redo.* The steel watchtowers or observation posts might look forbiddingly phallic, but the spiraling stairs with their sturdy rails and fenced platforms speak of the sort of security furnished by fire escapes.

Museumgoers could go up and down the stairs looking at themselves and each other in the mirrors at the top, where they could also view the two nearby towers. Unlike the Cells, *I Do, I Undo, I Redo* places visitors not in a past replete with enigmatic memories but in the changing realities of the here and now. Yet small doll-like and Cell-like elements persist, for in each tower, one can see a contained sculpture of a woman and baby. Within the bottom of the first tower, a pink patchwork mother-doll sits nursing an infant inside a glass bell jar that protects their intimacy. In the second tower, glimpsed through a window, a sculpted maternal figure spurts milk out of one breast onto the floor, while an out-of-reach child-figure holding on to one of her legs looks up at her. On one of the landings on the third, a sculpted mother-figure sits connected by an umbilical cord to a baby floating above her, both enclosed within a protective glass bell jar.

Bourgeois originally called the three towers "Toi et Moi" and considered them "a family affair." The nursing couple—united in *I Do,* separated in *I Undo,* attached in *I Redo*—establishes the bond between you and me, self and Other that, when broken (as it is in the sculpture of spilled milk), results in the fearful abandonment, sense of lack, rejection, rage, and aggression emblematized by the middle tower. The baby unable to breastfeed in *I Undo* could be male or female; its ordeal predates gender.

The earliest trauma for the child, Bourgeois suggests here, occurs before any sighting of the penis: it has to do with breast milk imbibed by infants from their first Other, the mother. Breast milk bespeaks

female amplitude, not lack, for the more the baby sucks, the more milk is produced. Yet the spilled milk and the baby unable to reach the breast in *I Undo* denote a shattering rupture from the mother. Like the psychotherapist Melanie Klein, whose works she valued, Bourgeois suggests that weaning can initiate a crisis. "The object which is being mourned is the mother's breast and all that the breast and the milk have come to stand for in the infant's mind: namely, love, goodness and security." As in many of her Cells, Bourgeois draws attention to barely recalled but grievous losses. As in her *poupées de pain*, she asks us to consider wounded abandonment and reparation. In this manner, Bourgeois makes a summary statement about all her doing, undoing, and redoing in old age.

There is no ceiling on or over the platforms on the towers of *I Do, I Undo, I Redo*, and many of Bourgeois's Spiders appear outdoors: both invite human interaction and both reflect the release from confinement that one can sense in Bourgeois's late, great works. Her final days would be devoted to the nurturance provided not only by memories of her mother but also by her own unflagging labors, undertaken during the long hours when insomnia made it impossible to sleep in the two rooms of her town house to which she became confined. Old age, if it did not mellow Bourgeois, gave her the opportunity to move from anger to grief and then to awesome proof of her creative longevity. A spider sews at night.

THE NUMBER OF works Bourgeois created in her last decade staggers the mind. A cursory glance at the chronology Deborah Wye put together for the 2017 MoMA exhibition *Louise Bourgeois: An Unfolding Portrait* indicates how extraordinarily productive the artist was during the first decade of the twenty-first century, when she was in her nineties. Granted, she had many helpers, collaborators, and caregivers. Printmakers played critical roles, as did Jerry Gorovoy and Mercedes Katz. Still, with their assistance, Bourgeois engaged in

forms of creative work that seem particularly well suited to very old age: casting off or repurposing old possessions, undertaking small-scale projects with collaborative partners, and returning to earlier enterprises in simplified forms.

Although Louise Bourgeois hoarded all sorts of things, in old age she began to recycle dresses, slips, nightgowns, negligees, blouses, and nylons that she or her mother had worn. Arranged on hangers or upside-down brooms or bones in her Cells, such hand-me-downs may have been displayed as a way of acknowledging that the costumes of femininity could now be discarded. But hand-me-down fabrics, especially the more colorful ones, could also be cut up to make other objects: Bourgeois drew or embroidered on them and sometimes made them into fabric books. As the onetime owner of a bookshop, she had long been invested in books.

Late fabric books like *Ode à l'Oubli* (*Ode to Memory*, 2002) and *Ode à la Bièvre* (*Ode to the River Bièvre*, 2007) are slightly larger than notebook size and made of old linen napkins. In the first, Bourgeois stitched geometrically cut fabrics (grids, circles, rectangles, spirals) on the right side; mimicking stitching appears on the left side. A few of the recto pages look like miniature bed quilts. One page displays a resonant saying—"I had a flashback / of something / that never existed"—that expresses Bourgeois's wry understanding that the traumatic past she had spent her career addressing had inevitably become a fabrication of her own making. *Ode à la Bièvre* employs digital printing on a prefatory page to describe the river near the tapestry workshop of Bourgeois's family. Its other pages feature fabric collages, often horizontal and striped, some of which also look like miniature bed quilts.

Hours of Bourgeois's last days and nights were spent drawing, painting, and printmaking, activities that brought all sorts of specialists into the Chelsea brownstone, which contained two printing presses on a lower level. Siri Hustvedt believes that Bourgeois's work "got funnier as she got older." In the illustrations of *The Laws of Nature* (2003), an acrobatic, long-haired, high-heeled (and otherwise

naked) woman engages in all sorts of ingenious copulation positions with a naked man who has a skinny penis.

Often, in smaller pieces, Bourgeois returned to the titles, themes, and images of her earlier work. By means of drypoint engraving and aquatint, for example, she produced drawings of *Spiral Woman* (2001), some in red, some in black and white, the figures now given the face that was obliterated in the earlier sculptures. Quite a few childlike works feature the figure of the mother, hinting that in older old age Bourgeois felt herself to be circling back to her earliest memories, getting in touch with pre-gendered states of consciousness.

Eight years after a series of prints called *Do Not Abandon Me* (1999–2000) depicted a bell jar with a floating baby attached by the umbilical cord to a seated mother, Bourgeois collaborated with the artist Tracey Emin on another *Do Not Abandon Me* series (2008–10). In a 2007 gouache, *Self-Portrait*, Bourgeois presents herself as an open-mouthed baby hanging on to a huge helium balloon of a breast. When the curator Ulf Küster visited Bourgeois in 2008, the artist was surrounded by red watercolors: "Women with large breasts, pregnant, the embryos visible in their stomachs."

Two years before she died, President Nicolas Sarkozy arrived at the Chelsea house to give Bourgeois the French Legion of Honor medal. She made him sit on a low classroom chair so he would have to look up to her. "Even in the hospital," Deborah Wye testified, "Bourgeois asked for paper and pencils." Before the heart attack that hospitalized her, Bourgeois had bought the house next door. With the aid of the Easton Foundation, Jerry Gorovoy turned both houses into public places dedicated to her art.

From 2008 until 2010, Bourgeois's friend Alex Van Gelder collaborated with her in producing a series of photographs, some of which are reprinted in *Mumbling Beauty: Louise Bourgeois* (2015). In the photographer's words, "She became a consummate performer in front of the camera," and what the nonagenarian mugged was a succession of moods. In the frontispiece, she appears mirthfully vindictive: wearing an executioner's mask and wielding a large, sharp-edged knife.

In other photos, she is unashamed of the many markings produced by nine decades of wear and tear on the body. The loss of teeth: in a succession of images, her mouth opens in a howl or scream worthy of Edvard Munch. Cognitive or hearing loss: in one still, her face looks like a waxwork.

Whether clutching a red watercolor of a massive breast or a paintbrush or a furry coat, her hands look gnarled, veined, and misshaped by arthritis, yet intensely alive. One poignant plate consists of Bourgeois's feet, shod in unlaced black shoes and dangling from a wheelchair several inches above the ground. The final, decidedly blurry photographs show her stooped, exiting the session with the help of a walker. Aided by Van Gelder, Bourgeois exhibited the deficits of old age with the same unflinching regard she had brought to the losses in her ever more receding past.

In 2008, Bourgeois presented her final Cell, which was titled *The Last Climb* (151½ × 157½ × 118 in.). Within a steel-mesh cage, blue glass orbs of various sizes hang suspended in midair. A circular staircase spirals up within the Cell, which contains an opening in its ceiling. Jerry Gorovoy views it as "an ascendance": "There's this escape." In any case, it manifests Louise Bourgeois's fearlessness in confronting fear, her flinty persistence in shaping physical forms that continue to illuminate ongoing disasters. Ferocious tenacity animated Bourgeois, even as the uncanny artifacts she created endure to instruct us on the need to counter the broken with the repaired, the breached with the latched, and pain with the milk of human kindness. Old age was, indisputably, the most productive time of her life.

Section III

SAGES

The supposition that aging people keep on doing what they had always done at lower decibels is shattered by the dynamic late lives of the jazz pianist-composer Mary Lou Williams, the poet Gwendolyn Brooks, and the dancer-choreographer Katherine Dunham. Showcasing quite different talents, all three underwent momentous transformation at midlife that invigorated their final decades.

Williams stopped playing and composing music until a religious conversion motivated her to forge a new relationship to jazz. Brooks described her political militancy as a secular conversion that compelled her to stop writing for White publishers and focus her energies on strengthening Black communities. Dunham, contending with the age barriers encountered by dance performers, stopped touring with her company and dedicated herself to writing projects that morphed her into an advocate for the arts and humanities. The subsequent careers of all three suggest that faith plays an empowering role in repurposing creativity, whether it be faith in a religion, in a political agenda, or in a particular art form.

Though cancer struck down Williams at seventy-one, she resembles Brooks to the extent that both continued to practice their disciplines in their last years, whereas Dunham trained her energies on establishing a number of civic institutions. But all three associated

their chosen art form with the process of "unselfing." They thereby illuminate a social dimension implicit in Iris Murdoch's concept: their art forms could lift them out of the confines of the self into an expansive sense of collectivity.

At first glance, it may look suspicious to group Black old ladies into one category. Of course, there have been senior women of color who presented themselves as lovers (like the dancer Josephine Baker) and as mavericks (like the sculptor Augusta Savage). Similarly, there have been elderly White sages (like the poets H.D., Denise Levertov, and Adrienne Rich). However, consider the historical prominence of Black sages from Sojourner Truth and Ida B. Wells to Margaret Walker, Audre Lorde, Lucille Clifton, Maya Angelou, and Toni Morrison—some of whom attained their stature before old age.

This lineage testifies to the synergy galvanized by the interaction of creative people with outrageous experiences of racial injustice. The historian Nell Painter, who recounted her own reinvention in *Old in Art School: A Memoir of Starting Over* (2019), views Black America in general as "the conscience of the United States of America," even though all the profound differences among individuals of color prove that "there is no such thing as Black America."

As is true of many African American sages, the civil rights movement influenced—and was in turn influenced by—the quite distinctive faiths of Williams, Brooks, and Dunham. A shared urgency about social justice connected all three to a wide network of friends and collaborators whose company sustained them. Energized by a sense of belonging to a community and a sense of purpose related to that community's needs, each concentrated on education: leading workshops, teaching master classes, and establishing courses, prizes, or schools.

In the following chapters, the late-life trajectories of my subjects confirm the liberating pattern in aging to which Agatha Christie testified:

I have enjoyed greatly the second blooming that comes when you finish the life of the emotions and of personal relations; and suddenly find—at the age of fifty, say—that a whole new life has opened before you, filled with things you can think about, study, or read about.... It is as if a fresh sap of ideas and thoughts was rising in you.

CHAPTER 7

Mary Lou Williams

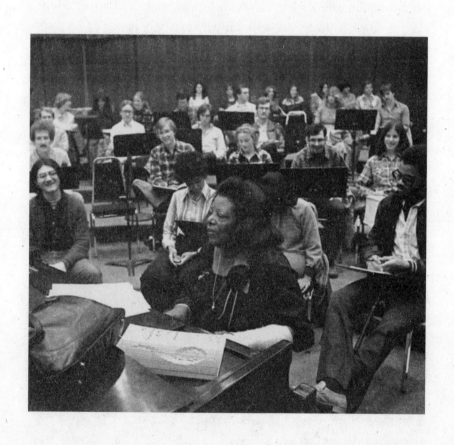

One of three women in Art Kane's 1958 photograph of fifty-seven jazz musicians, *A Great Day in Harlem*, Mary Lou Williams was dubbed the Lady Who Swings the Band. She played spirituals, ragtime, boogie-woogie, the blues, stride, swing, and bebop, often with a backup combo and sometimes with Duke Ellington, Charlie Parker, Dizzy Gillespie, and Thelonious Monk. Having worked to support her family by means of her dazzling piano performances from the age of six onward, Williams was much older than her forty-seven years when she determined to stop making music and converted to Catholicism.

The story of how the conversion enabled Mary Lou Williams to stage a stunning comeback illuminates the transformative role that religious faith can play in the creative process. In the second half of her life, the pianist would put a radically new spin on the term *soul music*—by infusing jazz with spirituality in ambitious compositions, by helping to elevate jazz from a commercial entertainment into an art form, and by teaching as well as embodying its history. But neither Williams's sacred creations nor her secular performances can be fully appreciated without some understanding of the toll taken by her earlier rise to fame.

THE PREJUDICE AT work in Williams's short childhood and long professional career clarifies her disenchantment with music making in midlife. Born Mary Elfrieda Scruggs in Atlanta, she was a toddler when she sat on her mother's knee before a pump organ and discovered that she could play anything she heard. That extraordinary gift, along with a capacity to see visions (which her mother associated with the membrane veiling the baby's eyes at birth), set her apart after the family moved to Pittsburgh. As a child prodigy,

she shielded herself with music whenever haunted by hallucinations or taunted by lighter-skinned children. Soon she was offering concerts to White kids in exchange for their not throwing bricks at her house. Known as "the little piano girl," she began hiring herself out for performances.

While Mary's mother labored as a domestic worker and raised a succession of babies, her stepfather smuggled her into gambling joints where she received tips for playing the songs she heard at home or in church. Soon the preteen was booked by bands touring Pennsylvania and then the Midwest. "The men of her family in particular took great care to help her grow musically," the biographer Tammy L. Kernodle explains, "and this may well account for her later ability to infiltrate the ranks of the male jazz fraternity, unlike most women at the time." Yet in later years, Mary Lou Williams confessed, "I had to leave home as a child to get away from fear, alcoholism, fights."

Touring took over her life in the '20s, when the teenager joined a succession of vaudeville shows for dangerous but lucrative stints on the road. Soon she teamed up with the saxophonist John Williams, who insisted that a female pianist playing "heavy like a man" would attract audiences. Traveling with John, Mary saw Fats Waller electrify crowds at a nightclub. When he heard her replay what she had heard him play, Williams later explained, "He was knocked out, picking me up and throwing me in the air and roaring like a crazy man." She also met the dancer Bill "Bojangles" Robinson: "I used to hate him because he wouldn't even talk to black women," she recalled. "He used to say about me: 'I don't like that type of woman, but she sure can play.'"

During her marriage to John Williams, Mary Williams performed with her husband's group, the Syncopators, in engagements that subjected her to violence, thefts, separate but unequal lodgings (or no lodgings at all), and unpaid gigs. After he joined a band eventually called the Twelve Clouds of Joy, under the leadership of Andy Kirk, the couple moved to Kansas City, Missouri, where she

served as the band's chauffeur and manicurist, though she jammed with touring musicians at after-hour speakeasies and learned from Kirk how to transcribe her compositions on paper. At one recording session, the band's pianist was unavailable so Andy Kirk was forced to ask Mary Lou Williams to step in. A sexual assault by a train conductor failed to prevent her arrival in Chicago, where—despite the trauma—she managed to record two original pieces, "Drag 'Em" and "Nightlife" (1930).

The "record man" Jack Kapp "laid the 'Lou' on me," Williams explained, to make her name less common. Throughout the 1930s, she would remain with the Twelve Clouds of Joy, quickly becoming the swinging big band's star. Although she continued recording original hits, a decade of one-nighters was taxing. She started to sell arrangements to Benny Goodman, Louis Armstrong, and Tommy Dorsey, but her husband left her and the band, attributing the marital breakup to her infatuation with the saxophonist Ben Webster and marijuana.

Also leaving Andy Kirk's band, Mary Lou Williams ended up replaying in quick-time her history with John Williams. In 1942, she married the trumpeter Harold "Shorty" Baker and for six months traveled with him as he performed in Duke Ellington's band. She produced successful pieces—"Trumpets No End" (1944) and "In the Land of Oo-Bla-Dee" (1949)—but the marriage broke down. Like previous partners, her second husband could be physically abusive. She moved by herself into an apartment on Hamilton Terrace, in Harlem's Sugar Hill neighborhood. Later she said, "I didn't marry men. I married horns. After about two weeks of marriage, I was ready to get up and write some music. I was in love with Ben Webster longer than anybody, and that was about a month."

Despite a shy or reticent disposition, Mary Lou Williams began to headline with backup musicians in popular New York clubs during the '40s. *Time* magazine enthused that she was "no kitten on the keys," nor was she "selling a pretty face or a low *décolletage*, or tricky swinging of Bach or Chopin. She was playing the blues, stomps and

boogie-woogie in the native Afro-American way—an art in which, at 33, she is already a veteran." The veiled allusion to her besting the pianist Hazel Scott, a glamorous entertainer who was also making a name for herself, failed to wreck their friendship.

In Manhattan, Williams was at the top of her game—first, through a series of recording sessions with Moe Asch, the founder of the independent Asch Records. Second, at integrated, left-wing Café Society downtown and later at Café Society uptown, she drew admiring crowds and started to compose the twelve-part composition *The Zodiac Suite* (1945), which she would air on her weekly radio program for WNEW, *The Mary Lou Williams Piano Workshop*, and premiere at Town Hall. She scored part of the piece and then performed it with the New York Philharmonic at Carnegie Hall in 1946, a historic merging of jazz with a symphony orchestra.

Finally, in her Hamilton Terrace apartment, the self-defined "bachelor girl" established an after-hours salon for the emerging generation of bebop artists. Both *Zodiac Suite* and the salon illustrate how well-connected Mary Lou Williams had become. "Scorpio," for instance, was dedicated to the comic actress Imogene Coca, the singer Ethel Waters, the double bassist Al Lucas, and the dancer Katherine Dunham, who adapted the piece for a ballet. At the piano in Williams's apartment, after-hours sessions with Thelonious Monk, Charlie Parker, Dizzy Gillespie, and Art Tatum featured the dissonant bebop compositions that Williams called "zombie music." She would get off work at 4 a.m., stop at Birdland to pick up buddies, and cook dishes from whatever she found in the refrigerator for feasts at 6 a.m.

However, Mary Lou Williams was beginning to resent "the rift between the demands of entertainment and her need to grow as a musician," as the biographer Linda Dahl puts it. Worse, she suffered a series of injuries that started to unravel her. A secret (illegal) abortion became a source of guilt, according to Dahl. With many of New York's nightclubs closing during the war, she had to take to the road, but on her return she found her apartment ransacked, the

gowns and jewelry she needed for performances filched. Growing poverty in Williams's neighborhood reflected her own money problems, as debts mounted. Musicians' strikes in the 1940s (which placed a temporary ban on recording), followed by a succession of broken record contracts and unreleased or unpromoted records, added to her financial woes, as did low-paying or appropriated arrangements, unreliable agents, and royalties unpaid because she had failed to file for copyright protection.

Consider the pernicious forces at work behind a personal trajectory that the discreet performer rarely decried in public: the racism and sexism she experienced on the road and in the music industry. When a discouraged Mary Lou Williams stepped on board the *Queen Elizabeth* in 1952 for a two-week stint in England, she was supposed to pay her way by performing, but she was too seasick to play most nights. She had no idea that she would remain in Europe for two years, that she would endure a dark night of the soul and emerge from it to become a pioneer in the sprouting of sacred jazz and jazz education.

MARY LOU WILLIAMS sailed for England to break the ban against American musicians performing there. The title of her composition "Tisherome" (1949), the scrambled letters for "more shit," captures the sorts of setbacks she confronted first in London and then in Paris, as does another great title, "A Fungus Amungus" (1964). Unforthcoming royalties, unsatisfying ensembles, dunning letters from the Internal Revenue Service, and mercenary music agents stymied her; and she did not have a return ticket home. Though she received more recognition there than in the States, restrictive work laws, unobtainable permits, and second billing distressed her. So did the fog and food in England and the critical commentators who reviled her for abandoning her earlier sound. European audiences wanted her to crank out "old time rags," she gloomily believed.

"They're the worst—not even original like [the] ones J. P. Johnson composed."

Yet in 1954 she managed to publish installments of "Mary Lou Williams: My Life with the Kings of Jazz" in *Melody Maker*, a British magazine. Throughout this retrospective narrative, Williams—among the kings, but not one of them—emphasizes the supportive encouragement of the men who dominated the world of jazz. She recalls the early days when she played with her elbows in a "novelty" act until an older musician explained "how ridiculous the clowning was, and there and then I decided to settle down and play seriously." Her gender surprised people: "We'll have to put pants on her, or something," one employer suggested. Physical abuse of women was rampant: "That's how they trained you in those days (half those chorus girls had black eyes!)." At times, she made money by driving for an undertaker in dangerous neighborhoods: "Whoever got [to a reported killing] first took the body." Still, the articles express her delight, especially in the heady Kansas City musical hub.

Beneath her affirmative tone, Williams's recollections reveal her growing sense of exhaustion. Arriving just in time to play and departing right afterward, she recalls about touring, "I have gone to sleep with my fur coat on, near to freezing, and woken up in the car hours later wet from perspiration in the sub-tropics of Florida." On the road and in clubs, she disliked playing the same pieces over and over again and exactly as she had recorded them. She was justly resentful at not receiving adequate recompense or credit for her arrangements. Overworked and acutely aware of "the danger of artistic stagnation," she quit Café Society. "I decided to find out what people and conditions were like in the slums of Harlem."

What Williams discovered rattled her and may have contributed to her decision to leave the States. First, she was swindled and "lost so much money, which I regularly drew from my postal savings, that the authorities thought some goon was blackmailing me." She only hints at a gambling addiction that threatened to impoverish her. Second, she witnessed "a terrible but fascinating environment, among

people who roamed the streets lamping [hunting] for someone to devour." She wondered "why the shrewd brains never ventured Downtown where the real gold was." The *Melody Maker* account ends with her dismal intuition that New York was growing too dangerous, "a town where you don't dare take a vacation. You must be on the ball or move out to the country." She concludes on a note of surprise about her decision to leave a job at Bop City for England: "That was November of 1952, and I'm in Europe yet."

In Paris, Mary Lou Williams turned down work with Louis Armstrong to play in the *caves* of Saint-Germain-des-Prés, but debts from the furs, dresses, and shoes she bought for performances mounted, along with depression. Alone in her hotel room, "it seemed as though everything I had done up to then meant absolutely nothing. I was despondent," she later recalled, "because everything seemed so meaningless and useless. Even my beloved music, the piano I played, all seemed to have lost appeal.... I felt everything I had been doing was no good." With no one to turn to, she "grew bitter at life, at people, at things" and overwhelmed by the "badness" she could hear in her own music: "it was torture as I groped there in the dark trying to make contact with God." She stopped playing in the middle of a set at Le Boeuf sur le Toit (The Ox on the Roof), a gay bar that had seen better days, and left the stage.

Retreating to the family home of the drummer Gérard Pochonet in the French countryside, Williams rebuffed his marriage proposals and read the psalms until Hazel Scott, who had encouraged her to pray, helped arrange airfare home. The death of the pianist Garland Wilson, Williams's friend, had compounded her disillusionment with the music scene in Paris, as did the death of Charlie Parker after she returned to the States, where she was viewed as a has-been, a washout. The jazz scene was in the process of migrating out of New York City and being superseded by rock 'n' roll as well as by television. The sorts of visions she had experienced in childhood returned to terrify her as she withdrew into her apartment.

Grief, loneliness, and self-blame engulfed the forty-four-year-

old Mary Lou Williams: "I just stayed in the house for two years; I turned the radio on once, heard Art Tatum had died, and turned it off again." Art Tatum, who had taught her how to articulate her notes "without using pedals" and how to keep her "fingers flat on the keys to get that clean tone," was forty-seven when excessive drinking did him in; Charlie Parker was thirty-four when heroin took him out. Both had been beaten by the police. Billie Holiday had been jailed for possession of heroin and could no longer perform in cabarets. Bud Powell, whom Williams had coached, had been hospitalized in a psychiatric facility after being arrested for possession of heroin. Distressed at the destructiveness of American society and the self-destruction of her contemporaries, Mary Lou Williams hit rock bottom.

Convinced that she would never play again, she gave away her Dior gowns, cared for her troubled half sister Grace, along with Grace's troubled children, and contended with her hallucinations. Williams determined to renounce music that felt "dead" to her: she had lost "all feeling for jazz since I found that the flesh is really the devil and worldly things." Though she could barely make ends meet, she would relinquish a nightlife too full of sinful temptations. She recalled transcendent moments in Paris, when frightful visions passed and the "deep spell of despondency" lifted, when she saw "beautiful things, people—not ugly, but people who were living and acting as they should—as children of God."

In the only church in her neighborhood open at all hours, Our Lady of Lourdes, Williams prayed for family and friends. To the numerous services she attended, she brought Lucille Armstrong and Thelonious Monk (who tanked up beforehand and then tripped on the way in), but her most frequent companion was Lorraine Gillespie. Williams typed long prayer lists (the neediest cases marked in red) and mimeographed prayer instructions to hand out on street corners. Miles Davis started calling her "Reverend Williams." Knowing that some viewed her as a crazed "witch," she later admitted, "I became a kind of fanatic for a while. I'd live on apples and

water for nine days at a time. I stopped smoking. I shut myself up here like a monk."

With a succession of down-and-out musicians or relatives being fed and lodged or detoxing at Williams's apartment, it turned into a sort of halfway house. Joined by Lorraine Gillespie, she decided to take instruction with Father Anthony Woods, a Jesuit, and the two friends were baptized and confirmed in 1957. Father Woods alleviated her anxiety about evil thoughts and moderated her very lengthy prayer sessions.

Like Father John Crowley, a friend of the Gillespies, Father Woods supported Williams's return to the keyboard when Dizzy urged her to perform at the 1957 Newport Jazz Festival. But perhaps what really convinced her came from within. While meditating and praying, she had begun to hear "the greatest musical sounds." Regardless of the reason, even at Newport she was unhappy with her music, though later, during a stint at a nightclub, she began to believe that God was inspiring and guiding her piano playing: "To be creative, you've got to pray."

Father Woods helped Williams set up the Bel Canto Foundation to fund a rural retreat for addicted or burned-out musicians. It was this charitable venture that in 1958 returned her to Carnegie Hall, where she lined up many illustrious friends for a benefit concert that cost more than it made. The financial failure motivated Williams to open a thrift shop on East 29th Street. At parties hosted at the shop to drum up business, she played the piano and tried to sell donated dresses, shoes, books, furniture, and Duke Ellington's mink bow tie. After that shop failed, she opened another, between 142nd and 143rd Streets, though it too flopped.

HEALING OTHERS THROUGH music became Mary Lou Williams's passion and it fueled a breakthrough composition infused with her Catholicism. The only Black priest she knew, Brother Mario Hancock in the Graymoore community, had reiterated the belief of

Fathers Crowley and Woods that she should not abandon music but instead use it to help troubled souls. Father Woods put a plaque of Martin de Porres on her piano and suggested she compose a piece for the Peruvian's impending canonization. In the seventeenth century, Martin de Porres was rejected by his White Castilian father because he was dark-skinned like his emancipated Panamanian mother. A Dominican monk trained as a surgeon, he would become the patron saint of the sick and impoverished as well as a personification of interracial concord. At Williams's urging and with her assistance, Father Woods wrote a short poem that Williams put to music.

Prolonged, complex, and modulating harmonies characterize Mary Lou Williams's cantata for trio and choir in a minor key, "St. Martin de Porres" (1964). The six-and-a-half-minute tone poem opens with rich and sustained chords sung a cappella by a mixed choir of soprano, alto, tenor, and bass voices. In four, six, and more parts, the voices meditate slowly and softly in bop harmonies with chromatically altered ninths and thirteenths. The progressions of chords "are constructed in such a way that they 'slide' from one chord to another by way of parallel motion," the musicologist Gayle Murchison explains. "Thus, for example, several voices form a new harmony within the resulting tonal context" to create a "gliding effect."

At the start, the choral piece stands in sharp contrast to the fast-paced, improvisational piano playing that had made Mary Lou Williams's name. The religious studies scholar Michael Scott Alexander, who had access to papers in archives I could not visit, argues that "these bebop harmonies were in fact *perfect* to represent the feeling Mary Lou had while praying." Linking Saint Martin's "dusty broom," symbolizing the significance he placed on menial work, to a "shepherd staff," the words praise him for gentling "creatures tame and wild" and sheltering "each unsheltered child." Softly and slowly sung, his name becomes a mantra likening Saint Martin to Jesus:

> *This man of love*
> *Born of the flesh yet of God*

> *This humble man*
> *Healed the sick*
> *Raised the dead*
> *His hand is quick.*

The solemnity of the pace makes the reverent opening sound like a jazz version of Gregorian chant.

The second stanza extends the analogies between Jesus and Saint Martin, who feeds "beggars / And sinners / The starving homeless / And the stray." The chorus asks for the saint's intervention: "Oh, Black Christ of the *Andes* / Come feed and cure us now we pray." But there is a shift in the turbulent third section where the words come from the Psalms. In a call-and-response, the singers plead "Oh God help us" more urgently through a distressed fugue of anxiety: "Oh God help us / Spare thy people / Lest you be angered with me forever / Lest you be angered with me forever."

A piano solo interrupts the dissonant choral voices with a long glissando and then recasts their melody in Afro-Latin, syncopated rhythms that emphasize the saint's origins and lift the tone. When the chorus returns, as if converted by the piano, the voices scat in accompaniment until they return to a more joyous rendition of the first stanza and conclude with the liturgical intoning of Saint Martin's name, his sheltering every "child." On this word, they ascend upward chromatically, swelling in volume and reaching the highest notes in the piece.

November 3, 1962, when Williams's jazz hymn premiered at Father Woods's church (after the mass), was Martin de Porres's inaugural feast day: he became the first saint of color from the Americas. His significance to Williams reflects her growing commitment to the church and the civil rights movement. While the Second Vatican Council was opening the Catholic Church to Indigenous languages and musical forms and while the civil rights movement was mobilizing sit-ins, boycotts, voter registration drives, and freedom rides, Mary Lou Williams again staged "St. Martin de Porres," this time

at New York City's Philharmonic Hall, after which Dizzy Gillespie's quintet played. They were the first African Americans to appear at Lincoln Center.

Williams had accomplished the unthinkable: making jazz, considered the Devil's music (at worst) or pagan music (at best), at home in a holy place and hitching it to the holiest of purposes at a symbol of American high culture. While Duke Ellington embarked on his sacred music concerts, *Mary Lou Williams Presents Black Christ of the Andes* was issued as a record, set to dance by Bernice Johnson, and praised at the 1964 Pittsburgh Jazz Festival, which Mary Lou Williams organized. The tone poem, along with her appearances on television and the establishment of her independent record company, signaled the comeback of the pianist, who began playing nightly at one of the few jazz clubs still open on 52nd Street, the Hickory House. After her long retreat from public view, Williams was still so withdrawn that when she left the bandstand after each set, she hid behind the coats in the cloakroom.

Under the aegis of Saint Martin de Porres, Mary Lou Williams dedicated her music making to a healthier future for jazz. When she performed in secular settings, she would distribute a one-page handout, "Jazz for the Soul." It concluded with a statement emphasizing the restorative power of jazz: "YOUR ATTENTIVE PARTICIPATION, THRU LISTENING WITH YOUR EARS AND YOUR HEART, WILL ALLOW YOU TO ENJOY FULLY THIS EXCHANGE OF IDEAS, TO SENSE THE VARIOUS MOODS, AND TO REAP THE FULL THERAPEUTIC REWARDS THAT GOOD MUSIC ALWAYS BRINGS TO A TIRED, DISTURBED SOUL AND ALL 'WHO DIG THE SOUNDS.'"

AFTER THE WHITE Jesuit seminarian Peter O'Brien walked into the Hickory House one night in 1964, Mary Lou Williams would become less lonely, though she did not know that he would become

her manager by the end of the decade. He looked, she thought, like a "little boy." Actually, he was twenty-three years old and she was fifty-three when a *Time* magazine feature about her newfound spirituality caught his attention. In it, Williams declares, "I am praying with my fingers when I play.... I get that good 'soul sound,' and I try to touch people's spirits." A fan of the performing arts, Father O'Brien admired her musicianship; a convert, she admired his vocation. The way he tells it, however, the meeting sparked his own conversion.

In the liner notes for a reissued recording of *Black Christ of the Andes*, O'Brien recalls Williams's appearance in a blue chiffon gown, with her hands "lying flat as they moved on the keys": "She had a beautiful throat and neck, good collarbones, and a dark brown face rising up from a strong chin to high cheekbones." Then he states that the "emotional experience of the music and the woman herself was so strong that my life at once took on a permanent new direction": "There was no confusion or doubt in me, and although I could not possibly have known the full consequences of that night's depth of feeling, *I had found my purpose. I was finally home*" (emphasis mine). Soon, he decided that "my ministry should be Mary Lou and saving jazz." As extroverted as she was introverted and thirty years her junior, he would secure bookings and fees, establish copyrights, send out promotional materials, arrange interviews, travel and teach with her, and become a lifelong companion.

Mary Lou Williams knew that Peter O'Brien would support her determination to foster sacred jazz, efforts that dated back to the apex of her earlier career. Before the trip to Europe, Williams had composed her first piece for voices, "Elijah and the Juniper Tree" (1948). Written for piano and a mixed choir, the composition focuses on a biblical passage in which the exhausted prophet receives sustaining food and drink from visiting angels. Like "Saint Martin de Porres," "Elijah and the Juniper Tree" uses complicated choral harmonies.

But this earlier piece reflects a quest to conjoin jazz with religion that predated her conversion and underscores the vital influence of Black Protestantism in Williams's musical evolution, an influence

that did not end with the conversion. A background in Black Protestantism "gave her biblically inspired hymnody, Old Testament (Hebrew Scripture) storytelling, the Negro spirituals, the evolution of the gospel blues among Black Pentecostals and Baptists, and musically intoned chanted sermons," the scholar Randal Maurice Jelks observes: "If Mary Lou were to live as a faithful Catholic, she would have to Blacken the faith."

The same holds true for Catholicism's sacred music, which Williams set out to Blacken. With the traditions of Black Protestantism not replaced but combined with her new commitment to Catholicism, she moved beyond difficult-to-sing compositions to shorter, more rousing scores. Two choral compositions—"Anima Christi" and "Praise the Lord" (1964)—eschew the sonorous gravity of "Saint Martin de Porres," instead relying on swinging gospel rhythms.

Employing electric guitar and bass clarinet along with piano and bass, the rollicking opening of "Anima Christi" ("Soul of Christ") features a tenor voice asking for divine intervention: "Passion of Christ my comfort be / O good Jesus listen to me." The staid Latin title contrasts with the singer repeatedly belting "Lord, have mercy on me" and the backup female voices repeatedly echoing: "Help, help!" Yet precisely this juxtaposition of sacred words with a swinging waltz rhythm issues in a funky gospel sound that delivers the joyous intimation that surely such a passionate request will not go unanswered. Similarly, "Praise the Lord" features a tenor ("Everybody clap your hands, everybody clap your hands now") with a vamping piano, bass, guitar, drums, and tenor sax background. A celebration of the eternal life and reign of Christ, it rocks with an urgent catalogue of creation ("Praise Him, sun and moon, praise Him, you shining stars"), conveying the jubilant intoxication of Mary Lou Williams's faith.

In more somber songs—"I Have a Dream" (1968) and "Tell Them Not to Talk Too Long" (1968)—Williams condensed two of Martin Luther King Jr.'s most famous speeches. Along with a flute, an organ riffs between stanzas and produces a dissonant accompaniment to

the male chorus. Quite short, both songs affirm the ongoing relevance of King's message. Especially in the second, Williams honors King's insistence in life that his death not derail the ongoing work of obtaining social justice for people of color in America.

While teaching jazz in high schools or community centers and performing at clubs, though barely managing to pay the bills, Williams produced sacred jazz designed to promote peace during a period characterized by escalating racial violence at home and geopolitical violence abroad. The desire to create a mass had taken hold of her imagination—not simply a sacred piece of music performed in a concert hall, as Duke Ellington's works were; not sacred music played after the church service, as "St. Martin de Porres" had been; but a musical celebration of the liturgy.

At a Catholic high school in Pittsburgh, Mary Lou Williams taught the girls to scat like Ella Fitzgerald and croon like Billie Holiday, though she was hired to teach music theory: "when the nuns came into the room, I'd shift to theory." The process inspired her to write her first mass, which was performed at Pittsburgh's St. Paul's Cathedral. It and her second mass, *Mass for the Lenten Season* (1968), also composed for children, went unrecorded. Yet she remained undeterred. When Williams accepted an invitation from a club in Copenhagen, it was to finance a trip to Rome and obtain the Vatican's commission for a mass.

Despite the aches and pains and weight gain she attributed to aging—"at 58 the old bones are pretty tired," she admitted—Williams traveled to the Vatican to make her case. She did manage to get a papal meeting, but Pope Paul VI did not respond to her request. In letters to Peter O'Brien, she conveyed her disappointment about being barred from performing the Lenten mass as a mass (because it included bongos), but being elated when "a big-shot priest" asked her to write "another mass for the peace of the world." She immediately returned to New York to create what would eventually become *Mary Lou's Mass*.

THE HISTORY OF the musical mass is an august one, established by, among others, Bach, Mozart, Beethoven, Brahms, and Verdi. In the twentieth century, it was extended by such composers as Benjamin Britten (1959), Paul Hindemith (1963), and Leonard Bernstein (1971). Many of them did not expect their works to be performed as a church service. Given the historical restrictions placed on how the mass could be musically conducted, Williams's ambition seems astonishing.

Back in 1903, Pope Pius X had forbidden pianos, drums, and bands at the mass, as well as female voices in choirs—on the grounds that women cannot perform a liturgical office. Although the Second Vatican Council began changing some of these rules and the so-called jazz priest Father Norman O'Connor had established a high profile in the media, Mary Lou Williams's determination would strike many worshippers as presumptuous or downright blasphemous. When she eventually brought *Mary Lou's Mass* to a church in her beloved Kansas City, picketers protested with placards: "No Jazz!"

Peter O'Brien recalled "the happiest I ever saw Mary": "in her own house with Bob Banks," the pianist who was helping her compose her third mass. "She was happy as a clam—house dress, half her teeth out, walking back and forth from the kitchen to the piano." In 1970, the extensive composition was released on Mary Records and premiered at Columbia University's St. Paul's Chapel as *Mass for Peace*. What we can now hear on the CD *Mary Lou's Mass* evolved out of various performances with multiple compositional changes made with many musicians.

Within an overarching liturgical framework of penitence and praise, Williams puts on display a remarkable range of styles. Indeed, one *Newsweek* reviewer called the piece "an encyclopedia of black music," though in its gestures toward European forms, it could be

considered a more capacious encyclopedia of Western music in general. In contrast to Duke Ellington's sacred music, *Mary Lou's Mass* draws on a mixed register of gospel, jazz, soul, rhythm and blues, opera, symphony, Broadway, and rock sounds.

The version of "Praise the Lord" at the start of Williams's mass consists of a very fast-paced chorus of mixed vocalists praising the Lord with a repetitive phrase modulating upward in words adopted from Psalms 148 and 150. Next, "Old Time Spiritual" provides a sharp contrast: no voices, instead flute and piano create a bluesy sound, providing an interlude for contemplation before the liturgy begins. Gospel music predominates in "The Lord Says," as the male preacher-singer urges on the chorus-congregation (and vice versa) to rejoice in being released from captivity with rhythmic ebullience.

Sung by a contralto, the slow "Act of Contrition" establishes the penitential tone appropriate to the beginning of a sacred rite, as does "Kyrie Eleison" with its antiphonal "Lord Have Mercy / Christ Have Mercy / Lord Have Mercy" prayer. "Gloria" sustains a gospel rock sound, but the bluesy "Medi I" and "Medi II" (two "meditations") showcase the piano keyboard. Combining three earlier works, "In His Day / Peace I Leave with You / Alleluia" moves through a tenor and a baritone song before it issues in a quicker-paced choral summation: "Peace I leave with you; my peace I give to you. / Alleluia, Alleluia, Alleluia."

Bass and guitar set up a funk groove underneath the vocal of "Lazarus," which is based on a passage from Luke (16:19–31). In a jazz ballad recalling the recitatives of classical opera, a solo contralto tells the story of Lazarus rebuffed when he begged some crumbs from the rich man's table: the rich man was consigned to hell and Lazarus achieved eternal life. For a high point of *Mary Lou's Mass*, it seems fitting that Williams chose a Bible passage that spotlights not just the importance of charity—a failure of compassion dooms the rich man—but also a figure associated with the death and rebirth that she had herself experienced.

Marking the start of the Eucharist section of the mass, the two

rhythm and blues "Credos," one vocal and the other instrumental, are based not on the usual Nicene Creed but instead on the shorter, earlier Apostles' Creed. "Holy, Holy, Holy" transitions from a rubato baritone and piano with ostinato bass ("Turn aside from evil") into a bossa nova of "Hosannahs" sung with the chorus responding with falsetto repetitions. The "Our Father" that follows a quick-paced and rousing "Amen" features a solo contralto singing the prayer, after which a chorus intones the Beatitude "Blessed are the peacemakers, for they shall be called the sons of God." Mary Lou Williams's sophisticated and moving version of the Lord's Prayer replaces European tonalities with complex jazz harmonies.

Perhaps no piece in *Mary Lou's Mass* stands out more than "Lamb of God," an avant-garde choral work that uses the dissonant chords created by the mixed voices to express fear that mercy may not be forthcoming. Eerie cries and shrieks of distress punctuate discordant chants with no resolution. They capture the meaning of the liturgical act of breast striking that accompanies this prayer and that signifies penance for sinfulness. As dramatic as the works of Webern or Schoenberg that it evokes, "Lamb of God" articulates a desolation that is immediately juxtaposed to a waltz tune, "It Is Always Spring," with its brightly fluttering flute and astonishing yodeling.

Mary Lou's Mass concludes with a series of songs focusing on peace and justice issues. With a chorus that produces an upbeat show tune, "People in Trouble" considers those who worked together "to find a brother." "One" addresses the need to imagine a world beyond prejudice—men of all races dancing together—this time in an up-tempo swing. On the CD, "Praise the Lord (Come, Holy Spirit)" and "Jesus Is the Best" end the celebration, along with the two songs Williams based on Martin Luther King's words. One bass player who performed the mass with her remembers "the dynamic way in which the diminutive Williams, five feet, three inches tall, would lead the large ensemble. Her writing of the text and its message can only be perceived as a loving and caring exercise."

The choreographer Alvin Ailey gave *Mary Lou's Mass* its name

when he showcased his dance rendition of it in the American Dance Theater's 1971 season at New York City Center. Both Williams's mass and Ailey's choreographed version of it began appearing in auditoriums and churches outside New York. The founder of the *Catholic Worker*, Dorothy Day, did not think "there has been anything to compare with it in any of the so-called folk masses being sung in colleges and churches around the country." Dorothy Day, like Brother Mario Hancock, was an influential member of the progressive Catholic community that grounded Mary Lou Williams's later life.

While attending Peter O'Brien's ordination at Fordham University, the composer caught sight of Cardinal Cooke, the archbishop of New York. Since she had previously written to ask his permission to bring her mass to St. Patrick's Cathedral, she wanted O'Brien to urge on her request, but he demurred. "So Peter hid behind a tree," she explained, "and I went chasing across the campus shouting 'Cardinal Cooke! Cardinal Cooke!'" When the cardinal agreed, Williams felt the need to warn him—"It's kind of noisy and loud"—but he countered, "That's what we need."

Official permission was not quick in coming. To pay the bills, Williams began playing nightly at the Cookery, a Greenwich Village restaurant owned by the same entrepreneur who had run the Café Society clubs. She talked him into renting and then purchasing a piano for what turned into a steady six-year stint. In 1975, when *Mary Lou's Mass* was finally performed at St. Patrick's Cathedral, the sixty-five-year-old Williams achieved two goals that would be replicated when she took the mass out of town: she drew young people into the performance as well as the audience and she integrated predominantly White houses of worship.

MARY LOU WILLIAMS'S personal trajectory mirrors the course of jazz. Both she and jazz in general rose to heights of achievement

from the 1920s through the '30s and into the '40s. During the 1950s, when jazz became defined by individual players in small group settings—Miles Davis, Coltrane, Mingus—she suffered a calamitous falling away from music, but then a new faith altered her relationship to it. Her comeback occurred when jazz began serving less as a commercial form of entertainment (on bandstands for dancers) and more as an art form (on stages in clubs and concert halls). Williams used her performance skills to advance and map that transformation. Her revival was driven by her sense of herself as a vessel of jazz history.

The offices of Father O'Brien helped facilitate Williams's comeback, though the relationship was not always easy. "To her, love meant exclusivity," he explained. "I was supposed to be absolutely devoted. Love meant I wouldn't go away, I wouldn't have anybody else in my life. I wouldn't be apart. Whatever she imagined love would be. But no sex." They had both taken vows of celibacy: he at his ordination, she at her conversion. In her case, it freed her from the sorts of relationships she had earlier had with abusive partners. The artist and her manager weathered their sometimes stormy tussles (often over money) as, somewhat counterintuitively, he prodded her to perform in secular venues and she urged him to promote her sacred music.

Williams's return to the stage hinged on her decision to present herself as the living repository of jazz and also its historian. A graphic summation, Williams's 1977 *History of Jazz* poster pictures jazz as a living tree. Executed with her friend David Stone Martin, a White graphic artist, it exemplifies her sense that jazz—in all of its various stages—must be honored as an organic growth. One type of jazz does not and should not supplant or replace another. They are all part of a single living and growing organism.

At the base of the jazz tree, the roots are provided by SUFFERING—specifically the suffering of slavery, which makes jazz, in Williams's mind, not African but profoundly American. The trunk of the jazz tree rises from its roots through an ascending order

of genres: SPIRITUALS, RAGTIME, KC SWING, BOP. Williams places spirituals closest to the roots because spirituals are "our only original American art form." She had heard about the suffering of slavery from her great-grandparents and judged its outgrowth, spirituals, to be America's sole indigenous creation.

All around the trunk of the tree and also springing from its roots, the BLUES encircle the evolution of all the other genres, like an outer bark. The blues, then, encompass or inflect spirituals, ragtime, Kansas City swing, and bop. The tree's branches are obscured by a multiplicity of leaves, each naming a particular jazz player, many of them cherished friends. A tribute to her contemporaries, the tree on *The History of Jazz* poster is a family tree. On the left side, however, dead or stunted branches sport leaves inscribed not with names but with terms: COMMERCIAL ROCK, AVANT GUARD (*sic*), EXERCISES, CLASSICAL BOOKS. Technique without feeling, formal schooling, a move toward rock, or the use of foreign forms would destroy the sap of jazz, Williams believed. Such dead branches should be lopped off so the tree can flourish.

In the record *Live at the Cookery* (1976), a testament to Williams's mature technical facility, she uses a performance of the song "Roll 'Em" to take "the listener through boogie-woogie, blues, swing, and bop styles, then back to the roots, showing a completeness of American music's evolution." Her bass accompanist at the Cookery, Brian Q. Torff, provides a second-by-second road map of this rendition, while recalling her "incredible" powers of concentration at the keyboard: "When she played her eyes would close as if she were in a trance. I can even remember her falling asleep once in the middle of a song. We were playing and I heard this soft, snoring sound. I looked over and there was Mary Lou, her head down, fingers moving, but playing the piano in her sleep. Like a rude alarm clock, I inadvertently hit a wrong note, and she woke up, startled." Since their usual gig lasted from 9:30 p.m. to 1:30 a.m., Mondays through Saturdays, her exhaustion seems perfectly understandable—she would sometimes drive back to Harlem and sleep in her car until she could legally park

at 6 or 7 a.m.—though the trance-like playing also manifests Williams's spellbound immersion at the keyboard.

At the start of her record *The History of Jazz* (1978), Williams explains why she had become a historian of jazz: "I have played through all the eras of Jazz." Here, too, she worries about its future. "After the bop era," she says, "it seemed that the creation and the heritage was a little bit lost." Here, again, she links jazz to Christianity: "Soul is a musician with love, charity and sacrifice for his fellow man in his music. The Presence of God through suffering." In an unusual confessional moment, she hints at the troubles she encountered while acquiring her knowledge of jazz: "to bring this history to you, I had to go through muck and mud."

On the second side of *The History of Jazz*, Williams emphasizes the collaborative nature of jazz, "the mental telepathy going on between bass, drums and a number of other soloists." Improvisation occurs "the moment a soloist's hands touches his instrument," when "ideas start to flow from the mind, through the heart and out the fingertips." While playing a sample of spirituals ("Lord Have Mercy"), ragtime ("Who Stole the Lock off the Henhouse Door"), and the slow blues ("My Mamma Pinned a Rose on Me"), Williams pays tribute to Moe Asch, for "there would be very little, if anything to tell about our only American art born through the suffering of slaves, if it were not for him and his great company, *Folkways Records*." It was a characteristically generous tribute.

Generosity also inflected her decision to perform with Cecil Taylor at Carnegie Hall in 1977. She had heard the avant-garde pianist play in England and he had attended her sessions at the Cookery. She asked if they could do a concert together, and he came up with the title "Embraced": "There's a love we have for one another musically," she stated in the liner notes of the live recording. Yet Cecil Taylor represented precisely the sort of free jazz to which Williams objected. Magazine articles explained that "any echo of the avant-garde enrages her": "Have you heard these 'freedom players?' she asks, lips curling in disgust. 'They're making people sick all over

town.'" Williams was convinced that the far-out experimentation of instrumentalists was losing jazz its audience, both White and Black.

Still, at Carnegie Hall, she hosted a performance that sounded, in the words of the jazz pianist-composer Deanna Witkowski, "as if one is hearing a loud person talking in a separate room who Mary has to fight in order to get a word in edgewise." Yet despite Taylor's overbearing keyboard pyrotechnics, critics concurred that Williams was a standout performer in the albums of the '70s: "she surpassed herself."

This judgment, issued by the critic Richard Brody, led him to distinguish Williams from her contemporaries: "Mary Lou Williams... did her most powerful distinctive, personal, and innovative work in her sixties. In this regard, she's unique in the history of jazz." The author and editor Phyl Garland concurred: "How anyone could sound this fresh after 50 years at the keyboard is almost beyond comprehension." Tammy Kernodle judges Williams's 1976 recording of "A Grand Night for Swinging" both "funkier and grittier" than her earlier renditions of it. Throughout her sixties, Williams knew that she was at the top of her game: "The old lady," she wrote a friend, "is wailing with foreign sounds, I'm playing my buns off."

Williams had been shocked that Cecil Taylor started out with "zombie music," instead of leading up to it through the history of jazz she had planned. She "started to get up from the stool, turn around and hit the piano with my butt—chung, *choonk*! *That* woulda got them!" Instead, she used the liner notes of *Embraced* (1978) to preach with missionary zeal: "After all Jazz comes under the heading of ART. And it should be played and heard everywhere—for the good of souls—in schools and universities, on the streets, in concert halls and clubs, in churches and convents, on the radio and TV and records, in pool halls—in fact, wherever music can be played and people reached."

Clearly, Mary Lou Williams had overcome her urgent desire to retreat into spiritual contemplation as well as her compunctions about performing. In late life, she acted on the belief that her playing

was a form of praying. As Williams dealt with weight gain that distressed her, hearing loss in one ear, and strained fingers and wrists and arms, quite a few awards and invitations and televised appearances raised her spirits, her stature, and the stature of jazz.

—⌒—

NONE OF THIS recognition—not even an invitation to play at the White House—translated into the security and stability offered by Duke University, whose administrators had been advised by the pianist-composer Billy Taylor to hire Williams as an artist-in-residence. Informed by the administrators that even people with PhDs did not receive the salary for which she held out, the high school dropout replied that she had an MLW—the initials of her own name! At sixty-seven and for the first time in her life, Williams had a steady salary, a house of her own, and health insurance. She would use her newfound solvency to continue helping members of her family, but it also liberated her from economic pressures. Peter O'Brien followed her to Durham and weathered their fights until they managed to wrangle funds from the university to supplement his salary as her manager.

It must have been wrenching to leave the Sugar Hill apartment, given all of Mary Lou Williams's memories of friends lounging on the white carpet near the upright Baldwin piano or consuming the meals she made in her bright yellow kitchen. She kept the rental when she bought the house in Durham and became an artist-in-residence at Duke in 1977, where she once again exemplified the history of jazz, for it too would continue to prosper in the halls of academe within jazz programs in music departments. Teaching twice a week left her free to attend festivals and perform in concert halls, though she still had to contend with her lifelong fear of flying.

During her four years at Duke, Williams faced and tackled two pedagogic perplexities, both also illustrative of jazz's history. For decades, she had functioned as a teacher, but she had always insisted

that schooling destroyed spontaneity. She had been hired to teach two classes—History of Jazz and Jazz Improvisation—and to direct Duke's jazz ensemble, when another problem arose: the kids who flocked to her classes were mostly White. This second hitch, related to the scarcity of Black undergraduates at Duke, she solved as soon as word got out about how popular her classes were: Black students began enrolling. But Williams remained perplexed that in the larger world of jazz, "there's more whites playing and the blacks can't play it at all.... [T]he whites are playing it with feeling—blues feeling and everything, and the blacks under forty can't play it at all."

The solution to the first quandary—how to teach what cannot be acquired in school—involved Williams in ear training: not talking to students about jazz but helping them to hear and reproduce the sounds of its manifold permutations. At rehearsals, she had students put down their instruments "and sing their parts in call-and-response style in order to internalize the music." In the film *Music on My Mind*, she explains, "Sing everything; it gets jazz running through your body." Warning her students—"If you keep on listening to rock, you're going to end up with the cramps"—Williams taught them how to rephrase jazz classics in the style of Billie Holiday, Count Basie, or Dizzy Gillespie. For the Wind Ensemble, she wrote "notes that are not on your instrument ... all the notes that Coltrane was playing in the South, you would not find on the tenor." Severity stood her in good stead: "She didn't teach down," O'Brien explained. "She would admonish them," he recalled, "by saying 'Play the note.'"

But most of all Williams exemplified the love of music. "You can have a husband or a boyfriend, fall in love and they leave you when you least expect it," she told a reporter at Duke. "That can kill you. But I couldn't care less if I'm with somebody. Music is my constant companion. It lives right here in my mind. It saves me." Peter O'Brien, who contended with her sometimes volatile moods and eventually served as the executive director of the Mary Lou Williams Foundation, judged her final years "a very good ending, very good."

After a diagnosis of bladder cancer, Williams continued teaching, despite the debilitation of surgeries, chemotherapies, and radiation. Though she had to deal with the difficulties of an ostomy and with sadness over the death of her favorite sister and the unraveling of her favorite nephew, she traveled to concertize. During one hospitalization, she arranged for a piano to be brought into her room so she could resume work on an arrangement.

"It could have been disastrous," Peter O'Brien admitted as he pondered what might have happened if she had not obtained the Duke appointment, "with no income, no nothing, and me running around trying to put her in Harlem Hospital. It worked." She died at home with hospice at the age of seventy-one. According to her wishes, the Mary Lou Williams Foundation was set up to offer children training with jazz musicians. One of its efforts, led by the composer-pianist Geri Allen (who played Williams in Robert Altman's 1996 film *Kansas City*), involved recording the music she had composed.

Throughout her late life, Mary Lou Williams stressed the distinctive nature of jazz: "It's not somebody else's notes you're playing. It comes directly from inside you and it has to be felt to be played." Playing, she explained, took her outside herself: "Whenever I play I throw myself away... I close my eyes and leave this earth." With groups, "mental telepathy" creates "something like a conversation": "The audience gives you energy and you do the same. You feed it back. And when you're playing you feel like you're feeding them love. Because that's what the music really is: love."

Three years before her death, at the first Women's Jazz Festival, *Mary Lou's Mass* was performed. Williams had resisted attempts to label her a woman artist, but before her crisis in Europe and on more than one occasion, she had put together what were then called all-girl bands, racially integrated ensembles. Those efforts reflect Williams's many collaborative relationships with female performers, including her White counterpart Marian McPartland, who played at her funeral, and, of course, Hazel Scott.

Williams's presence at the first Women's Jazz Festival also draws

attention to an early role model. At the start of her memoir, she recalls being entranced as a child in the theater by a "lady pianist" who "sat cross-legged at the piano, a cigarette in her mouth, writing music with her right hand while accompanying the show with her swinging left! Impressed, I told myself: 'Mary, you'll do that one day.'" And she did end up doing what she had seen Lovie Austin do. Late in life, Williams recalled the exceptional female musicians she admired: Lil Armstrong, Valida Snow, Una Mae Carlyle, Norma Teagarden, Melba Liston.

A belated recognition of women's role in jazz—not as novelties but as serious participants—arrived just as Mary Lou Williams's life ended. At the close of the movie *The Girls in the Band* (2014), her unsung contemporaries assemble with their successors on the same street that Art Kane had photographed back in 1958 for *A Great Day in Harlem.* Like her, these instrumentalists and singers personify the grit it took to counter the prevailing assumption that "Only God can make a tree and only men can play jazz."

Given Mary Lou Williams's tenacity and fortitude, the second half of her bifurcated life was just as profoundly collaborative and edgily improvisational as her formative years, but it was focused on a sacred mission, and happier. It would be presumptuous of me, a secular Jew, to encapsulate what Catholicism gave her. But at the very least, religious faith supplied fresh subjects and forms for her musical compositions, new venues and audiences, a dedicated manager and community, and a vocation that imbued Mary Lou Williams's last years with an evangelical sense of purpose.

CHAPTER 8

Gwendolyn Brooks

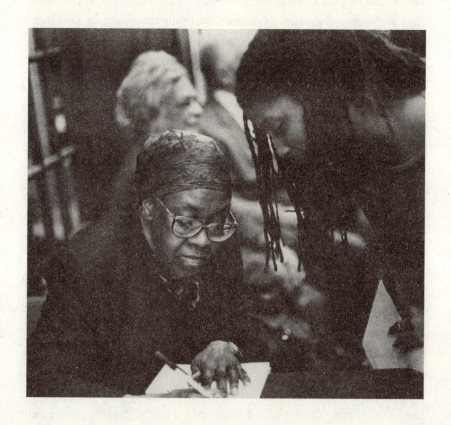

Some seventeen years after becoming the first African American to win the Pulitzer Prize, Gwendolyn Brooks was galvanized by youthful proponents of the Black Arts Movement at the 1967 Fisk University Writers' Conference. Expressing dissatisfaction with her less political past, the poet confessed, "It frightens me to realize that, if I had died before the age of fifty, I would have died a 'Negro' fraction." Newborn militancy influenced her self-presentation—she adopted an Afro hairstyle—and suffused her late verse with a mission. Radicalized, Brooks risked losing a large number of readers when she divorced herself from the White-dominated literary establishment. Throughout her final decades, the uncompromising writer analyzed and contested the ghastly repercussions of racial discrimination, especially on children.

The stability and support of Gwendolyn Brooks's parents may have accounted for her early success. Her father, the son of a runaway slave, worked as a janitor after he was forced to relinquish his dream of becoming a doctor. He encouraged the aspirations of Brooks and her younger brother, as did his wife, a former schoolteacher. Before the adolescent began publishing poems in the *Chicago Defender*, her mother had assured her that she would grow up "to be the *lady* Paul Laurence Dunbar." Yet without an active social life in high school—the boys told her that being "DARK... was the failings of failings"—she felt disaffected from the three schools she attended: one White, one Black, and one mixed.

Brooks had graduated from Wilson Junior College (now Kennedy-King) when she intuited that Henry Blakely Jr. would become her husband. While he laid aside his own literary ambitions to support the family, the couple moved into a succession of sometimes cramped, sometimes mice-infested apartments in Bronzeville, where the NAACP Youth Council widened their intellectual circles. One year after the birth of their son, Henry, a White patron of the

arts further boosted Brooks's career. Connected to *Poetry* magazine, Inez Cunningham Stark led a succession of evening poetry workshops at the Southside Community Art Center. They provided the poet a solid education in modernist verse and links to the literary marketplace that quickly led to well-received publications.

When in the full-blown fervor of her political conversion Brooks demoted her earlier self to a "'Negro' fraction," she may have been suggesting that if she had died before fifty, her death would simply count as a statistic of Black mortality rates of little significance to Whites. But she was also indicating that the work she produced before her fifties had failed to register the full humanity of its Black subjects. The phrase "'Negro' fraction" refers to an emendation to the Constitution in which Blacks as individual slaves were deemed three-fifths of a person. In other words, Brooks was judging her earlier self to be enslaved human property.

There *is* a contrast between Brooks's verse before and after the Fisk conference; however, it pertains to modifications in lexicon, form, marketing, and audience, not to any failure of the early poetry to express the quotidian dilemmas of her neighbors, who always served as her inspiration. From her fifties until her death at eighty-three, the poet decried the devastation wrought by racism, which, she believed, needed to be addressed in a less obscure style attuned to national and international injustices. She knew that her verse was meant for anyone to whom it spoke. After the Fisk conference, though, Brooks defined herself as a Black poet who increasingly wrote not only *about* Black subjects but also *for* and *to* and *with* the Black compatriots she sought to mentor.

Abandoning White publishers was a risky business—not just economically. Brooks would be faulted for sacrificing formalism to didacticism and her books would be less widely circulated and reviewed. But her fresh convictions rejuvenated her. Though she arrived at the Fisk conference feeling like "another Old Girl, another coldly Respected old Has-been," she left convinced that she was "qualified to enter at least the kindergarten of new consciousness." Endowed

with the sense of humor evident in this self-assessment, the elderly poet relished the social networks that her pedagogic activism forged.

ALTHOUGH GWENDOLYN BROOKS disparaged her early career in order to underscore her transition from an integrationist to a Black nationalist position, her dismissal does a disservice to her first three books of verse, all of which include powerful poems exploring the debilitating consequences of racism. The knowledge of prosody and the formal rigor she brought to early depictions of Black characters endowed them with the dignity historically accorded only Whites.

Take, for example, her World War II sonnet sequence "Gay Chaps at the Bar" in *A Street in Bronzeville* (1945), which records the disillusionment experienced by Black veterans whose traumatic experiences of a violent enemy and a racist army have alienated them from the home front. Or, in that same volume, "the mother," which adopts the dramatic monologue used by the likes of Alfred Tennyson and Robert Browning, but here—possibly for the first time—to convey the sorrowful ambivalence of a woman who has undergone several abortions.

Brooks's masterful manipulation of classical forms took center stage in her second book, *Annie Allen* (1949), especially in its title poem, a mock-heroic riff on Homer's *Iliad* and Virgil's *Aeneid*. The heroine of "The Anniad" is left by a lover she idolizes when he goes off to war and then again when he returns home wanting "his power back again." As in her only novel, *Maud Martha* (1953), the writer addresses the colorism in the Black community that blighted her own school years, the tendency among her contemporaries to value lighter-skinned over darker-skinned women.

The birth of Brooks's second child, Nora, in 1951, as well as the publication of her novel, partly explains the ten-year gap between the Pulitzer Prize for *Annie Allen* and the appearance of *The Bean Eaters* (1960), though it is also telling that when the thirty-two-year-old

discovered she had won the Pulitzer, she was at home in the dark. There had not been enough money to pay the electricity bill.

Many poems in *The Bean Eaters*—with its title a nod to Vincent van Gogh's *The Potato Eaters* (1885) and its dedication to the memory of her deceased father—exhibit Brooks's determination to use her technical virtuosity to protest the catastrophic circumstances of her neighbors. "We Real Cool," one of her most popular texts, deploys line breaks between the "We" of her pool-playing, street-smart adolescents and their acts of leaving school, lurking late, striking straight, thinning gin, jazzing June, and dying soon. These young men are not fully in control of what they do: malevolent forces are at work abbreviating their existences. "By the end, the missing 'we' that the poem's pattern has led us to anticipate is a yawning cavern," the poet Elizabeth Alexander points out.

In "Bronzeville Woman in a Red Hat," also in *The Bean Eaters*, Brooks adopts the prejudiced perspective of the White employer of a Black servant to focus on interracial tensions between women. Mrs. Miles had never had "one" in her house before, and this "one" reminds her of a lion, a puma, a panther, a black bear, and an "it." The final stanza of the poem contrasts the upheaval inside Mrs. Miles with the serene scene she witnesses in her kitchen. As the horrified housewife watches her child and the maid kiss, Mrs. Miles ends up personifying the "ordure" she attributes to a dark complexion.

This is not poetry composed by a "'Negro' fraction": Gwendolyn Brooks was clearly debunking Whites who reduce Black people to a subhuman category. How, then, did the new perspective of the Black Arts Movement begin to modify her aesthetic projects? She started learning from youthful militants when the Pulitzer Prize licensed her to teach college courses without a college degree. With her children in school, Brooks began conducting poetry classes at Chicago's Columbia College and then at Northeastern Illinois State College, Elmhurst College, and New York's City College. She used them to challenge the White canon of established classics that were then standard fare in literature departments.

In poetry workshops, Brooks focused on the sonnet, the ballad, blank and free verse, the heroic couplet, haiku, and the tanka. Besides requiring a book of twenty poems, ten in prescribed forms, from each participant, she assigned readings and recordings, panel discussions, debates, and "round-robin response to controversial 'creativity'-based questions." Brooks paid for tickets so students could attend literary events at other institutions and involved them "with black literature and Jewish literature, rarely touched upon by standard texts."

At a series of conferences to which Brooks was invited to read her poetry, she met the militant poet-playwright LeRoi Jones (later Imamu Amiri Baraka) and the poet-publisher Dudley Randall. Even as these youthful militants made her feel out-of-date, they also held out the promise of a revitalized seniority. The electrifying 1967 Fisk conference intensified her sense of urgency about addressing social injustice head on. Back in Chicago from Nashville, she linked up with the singer-playwright-poet Oscar Brown Jr., who encouraged her to lead writing workshops for gang members of the Blackstone Rangers, sessions that were facilitated by the young community organizer Walter Bradford and attended by the young poet-activist Don L. Lee (later Haki Madhubuti). Both would become lifelong friends. Members of the writers' group accompanied her in 1967 to an exhilarating reading at *The Wall of Respect*, a neighborhood mural that honored Black luminaries, including herself.

Soon thereafter, the manuscript of *In the Mecca* (1968) arrived at Brooks's publisher, Harper & Row. Its title poem is almost twice as long as T. S. Eliot's *The Waste Land* (1922), but more concentrated than his deliberately fragmented dreamscape. "In the Mecca" centers on an apartment building that Brooks uses to symbolize divisions within a Black population confined and fractured by pervasive segregation. Back in 1891, the name of the Islamic holy city had been bestowed on a palatial South Side construction that initially housed elite Whites, and then elite Blacks, but soon descended into a squalid tenement, which is when Gwendolyn Brooks first entered it.

At nineteen, she had briefly worked for a charlatan healer in the Mecca building. The dancer-choreographer Katherine Dunham, who once visited a relative in the Mecca, described it in a memoir:

> Four floors of rat-infested, cockroach-dominated cubicles rose from a paved courtyard to a roof festooned with wash, which often blew free and tangled itself into the debris of broken furniture and old bedsprings brought up from some sweltering enclosure for the hot nights, or piled into the corners of skylights to add to the drifts of dusty newspapers, rusty nails, pigeon feathers, and cigarette butts.

The showcase-turned-slum had been razed in 1952, to make room for the expanded campus of the Illinois Institute of Technology.

Centered on a topic that Brooks had first approached in prose, "In the Mecca" evolved into a verse epic about decline and fall. It signals the start of "a new movement and energy" in her evolution, as the activist-writer Toni Cade Bambara noted. In comments about the poem, the poet stated her aim: "To touch every note in the life of this block-long block-wide building would be to capsulize the gist of black humanity in general. (How many people lived there? Some say a thousand, some say two thousand)." For what might be considered her most ambitious undertaking, she assembled her largest cast of characters.

"IN THE MECCA" hinges a "capsulized" portrait of "black humanity in general" on mythic figures. First, Demeter, the goddess of agriculture whose anxious search for her abducted daughter Persephone brings about deathly winter. Returning home from work to a place where many flowers look choked, Brooks's central character, Sallie Smith, realizes that her daughter Pepita—whose name means "Little Seed"—has gone missing and questions a succession of neighbors

about the girl's whereabouts. Brooks grafts the story of the grieving Demeter and raped Persephone to Christianity's central sacrifice. A hortatory line—"Now the way of the Mecca was on this wise"— echoes Matthew's "Now the birth of Jesus Christ was on this wise" (1:18). Whereas Matthew celebrates the good news of resurrection, just as the Demeter story acclaims the reunion of mother and daughter in springtime renewal, Brooks delivers the bad news of degeneration and death.

Composed in lines of free verse (that slide in and out of rhymes), the stanzas of "In the Mecca" express the disjointed views of the multiple apartment dwellers with whom Mrs. Sallie comes into contact. All the renters remain as confined in their heads as they are within their apartments. In the first section of the poem, the mother ascends the stairs, encountering old St. Julia Jones, who loves the Lord for the coffee in her cup; Prophet Williams, who lusts for his disciple; Hyena, who paints her hair gold; and Alfred, whose reading of Horace and Hemingway lulls him into the comforting notion that the universe somehow coheres, though in a not-yet-discovered pattern.

While Mrs. Sallie rises to the fourth floor, she considers the dinner she will cook (a ham hock, mustard greens, cornbread cooked with water), the deplorable state of her kitchen, and the children whom she needs to feed. All of them are as insulated as their neighbors. The children hate anyone who has what they never received: mittens, picture books, trains, and frocks. Mary likes roaches; Tennessee tries to stay as still as a cat; Emmett, Cap, and Casey were never given chocolate or ice cream cones.

Like her children, Mrs. Sallie loves and hates what she cannot have: her employer's child. Her envious thoughts are interrupted when, counting her children, she "SEES NO PEPITA. 'WHERE PEPITA BE?'" Mrs. Sallie's shock triggers more questions to her children, as they respond with fright at the urgency of her alarm: with no knowledge of Pepita's whereabouts, they are instantly flooded with their mother's anxiety.

In the second part of "In the Mecca," the worried children and

their mother set off knocking down the halls in search of the missing girl, and we meet up with more denizens of the Mecca. Great-great Gram, who hasn't seen Pepita, remembers a slave cabin where something "creebled in that dirt" that she "squishied." Loam Norton, lost in thought about the victims of the Holocaust, has not seen Pepita either. Brooks turns Loam Norton's section into a Holocaust poem that contrasts the Lord's prayer with the fact that the inmates of Belsen and Dachau died uncomforted by rod or staff. Locked in horrific atrocities of the past, neither Great-great Gram nor Loam Norton takes in the present disaster.

Although Mrs. Sallie tries to ease her own and her children's fears, everybody starts to seem malevolent to them; so one of the children phones the police, who arrive with "A lariat of questions" but quickly leave as the mother's alarm over Pepita's fate escalates. She is not reassured by Aunt Dill, who arrives with tales of a little girl raped, choked, her nose bitten off.

When the law returns to investigate in the conclusion of "In the Mecca," a succession of renters attests to no knowledge of Pepita; but Mrs. Sallie has disappeared from the poem, never to be heard from again. The cacophony of the renters' different perspectives as well as the speaking silence of Mrs. Sallie's absence qualify even the most sympathetic inhabitants of the Mecca: three renters—Alfred, Don Lee, and Amos—seeking to address and redress its deterioration.

Alfred, moving away from Western paradigms and toward the model of the African poet-statesman Léopold Senghor, has begun believing in the possibility that blackness can be reimagined in alignment with beauty. Don Lee stands up for a political movement, nationalism, with its own arts and anthems. Amos argues for the punishment of an unjust White America: he wants a bloodbath to wash America clean, and "Great-nailed boots / must kick her prostrate, heel-grind that soft breast," so that she will never forget the atrocities she has inflicted on a subjugated population.

Some readers see in Alfred, Don Lee, and Amos Gwendolyn Brooks's newborn allegiance to the Black Power/Arts movements. In

different ways, they engage in a struggle to confront the damages evident in the Mecca. However, the misogynist language of Amos, the absence of Mrs. Sallie, and the fact that none of these characters has any knowledge of or concern about Pepita indicate that Brooks is pondering a more complicated relationship to militancy. A host of other inhabitants of the Mecca underscore widespread ignorance of or indifference to Mrs. Sallie and her daughter.

Hyena has not seen the girl she considers puny and putrid. In a ballad of her own, Edie Barrow tells of falling in love with a fair boy who marries a White girl. Prophet Williams advertises powders and serums for unfaithful men and women. To all these and more, the narrator wonders if any care about Pepita. The catalogue of names—Staley and Lara and Bixby—suggests that none care. Not Darkara who peruses *Vogue*, or Mr. Kelly who begs from door to door: none cares what has befallen the child or her bereft mother.

The sixtyish sisters who flour their faces have not seen Pepita. Way-out Morgan, who collects guns and feeds on visions of murdering White men, has not either. Neither has Marian, Pops Pinkham, or Dill. Alfred, leaning on a balcony, begins to hear an apocalyptic call from the Mecca—it seems to speak of redemption and perhaps even of a reconstruction. But the poem does not conclude with Albert's evolving vision.

Instead, Brooks ends "In the Mecca" with the murderer of Pepita "thrice" denying culpability, like the apostle Peter, while "a little woman lies in dust with roaches" under his bed. A child, Pepita is not a woman, but "little woman" hints that she was preyed upon as one. Both the roaches and the dust return us to the slave system and the Holocaust that haunted Great-great Gram and Loam Norton. The sacrifice of innocence leads Brooks to an elegiac summing up:

> *She never went to Kindergarten.*
> *She never learned that black is not beloved.*
> *Was royalty when poised,*
> *sly, at the A and P's fly-open door.*

Will be royalty no more.
"I touch"—she said once—"petals of a rose.
A silky feeling through me goes!"
Her mother will try for roses.
She whose little stomach fought the world had
Wriggled, like a robin!
Odd were the little wrigglings
and the chopped chirpings oddly rising.

That the only words ascribed to Pepita are a rhyming couplet suggests that she might have become a poet, as does her resemblance to a bird, also a singer. Amid the rising chirpings that are chopped, Brooks mourns the cancellation of potential. The little seed will never sprout. Brooks's dedication of "In the Mecca" to a list of Black Arts advocates makes it clear that she set out to record not only the rise of Black nationalism but also why it was sorely needed. However, she also underscores the masculinism of that militancy and its indifference to or ignorance of the plight of Black mothers and daughters.

IN THE YEAR that *In the Mecca* appeared, the fifty-one-year-old Gwendolyn Brooks succeeded Carl Sandburg as the Poet Laureate of Illinois. The next year, she separated from her husband and also from Harper, determining to publish her poetry with Black-owned firms. Before making this defiant decision, Brooks insisted that the verse contained within *In the Mecca* be included in *The World of Gwendolyn Brooks* (1971): "my work is changing and is going to continue to change, and the first hints of the changes are in the Mecca book." She was no longer interested in being extolled for resisting the "temptations of special pleading" in compositions "with no grievance or racial criticism," as she had been in the 1950 letter recommending her for the Pulitzer Prize.

Being radicalized connected Gwendolyn Brooks to youthful

activists, community organizers, and writers: not only Haki Madhubuti and Walter Bradford, but also Etheridge Knight, Carolyn Rodgers, Sonia Sanchez, and Nikki Giovanni. In the years following the Fisk conference, the Blackstone Rangers workshop "moved into her home and became the Gwendolyn Brooks Workshop," Madhubuti has explained. Populated increasingly by college-attending participants, an informal salon gathered regularly in her apartment to discuss literary as well as political tactics. Its participants recommended new books to her: *The Autobiography of Malcolm X*, Frantz Fanon's *The Wretched of the Earth*, W. E. B. Du Bois's *The Souls of Black Folk*, and the novels of Zora Neale Hurston. She fed them and invited esteemed authors like James Baldwin and John O. Killens "to meet them, to exchange views with them": "the air was hot, heavy with logic, illogic, zeal, construction."

Topicality and accessibility began to take priority in Gwendolyn Brooks's work, and so did male characters. Just as the Black Power/Arts movements stressed the virility of their leaders and urged women to play a supportive role, Brooks's poetry celebrated Black men: "on account of everything that was being done to smash our men down," she explained, "there was a tendency on the part of women—announced too—to lift the men up, to *heroize* them."

Already in the second section of the Mecca book, Brooks had included tributes to the slain civil rights activist Medgar Evers and the assassinated leader Malcolm X. The two concluding sermons on the "Warpland"—a coinage that evokes the warping of lives in the war-land of racial conflict—use the hortatory cadences of Black preachers to exhort readers to bloom amid the whirlwind of racial conflicts swirling around them. Young people need to be instructed to attend to their personal growth in spite of—in the midst of—ghastly events so they might evade the grim fate of Pepita.

In her next two books, Gwendolyn Brooks used male characters to concentrate on a gruesome consequence of systemic racism: the inflated self-esteem of Whites and the deflated self-esteem of Blacks. *Riot* (1969), published by Dudley Randall's Broadside Press in Detroit,

includes a quotation from Martin Luther King Jr. appended to its title poem: "A riot is the language of the unheard." Confronting the race riots that ensued after the assassination of King, its title poem focuses on the snobbish WASP John Cabot and specifically on an arrogance plumped by his privileges—a Jaguar, Grandtully scotch, and kidney pie at Maxim's—which he "almost / forgot... Because the Negroes were coming down the street."

Not unlike Mrs. Miles in "Bronzeville Woman in a Red Hat," John Cabot in "Riot" views the mob as "Gross. Gross" so he prays that "It" won't touch him. When "It" does, he feels suffocated by the fumes of chitterlings and chili. As he collapses in fright or dies, his final prayer—"Lord! / Forgive these nigguhs that know not what they do"—provides chilling insight into his grotesquely misguided view of himself as a sacrificial and sanctified victim. Mangling Jesus's last words on the cross, John Cabot betrays his own bigotry. According to Brooks, the psychology of White supremacy, often licensed by contorted Christian precepts, sponsors a melodramatic master narrative that casts Whites as saviors threatened by disloyal, treacherous Blacks. Under a delusion of grandeur, John Cabot sees himself as helplessly persecuted by malevolent Black hordes whom (he is convinced) he is actually trying to save.

Is the riot in "Riot" occurring only in John Cabot's head? Was it triggered simply by seeing "Negroes... coming down the street"? Perhaps he is destroyed not by a violent mob but by his own terror of Black people who, he assumes, are out to get him for his (undeserved) privileges and their (undeserved) privations. The source of his delusion of grandeur is a guilty conscience. In "Riot," Brooks provides a scathing portrait of the racial supremacist as a hysteric. That White people rarely died in the race riots of the late 1960s only underscores the bitter ironies of the poem, which are extended in a work in her next volume, *Family Pictures* (1970), that Brooks frequently chose to read aloud: "The Life of Lincoln West."

Whereas "Riot" dramatizes John Cabot's overblown estimate of himself, "The Life of Lincoln West" dwells on wrecked self-esteem

in the Black community. A narrative poem about the "Ugliest little boy / that everyone ever saw" begins with Lincoln West's background, which includes a father who cannot bear the sight of him and a mother who judges his worth as neither more nor less than the hairpins in her dyed hair. Against their hostility and that of a kindergarten teacher who spurns him as a monkey, Brooks contrasts the ironically named Linc's loving-kindness for everyone and for the natural world of ants and caterpillars that he inhabits.

At seven a startling event mitigates Lincoln West's despondency when, at the movies, a White man points him out:

> "One of the best
> examples of the species: Not like
> those diluted Negroes you see so much of on
> the street these days, but the
> real thing.
>
> Black, ugly, and odd. You
> can see the savagery. The blunt
> blankness. That is the real
> thing."

After hearing that comment, whenever Lincoln West felt hurt or stared at or lonely, he took comfort in the idea that he was the real thing.

A poem about the pernicious dynamics of internalization in a racist culture, "The Life of Lincoln West" supplements the militant slogan of the day—"Black Is Beautiful"—with the sorry consequences of being inducted into a conviction of one's own ugliness and then of accepting a racist's definition to offset that conviction. Or has Lincoln West won through to a sense of his genuine power, despite the suspect source, as Brooks sometimes suggested? By the end of the poem, Lincoln West has transformed a racist insult into a compliment. Ironically, the racist's image of him is more amenable to such a repurposing than

the image provided by his Black family and friends, who have internalized the hatred bred by White Americans' conviction that, as she wrote in the conclusion of "In the Mecca," "black is not beloved."

"In Montgomery" (1971)—a long poem published in *Ebony* magazine—sustains Gwendolyn Brooks's concern with Black children. It depicts elders still caught up in Martin Luther King's transformative vision but fearful that younger people have not inherited his dedication. The elders remember their parents telling them that changes were on the way and they would see progress, and that prophecy came true. But in a town where "The catcalls of history hang in the air: / **niggers! black cows! black apes! black scum!**" the aging generation asks, "Where are the young folks that's buildin'?" The question motivated Brooks for the rest of her life.

THOUGH A 1971 heart attack made prolonged teaching stints impossible, Brooks continued to travel at an astonishing pace to numerous campuses across the country, where she gave readings, lectured, and led master classes. She approached legions of these visits less as a celebrity and more as an instructor.

Whereas visiting (and mostly male) poets on college campuses often swaggered at the podium during readings and then quickly departed with groupies to party, Gwendolyn Brooks frequently sat behind a desk and then signed books or broadsides until the last member of the audience departed. Dedicated to community service, she worked to establish the Illinois Poet Laureate Awards first for high school students and then for elementary school students, and funded budding authors, often out of her own pocket: "The best thing you can do for a writer is to keep him from starving, and to provide some degree of free time for him," she explained in the memoir she published in 1972.

Report from Part One is an oddly reticent book that includes some happy memories of Brooks's childhood and the childhoods of her

children, but then veers off into snippets of book reviews, accounts of her travels in Africa, and interviews. Throughout she is evasive about the personal details surrounding the breakdown of her marriage, but insightful about the dynamic underlying it and voluble about the watershed event at Fisk.

After thirty years in what friends deemed a model marriage, Brooks believed that a "separation was best for the involved. (That won't be enough for the reader but it is enough for me.)" She refuses to see the breakup as a "failure," for she expects her single life to lead "to arrivals, to adventures, to a peace, to personal shapings not possible before." In *Report from Part One*, Brooks hints that her rising fame and her newfound militancy may have contributed to the couple's estrangement, for though her husband was "an excellent writer," he had not yet published a book; and "he didn't agree" with the "new, young movements," because he was "an integrationist."

At fifty-five years of age, Brooks has no intention of marrying again. "Especially if you're a woman, you have to set yourself aside constantly. Although I did it during my marriage, I couldn't again. After having had a year of solitude, I realize that this is what is right for me to be able to control my life." Relishing her independence, Brooks had not enjoyed "walking on eggs": "In my case, part of it was due to the fact that we both wrote. It's hard on the man's ego to be married to a woman who happens to get some attention before he does." This is as close as she gets to expressing her sense that a wife's success can breed resentment, envy, or anger in her husband.

Brooks's respectful language about her husband helps explain why the couple would soon reunite. A later poem, "Shorthand Possible" (1986), clarifies the pleasures of their lengthy partnership: "A long marriage makes shorthand possible." With so many shared conversations over the years, a single word or phrase can unlock multiple meanings for long-term couples. Brooks associates their silences and "shorthand" with their layered past. Able to finish each other's sentences, they often don't have to. A look is sufficient to recall what

is meant, as they measure who they have become in terms of who they had been. Endowed with "old-time double-seeing," aging couples are "comfortably out-of-date." They may not understand new-fangled inventions or contemporary allusions, but they share their bemused incomprehension.

The remarriage probably also reflects Brooks's convictions about the responsibilities of Black women. Addressing the women's movement in the memoir, she argues that "Women's Lib" is not for Black women, because "black men *need* their women beside them, supporting them in these very tempestuous days." But she emphasizes that this is the case "for the time being": "if [men] treat us considerately, we may never need to subscribe to 'the movement.'" Brooks adds, "It's entirely wrong, of course, for women to be denied the same job income men have. When it comes to that, black women should be fighting for equal pay just as white women should."

Report from Part One returns over and over again to Brooks's admiration for the young people whose political fervor infused her late life with purpose. At the Fisk conference, she observed the poet-playwright LeRoi Jones shouting, "Up against the wall," which inspired a White man to shoot up and scream "Yeah! *Yeah!* Up against the wall, Brother! KILL 'EM ALL! KILL 'EM ALL." Brooks dryly remarks, "I thought that was interesting."

Before Fisk, Brooks believed that "All we had to do was keep on appealing to the whites to help us, and they would." After, she realized that integration "was not working": "The thing to stress was black solidarity and pride in one's brothers and sisters." Moving beyond the nonviolent approach of Martin Luther King Jr., she looked to African independence movements for models: "I know now that I am essentially an essential African." Though in young adulthood she was "a loner," often conversing about "white writing" with White people who considered her "a sort of pet," the poet takes as her future task the attempt to call "black people in taverns, black people in alleys, black people in gutters, schools offices, factories, prisons, the consulate."

In part, Brooks attributes her brand-new freedom from the need for White approval to aging: "As you get older, you find that often the wheat, disentangling *itself* from the chaff, comes to meet you..." (emphasis and ellipsis hers). She tellingly concludes *Report from Part One* with her delight over a letter from a young boy convinced by "We Real Cool" to stay in school and with the note of encouragement she sent back to him. She must have composed zillions of these sorts of letters. Haki Madhubuti represented many others when he praised Gwendolyn Brooks as "a cultural mother" motivated by a "religion of kindness."

A commitment to pedagogic activism within the Black community shaped Brooks's publications throughout the 1970s and thereafter. In her collection *Jump Bad: A New Chicago Anthology* (1971), she gathered the verse of some of the younger poets in her workshops who "do not care if you call their products Art or Peanuts": "appointment to Glory among the anointed elders" does not concern them. Instead, because "it is not likely all blacks will immediately convert to Swahili, they are blackening English." In her section of a 1975 collaborative instructional pamphlet, *A Capsule Course in Black Poetry Writing* (1975), Brooks declared "that NOW the address must be to blacks; that shrieking into the steady and organized deafness of the white ear was frivolous—perilously innocent." By the end of the seventies, she considered Haki Madhubuti and Walter Bradford her adopted sons: "they have been more like my sons to me than my own son because they have ideas that are like my own."

IN 1980, BROOKS visited seventeen different states to give readings or workshops. At them, she often discussed the ideas in the manuals for young writers that she published: *Young Poets Primer* (1980) for middle and high school children and *Very Young Poets* (1983) for those in elementary school. Many critics see a decline in the verse Brooks published in her sixties and seventies, but what it lost in eclectic

vocabulary and formal rigor it gained in clarity of purpose as she continued to address the plight of Black children.

A series of publications—from *Beckonings* (1975) to *Winnie* (1988)—contain didactic poems that tackle racial injustice with perspectives still sadly relevant today. The woman who speaks in "The Boy Died in My Alley" (1975) comprehends the complicity of the state, the police, the family, the neighborhood, and even herself in the red floor of her alley, which "is a special speech to me." Brooks uses the injunction "*Never to look a hot comb in the teeth*" to joke that the hot comb is a gift horse in her poem "To Those of My Sisters Who Kept Their Naturals" (1980), which praises girls who have not dyed their hair or worshipped Marilyn Monroe.

In "The Near-Johannesburg Boy" (1986), a boy habituated to being jailed under apartheid contemplates the fate of his shot father and determines to walk with his friends into segregated areas so as to forge an apocalyptic challenge to the corrupt social order. *Winnie*, in particular, expresses Brooks's urgency about the Black poet's vocation: here she calls for poems "roaring up out of the sleaze, / poems from ice, from vomit, and from tainted blood." For this reason, real historical speakers become prominent in her verse: Winnie Mandela, the composer Louis Gottschalk, Duke Ellington, Martin Luther King Jr., and Jane Addams. The social worker speaking in "Jane Addams" (1988) addresses "children coming home" from school to assure them that despite all the threats that multiply their trepidations, they might be able to live their lives.

Appearing when Gwendolyn Brooks was seventy-four years old, her last volume of verse, *Children Coming Home* (1991), presents portraits of twenty schoolchildren moving from school back to their homes, where not all of them will receive "cookies and cocoa." The opening poem, "After School," explains why the volume is not called "Children Going Home." The speaker is estranged from White schoolteachers ripe to report some kids to the principal or cursing them behind their backs. Instead, readers are encouraged to identify with the teacher who will take the children "home for home-

work" or with the Black parents welcoming the children returning from school. "I don't sit down now and write, hoping to change the hearts of white people," Brooks explained. The homework that needs to be done involves the reader in acknowledging what work on the home is needed to make it an environment less hostile to the children's well-being.

Children Coming Home was issued by the David Company, a press Brooks established in honor of her father. Its cover looks like the black-and-white mottled notebooks that many schoolchildren used to use. The first of the children's poems, "The Coora Flower," makes it clear that for some kids, school is a "tiny vacation" compared to the big business of returning to a crack house, where they dare not sleep. A number of the children in the book were based on students who lived in the notorious Cabrini-Green Housing Projects and attended Jenner Elementary School, where Brooks had interacted with them. The contrast between the playful poems in the early *Bronzeville Boys and Girls* (1956) and the raw dramatic monologues in the late *Children Coming Home* could not be more striking.

Gwendolyn Brooks chose to read one of the poems in *Children Coming Home*, "Uncle Seagram," in a filmed interview. Five-year-old Merle is returning home from kindergarten to a family consisting of his parents, six siblings, and uncle. The figure who frightens him is the six-foot-tall uncle, who stumbles because of the "Wonderful Medicine" always packed in his pocket. As Merle describes his uncle—sitting "*close*" on his lap and "As I sit, he gets hard in the middle"—it become clear that he fears molestation. The whiskey in the Uncle's pocket and the hardness in his middle coalesce in his sinister name and furtive advances.

In the conclusion of "Uncle Seagram," Merle recalls a bathroom scene in which his uncle insinuates that he must keep their physical contact a secret. Whether Merle will confide in his parents, whether his parents will believe him and act on his behalf, what other recourse he might have: these are left as open questions. Subsequent poems in this neglected volume focus on children coming home to

adults wanting them to deal "white powder" or assuring them they are "Black But Not Very," although the concluding poem captures a child in better circumstances.

A tribute to Brooks's daughter, "I'll Stay" presents Nora admiring plates standing on edge in a ledge of a dining room wall. Easily breakable, they tell her that "Confident things can stand and stay!" Filled with ambition and assurance, she attributes both characteristics to her mother, who compares her with the rising sun. The analogy lends Nora the warmth and energy that she needs to persist in her staying power. Unambivalent and solid, the mother–daughter bond resurfaces in the second memoir Brooks wrote toward the end of her life, a book that reveals how a keen sense of humor fueled her own staying power.

NO COMPOSITION BETTER illuminates Gwendolyn Brooks's wry temperament in old age than *Report from Part Two* (1996), which she published with Haki Madhubuti's Third World Press when she was seventy-nine years old. Its title reiterates her ongoing conviction that militancy split her existence into two parts. Madhubuti had lured her back into the college classroom, though in 1997 she retired again from teaching. Like her earlier memoir, the second contains a potpourri—in this case, accounts of her mother's death and of trips abroad as well as speeches related to her position as poetry consultant for the Library of Congress (1985–86), a post that would later be renamed Poet Laureate of the United States. All of its sections manifest Brooks's lasting delight in irony and paradox.

In the chapters of *Report from Part Two* devoted to the old age and death of Keziah Brooks, the poet details her mother's dying to describe her own trepidations about caring for a declining parent and also, one senses, to come to terms with her own aging. A robbery precipitated Keziah Brooks's decline in 1978: she felt violated, invaded. The same thing later happened to Brooks: her apartment

was burglarized and she and her husband left their neighborhood in 1991 to live in an apartment on South Shore Drive in Hyde Park.

But Keziah Brooks responded differently. She stopped eating, going to church, and talking. It was a withdrawal that placed full responsibility for her care on her daughter. Included in *Report from Part Two*, the poem "My Mother" (1975) portrays the elderly as wary time-travelers from the epoch just preceding ours. Brooks's rhythms sound like Emily Dickinson's. Brought up in an earlier period, her mother nevertheless tries to inhabit the present, though the future is too daunting so she retreats from it. Teetering and toppling, she experiences her own fragility as well as the disorientation of surviving as a stranger in a baffling new era. Yet the past taught her how to make do with what's at hand and how to dig or dredge up resiliency or meaning from her experiences. Yesterdays also trained her to "thoroughlize," a coinage to convey her mother's rigorous standards of cleanliness, healthiness, and godliness, all of which endowed her with the capacity to enjoy the surprise of encountering if not new then "not-old" phenomena. "My Mother" reminds seniors today that though we cannot tell ChatGPT from Substack and Twitch, many of us can still use FaceTime.

In a droll afternote to "Keziah's Health Book"—containing her mother's advice to the elderly on diet ("non-constipating"), exercise (only housework), rest (sitting while peeling potatoes), and healthy habits (cultivating "cheerfulness" by letting "others have the last word")—Brooks explains that near the end of it, she found a slip of paper on which her mother "had tabulated her wordage per page. The total was 746 words." Humor tempers even the grimmest moments in *Report from Part Two*.

For example, Brooks's account of visiting Elmina Castle on the Cape Coast of Africa. The dungeons in which many of the enslaved died, the doors through which others were shipped out to bondage: "No one—well, no Black—experiences Elmina without exhaustion, ache, rage, and a drained and helpless Oh." Yet Brooks follows this encounter with an exchange that challenges her identification with

her roots. Engaged in conversation with a young Cape Coast businesswoman, her husband says, "We Blacks in the United States envy you. You ARE AFRIKANS. You KNOW this country is YOURS— that you BELONG here. We Blacks in the United States don't know what we are." The businesswoman replies somewhat impatiently, "YOU AmeriCAINE!" Brooks realizes that no matter how much she stresses the need to resist the label *African American* and to embrace the identity *Black* so as to stress her identification with Black people all over the globe, in Africa she and her husband would always be viewed as Americans.

Brooks ends "In Ghana" with the amusing inscriptions on the sides of trucks on the highways: "The Lord Is My Shepherd—I Don't Know Why" and "Friends Today—Enemies Tomorrow." *Report from Part Two* is peppered with Gwendolyn Brooks's jokes, even about her own fame. When describing the downtown public library in Chicago, which contains Sara Hiller's bronze sculpture of her—"staring across the room at Saul Bellow"—she wonders, "Just the two of us. What do we say to each other when the library is closed?"

In other sections of *Report from Part Two*, Brooks pokes fun at her technological incompetence and the decided limits of her fame. Delighted by the serious Black actors she sees in movies, Brooks admits that she watches them on television with a VCR, "but my daughter, Nora Brooks Blakely (brilliant), or my husband, Henry Blakely (brilliant), must set it up for me." In a Wisconsin town, Brooks remembers, she met a bookseller who could not believe that "this old Black woman ... was buying almost $300 worth of books." While he wonders if she is buying them for her employer—he is too polite to say "Your Lady"—she explains that she likes to read. "He looked at me a though I had said 'I like to climb to the top of Mount Everest.' Indeed I believe **that** announcement would have made more sense to him."

Irony empowered Brooks to spurn White literary establishments, even when she was placed in the position of the token Black. In an account of her attendance at the Sixth Annual Soviet-American

Writers' Conference, she skewers White Americans and their Russian hosts. Brooks is derisive when a Soviet writer responded to "The Life of Lincoln West" by claiming he had found one little Black boy "*touchable* and absolutely *darling*" and "'NEVER PAID ATTENTION AT ALL TO THE FACT THAT HE WAS NEGRO'!!!!!!!!!" About the Russian's supposed color blindness, she exclaims, "*Essential* Blacks—by that I mean Blacks who are *not* trying desperately to be white—are happy to have you notice that they do not look like you.... We essential Blacks do *not* think it would be a blessing if everyone was of the same hue."

With some of her American colleagues, Brooks could be more lighthearted. To the poet Robert Bly, she tells a story she had heard about his "three-or-four hour readings, and how, at one of them, there being no door to use without disturbing the entire assemblage, the students began to leave, one by one and two by two, out of the back windows." She deadpans: "Whether Robert is happy to have this bit of information or is *not* happy to have this bit of information I cannot tell." At various functions, "Erica Jong wants to know: 'Where are the women writers? *Where* are the *women* writers?'" Because the Russians typecast Jong as a sexpot, "They are surprised and discomfited when her major speech at the table turns out to be brilliant, informed, managed, sane."

Brooks aims her sharpest sarcasm at the "determinedly intellectual" Susan Sontag, who asks at one lunch, "'Why are the *wives* here?' (meaning the American wives Mrs. Irving Stone, Mrs. Harrison Salisbury, Mrs. Arthur Schlesinger, all of whom are writers of distinction...)." In Leningrad, "Susan got very 'mad'" when a Russian reporter asked Brooks what it means to be Black. "Susan begins to inform her. I *burn*.... I say (approximately) 'Why do you turn from me to her with this question. Obviously, being Black, I know more about What It Means To Be Black than does *she*.' Susan (approximately): 'How *dare* you assume such Nonsense' (her rage capitalizes the word) etc. etc. etc., in agitated spew" (ellipses mine).

Sontag's "screaming" has pushed her into "wild-eyed frenzy."

When she and Brooks sit down in a palace they are touring, Sontag says, "I TURN MY BACK UPON YOU," and then "carries out this awesome threat. She turns her Back upon me, with a gr-r-eat shake of her bottom to appall me." Brooks declares, in a succinct paragraph, "I am ass—uredly impressed" and then states, "I was guilty of a breach of etiquette. So were the hosts of the Boston Tea Party." Brooks's capitalizations, italicizing, paragraphing, and hyphenation enhance the inanity of the episode.

An appreciation of absurdity permeates Brooks's annual report at the Library of Congress. "The general understanding is that the Consultant in Poetry does *nothing*. Of course, many people *laugh* when they hear the word 'poet.' Being a poet, it is supposed, is akin to being a lunatic." In fact, she says of her year of commuting from Chicago, giving presentations, being interviewed, visiting schools as well as prisons, planning programs, attending receptions, greeting foreign visitors, and introducing speakers, "I have never worked so hard in my life!"

In an introduction of Sandra Cisneros, Luis Omar Salinas, Alberto Rios, and Lorna Dee Cervantes, Brooks expresses her pleasure at the audience's attendance, "If only because your children may be studying a plump Laurence Perrine anthology—very popular in contemporary schools—that carries not one poem by an Hispanic in any category." When introducing Haki Madhubuti and Sonia Sanchez, she defends them against accusations of racism by defining racism as "Prejudice With Oppression": "you are permitted to detest green eyes.... You are not permitted to kill every green-eyed individual you encounter." Then she states the obvious—"These two people are not killers"—before joking that a comment about "non-spunky" White critics who misuse and appropriate some Black poets will be twisted into an accusation: "GWEN BROOKS CALLS ALL WHITE CRITICS NON-SPUNKY!"

Brooks's teasing introductions enabled her to express her knowledge of the tenacious history of racism without getting on a soapbox. In her introduction of the radio raconteur Garrison Keillor that

mentions his great-uncle whose first name was "Senator," she recalls that Blacks in the old South did not appreciate Whites calling adults by their first names, so they "named their children Captain, Major, Colonel, Squire, Duke, King, Highness and LORD. (That drove many a poor 'master' wild OR to an unwilling courtesy.)" In the second to last essay in *Report from Part Two*, "Family Pictures," Brooks accepts "a once-spanked Decision, that old legislation. If you have 'One Drop' of Blackness blood in you—yes, of COURSE it comes out red!—you are mine. You are a member of my Family. (Oh, mighty Drop.)"

Tongue-in-cheek, Brooks used humor to articulate her anger at injustice, which partly explains her popularity with White as well as Black audiences. In 1995, she received the National Medal of the Arts from President Clinton. Soon her name started appearing on cultural centers and schools. Yet several blows cast the poet down in her last years, including the death of her husband and the theft of some of her papers, which were sold without her permission to the Bancroft Library.

Still, her students attested to her ongoing vivacity when, for example, she assigned them "the task of creating original insults without including curse words." In 1997, a participant in her last poetry workshop, Quraysh Ali Lansana, described the benefits he received "from her fierce red pen" and her engaging presence:

> Ms. Brooks in a workshop was a marvel and a wonder. She was an igniter of mind riots. She dropped morsels of ideas: clippings from newspapers, poems by authors she admired, assignments in traditional forms, then sat back and watched us scramble, scrap, and heave. All the while a mischievous, wide grin on her dimpled face, rubbing her hands in delight. She loved instigating, agitating.

Two years later, Lansana, visiting a visibly sick Brooks, saw that "she was weak and clearly in pain, though gracious and playful as always."

According to the poet-biographer Angela Jackson, Brooks took to a hospital bed at home one week before her death from stomach cancer. Haki Madhubuti and Nora stayed with her, and at the end "Nora placed a pen in her hand."

Before she died, with some sixty-four honorary doctorates to her name, Brooks felt inspired by Queen Latifah and Public Enemy "to write a few raps myself," to participate in a music phenomenon she could be said to have initiated with "We Real Cool." That poem, set in the Golden Shovel pool hall, has recently generated an entirely new poetic genre. When the poet Terrance Hayes "decided to string the whole poem down the page [on the right margin] and write into it," the Golden Shovel form was born: the writer takes each word in a previously published poem and uses it to end each line of a new poem. The earlier poem is preserved vertically within the new poem it has hatched. The Golden Shovel is a fitting tribute to Brooks partly because it is so much fun to try and also (I suspect) to teach.

Posthumously published, *In Montgomery and Other Poems* (2003) concludes with the crowning achievement of "In the Mecca." It would be wonderful to know if the poet had a say in this editorial decision. Given the current state of scholarship on Brooks, however, it is impossible to ascertain. Shockingly, her letters have not been published, her prose has not been collected, and no edition of her complete poems exists. Nor is there a definitive critical biography. It is clear, though, that Gwendolyn Brooks blazed with a feisty passion that infused her old age with resolution and camaraderie. Late-life militancy supplied her with adopted sons, new poetic subjects, the determination to support aspiring artists of color, and an intensified sense of belonging to the far-flung populations she considered her extended family.

CHAPTER 9
Katherine Dunham

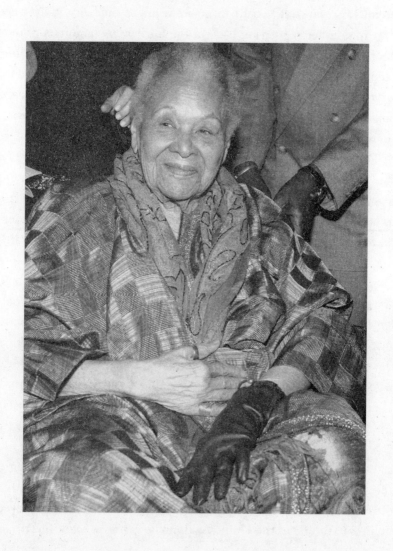

At the age of eighty-two, the dance pioneer Katherine Dunham undertook a forty-seven-day hunger strike to protest the forced repatriation of Haitian refugees ordered by then-President George H. W. Bush. When the comedian Dick Gregory organized a vigil at her home in East St. Louis, Illinois, and the Reverend Jesse Jackson visited to generate more publicity, they were drawing on her reputation back in the 1940s as a glamorous proponent of Caribbean culture. On stage and screen, she had become, according to one twenty-first-century admirer, "the Beyoncé before Beyoncé." By means of theatrical presentations, Dunham showcased pan-African artistry all over the globe. How and why did an international star end up an activist in East St. Louis?

Dunham published the first of two books about her youth when she was fifty years old. It was composed while she lived alone in Tokyo, during a period of mounting stress after her remarkable rise to fame. She had pursued graduate studies in anthropology, undertaken fieldwork in the Caribbean, and received classical ballet training before beginning to translate her ethnographic research into choreographed pieces that put on display the value of African- and Caribbean-infused dance traditions. Dunham's first full-length ballet, *L'Ag'Ya* (1938), took its name from a Martinique martial arts dance that probably originated in a Nigerian wrestling match. Attired in the exotic outfits created by the White costume designer John Pratt, who would soon become her husband, Dunham radiated erotic allure in the shows she directed with the groups she led in Chicago.

Two years later, in New York City, Dunham's *Tropics and Le Jazz "Hot"* (1940) included Caribbean, Afro-Cuban, and Peruvian dances as well as vernacular dances like the jitterbug, the boogie-woogie, the shimmy, and the black bottom. On Broadway, she appeared in *Cabin in the Sky* (1940) as a temptress vying with the pious wife played by Ethel Waters. In the Hollywood movie *Stormy Weather* (1943), she

and her company were featured along with Bill "Bojangles" Robinson, Lena Horne, and Fats Waller. By establishing the Dunham School of Dance and Theater in 1944, located in Manhattan's Times Square district, Dunham was able to attract such students as Eartha Kitt, Arthur Mitchell, Chita Rivera, James Dean, Butterfly McQueen, Marlon Brando, Shirley MacLaine, and Sidney Poitier.

At the height of her popularity, Dunham took center stage in a succession of theatricals, from *Tropical Revue* (1943–44), which included a number called "Rites of Spring" that was banned in Boston for being too sexually explicit, to *Carib Song* (1945) and *Bal Nègre* (1946). The impresario Sol Hurok floated the rumor that Dunham's legs were insured for a million dollars. Her dancing, she said, was "called anthropology in New Haven, sex in Boston, and in Rome—art!"

Yet on Broadway and in Hollywood, Dunham struggled with moguls who wanted her to cast only "pale-skinned" dancers and produce only stereotypically "racy" productions. Wherever she performed in the States, Dunham and John Pratt had to deal with prejudice against interracial couples and with the prejudiced assumption that dancing was an instinctual trait of Black people rather than a learned discipline. While touring in segregated cities, Dunham confronted the fact that people like her could not sit in the audience. In Lexington, Kentucky, she enjoyed recalling in her nineties, she pinned a sign on the back of one of her fancy skirts and turned her backside to the audience: "No Whites Allowed." "It was a rude thing to do," she chuckled, but it made the point that she would not return until the theater desegregated.

With her company on the road, Dunham recycled her repertoire of dramatic ballets, sometimes including African American plantation dances, sometimes accompanied by a full orchestra. The revues led to tours in Europe, where she and her husband received raves and adopted their daughter, Marie-Christine Pratt. Though Dunham choreographed the dance sequences for the movie *Green Mansions* (1959), from 1947 until 1967 she lived mostly outside the States,

touring with a company always teetering on the edge of bankruptcy, and eventually visiting some fifty-seven countries.

A series of troubles beset Dunham when she was in her forties. In 1949, her beloved brother died and so did her father. While she was in Chile with *Southland* (1951), a ballet about the horrors of lynching, the U.S. State Department suppressed reviews and canceled her troupe's visas. FBI Director J. Edgar Hoover, suspicious of her contacts with members of the Nation of Islam, started investigating her. In 1954, she had operations on her knees, which had given her trouble even in youth. In 1956, her husband left her during a taxing Australia–Asian tour. Dunham's stepmother died in 1957 and the Dunham School shut down, which was "a great shock," she later admitted: "It was never a school that paid for itself, and I felt terribly disappointed when the general public would not rise to its aid and when foundations would not give it support." At her closing night in Tokyo, Dunham fell on a knee during a precarious lift. Saddled with mounting debts, in need of recuperation, she disbanded her company in Japan and began channeling her energies into creative nonfiction.

The memoirs that Katherine Dunham produced at fifty and then sixty years of age—*A Touch of Innocence* (1959) and *Island Possessed* (1969)—recount, respectively, her childhood in the Midwest and the fieldwork that she did as a graduate student in the Caribbean. They also explain her project in old age: teaching a form of dance that could liberate the body from sickening Western values by drawing on African-derived kinetic movements. Dunham's retrospective books clarify the decision of a peripatetic celebrity to devote her old age to enriching a ravaged Midwestern town. During the last decades of her long life, she took her experience of thinking globally as a permit to act locally.

DANCE STANDS ALONE in the creative arts as age discriminatory. Because of strains on the body, many dancers retire in their thir-

ties, whereas Katherine Dunham's last performance occurred in her fifties. When, a few years before it, she adopted the less physically strenuous profession of authorship, she may have been preparing for retirement, but Dunham was also hoping for a bestseller that would resolve her hassles with the Internal Revenue Service. The wear and tear of finding and funding food and lodgings for a sometimes-quarrelsome company that she dubbed "The Insatiables"—because "she couldn't figure out exactly what it was that her troupe wanted of her, or of their own lives"—was a constant source of worry.

Although Katherine Dunham was hailed as a spectacularly beautiful and sensual dancer, she did not produce the sort of steamy chronicle of famous people and places that one might have expected. Instead, in *A Touch of Innocence*—which was dedicated to one of her mentors, the art historian Bernard Berenson—Dunham emphasized her fraught personal origins. Strikingly, the memoir is written in the third person about "the girl" Katherine, who only faintly remembers her dead mother's "fair skin, her French-Canadian background." The grammatical remove underscores the loneliness that overwhelmed Katherine Dunham's early development. Through the distance enhanced by the passage of time and by means of the third person, Dunham could tell the painful tale of her childhood desolation because all the members of her nuclear family were dead. Indeed, the original title of this undervalued memoir was *Requiescat in Pace*.

Dunham's introductory note to the reader states, "This book is not an autobiography." Instead, "It is a story of a world that has vanished," much to the author's grief and relief. The stressed girl, whom the author "rediscovered" in the process of writing the narrative, stands in marked contrast to Dunham's stage presence. In dance productions, she looked hot, torrid, full of desire, and maybe animated by a touch of evil from the various (pagan) rituals upon which she drew. Berenson's admiration at her company's ability to wake up "the sleeping dogs of almost prehuman dreads, aversions, aberrations" typifies the way the star was repeatedly associated with primitivism: "We feel at last free to return to the primitive, the infantile, the bar-

barous, the savage in us," he enthused, "even the way the Greeks of the best period did in Bacchic rites, so wild, so cruel, so filthy!"

In contrast to Dunham the performer, who often evoked lauded or reviled but generally racist stereotypes of barbarous Blacks, Dunham the director was viewed as imperious. She became famous for keeping people waiting, expecting everyone to do her bidding, and generally having a highly inflated sense of self-importance. One journalist, noting that she drove John Pratt into fits of anxiety by breaking her diet and arriving late to appointments, concluded, "She's a law unto herself." An early biographer stated that she "had long behaved in a regal way—like a queen who is holding court," especially on the tour that brought her to Tokyo when "she became a complete tyrant." When later in life Dunham was asked by an affectionate interviewer "*where the myth or truth came* [from] *that Dunham dancers hated you?*" she attributed it to her criticism of them "in no uncertain terms," even during the intermissions of performances, and described her mature personality as "authoritarian."

But in *A Touch of Innocence*, Dunham shaped an image of herself as a frightened, naïve girl alienated by the color codes that governed her community and imperiled by the aggression within her own family. Racial bigotry challenges her progress at every turn of childhood and adolescence, as does the hurtful impact of her upbringing by a workaholic father. By means of the character Katherine, Dunham the author stresses the divide that aging happily positioned between herself and her clueless, endangered younger self. Although biographers tend to use *A Touch of Innocence* as an unmediated source of information, it was clearly constructed by its author to contest and complicate her public images.

Katherine's mother, a divorcée with five children and four grandchildren, was quite a bit older and much lighter skinned than her father. At three years of age, the girl associates her mother's death with the cessation of music in the house and the Hatfield–McCoy feuds between her mother's light-complexioned family and her father's darker relatives: "the 'near whites' against the 'all blacks.'"

When her father, Albert Dunham, goes on the road as a traveling salesman, his son and daughter land with his sister, Aunt Lulu, a beautician living on the South Side of Chicago.

There, in cramped flats, the four-year-old dreads the violence and destitution she sees on the streets, but she also witnesses relatives rehearsing a musical dramatization of *Minnehaha*—in full "Indian dress" and "war paint"—scenes that "may have inspired in some small way her own eventual choice of a theatrical career." A babysitting cousin takes her daily to matinees where she sees "innumerable vaudeville shows," acquainting her "with the residuum of the minstrel era and with forerunners of the Broadway revue."

During the influx of Black people from the South into Chicago during the Great Migration, however, racist barriers solidify and Aunt Lulu loses her job. The child Katherine is uprooted from her aunt's stimulating though impoverished community by her half sister Fanny June Weir and taken to the wealthier "far South Side where a community of people neither white nor black, but mostly passing for white, had penetrated beyond the barriers set up against their darker brethren." Katherine, made to feel ashamed of her skin color, is rescued when Albert Dunham marries Annette Poindexter and moves the family to a mostly White town (which was in fact Joliet).

Only later, on a much-needed holiday in St. Louis with her stepmother, does the girl witness "ebony and mahogany and pale yellow" people endowed with "abandon and naked joy and fullness of meaning" while "enjoying whatever soft creole humor they were passing back and forth." At a catfish stand, "they weren't becoming dimmer and dimmer likenesses of what they should have been"; nor were they "picking up life-draining habits from the great middle class that they imitated, losing in the process all of the ancient, life-giving ones." The catfish she eats in St. Louis takes on "the proportions of the first ritualized sacrificial food of the initiate, dedicated through blood for life." The pleasures of working-class people—their music, humor, vitality, food—stand in stark contrast to her middle-class family's grinding obsession with productivity, frugality, and propriety.

In the high school days depicted in *A Touch of Innocence*, Dunham emphasizes the girl's growing involvement with international forms of dance. Katherine becomes enraptured with the Terpsichorean Club at a recital where a dancer appears as a Russian princess "thrusting first one leg and then the other forward from a squatting position with her arms folded." The *hopak* inspires her to organize a cabaret party, her "first experience as impresario, producer, star, and director." She performs "an Oriental dance (to Grieg), which she had reconstructed from a picture of a Turkish maiden on the cover of a pulp magazine and her recollections of Theda Bara as Salome," then leads a chorus in a cakewalk, and manages some of the knee squats of the Russian dance. A daring undertaking, the Blue Moon cabaret party raised enough money for her stepmother's church that it was judged a success, though it triggered schisms from objecting conservatives in the congregation.

Katherine's parents support her in this episode, as they do when the high schooler encounters the racism of a White band director who "carefully weeded out from among his students all possible non-Aryan elements." To her shock, the girl "found herself listening to classmates singing about a traveler who 'jumped on a nigger' in order to cross a river because he mistook the Negro for a horse." After Katherine refused to sing the offensive words, her stepmother and father circulated a protesting petition and the bandleader was confined to John Philip Sousa's marches.

Katherine's origins testify to the oppression, parochialism, and prejudice that Dunham spent her adulthood contesting. The girl's aversion to the White-dominated values of middle-class Blacks explains the older woman's recurrent sojourns in countries she associated with the African diaspora. Within societies where people of color constituted a majority, she sought alternatives to the lethal repercussions of systemic racism: poverty, ghettoization, violence, unemployment, shame, White mimicry, verbal abuse. Young Katherine's suffering from America's color prejudice clarifies not only Dunham's midlife expatriation but also her lifelong attraction to

proletarian, peasant, and folk forms of entertainments and her ongoing determination to establish multiracial, multinational dance companies and schools.

Just as important, through memoir writing Katherine Dunham escaped the straitjacketing images that threatened to encase her as a dancer and a director. A record of the shifting interiority of the consciousness of its very human subject, the autobiography blows to smithereens the barbarous primitivism ascribed to her as a speechless dancer. Her unusual narrative also underscores the insecurity behind the façade of the tyrannical director.

SIGNIFICANTLY, *A Touch of Innocence* begins not with its embedded critique of the color and class divisions in mid-America but instead with the frightened child left alone on a rabbit hunt undertaken by her father and brother, the two figures whose respective ferocity and fragility haunt Dunham from start to finish. Cold and wet, Katherine has urinated in her underwear so she wouldn't have to "expose bare flesh to the bitter still air and squat like a *girl*." Would her damp underpants activate the wrath of her father, the scolding of her stepmother, the disdain of her brother?

Katherine's father no longer resembles the music-loving husband who adored her mother. On the one hand, the exceptionally industrious Albert Dunham determined to use his dry-cleaning business to raise the family economically. On the other, he was an abusive penny-pincher who forced his second wife, son, and daughter to work long hours at his business and beat both children and sometimes their stepmother with his hands or a leather belt strap. One monstrous piece of equipment used to clean carpets, a dust wheel, symbolizes the father's violent power. Its maintenance terrifies both children.

Throughout the memoir, Katherine's protective brother furnishes a role model of resistance for his little sister: excelling at school,

defying his father's commands to focus on the cleaning business, and winning a scholarship to study philosophy at the University of Chicago. However, he breaks away only by threatening to shoot the father and incurring his undying wrath. Toward the end of *A Touch of Innocence*, Katherine's brilliant sibling is recuperating in Chicago from tuberculosis brought on by starvation and overwork. Dunham does not disclose the subsequent bouts of mental illness that landed him in an institution where attempts to take his own life and a lobotomy led to an early death. Until the end of her life, Katherine Dunham mourned the casualty her brother became.

Both of Katherine's parents subscribe to puritanical practices that keep their daughter socially isolated and sexually ignorant. Extracurricular activities and dating had to be relinquished for work or were forbidden outright. As the girl reaches puberty, Albert Dunham's rages feed off jealousy as his daughter bonds with his son and wife against him. When her half sister Fanny Weir's daughter comes to live with them, Katherine undergoes "a matriculation from juvenile optimism" that solidifies her "cold hatred" of her father and her "contempt" for her stepmother. Her revulsion arises from the realization that Albert Dunham had been trying to lure her young relative into some sort of assignation. This turning point in *A Touch of Innocence* foreshadows the father's ghastly attempts to seduce Katherine.

While the girl grew to resemble her biological mother, Dunham suggests, Albert Dunham's "frustrations became focused upon his daughter." His "touch and fondling" made "everything about her in life seem smudgy and unclean and waiting." Not exactly knowing what she is waiting for, Katherine senses that "the terrible *unknown*, the unclean thing smirked at, was in some way associated *unnaturally* with her own father." In this confused state of mind, when she is crossing a park, a vagrant accosts her and enlists her as a spectator while he "unfastened his loose-fitting, soiled trousers and inserted one hand into the opening." Thus initiated, "she lost the crystal-clear virginity that had until now carried her, untouched, past a knowledge too long held off."

Connecting the tramp with her father, Katherine later responds to his stroking the flesh above her knees with the "hands of a lover in first caress" by contracting in resistance. With newfound strength, she tells her father, "I don't want you to touch me again, ever.... Because now I know that I hate you!": the girl "fastened well the protective mantle of aversion into which she had been retreating farther and farther since childhood." At the close of *A Touch of Innocence*, the nineteen-year-old Katherine hopes to "find freedom from the parental vise" of her father's sexual abuse and her stepmother's ineffectual mediation.

Like her brother before her and with his help, Katherine goes to the University of Chicago and gets a part-time job working at a branch library where "Jews were unwelcome, foreigners of less than two-generation citizenship scarce, and Negroes unknown except as part-time hired help." Throughout the memoir, one senses the fifty-year-old author's pity for her confounded younger self, the undergraduate who does not realize that she has been shunned by the White librarians, as well as her scorn of decorous churchgoers like her stepmother who fail to obstruct the molestation going on within their own families.

Little Katherine immobilized in her sodden underpants at the start of *A Touch of Innocence* stands in marked contrast to the adult Dunham, who sometimes forgot to put on her underpants before performances and experienced a "cool breeze and feeling of freedom while dancing." The joyless Katherine suffers from the veneer of propriety that cloaked her father's incestuous advances, whereas Dunham dedicated her adult career to celebrating, even flaunting the body and its joyful erotic energies. Sexual repression breeds sexual predation, she learned at home, and her subsequent career set itself against such repression. Like her father, Katherine Dunham was driven by ambition, but it was dedicated to playfulness and sexual liberation.

In old age, Katherine Dunham stressed that she never aspired to be a solo dancer, because of her feelings of isolation in childhood.

Throughout her dance career, she rebelled against the inhibitions inculcated during her youth by means of uninhibited performance styles in one of the few art forms that put the body of the artist front and central. The disjunction between mortified Katherine and provocative Dunham reflects the confusion and shame that propelled a quest for physical, mental, and spiritual integration through performances of sensuality-in-motion.

WHEN MARTHA GRAHAM determined to stop dancing, she later explained, "I ... lost my will to live": she stopped eating, started drinking, and ended up hospitalized in a coma. It must have been a perilous passage for Katherine Dunham too. During her fifties, she pivoted away from her performance career by embarking on the sorts of choreographic enterprises that a fully recovered Graham would eventually take up in her last years.

Between 1959, when Dunham published *A Touch of Innocence*, and 1969, when *Island Possessed* appeared, the Dunham Company of dancers disbanded again after another European tour. The biographer Joyce Aschenbrenner attributes the breakup to "financial problems, exacerbated by the promotion of other performing groups by the U.S. State Department, and ongoing and increasing conflicts within the group." While plagued by debts, Dunham found it difficult to maintain the extensive property she had purchased in the 1940s, a historic plantation in Haiti called Habitation Leclerc, and her marriage remained strained. Her efforts to advertise the Haitian compound as a tourist attraction—complete with dinner shows, her own dancing, and "a voodoo ritual" in "an outdoor amphitheatre"—failed to pan out.

In 1962, Katherine Dunham returned to Broadway in *Bamboche!*, a production that took its name from the Haitian word for "having a good time." Noting Dunham's absence from Broadway for seven years, the *New York Times* dance critic marveled that "she did the

shimmy, a cakewalk, even a belly dance, with the gusto of a youngster." Yet despite its Moroccan, gospel, and jazz numbers, the show flopped. Indeed, the same *Times* reviewer found it "a hodgepodge" with its African and South American roots "covered by an overlay of 'showbiz' approach." The ethnic dances looked "a bit strange" when presented "with the trappings, manners and general hullabaloo of the music hall and nightclub."

Ironically, the Indigenous dancers Dunham had inspired in the Caribbean, Africa, and South America were now competing with her stagecraft and implicitly questioning its authenticity. But Dunham was also hampered by a newspaper strike that made it impossible to advertise the show. To help pay for the dancers' airfare home after the closing of *Bamboche!*, Dunham arranged a booking at the Apollo Theater in Harlem for her very last performance and the final appearance of the Dunham Company.

Enlisted to work on John Huston's film *The Bible: In the Beginning...* (1966), Dunham also choreographed a production of *Aida* (1964, 1966) featuring Leontyne Price at the Metropolitan Opera. She trained the (mostly White) Met dance company at the reconstituted Dunham School, which also provided dancers of color. After studying ethnological and archaeological findings, she decided that "the army's triumphal march" in the opera would include "people from different tribal groups." Highlighting the African (over the Middle Eastern) nature of Egypt, she included "Bedouin girls swathed voluminously in shades of pale and indigo blue," "four high-leaping Somalis from south of Ethiopia," and Nubian warriors enacting the "striking, punching, kicking and springing movements of traditional *karate*."

To one performance, her brother-in-law, a professor of design at Southern Illinois University in Carbondale, brought an administrator who offered to make Dunham an artist-in-residence. In 1965, she accepted the position and began proposing educational programs for East St. Louis—she was angling for the establishment of a performance arts training center—to meet the needs of a town that,

she explained in the proposal, "had been the focal point of racial resentments, riots, delinquency and poverty for many years." At the same time, she was choreographing Charles Gounod's opera *Faust* at SIU in Carbondale—setting the Walpurgis Night ballet in a Nazi concentration camp and transforming Mephistopheles into a storm trooper on a motorcycle.

The next year Dunham underwent surgery on both of her knees in Paris, which did not stop her from traveling to Port-au-Prince, where she oversaw Habitation Leclerc, and to Senegal, where President Léopold Senghor appointed her to train the Senegalese National Ballet and to serve as advisor to the 1966 First World Festival of Negro Arts. While in Dakar and with characteristic grit, she stymied efforts to build a Club Med on the island of Gorée, the place where captured Africans had awaited transport into slavery. Dunham's plan for establishing a cultural center there failed, but it reflected her ongoing commitment to the international Black Arts Movement. In Dakar, too, the fifty-seven-year-old began writing *Island Possessed*, an ethnographic account of her 1935–36 fieldwork in the Caribbean that illuminates her decision *not* to spend her senior years choreographing new ballets and staging revivals of the earlier ones, as Martha Graham did.

IF *A Touch of Innocence* represents the traumatizing America that Katherine Dunham fled, *Island Possessed* holds out the hope of a restorative Haiti, where she first experienced the bliss roused by the bodily movements taught by nonprofessional Caribbean dancers. In a first-person narrative composed more than three decades after the graduate fieldwork that it recounts, Dunham identifies her younger self as a budding anthropologist relieved that the oppressive American occupation of Haiti has ended and aware that she was "easy to place in the clean-cut American dichotomy of color, hard to place in the complexity of Caribbean color classifications." The book's most

sustained account—of her youthful initiation into "vaudun" (which many Americans still call *voodoo*)—explains why the youthful Dunham chose to commit herself to dance instead of anthropology and why the elderly Dunham would dedicate herself to dance pedagogy instead of choreography.

As a graduate student, Dunham may have been allowed to participate in the initiation ritual of *lave-tĕte* (head washing) because Haitians assumed that anyone from Africa "is potentially 'vaudun'" and that "those of us black people carried from Africa to other parts of the world, especially to the United States, are known to be in total ignorance of many truths," including "what we have been made into by slavery and/or colonialism." The dance rituals of vaudun would become a conduit to her roots and an antidote to the psychological disorders suffered by the enslaved and colonized. Yet Dunham the author emphasizes the disorientation her younger self experienced throughout the initiation process. Though she started out trying to be an observer-participant, that anthropological stance was very difficult to sustain.

In her description of how she became a *hounci* (a first-degree servitor of the gods), Dunham stresses how unnerving the experience was. It begins with the physical distress of being *couch'd* (put down on a dirt floor) for three days in a temple. Turning over only when instructed to do so, the initiates lie "spoon fashion, well fitted into each other, nine of us, ranging in age from seven to seventy, both sexes." After the woman next to Dunham is possessed by a *loa* (a god) and losses bladder control, the smell and damp as "the hot stream of urine spread over my new baptismal nightrobe" swelled Dunham's disconsolate suspicion that the "promised ecstasy" would never arise. Hungry, thirsty, chilled or sweaty, but generally aching, "I condemned all mysticism, all research, all curiosity in the ways or whys of other peoples, all 'call,' all causes."

Providing thick descriptions of the garments, foods, and animals brought by initiates for propitiatory acts, Dunham depicts the sense of kinship she began to feel with the other eight participants. She

recounts their varied backgrounds as well as the gods they seek to serve and their guides, one of whom decides on Dunham's *loa* after seeing her "dipping and swaying, knees close-pressed, bent back undulating in the yonvalou as seen in Dahomey today, in obeisance to Damballa, the serpent." Yet on her first field trip in Haiti, described at the start of *Island Possessed*, when Dunham had encountered a python the revulsion it triggered caused her to vomit.

Throughout the preparatory ritual to the marriage ceremony with Damballa, Dunham feels poised between observation and participation. Watching a possessed drummer, she realizes that her efforts to note choreographic patterns keep her "on a profane level," and she feels "ill and squeamish about the diet" of her god, which includes raw eggs. As an audience arrives to witness the marriage ritual, the "drumming, possessions, and celebrations outside seemed banal." Even when the bells, incense, rattles, and drums give her a "trance feeling," it would depart, "and instead of feeling the god in possession of me, the calculating scientist would take over, and I would be making mental notes on clothing, social organization, speech habits, associated traits, and so forth."

The split between skeptical observer and entranced participant motivates Dunham's efforts to believe if not in the gods, then at least in the sincerity of the other acolytes. Each initiate recites an oath to his or her god before approaching the altar—at which point Dunham goes on to celebrate "the dance of religious ecstasy," when body and being unite, "when form and flow and personal ecstasy became an exaltation of a superior state of things." Her younger self hopes that her marriage to Damballa might release her brother from "the torment that had confined him to St. Elizabeth's Hospital," or at least help her come to terms with "the supreme tragedy of my life, my brother's illness."

The title of *Island Possessed* gestures toward Haiti's having been possessed by the Spanish, the French, and the United States; it is a country possessed by syncretic traditions created by slaves abducted from many different homelands; it is possessed by Catholicism and

Catholicism's doppelgänger, vaudun; and vaudun's participants are possessed by the gods who protect or threaten their families. But Dunham herself becomes possessed by dance at the climax of the initiation ritual, which is prefaced by a quote from Nietzsche: "*now I see myself raised above myself, now a god dances in me.*"

After the initiates move from the temple into an outdoor arena, they assemble in front of an audience that includes Dunham's friends Doc, Cécile, and Fred. Bells, rattles, and drums rescue Dunham from worrying about whether or not she would be god-possessed during "the pure dance part" of the ceremony. All of the initiates begin "a spasmodic, hunching forward and releasing of shoulders, which, when continued for some time, particularly when driven by the piercing beat of the *kata*, enriched by the broken rhythms of the seconde, and eroticized by the deep insistent tones of the mama drums, produces a state of mixed lightheadedness and well-being."

As the rapt participant rocks her shoulders, the excitement of "forced regular breathing," along with rhythmic moving and "fast-induced hypnosis," instills "harmony with self and others": "Now I was 'out and above and beyond myself,' dancing." In particular the slow and fluid *yonvalou* dance—"penetrating and involving the solar plexus, the plexus sacré, the pelvic girdle"—leads to transcendence. Undulating in a low squatting position, Dunham enters a "transported world." Amid the "tongue-whirr of the serpent god," serpentine motions mesmerize her until she feels herself to be "belonging to myself but a part of everyone else."

Dancing proves that her god has "an undisputed position of sexual authority." She associates her celebration of him not only with "the 'ecstatic union of one mind' of Indian philosophy, but with the fixed solidarity to the earth that all African dancing returns to," for "I felt *sublimely free because I was experiencing ecstasy without being taken over, 'mounted,' or possessed*" (emphasis mine). As is true for the presiding priests, "the god is there, speaking through the person but not attempting to take over the person in terms of unlimited control."

Dance emerges as a blissful and visceral form of god-infusion but

without god-control, a form of sexuality but without having sex. It gives Dunham a sense of the singularity of herself connected to others through shared euphoria. The sensation of *"now a god dances in me"*—while she is surrounded by other brown bodies also suffused with divinity—sparks exultation at escaping the hatred, self-hatred, and repression of her American upbringing. At the moment *"a god dances in me,"* she is released from the shackles of racism.

Yet the youthful Dunham's full participation in dance contrasts with her inability to fully participate in the rituals of vaudun. When a possessed votive demands the sacrifice of a living chicken, seizes it with his teeth, and begins sucking its blood, she flees and again vomits. She takes refuge in the "cool, white, pink-embroidered hope-chest sheets" of Cécile and finds solace in a ham sandwich on French bread brought to her by Fred.

With all public dance performances behind her and none ahead of her, Dunham used *Island Possessed* to explain why dance, rather than anthropology, became her mainstay for forging a transnational existence. As an anthropologist-observer, she felt disaffected, obtrusive, or voyeuristic; as an anthropologist-participant, she felt nauseated and revolted or a failure. Not Western ways of knowing but Caribbean dance would serve as the source of her lifelong belief that African-based performing arts—transcending language barriers—could provide physical and spiritual balm to offset the estrangement accompanying not only assimilation into White societies but also transnational interactions within Black societies. By reuniting diasporic populations with the traditions of Africa-influenced countries and by confounding American racism with the rapture induced by grounded Afrocentric rhythms, dance could heal psychic wounds.

At the same time, the initiation ceremony in *Island Possessed* underscores the mature Dunham's recognition that the showbiz versions of Caribbean dance that she had marketed for thirty years could not instill the ecstasy that characterized her immersion in the Indigenous rituals on which they were based. The risqué performances that had made her name packaged a stylized version of

Caribbean culture palatable to Western audiences because only such commodified renditions could get commercially produced; however, they could not excite the transcendent feelings she experienced in learning Caribbean dance.

By her sixties, Katherine Dunham knew that the island sold on Broadway failed to convey the island that had possessed her. The last decades of her life would increasingly find her not on the stage of theaters but in the dance studio of schools populated by people in need of the jubilant sensation of godly glory that dancing could kindle.

BEFORE AND AFTER the central initiation in *Island Possessed*, Katherine Dunham expresses her reservations about anthropology and Haiti. The book opens with Dunham's realization that the Western ethnographer will be viewed—and may experience herself—as a colonizer: "It is with letters from Melville Herskovits, head of the Department of Anthropology at Northwestern University, that I *invaded* the Caribbean" (emphasis mine). That anthropologists would fare no better than other colonizers becomes clear during her last research project, when the persistent graduate student investigates legends about a priest, with zombie wives, who practices cannibalism. She finds out nothing about ritual human sacrifice and can only theorize that the zombie wives have been hypnotized by a magnetic leader.

When, before leaving the island, Dunham attends a ritual to renew her marriage vows to Damballa, she again dramatizes her failure as an anthropologist, but also her success as a dancer. Amid singing and dancing of the *yonvalou*, Dunham was supposed to consume her god's food, but "I succumbed to one of my old taboos, a revulsion toward eating raw eggs," augmented "by the fact that the egg was not quite fresh." Inching rhythmically toward the sacrificial plate, she crushed the egg with her chin, "unable to overcome my repugnance." The writer depicts her tearful humiliation, but then

her recovery: "I danced out all my anger at unknown things and at myself for trying to know them, frustration at the rotten egg and weariness with strange mores," as others clapped and "it dawned on me that it was with affection and encouragement." Once again, "my dancing had saved me from disgrace."

The aging Dunham's doubts about anthropology counterpoint her deepening gloom about Haiti's prospects. At the start, she focuses on her friend Dumarsais Estimé, who condemned vaudun for diverting Haitians from tackling their socioeconomic problems. His personal history quickly spirals down. An idealistic politician dedicated to solving the education problems besetting his people, President Estimé would reform school curricula, replacing French with Haitian history, because without it the young "would be as deracinated as American Negroes, who knew only the brilliant exploits of people whose skin color automatically made them superior in the social structure."

Thus, Dunham sees Estimé as a pioneer in the international call for *négritude*, the movement for valorizing Black identity that has "now become a cry for revolution in North America." Though here Haiti seems to be in advance of America, by 1950 the exiled Estimé was a "haunted, hunted" outcast. That his life was in danger "turned all the years that I had known Haiti into a mockery. I had dreamed of, written about, acquired property in, spread the good word far and wide about *a country of which I really knew nothing*" (emphasis mine).

Toward the end of *Island Possessed*, François Duvalier's presidency casts a pall. Dunham contrasts the Mardi Gras on her first trip to Haiti with a later one under Papa Doc's aegis. In the first, "the sexual ecstasy" of the dances is not linked to physical consummation: "So in this mass dancing I have never taken sexual gestures or close physical contacts as a direct advance." But under Duvalier's rule, she "felt sad and sick at the increased poverty" and "unnerved at the lost rhythm set off into epileptic spasms by the badly hooked-up portrait of the President." Whereas in earlier days carnival was a "catharsis in national spirit," now "there is no place for such in a starving nation."

Island Possessed concludes with a meditation on the prediction that "the master of Leclerc will never be happy." Despite its beautiful springs, tropical trees, and views of the bay, Habitation Leclerc "had brought some deep, insoluble sadness" during the decades in which Dunham remained married to John Pratt and their daughter grew up. She attributes that sadness to the ghastly history of the plantation when Leclerc's successor "drowned, asphyxiated, hanged, fed to man-killing dogs, starved to death and buried alive" many slaves.

At the compound, Dunham realized that she had to have the soil exorcised so "all of the restless, vengeful, agonized souls" could drift back to Africa. Convinced that the ritual had worked, she opened a clinic in Habitation Leclerc that at one point treated "as many as four hundred outpatients and a half-dozen inpatients monthly" while she rerouted "energies formerly used on stage or at a typewriter" into "therapeutic massage, injections, cleansing and salving ulcers, boiling needles, worming babies, and other clinic demands."

But Dunham had a hunch that she should reject an offer of funding that would empower her to expand the "feeding station for mothers and babies" and address the "delicate subject" of birth control. She closed the clinic and later learned that the financial aid would have turned it into "a subversive munitions station" for Duvalier's political opponents. By ending *Island Possessed* with this act and emphasizing throughout the perplexities of cross-cultural contacts, Dunham suggests that she was beginning to believe that she could be a more effective healer back in her home state.

Dunham's recounting of her entrance into Haiti prefaced her departure from it. For the rest of her life, she would deploy dance as a therapeutic form of community building in Illinois, where she could rely not just on her past prestige as a dancer but also on the wisdom that she had gained as a memoirist. Dance and anthropology had rescued her from the racism and repression that beleaguered her youth in America. She would dedicate her old age to youngsters less well off than she and her brilliant but doomed brother had been—by becoming an advocate for the arts and the humanities.

EXORCISM AND HEALING were Katherine Dunham's goals in East St. Louis. She was interviewing members of a street gang, the Imperial War Lords, when she was jailed for disorderly conduct. She had been attempting to enroll the young men in a training program at Southern Illinois University when they were hauled away in a police car and Dunham insisted on knowing why: "One cop started pushing me around and two other pig cops started twisting my arms." Headlines about the arrest embarrassed city leaders, who quickly presented her with the official key to the city. But her feisty resistance to police profiling may have secured the community's trust.

Dunham was shocked at how badly race relations had deteriorated during her sojourns overseas, especially "the violence, the rage so often turned inward on the community itself. It was so disheartening, all those young men going up in flames." Though she planned to stay in the Midwest a month, "Once there, I was so moved by the terrible situation of East St. Louis, the hopelessness, apathy, and utter despair that had been intensified by the riots, that I remained." The city was worse off than many of the impoverished districts Dunham had visited overseas: condemned tenements, shattered windows, burned-out vacant lots, a cultural wasteland without even a movie theater. In 1968, she and her husband moved from a house in nearby Alton to a home in East St. Louis. It was a gutsy relocation.

Touting karate and judo and drumming, Dunham began recruiting youngsters into the newly formed Performing Arts Training Center (PATC) in order to "direct their energies in alternative ways, in ways that would be good for the community and not so self-destructive": "The young man who might be out on a bombing raid one night would probably be in on a drumming class the next." The point was not so much to teach, say, drumming as it was to teach youngsters "through performing, that they have individual worth and can relate to other people." In 1976, Dunham confided to a jour-

nalist, "Being on stage was, for me, making love. It was an expression of my love of humanity and things of beauty," precisely the emotion she sought to instill in her pupils.

When shootings or bombings occurred in her neighborhood, Dunham wrote a friend, "It is interesting how feeling certain now of the date of my death I find I have something to live for!" When university officials asked her to move for her personal safety, they ignited her tenacity: "That's the wrong thing to say to me," she informed them: "Now I'll never leave." Weekly funerals punctuated internecine violence in the neighborhood. What kept her in East St. Louis, she often said, was thoughts of the grandmothers.

Though she occasionally traveled to other college campuses, Dunham settled down. She served as the cultural affairs consultant to the Edwardsville campus and as the creator/director of the Performing Arts Training Center and the Dynamic Museum (now the Katherine Dunham Museum). With the assistance of Jeanelle Stovall, a friend she had made in Dakar, Dunham employed teachers and consultants who had worked in her school, former members of her company, and musician friends, as she dedicated herself to inner-city kids who could profit from what she called "universities without walls."

Amid escalating police violence as well as growing militancy in the Black Power movement, the fervent administrator procured funding from major foundations and the government by deploying the language of humanism. She attributed her faith in humanism to the influence of a series of intellectuals: the anthropologists with whom she had studied, Bernard Berenson, and the social psychologist Erich Fromm. Late in life, with a group of youthful militants, Dunham flew to visit Fromm when she felt they needed his guidance: "So, in addition to our cherished audiences with 'Miss D,'" recalled Eugene Redmond, the poet who would become East St. Louis's laureate, "we never knew whom or what we might meet or see!"

Dunham sought to raise the status of dance within the arts and integrate it with disciplines clustered in the humanities. In her

efforts to instill in her Black students a sense of pride derived from their diasporic heritage, she managed to attract young and old members of the community into college credit as well as adult education classes that might inspire in them the hopes and dreams of a future. With students and teachers encouraged to congregate at her house, it became, according to Redmond, then a student who was serving as her chauffeur, "like a salon, the equivalent of those cafés in France." One former dancer remembers that Dunham "insisted on preparing meals from scratch rather than using prepared foods," often starting with "Haitian rum punch, made in a blender from a recipe whose formula is always kept secret." Redmond recalls her cooking foods as exotic and sundry as her foreign languages.

Consistent with her commitment to community service, Dunham insisted that she did not want to remained focused on her past alluring image. Not glamour but education engaged her. "In our capsule of arts training here in East St. Louis," Dunham boasted, "we have seen art serve as one of the methods of arousing awareness, of stimulating life to be thinking, observant, and of serving as a rational alternative to violence and genocide." According to the dance historian Joanna Dee Das, "By 1970, between 200 and 300 students took PATC classes at the main building, and another 1,400 took classes at neighborhood community centers or public schools; 1,000 (preschoolers) took classes through Head Start, and 200 adults through the Concentrated Employment Program."

Dunham organized some of the musicians and dancers in the PATC classes into a performing company that toured extensively—sometimes in front of Ku Klux Klan protesters, sometimes amid threats of gun violence—with dances that drew on legends about African folk heroes. At 1968–70 festivals, the Dunham-produced ballet *Ode to Taylor Jones* paid tribute to a Black Power activist who had died in a car accident. In 1970, Dunham took forty-two of her students to perform at a White House conference on children. In 1972, when she choreographed the premiere of Scott Joplin's opera *Treemonisha* (1911) at Morehouse College, her students—enlisted in the

chorus—received rave reviews for the "scalp-tingling power" of the big song-and-dance numbers.

By 1977, the Dynamic Museum was reversing the preservationist principles of most museums and instead putting on interactive display the costumes, musical instruments, carvings, tapestries, photographs, programs, records, and films that Dunham and John Pratt had collected or made throughout their travels. Objects could be worn, touched, or played. "Beauty rubs off," she said. Though she wanted to compile her correspondence with Berenson and to compose both another memoir to be titled "Minefields" and a book about the Dunham Technique, fundraising and grant writing, workshops and rehearsals, and numerous administrative tasks nudged aside those writerly projects.

The Dunham Technique, which the instructor taught in a succession of East St. Louis summer seminars and artist-in-residence programs elsewhere, evolved because of her own knee problems. As therapy, she engaged in extensive muscle-stretching exercises. Dunham trained student dancers to move the head or the rib cage to one side and then the other and then in continuous circles, while holding the rest of the body stationary. At the barre her "isolation breakdown" derived from classical ballet and modern dance as well as from other sources: head and neck movements from the Pacific Islands, torso and arm movements from Africa and the West Indies, toe and foot movements from Haiti.

On the floor, Dunham students practiced progressions—prances, jumps, rocking steps, and leg swings—while isolating the pelvis, contracting it every which way. The "serpent mimicry" of the *yonvalou* remained her signature—"The movement is prayer in its deepest sense"—which is why Martha Graham (somewhat derisively) called Dunham "the high priestess of the pelvic girdle." In keeping with the insights obtained through writing *Island Possessed*, the elderly Dunham was convinced that the curative capacity of dance could be best tapped not as a commercial spectacle staged for White (or at best mixed) audiences but rather through Black, brown, and sometimes

White bodies sharing a single space in restorative and highly disciplined exercises and routines.

Considered a "severe taskmaster," Dunham enjoined students, "Never say I'm hot, never say I'm tired, just go on." Throughout her last years, Miss D, as she was called, stressed the physical, psychological, and spiritual benefits of rhythmic movements that could align the head with the heart and the feet in a joyous affirmation of the worth of embodied life. According to Eugene Redmond, some people could not bear the "crush, a psychological pressure that you can't identify at the time, when you're working under Miss Dunham." Perhaps because of her rigor and perfectionism, or because of her collection of god and goddess statues, she was known as the Black Witch of Tenth Street.

Sometimes wearing "a chic headwrap or bare-headed, letting her mingled gray [and later white], medium-length afro frame her well-structured face," often attired in African robes and many necklaces and rings, Dunham had become a grand figure who banked on the fact that she was reputed to be "a mystic and a clairvoyant and a Voodoo priestess and all that." Tongue in cheek, she would taunt and threaten the dancers she trained so as to get their full engagement at rehearsals. The voodoo priestess role served her purposes. "It's true," she told her students. "I'll just say that I promise not to use any of my powers—unless I have to." Except for being "very concerned about being overweight," Dunham remained "happy to find myself among the authorities in what I have done and researched."

Throughout her eighties and nineties, Dunham drew on her ethnographic studies of seasonal, social, cult, and funeral dances that fulfilled a host of functions for mid-Americans, as they had throughout the African diaspora: recreation, the building up or releasing of emotions like rage or grief, sexual stimulation, the creation of group cohesion, prayer, catharsis, self-hypnosis, transcendence, and the exhibition of virtuosity. Dance pedagogy remained her mainstay, as did all the colleagues in her educational community—dancers and instrumentalists who arrived in East St. Louis from many of the

countries she had toured. Unlike the last years of the novelist Zora Neale Hurston, who back in the 1930s had taken potshots at her rival in anthropology, Dunham's were not characterized by isolation, poverty, and obscurity.

Like the dancer Pearl Primus, Dunham received plenty of late-life recognition. She served as a consultant for innumerable arts education projects, received the Kennedy Center Honors Award in 1983, oversaw Alvin Ailey's staging of "The Magic of Katherine Dunham" in 1987, accepted a National Medal of the Arts in 1989, and celebrated her ninety-third birthday by being honored at the Jacob's Pillow Dance Festival.

Despite quarrels and separations, Dunham's marriage to John Pratt survived for forty-nine years. Before his death in 1986, she believed that they were "brought closer" by his "three serious bouts with cancer, [and] all kinds of dehydration and malnutrition crises brought on, I suppose, by a daily liter of brandy, rum, or in later years, vodka." The widowed Katherine Dunham continued teaching, even when lifelong arthritis and the physical repercussions of her 1992 hunger strike confined her to a wheelchair in an old house that was difficult to negotiate. Her daughter, living in Rome, recurrently visited. Dance is more than personal pleasure, she explained in her last television interview; it involves "expressing the meaning of your life, the meaning of the people you came from, your roots."

Only when Dunham needed more nursing aid did her former dancer Julie Robinson and Robinson's husband Harry Belafonte help move her to New York City. There she worked on "Minefields" while undergoing physical therapy on her surgically reconstructed knees. Dunham died in her sleep, a month before her ninety-seventh birthday. In old age, her attempt to serve as a catalyst for change addressed the most basic need for survival: Dunham sought, she said, "to create a desire to be alive." In the most unlikely of cultural meccas, where that desire was daily under siege, her students cherish one of her favorite sayings: "Go inside every day to find your inner strength so the world will not blow out your inner candle."

At one birthday celebration, where Katherine Dunham informed Eugene Redmond that "even at ninety years of age you have the same spirit," the poet laureate of East Saint Louis presented an homage to the

> *Witch-queen of TenthStreet:*
> *Temple-founder: Swordswoman: Drumpriestess:*
> *Caribbeanologist: Damballah's lover:*
> *Born again Civil-warrior.*

CONCLUSION

Inventive Endgames in Our Times

BRAVO, I want to say to all my gallant old ladies. Kudos! The final stage of existence for artists from George Eliot to Katherine Dunham functions like the last scene in an opera, one that is often full of grief but also triumph, for the story has almost entirely played itself out and is being witnessed and performed as best as it can be, under the circumstances. The pleasures these women must have obtained from making use of their gifts fly in the face of entrenched assumptions about the prime-and-decline narrative we all grew up with.

One touchstone on old age, William Shakespeare's *King Lear* (1606), presents the last stage of life as a time not of receiving, enhancing, or repurposing gifts but of having them stripped away. It became a touchstone because it speaks to the universal losses of aging, which all my subjects did encounter: losses of intimates, strength, mobility, vision, hearing. Lear's two vicious daughters rob him of all the symbols of his power until he is reduced to a poor, naked, maddened wretch.

Yet even in the very bleakest depiction of old age, Shakespeare

imagines the dethroned and no longer deluded Lear speaking hopefully to the third beloved daughter with whom he wants to share his remaining time on earth:

> *Come, let's away to prison:*
> *We two alone will sing like birds i' the cage:*
> *When thou dost ask me a blessing, I'll kneel down*
> *And ask of thee forgiveness: so we'll live,*
> *And pray, and sing, and tell old tales, and laugh*
> *At gilded butterflies, and hear poor rogues*
> *Talk of court news; and we'll talk with them too,—*
> *Who loses and who wins; who's in, who's out,—*
> *As if we were God's spies: and we'll wear out,*
> *In a wall'd prison, packs and sects of great ones,*
> *That ebb and flow by th' moon.*

Although Lear clearly envisions the final stage of his life as a lockdown, he imagines singing and praying within it, recounting stories and marveling at golden butterflies, keeping up with who's in power and who's out, and persevering with the cordiality he hopes to share with Cordelia. Such activities match many people's needs after the insecurities and strivings of youth and midlife recede: to reconsider the joys and anguish of the past, to accept marginality in culture by finding solace in nature, to keep up with the news, and to nurture intimate relationships through recurrent rites of forgiveness and blessing.

In retreat, Lear sees himself and Cordelia becoming "God's spies." His pipe dream of a contented retirement will not come true, but the phrase captures one gift of old age: a comprehension and appreciation of ephemerality. At the end of his life, Lear seems to believe that he will gain a spiritual authority quite unlike his previous secular authority, for as God's spy, he will have little earthly agency. He will, however, have insight—bequeathed to him through

aging—into the mutability always and everywhere at work in the fleeting ebb and flow of things.

In the midst of grievous losses, quite a few of the artists in this book had the boldness to consider themselves cosmic spies. In very different mediums and with quite varied aims, they continued to express their perspective on the human condition with a daring rooted in the layers of experience always accruing in old age. In more recent times, too, elderly women have produced visionary, even prophetic artworks imbued with the long-ranging outlook that aging lends. Indeed, one no longer needs to search out exemplars of creative longevity, because they are thriving in large numbers among us.

Like a number of my previous subjects, elderly women today were influenced by the social justice movements swirling around the civil rights, feminist, and environmental activism that surfaced in the 1960s. When we consider them with their predecessors, what does this lineage of aged artists tell us lesser mortals about the ways and means of fostering creativity in the last stage of existence? There are lessons to be learned; but first, so we can better discern them, a cursory romp through Little-Old-Lady-Land in our times.

TOWARD THE END of the movie *Good Luck to You, Leo Grande* (2022), the sixty-two-year-old Emma Thompson plays a widow who stands naked before a mirror with "a neutral gaze": "It's not approval—Oh my God, I look great.' And it's not, 'Oh my God, I look horrible,'" the actress explained. "It's 'That's my body. And I know that it can bring me joy.'" The scene reminds me of Alice Neel's 1980 nude *Self-Portrait* and Jocelyn Lee's 2020 photographs of naked elderly women posing in natural settings. These images underscore my own grotesque but persistent efforts to hide my aged body: with a wig to disguise my balding pate, turtlenecks or scarves like "I-Feel-Bad-About-My-Neck" Nora Ephron, oversized tunics to camouflage a

concealed ostomy pouch, and long pants as well as long sleeves to cover crinkly or discolored skin.

Have we entered a period when the taboos on honestly revealing the signs of aging are finally being lifted, if not by me then by my bolder peers? Are a sizable number of contemporary elders finally able to do what Virginia Woolf believed her generation incapable of doing—telling the truth about the female body? When the eighty-year-old author Joan Didion—in black sunglasses—became the face of the luxury brand Céline, she upended the commercial establishment's obsession with nubile girls. Or was she simply selling outrageously expensive accessories as the thinnest woman artist then extant? In any case, Didion's late memoirs and the recent proliferation of illness narratives suggest that many women have begun telling difficult truths about the aging body, as do the works of two living poets.

Throughout her career, Sharon Olds was celebrated as a confessional author. In her mid-seventies, she published a volume, *Odes* (2016), containing works titled "Hip Replacement Ode," "Ode of Withered Cleavage," "Ode to Wattles," and "Ode to Stretch Marks." Within a genre associated with praise, the last poem concludes with a passage affirming the marks of old age:

> I always liked old ladies, I had never
> Met one who looked as if she wanted
> To beat me up. So the language of aging,
> The code of it, the etching, and the scribbling
> And silvering, are signs, to me, of
> Getting to live out my full term,
> Enduring to become what I have loved.

Olds has explained that the tremor in her hand, which makes it difficult for her to eat soup neatly, does not rob her of pleasure in the taste of a bowl of soup. In "Crazy Sharon Talks to the Bishop," a work that appears in her next publication, *Balladz* (2022), the poet takes on

William Butler Yeats's iconic portrait of an antique bag lady: "maybe everything can be rent / everything can be sole or whole— like an // asshole." She concludes the volume with a series of tender meditations on caring for a dying lover, including a moment when "I'd / jungle-gym up into the hospice trough—he could / no longer move—," as she finds comfort in "being able / to calm the one you love best / who loves you best."

The New Zealand–born poet Fleur Adcock also attends wittily and poignantly to the deficits of aging. In her late seventies, she wrote about her aphasia, for example, when she steps on a bus and a missing word "skipped briskly into my head, / impatient at having been kept waiting." Adcock concentrates on disability in another poem, about acquiring a walking stick in a pharmacy, where she staunchly declares, "It's only temporary." And in another, on macular degeneration that makes it difficult for her to discern a wheeling flock of birds; surely, they aren't swans or geese: "Settle, down, damn you! I think they're ducks." In "Having Sex with the Dead," she poses a question: "How can be it be reprehensible" to dream about "The looks on their dead faces, as they plunge / into you, your hand circling a column / of one-time flesh and pulsing blood that now / has long been ash and dispersed chemicals"?

When Ursula K. Le Guin made her sly comment about wanting to invent old women, she seemed to see into a future inhabited by Olds and Adcock. Or, for that matter, by Grace Paley, who in one poem knows herself to be "an old woman with heavy breasts / and a nicely mapped face" wanting to summon her husband to her side: "I / am suddenly exhausted by my desire / to kiss his sweet explaining lips." Or by Adrienne Rich, who in "Memorize This," a poem memorializing her lengthy partnership with the Jamaican American author Michelle Cliff, celebrates their ongoing sexual relationship: "One loses an earring the other finds it / One says I'd rather make love / Than go to the Greek festival / The other, I agree."

Le Guin's phrase appears at the end of a spoof, "Introducing Myself" (1992), about what it means to be born during the long

swath of history when the word *man* was the default position for humanity:

> now I'm over seventy. And it's my own fault. I get born before they invent women, and I live all these decades trying so hard to be a good man that I forgot all about staying young, and so I didn't. And my tenses get all mixed up. I just am young and then all of a sudden I was sixty and maybe eighty and what next?

Mimicking the confusion inculcated by a male- and youth-oriented culture and by the brain fog of so-called senior moments, Le Guin concludes: "If I'm no good at pretending to be a man and no good at being young, I might just as well start pretending that I am an old woman. I am not sure that anybody has invented old women yet, but it might be worth trying." In the previous chapters, we have seen a succession of elderly women inventing themselves, but for the most part those efforts dropped out of public view, so the task of such invention continues to feel unprecedented. Le Guin's existential and aesthetic efforts to invent old women were undertaken by a slew of her contemporaries.

Leonora Carrington was sixty-nine years old when she painted *The Magdalens* (1986, 24 × 30 in.), a picture of a hirsute, shrunken crone placing a tiny capsule in the hand of a younger woman. To her biographer, the painter explained: "The tablet she is handing over... is a contraceptive pill. In a matriarchal world, a woman's right to control her fertility would be sacramental." Ancient crones, mythic female figures, and partly human or nonhuman and endangered creatures preoccupied Carrington's imagination throughout her life. Back in the 1970s, she had composed manifestos for the women's movement that linked the empowerment of women with the survival of the planet. But decades before the emergence of the second wave, Carrington wrote a novel in which she depicted herself and her friend Remedios Varo as radical old ladies.

It is startling to learn that *The Hearing Trumpet* (1974) was penned

by someone in her thirties, because in this zany fantasy, Carrington presents herself as the toothless, deaf, bearded nonagenarian Marian Leatherby. The painter Remedios Varo morphs into Marian's ancient and bald friend who warns: "People under seventy and over seven are very unreliable if they are not cats." When Marian's relatives send her away to a retirement institution—"She's a drooling sack of decomposing flesh"—a Monty Python sort of plot ensues involving a group of intrepid geriatric inmates who turn into spinners, foragers, farmers, and cooks to recover the Holy Grail. The recovery must be undertaken to remove the Grail from "the revengeful Father God" and restore it to the Goddess. The art critic Whitney Chadwick connects Carrington's early and late rejection of "the ideals of youth and beauty" with her "belief that unless women reclaim their power to effect the course of human life, there is little hope for civilization."

In Carrington's painting *Kron Flower* (1987, 24 × 40 in.), three robed crones circle around a red blossom. The elderly creatures peer through eyeglasses and a magnifying lens at a flower that has inexplicably bloomed in the cracks of pavement under their feet, while another old lady—puffing on a pipe—saunters nearby with animals that look somewhat like cats. In older age, according to the art historian Susan L. Aberth, Carrington "began casting sculptures in bronze, and her *La Vieja Magdalene* (1988) is a totemic standing presence whose wrinkles have been transformed into swirling decorative ridges worn as a badge of honour."

Toni Morrison also foregrounded the sage role that can be played by aged women. In a lecture about young people consulting a wise woman, delivered at the Nobel Prize ceremony, Morrison concerned herself with intergenerational communication. "Old woman," one of the young people says, "I hold in my hand a bird. Tell me whether it is living or dead." Since the wise woman is blind, she cannot say, but she knows that "it is in your hands." Morrison goes on to interpret the bird as language, the children's imperative responsibility, for its manipulation can oppress, police, or countenance "rape, torture, assassination."

In the second part of her fable, though, Morrison records the youngsters' annoyed reaction. They believe that the old woman is preserving "her good opinion of herself" by being withholding: "Why didn't you reach out, touch us with your soft fingers, delay the sound bite, the lesson, until you knew who we were?" Besides, "What could [responsibility] possibly mean in the catastrophe this world has become"? Outraged, they admit that there is no bird in their hands and ask, "How dare you talk to us of duty when we stand waist deep in the toxin of your past?" It is a haunting question about all sorts of disasters not of their making.

After spinning a tale of their own, the youngsters fall silent and the wise woman concludes Morrison's lecture: "I trust you with the bird that is not in your hands because you have truly caught it. Look. How lovely it is, this thing we have done—together." The author of masterpieces from *The Bluest Eye* (1970) to *Beloved* (1987) cautions herself on the limits of any singular perspective. Unownable, language is never a bird in the hand. Instead, multiple languages in many tongues, coming out of old as well as young mouths, are always birds that can be momentarily caught only by collaborative, intergenerational efforts.

Was Morrison drawn to experiment with musicians in old age because of her enduring fascination with the sounds of words, or because of the collaborative nature of music making? Probably both. She had spent a considerable amount of time collaborating with her son Slade on eight children's books. In late life, the novelist worked with composers and opera directors, providing lyrics for songs and song cycles. Her texts for original, classical scores were sung by the revered American opera singers Kathleen Battle, Sylvia McNair, and Jessye Norman. *Honey and Rue* (1992), *Sweet Talk* (1997), *Spirits in the Well* (1998), and *Desdemona* (2011) represent the blossoming of the novelist's lifelong interest in spirituals, blues, and jazz, derived in part from her mother's beautiful singing voice.

The "irritability" of being in her eighties and of "not being as physically strong as I once was" meant to Morrison that "writing, for

me, is the big protection." To her friend Oprah Winfrey, she emphasized that she found her own "sacred" and "free space" in her fiction: "It's my world, I have invented it," and "everyone needs one of those places." As so often in Toni Morrison's oeuvre, in her last novel, *God Help the Child* (2015), a wise old woman helps younger characters heal. Queen guides the way, in part because she "had been through it all, and now lived alone in the wilderness, knitting and tatting away, grateful that, at last, Sweet Jesus had given her a forgetfulness blanket along with a little pillow of wisdom to comfort her in old age."

Like Morrison, Faith Ringgold embarked on new ventures in late life. From her studio/home in Englewood, New Jersey, the nonagenarian sometimes traveled to retrospectives featuring the work she had produced at the start of her career: paintings that riffed on key American symbols like the Statue of Liberty, the flag, postage stamps, and Aunt Jemima. But in her sixties, Ringgold—possibly influenced by her seamstress mother—produced story quilts: an ambitious melding of painting with quilting and writing that may ultimately be considered her greatest achievement.

The twelve narrative quilts in the beautiful *French Collection* (1991–97) splice together the evolution of Continental art history with the intellectual activity associated with the civil rights movement. On borders inside bindings composed of pieced-together fabrics, most of the painted quilts display a handwritten script about a fictional Black expatriate who arrives in Europe to participate in the emergence of modernism. Within the complex interplay of words and images and of paintings within paintings, Ringgold presents counter-historical scenes in which, for example, Sojourner Truth meets up with Vincent van Gogh in a field of sunflowers. The *French Collection* asks us to imagine what might have happened if Black women had shaped European art history.

Founded in 1999, Ringgold's Anyone Can Fly foundation takes its name from the most beloved of the twenty picture books for children that she published, *Tar Beach* (1991), which gave her the title of her autobiography, *We Flew over the Bridge* (1995), and which was itself

a spin-off of her story quilt *Tar Beach* (1988). In her eighties, Ringgold created an art app, Quiltuduko, using images instead of the numbers of Sudoku. At work on paintings of lively old people, she said, "As you get older, you become more free." In her nineties, Ringgold declared, "I'm not done yet.... I've got so much more to do."

A comparable sentiment emerges in the autobiography Yayoi Kusama published when she was eighty-two years of age, *Infinity Net* (2002). The popular visual artist admits that she is "always exhausted" and suffers "endless aches and pains," but "new visions of things I want to create are always percolating and swirling around in my head." In old age, "I am more keenly aware of the time that remains and more in awe of the vast scope of art. *O Time: hold still awhile. I have so much more work to do. There are so many things I want to express.*"

In New York City during the 1960s, Kusama had painted dots on huge canvases or on the naked bodies of free love and antiwar protesters. But in 1977 and back in Japan, she suffered a breakdown and eventually decided to make her home in a Tokyo psychiatric asylum from which, into her nineties, she travels daily to work at a nearby studio. Propelled partly by unusual commercial success, Kusama created a series of immersive installations that she calls Infinity Mirror Rooms (1965–the present). Within a total environment produced by LED lights suspended in a dark cube, spectators enter on a path set in mirroring floors. Twinkling on and off in a multiplicity of erratic rhythms, the multicolored lights move spectators away from "the arrogance of human beings" into "radiance." Kusama seeks to elicit amazement at "the infinite existence of electronic polka-dots" that look like the galaxy.

Often seated in a wheelchair for interviews, wearing a synthetic red wig, the artist describes her late-life efforts to arouse a feeling for the "vitality" of "Eternity." The scholar Kate Flint, writing about Kusama's Mirror Room *Fireflies on the Water* (2002), expresses the sense of poignancy felt by visitors to this installation when fireflies are in the process of disappearing: "To stand here is to experi-

ence infinity. It recalls the extraordinary beauty, yet fragility, of our natural environment."

To Margaret Atwood, a writer recognized for her ecological activism, the horrific prospect of the end of life on earth dwarfs concerns about old age. In a video, with a face graced by an aureole of silver curls, the novelist aimed a flamethrower on an unburnable copy of *The Handmaid's Tale* (1985). The publicity stunt sought to raise money for PEN, which sponsors anti-censorship activism around the world. A self-defined "supposedly revered elderly icon or scary witch granny figure," Atwood told an interviewer that since her future days were limited, "why waste your time worrying and being afraid?" A photo layout in the London *Times*—of the writer in haute couture and with hair extensions—depicts the artist's antic hilarity, though her fiction remains as apocalyptic as ever.

In the story "Torching the Dusties" (2014), Atwood imagines the rising population of oldsters—what some term "the silver tsunami"—triggering gerontocide. Geriatric social services have depleted an overwhelmed economy just as a youthful generation blames all the ills of the world on seniors. Inside the assisted living facility Ambrosia Manor, the mostly blind Wilma and her sighted companion Tobias watch as a group called Our Turn, wearing baby masks, amasses outside. Motivated by "the shambles, both economic and environmental, that those under, say, twenty-five have been saddled with," the protesters brandish signs: "TIMES UP, TORCH THE DUSTIES, HURRY UP PLEASE IT'S TIME." After Wilma and Tobias escape into the garden, the demonstrators block all exit routes and set fire to the establishment.

Atwood's tale reflects a startling fact about the swelling numbers of old people: namely, that human longevity endangers other beings on the planet. Today's seniors constitute the first generation of old people glimpsing the possible destruction of life on earth. Sounding that alarm, before it is too late, motivates many of Atwood's contemporaries who provide survival guides for trying times, to paraphrase one of Jane Goodall's book subtitles.

In an era of "emboldened grandmothers," Isabel Allende believes, elderly women "are anxious about the situation of humanity and the planet. Now it's a matter of agreeing to give the world a formidable shake." Though at ninety-eight the painter Luchita Hurtado felt "very weak," she said, "I still can paint, I still can draw" works seeking to raise awareness about global warming and species extinction. Because of the amassing layers of experience with which these artists contend, they know that time warps; it is more loopy than linear. While that warping often careens us back into the past, it can also hurtle us forward into a future in which we no longer exist.

AN URGENCY TO keep on going on threads its ways through the late lives of contemporary women artists. The eighty-two-year-old memoirist Annie Ernaux explains why. After she won the 2022 Nobel Prize, Ernaux worried that the publicity would "steal my old age from me," a theft that would be especially horrific: "I won't be able to remember my old age. So! I have to live it to the fullest." Though we can and do remember other phases of life, none of us will be destined to remember our old age . . . or so those of us without a firm conception of an afterlife presume. Childhood, adolescence, young adulthood, and maturity are all recalled in an old age that will go unrecalled and that therefore must be abundantly experienced as it unfurls.

Like Kusama's "*I have so much more work to do*" and Ringgold's "I'm not done yet," Ernaux's determination to live old age "to the fullest" underscores the passion infusing the grand finales traced here. As in the endings of some operas, in the conclusions of books the volume may be upped so as to amplify their significance. It is here, then, that I will risk some generalizations about what women artists can tell us about how to sustain creativity in old age.

All of the elderly women whom I have studied in this book fully comprehended the deficits of old age, and yet they soldiered on.

Needless to say, all of them could do so because they were economically secure. And with their reputations well established, all of them had an audience for their endeavors. Still, their final acts clarify the circumstances that foster the longevity of creativity. Commonalities emerge from the strikingly different case histories traced in these pages, furnishing clues about what sorts of communication skills, environments, relationships, activities, and attitudes support a creative old age.

With respect to expressive skills, quite a few of my subjects eschew the pyrotechnics of their earlier styles. Instead, they aim for more direct, accessible methods to convey their meanings to wider audiences. A forthright George Eliot denounced the anti-Semitism she had earlier portrayed in nuanced fiction. Colette and Isak Dinesen pitched their tales to popular markets. Louise Bourgeois created interactive installations. Sloughing off some of the elitism of high art, Marianne Moore and Gwendolyn Brooks sought an audience wider than one consisting of poetry devotees. Like Brooks, Mary Lou Williams and Katherine Dunham organized outreach programs. Many elderly artists worked with youngsters or produced artworks for children.

This quest for simpler, more demotic venues puts their work at odds with the discordant late style of the male writers, composers, and painters studied by scholars like Edward Said and Kenneth Clark. A pedagogic imperative emerges in women artists' less dissonant late works. Since many of my old ladies clarified their communications to serve progressive causes, they also call into question the common assumption that aged people become allergic to radicalism or liberalism. And even those who espoused conservative causes were decidedly able to articulate exactly what they wanted from the people with whom they interacted.

Old age is not a time for beating about the bush or sending off mysterious signals, according to the elderly women in this book. The weight of experience lends their voices an authority that they repeatedly tap, sometimes somberly and sometimes drolly. To a remark-

able degree, they say what they mean, mean what they say, and do what they want. If not now, when? The food writer M. F. K. Fisher knows precisely why she would "rather be old than young": "I can get away with more. Say more what I want to say and less of what I think people want to hear." The usually tactful poet Maxine Kumin characterized her final years in similar terms: "You say what you think, and screw it. If people don't like it, then they don't like it."

Second, let's consider the environments of my old ladies. Prosaic as it sounds, most of the subjects in this book spent large amounts of time at home. Kusama's regimen might seem extreme, but the older each artist became, the more she limited her interactions, partly because of frailty. Even the globe-trotters resided somewhat reclusively toward the end, whether on a divan-bed in the Palais-Royal or in a house in East St. Louis.

It seems clear, though, that old people derive great benefit from not being segregated or ghettoized. Many of my subjects found their creative activities enhanced by their exchanges with younger people. An unusual number of aging women artists assembled their younger associates in periodic get-togethers. Dinesen, Bourgeois, Williams, Brooks, and Dunham used their residences as settings for salons thrumming with animated conversations. Not a few aging artists resemble Simone de Beauvoir, who took a much younger male lover and later adopted a much younger woman as a daughter, although many of the productive relationships between older artists and younger facilitators were nonsexual and nonfamilial.

In remarks on the productivity of aged (male) architects and movie directors, the scholar David W. Galenson speculates that highly collaborative undertakings involving younger colleagues "may permit experimentalists to continue to use their valuable skills and expertise to best advantage later in their lives than would otherwise be the case." While only some of my subjects embarked on fully collaborative initiatives, many engaged the expertise of younger assistants, depended on the aid of younger partners, drew on the energies of younger students, or relied on paid younger companions.

The productive old age of Colette without Pauline Verine and Maurice Goudeket, O'Keeffe without Juan Hamilton, Dinesen without Clara Svendsen, Moore without Gladys Berry, Bourgeois without Jerry Gorovoy, and Williams without Peter O'Brien would be inconceivable. In more recent times, adopted and biological children acted as facilitators, collaborators, or caregivers (for Brooks, Carrington, and Morrison), but the majority depended on paid helpers. All of them knew that they needed help, and their relationships with helpers were not merely transactional—a fact that underscores how creative activity in old age hinges on supportive interpersonal exchanges.

My subjects' dependency on daily interactions with younger people raises questions about the rising and often isolated population of old people today. Contemporary research indicates that the elderly who live alone become more vulnerable to physical and mental problems. Since most of us today cannot afford live-in paid companions or caregivers, it behooves us to get creative about finding assisted living facilities that do not rob the elderly of their autonomy. Or we should devise alternative forms of cohabitation—such as living apart together (known as LAT) with younger relatives and friends—in accessory dwelling units (ADUs) like granny flats or in-law apartments so helpers can be supplied or paid by the collective. Especially when the weakened body requires help, paid caregivers play a major role: oiling the wheels that keep a household going, expediting safe living arrangements, and providing daily stimulation.

With respect to erotic relationships, the evidence is scarce, because until recently it would have been taboo to divulge such a personal matter in the way contemporaries like Olds, Adcock, Paley, and Rich do. For centuries, elders have been stereotyped with grotesque or dysfunctional sexualities or with asexuality. And in recent times, seniors are regularly informed by self-help authors that sex after sixty can be raunchier than ever. If we avoid equating sex with "the coital imperative," as oncologists put it to prostate cancer survivors and their partners, my subjects exhibit a wide range of desires

and pleasures. Colette, the most famous for her sexual escapades, seems to have experienced a masterful virility in and after her fifties. The artist who lived an openly post-sexual life, Isak Dinesen, remained entranced by female erotic power in her fiction.

Biographical information on the subjects in this study does illuminate the longevity of love and sensuality. Eliot and Colette treasured their husbands, as did Brooks and Dunham. For all we know, they may have spent a good deal of time canoodling: the pleasures of affectionate intimacy and companionship continued to enthrall. O'Keeffe palmed stones and bones, Dinesen donned elegant outfits, and Dunham concocted heady Haitian drinks: the gratifications of the sensual world continued to captivate them. After a vow of celibacy, Mary Lou Williams freed herself from physically abusive partners. Like her, the unpartnered Marianne Moore and Louise Bourgeois never expressed discontent about the celibate relationships that sustained them.

Indeed, friends clearly play a major role in facilitating a creative late life. George Eliot and Marianne Moore were geniuses at the sort of gift and letter exchanging that friendship often involves, but even the most snappish old ladies in this study (Dinesen, Bourgeois) sustained meaningful friendships, often with the facilitators of their work. Collaborative art forms like music and dance generate tender and lasting bonds. The final years of those who became teachers were enriched by stimulating friendships with colleagues and former students. That Gwendolyn Brooks adopted two of her students as sons exemplifies how emotionally committed such relationships can become.

Yet even with such facilitators, the activities of old age as it progresses have to be accommodated to deficits. Hospitalizations, surgeries, strokes, heart attacks, illnesses, incapacities, and bouts of pain interrupted the daily rhythms of my subjects, as they do many aging people. When Agatha Christie celebrated "the second blooming" of life after fifty, she admitted that the fresh "sap" of rising ideas and thoughts is accompanied by "the penalty of increasing old age—the

discovery that your body is nearly always hurting somewhere." Still, she asserts, "one's thankfulness for the gift of life is, I think, stronger and more vital during those years than it ever has been before."

As the deficits of aging prohibit all sorts of activities, the capacity to switch gears becomes a boon. For artists, this might mean changing genres or mediums, transitioning from the novel to the essay (Eliot), from stone to fabric to watercolor (Bourgeois), or from the stage to the page (Dunham). The process involves being willing to let go of one activity and being able to find an adequate substitute. In old age, the contingency posed by disabilities can paradoxically function like a muse. Handicaps and eating or anxiety disorders sometimes act like cues, underscoring how necessity can become the mother of invention.

The immobilization caused by Colette's arthritis motivated her to stage the final scene of her life and compose a series of memoirs. O'Keeffe's impaired vision led her to paint canvases in which there is nothing to see. Dinesen's bouts of pain informed the demonic identification that fueled her stories, and anorexia shaped her most admired praise song to food. It is quite probable that Moore's stroke produced moments of confusion, which in turn prompted her parodic self-presentation, and that agoraphobia provoked Bourgeois to create her Cells. After a heart attack barred Brooks from teaching, she started generating textbooks. Dunham's injured knees resulted in her devising the Dunham Technique. In these cases, physically cautious but aesthetically intrepid elders do not transcend disability so much as they adapt and make use of it.

In other contexts, too, changing course takes the courage to break from earlier customs: embarking on a new relationship (Eliot), moving from one location to another (O'Keeffe, Williams, Dunham). It can seem involuntary and include conversions—to a religion (Williams) or a political agenda (Brooks)—that infuse old age with purposefulness and also provide a new, wider network of social support. Though we hear a good deal about midlife crises, the trajectories of my old ladies suggest that such crises can be accompanied by

epiphanies. When midlife insights result in a change of course, they supply a second wind: renewed enthusiasm and energy for a sort of undertaking quite different from the endeavors of previous years.

One new gear that is often engaged involves exploring the layers of experience that continue to pile up in memories. Quite a few of my subjects became archivists of their own past. The output of excavation might be a memoir or two (O'Keeffe, Brooks, Dunham), but it might also be a treatise on the sexual mores of an earlier era (Colette) or a series of architectural installations about memory (Bourgeois) or a performance that maps the evolution of a musical tradition (Williams) or the establishment of a fund, a school, a foundation—to preserve an endangered and precious place (Dinesen, Moore, Bourgeois) or to carry the past of a discipline forward into the future (Williams, Brooks, Dunham, Ringgold).

When the subjects of this book engaged in self-mythologizing, they clarified another way to tap the layers of experience in old age. Like the centenarian designer Iris Apfel's outsized round glasses, Colette's permed hair, O'Keeffe's gaucho hat, Dinesen's Little Devil costume, Moore's George Washington outfit, and Dunham's African robes made their aging memorable. Outré styles glamorized their old age—and thereby counteracted the body dysmorphia inculcated by a youth-oriented culture—while putting on display aspects of their personal histories. In this sassy way, self-presentation mines multilayers of memory, as retrospective chronicles do more directly.

No wonder so-called life writing classes are so popular in senior citizen and retirement centers. The trick here is not to get buried in the past. We all know old people whose tedious monologues about their long-ago adventures drain the present of its pleasures. Only when those memories become a source of new activities do they prove mesmerizing. Just as it makes sense to draw up inventories or a will, to assemble photo albums or map family trees, and to give away prized possessions as life draws to a close, so recycling becomes a worthwhile intellectual activity because it involves retrospection. When we return to an earlier experience to understand it or to an

earlier undertaking to repurpose it, we become involved in precisely the sort of reverie that many old people welcome as a means of comprehending the totality of their time on earth—a life review—but in the process, we pull the past into the present.

Unexpectedly, the old age of the artists studied here suggests that the sooner we settle into old age the better. Quite a few of my subjects were motivated to establish the domestic arrangements and social networks that would facilitate their creativity in old age before they were old: that is, in their forties or fifties. If we take seriously their trajectories, the lesson we learn flies in the face of the common assumption that we should stay as young as possible as long as possible. Instead, it implies that those who use their vigor to launch a durable lifestyle for their final years, before the advent of those years, profit from their imaginative foresight.

In toto, the artists in *Grand Finales* prove that creativity functions like a muscle: use it or lose it. Twyla Tharp makes this point at the start of one of her books: "Creativity is a habit, and the best creativity is a result of good work habits." Since creative projects generate creative projects, it is not a difficult habit to acquire. In fact, many artists suffer a profound feeling of loss at the conclusion of a project and that dejection leads them to quickly begin another. Eliot wrote her essay about anti-Semitism because she had written *Daniel Deronda*. Georgia O'Keeffe painted portraits of the air after having painted skyscrapers and cloudscapes.

Where does the imperative to construct Cell after Cell, song after song, come from? From various sources, we have seen in individual cases, but also possibly from a shared desire for immortality heightened by the awareness of mutability that accompanies aging. At eighty-five, the prolific author Joyce Carol Oates was contemplating the losses of old age when she declared, "Everything that you think is solid is fleeting and ephemeral. The only thing that is quasi-permanent would be a book or a work of art or photographs or something. Anything that you create that transcends time is in some way more real than the actual reality of your life." Artists may

be endowed (or plagued) with a greater intensity of this passion for immortality, a desire that counteracts the awareness of finitude bred by aging. As we grow older, though, a closer proximity to death can lead many of us toward varied efforts to preserve our names in a nearing future we will not inhabit.

Quite a few of my old ladies would agree, I suspect, with Edith Wharton's and Simone de Beauvoir's advice on aging. Wharton believed that "in spite of illness, in spite of the archenemy sorrow, one *can* remain alive long past the usual date of disintegration if one is unafraid of change, insatiable in intellectual curiosity, interested in big things and happy in small ways." Beauvoir argued, "There is only one solution if old age is not to be an absurd parody of our former life, and that is to go on pursuing ends that give our existence meaning—devotion to individuals, to groups or to causes, social, political, intellectual and creative work."

Consider the evident fact that many artists never retire. Although Americans are retiring earlier now than ever before, the life stories in this book suggest that working (at what one loves to do) into and throughout old age makes more sense for many people than devoting decades to so-called leisure activities. According to the psychologist Laura L. Carstensen, the traditional life script—with the young studying, the middle-aged working, and the old resting—"has way too much action in Act II and not enough in Act III." Her proposal to *"diffuse work across the life span"* is precisely what artists (and professors, physicians, rabbis, and nuns) have often done. At eighty, Ursula Le Guin was asked what she did in her spare time: "I'm going to be eighty-one next week. I have no time to spare."

If (paid or unpaid) work is an integral part of our identities or a primary source of our love, we need to find ways to continue engaging in it as we age, albeit in modified forms. Frequently in the senior years, this work is unpaid or it can require the worker to finance it herself so as to pay forward enterprises that can be characterized as charitable. Neither a job nor a career but a calling, such work provides the payoff of civic, philanthropic, or planetary happiness, the

satisfaction that derives from contributing to the health and welfare of a park, a town, a galaxy. The case studies of my old ladies illuminate the splendid (though often unsung) history of elderly women in all sorts of volunteer efforts. This type of caregiving is "rhizomatic," as the poet Ross Gay puts it, for it "extends in every direction, spatially, temporally, spiritually, you name it."

OUR ATTITUDE TOWARD aging inflects the old age we sponsor for ourselves. At seventy-nine and suffering from arthritis and Parkinson's disease, M. F. K. Fisher circumvented all the mistakes she made with the pen or the typewriter by asking a helper to transcribe a letter. She needed to inform an esteemed friend that he was "peeved as hell" at being old because he was "just plain stupid" and "dumb": his petulance derived from the fact "that you were unprepared for what is happening to you. All your life you have seen other people spoil, deteriorate, fade away, and yet you have never really accepted the fact that it would happen to you too." But "admitting that you are human makes it inevitable that you must admit to growing older, if indeed you are fortunate enough to grow old, and even to deteriorate, disintegrate, fall apart, and finally die."

In stark contrast to longevity experts who inform people of the steps they must take to ward off physical deterioration, the preeminent food writer takes its inevitability for granted. Nor does she want to put a pretty gloss on it. About the deficits of aging, she seems to be saying something like "get used to it" or "face the music." Less is not more, less is less; but less is more than enough to keep one going on. Much can be made of less. Instead of settling with less, my old ladies made much of it.

Fisher decides that "perhaps the best thing about finding oneself old is trying not to be as dull and boring as all one's peers." Men and women "kicking sixty or seventy in the ass" should not forget "to watch for the glazed grin, that nodding courtesy, that they

once showed to their own almost unbearably boring grandparents." Implicitly, the writer makes two points: first, like her and her correspondent, all old people are not alike; and second, recognizing the unavoidability of degeneration and death can rescue us from a boringly crotchety, self-pitying, or angry old age.

The first point, which seems obvious, is nevertheless heartening. We are as different from each other in old age as we were in our childhoods. The biographical approach in this book underscores Fisher's perspective on the heterogeneity of the aged. Given the distinct personalities and values of my subjects, it is not surprising that those who conceptualized oldsters did so in markedly different ways: as virile survivors of a stacked sexual marketplace (Colette), frustrated manipulators or paradoxical storytellers (Dinesen), trauma victims dealing with PTSD symptoms or magnificent spinster-widows (Bourgeois), treasured but vulnerable incarnations of the past (Moore and Williams), or time-traveling strangers in a strangely new world (Brooks). They also dealt with aging in markedly different ways. Indeed, most probably wouldn't have approved of the others' approaches.

George Eliot would surely have condemned Colette's selfishness, while Colette and Georgia O'Keeffe would have judged Isak Dinesen's diet decidedly unhealthy. Georgia O'Keeffe and Marianne Moore shared a birthday and an appreciation of Alfred Stieglitz's galleries, but Moore might have been shocked at O'Keeffe's harsh treatment of her friends. And Louise Bourgeois would have found Moore's urban gallivanting a colossal waste of time. Gwendolyn Brooks and Katherine Dunham admired each other's accomplishments when they were both honored at the 1971 banquet of the Black Academy of Arts and Letters, but they might have been put off by Mary Lou Williams's fervent Catholicism. Because of their diversity, my nine old ladies would have made a wacky baseball team and an even greater Supreme Court.

A grand finale can be conducted earnestly (Eliot), flamboyantly (Colette), staunchly (O'Keeffe), perversely (Dinesen), ambitiously

(Bourgeois), devoutly (Williams); or with gusto (Moore), humor (Brooks), or executive acumen (Dunham). The only characteristic shared by all my subjects is the all-important one: pluck. Did their art-making give them pluck or did pluck give them art-making? If, as the ninety-two-year-old psychologist Edith Eger put it, "the opposite of depression is expression," an ongoing commitment to a lifetime of expression provided my old ladies a defense against the stagnation or depression often instilled by the losses of aging.

The verb *to express* is generally followed by the words *of* or *for* or *to*: we express some aspect *of* ourselves, *for* a particular reason or purpose, and *to* someone else. It bespeaks a sense of connectedness. Ex-press: the act of pressing *out* of the self an emotion or idea that is then grasped and processed by others. The word encapsulates the phenomenon of art-making, for in their different ways, writers, painters, sculptors, musicians, and dancers translate subjective thoughts, visions, feelings into objective and sharable artifacts or performances. Such artworks connect the artist to a host of others: facilitators and participants, but also readers, viewers, or listeners. Though since classical times the legendary beauty of the swan's last song has been associated with mournful lament, the swan songs of the elderly artists in this book were often serene, boisterous, funky, or funny.

Quite a few critics would claim that the output of some of my subjects in their final years did not measure up to their earlier achievements. But such thinkers are employing purely aesthetic criteria. What they mean is that the final works are not as nuanced as the earlier or that over time the final works have not received the highest accolades. However, if we think about the functionality of artworks, instead of their aesthetic sophistication and critical reception, it is clear that all of the elderly women in this study found that expressing aspects of themselves for a particular reason and to others forged the connections that bound them to their ongoing existence.

Although generally old people are believed to shift their focus to "being rather than doing," the evidence is clear: making something *in* old age makes something *of* old age. Plenty of oldsters intuit

this insight when they invest themselves in activities such as baking, knitting, gardening; or when they make something with others in community kitchens, animal shelters, hospital facilities, libraries. So-called hobbies or service ventures become a passionate avocation.

M. F. K. Fisher believes that "women have it over men" in dealing with the inevitable injuries of aging, for "they are more accepting. And perhaps they are less hurt by actual pain and sorrow than men": "they make less fuss about some things, basic things, like hurting and dying and so on than men seem to do." Her view might find confirmation in the fact that aged men account for the greatest proportion of suicides.

Are women better able to take in stride the injuries of old age because in their prime they rarely enjoyed the sort of autonomy that men had? As all sorts of domestic responsibilities drop away, many women profit from freedoms that temper the losses of old age. In addition, a lifetime of caregiving may reconcile some women to the dependency they will themselves encounter in their last years. In any case, Fisher once again emphasizes that we vary in our responses, some finding in decline an outrage to rail against, but others discovering that degeneration adjusts us to our own mortality, making it seem not an insult or injury but rather a natural consequence to which we can accede with a modicum of acquiescence, or even grace.

Fisher's second point, that we should prepare ourselves for the inexorable deterioration of aging, is not far removed from the view of contemporary people who subscribe to the positive death movement. Within this loosely grouped coalition, attendees at death and dying seminars and Buddhists engaged in meditative practices—as well as readers and viewers of documents about the aging process, volunteers in hospice facilities, frequenters of death cafés, and activists for medical-aid-in-dying care—believe that contemplating and preparing for degeneration, being present at the deaths of friends or relatives, and making plans for one's own dying decrease fear and increase acceptance of physical deterioration and death. Examining the dying process or confronting the fact of one's own or a mate's

imminent mortality can strangely short-circuit morbid perseverating, especially when it links us to networks of people also contemplating what it means to be living on the cusp of the precipice.

Yet the conviction that pondering losses-to-come will ease them might be aspirational. Preparing for loss may not eliminate shock and misery at the sledgehammer blow of a body function, a mental faculty, or a beloved mate gone. There is a reason why my accounts of creative activity generally conclude a few years before a death. Though the timing of its cessation varies, at a certain point creative activity is trounced by physical degeneration. Some handicaps and diseases rob us of our creativity, and even healthy people's consciousness can begin to flicker toward the end of a very long life. Many of us will lose our capacity to enact our creativity, just as we will lose our independence and our intimates.

Only while I was composing the conclusion of this book did I realize that it has been rooted not only in the miraculous drug that gave me an unanticipated old age but also in my fear of a more debilitated and lonelier older old age. "There is no 'if' about whether you will lose your loved ones," the youthful but wise memoirist Kathryn Schulz reminds us; "there is only the how and the when." At older ages, one becomes hyperconscious on a daily basis that there is no "if" about whether you will lose a trusted body function, mental faculty, or mate, only the how and the when. While engaged in this project, I sensed that I was trying to counteract that fear, to find positive incentives for coping with foreseeable but grievous tribulations.

I did come across three mystic and very brief statements by elderly women writers whose testimonies assuage dreads like mine. Toward the end of a grand finale brimming with feelings for what seems so fleeting, they suggest, a last phase emerges. Even when we lose the capacity to enact our creativity, creative *perception* remains in play.

In an essay titled "Old Age" (1966), the novelist Dorothy Richardson stated that the "process of living through the decades" functions like "a Montessori system" abetting life's "secret aim" to make "artists of us all." Through a series of difficult lessons—the failure

of physical and mental faculties, the vanishing of possessions, the horror of being at the mercy of others—we see death differently: "As the immense relief, in turning our faces to the wall, of the removal of responsibility and concern, an immense freedom and wonder." Gaining "the artist's detachment," we become aware "at last of entering upon the fullness of our being."

According to Richardson, very old age bequeaths a sort of otherworldliness, transforming us into cosmic spies: "All our intolerance and fixities are gone. In a world, more amazing, more beautiful than ever were the trailing clouds of glory, we dance the lightest footed dance of all." In a meditation titled "Gerotranscendence" (1997), the author Joan Erikson coined the word "transcen*dance*" to mark the shift some old people make from a materialistic and rational perspective to a more magical communion that she associates with deepening responses to, say, music or poetry: "Transcen*dance* calls forth the languages of the arts.... The great dance of life can transport us.... I am profoundly moved, for I am growing old and feeling shabby, and suddenly great riches present themselves and enlighten every part of my body and reach out to beauty everywhere."

In an essay simply titled "Old" (2002), the novelist Doris Lessing concentrates on enchantment. She records her delight at time becoming "fluid"; and "inside this fluidity" she finds "a permanence," for the elderly face in the mirror shares her earliest memories. But "best of all, nor ever predicted nor, I think, described," is "a fresh liveliness in experiencing":

> It is as if some gauze or screen has been dissolved away from life, that was dulling it, and like Miranda you want to say, What a brave new world! You don't remember feeling like this, because, younger, habit or the press of necessity prevented. You are taken, shaken, by moments when the improbability of our lives comes over you like a fever. Everything is remarkable, people, living, events present themselves to you with the immediacy of players in some barbarous and splendid drama that it seems we are

part of. You have been given new eyes. This must be what a very small child feels, looking out at the world for the first time: everything a wonder.

Isabel Allende encapsulates the point of all three writers: "While my body deteriorates, my soul rejuvenates."

Oddly, though, I find myself uplifted less by inspirational testimonies and more by quirky anecdotes: Colette laughing at rude phone calls or letters on her divan-bed and Georgia O'Keeffe walking with a chow on desert paths; Isak Dinesen inviting a protégée onto her broomstick and Marianne Moore serving a guest Fritos in a paper cupcake liner; Louise Bourgeois in a wheelchair drawing pictures of a ballooning red breast and Mary Lou Williams entranced at a piano in a hospital room; Gwendolyn Brooks regaling readers with jokes about Susan Sontag's backside and Katherine Dunham keeping dancers in line by spinning legends of herself as a voodoo priestess.

Old age often seems like the end of the world, but of course it isn't curtains, because the show's not over till the fat—or skinny—lady faces the rousing music and sings. The sense of connection that anchored my subjects to the last stage of existence taught them daily that we go on without the missed body function, mental faculty, or mate, just as the show will soon go on without us. Remembering my old ladies' finales can make their audacity our legacy.

Acknowledgments

MY CHERISHED COLLABORATOR Sandra M. Gilbert inspired me even as we both sensed that she was nearing her end time. I am also grateful for the wide-ranging knowledge of friends who responded to individual chapters: Jonathan Elmer, Jason Fickle, Constance Furey, Jennifer Fleissner, Roger Stephen Gilbert, Margaret Homans, George Hutchinson, George Levine, Nancy K. Miller, Alexandra Morphet, Jean Robinson, Nikki Skillman, Shane Vogel, and especially Judith Brown, whose comments on early and later revisions invariably refined my thinking.

Many other dear friends enriched my life during the composition process: the late Alesha Arnold, Evelyne Brancart, the late Shehira Davezac, Nathan Davis, Dyan Elliott, Mary Favret, Ken Johnston, Georgette Kagan, Ivan Kreilkamp, Jon Lawrence, Julia Livingston, Consuelo López-Morillas, Daniela Matei, Douglas McClellan, James Naremore, Jan Sorby, and Rick Valicenti. Graduate students—Anne Boylan, Abby Clayton, Brooke Opel, and Denny Weisz, as well as Maggie Ephraim, Sushmita Samaddar, and Alex Wignall—provided invaluable research assistance by brainstorming about sources, wrangling publications from various archives, and tracking down citations.

Big thanks go to the biographers of my subjects, especially Judith Thurman. Jerry Gorovoy answered quite a few questions and Deanna Witkowski furnished hard-to-find material, as did a num-

ber of librarians at Indiana University, whose administrators generously supported my research. In the last minute, Brenda Weber, the director of IU's College Arts and Humanities Institute, and Russell J. Mumper, IU's vice president for research, devised ingenious ways to help me cover mounting permission expenses.

As in the past, I have been buoyed by my sage agent Ellen Levine's belief in an early iteration of this project. At Norton, Jill Bialosky challenged my obstinacy with extraordinary patience and savvy advice during the long haul from the manuscript's inception to its completion. The efficiency and courtesy of her assistant, Laura Mucha, are impossible to exaggerate. Without the aid of the incomparable copyediting skills of Alice Falk, I would have been lost.

Exchanges with my overseas cousins Bernard and Colin David and with my honorary son-in-law Suneil Setiya rescued me from parochialism. Don Gray's wit and clarity enhanced this book. Marah Gubar made substantive contributions by urging me to broaden my horizons beyond the area of literature. Simone Silverbush buoyed my thinking with frequent and always engaging communications. Like my daughters, my stepdaughters—Julie Gray and Susannah Gray—provided the advice and help that Don and I often needed. Our sons-in-law John Lyons, Kieran Setiya, and Jeff Silverbush enliven our lives, as do our grandchildren: Jack, Elle, Samuel, Jonah, and Gabriel.

Don's creative longevity never ceases to amaze all of us, so I end with samples of his poetic acumen (which happily do not require copyright permissions). Produced in his ninety-fifth year, the first reflects his sense of his social life:

> *I think that I will not again go out to see*
> *Anyone whose name does not end with MD.*

The next two his daily and nightly domestic life:

> *Read me a poem about golden lads and lasses,*
> *But tell me first, have you seen my glasses?*

> *Many brave hearts are lost in the deep*
> *My problem is, I can't get to sleep.*

The last is my favorite:

> *That time of year thou mayest in me behold*
> *When no matter what the temp, I'm always cold.*

He can always make me laugh.

Notes

Introduction: Creativity in Old Age

1 **"the double standard of aging"**: Susan Sontag, "The Double Standard of Aging," in *Susan Sontag: Essays of the 1960s and 70s*, edited by David Rieff (Library of America, 2013), pp. 320–52. See also J. Brooks Bouson, *Shame and the Aging Woman: Confronting and Resisting Ageism in Contemporary Women's Writings* (Palgrave, 2016), pp. 1–38.

1 **images of decline**: See Margaret Morganroth Gullette, "Creativity, Aging, Gender: A Study of Their Intersections, 1910–1935," in *Aging and Gender in Literature: Studies in Creativity*, edited by Anne M. Wyatt-Brown and Janice Rossen (University of Virginia Press, 1993), pp. 19–48, as well as her books *Aged by Culture* (2003) and *Agewise* (2011).

3 **"under seventy and over seven"**: Leonora Carrington, *The Hearing Trumpet* (1976; reprint, New York Review of Books, 2020), p. 11.

3 **"I wouldn't have dared"**: Henri Matisse, quoted in Hilary Spurling's *The Unknown Matisse: A Life of Henri Matisse: The Early Years, 1869–1908* (Alfred A. Knopf, 1998), p. 29.

3 **less attention than those of men**: Edward Said's *On Late Style* (2006) focuses exclusively on men, as does Carel Blotkamp's *The End: Artists' Late and Last Works* (2019). Women appear on the margins in Richard Lacayo's *Last Light: How Six Great Artists Made Old Age a Time of Triumph* (2022), Nicholas Delbanco's *Lastingness: The Art of Old Age* (2011), David W. Galenson's *Old Masters and Young Geniuses: The Two Life Cycles of Artistic Creativity* (2006), and John Updike's essay "Late Works," in *Due Considerations: Essays and Criticism* (Alfred A. Knopf, 2007), pp. 49–67. On aging artists, also see Scott Herring's *Aging Moderns: Art, Literature, and the Experiment of Later Life* (2022) and Katie Roiphe's *The Violet Hour: Great Writers at the End* (2016).

3 **"taken better care of myself"**: Eubie Blake, quoted in "Notes on People: Eubie Blake Is Almost Not at the Show on Time," *New York Times*, 5 February 1979.

NOTES

5 **"seeing others die around them"**: Charles Dickens, *The Old Curiosity Shop* (1840) (Oxford University Press, 1951), p. 194.

5 **"old age is a massacre"**: Philip Roth, *Everyman* (Houghton Mifflin, 2006), pp. 143–44, 156.

5 **"a corresponding proximity to life"**: Tim O'Brien, *The Things They Carried: A Work of Fiction* (Houghton Mifflin, 1990), p. 87.

6 **"That is old-age normal"**: Delia Ephron, *Left on Tenth: A Second Chance at Life* (Little, Brown, 2022), p. 275.

6 **"there are plenty more to come"**: George Eliot, *Middlemarch: A Study of Provincial Life* (1871–72) (Oxford University Press, 1998), p. 514.

6 **"order the flowers and send the note"**: Margaret Atwood, quoted in Jennifer Senior, "Margaret Atwood on Envy and Friendships in Old Age," *The Atlantic*, 18 February 2022, https://www.theatlantic.com/culture/archive/2022/02/conversation-with-margaret-atwood/622845/.

6 **"more positive emotions and fewer negative ones"**: Sonja Lyubomirsky, *The Myths of Happiness* (Penguin, 2013), p. 244. See also Jonathan Rauch, *The Happiness Curve: Why Life Gets Better After Fifty* (St. Martin's Press, 2018).

7 **"getting a word in now and then"**: Penelope Lively, *Ammonites and Leaping Fish: A Life in Time* (Penguin, 2013), p. 55.

7 **proclaim ourselves "a kosmos"**: Walt Whitman, *Song of Myself* (1855), in *Whitman: Poetry and Prose*, edited by Justin Kaplan (Library of America, 1982), pp. 1–146, at 87, 24.

7 **"'Live in the layers, / not on the litter'"**: Stanley Kunitz, "The Layers," in *The Collected Poems* (W. W. Norton, 2000), p. 218.

7 **"I'm listening to myself"**: Maya Angelou, "On Aging," in *Don't Bring Me No Rocking Chair: Poems on Ageing*, edited by John Halliday (Bloodaxe Books, 2013), p. 78.

7 **"the more he appreciates me"**: Though variants on this quote are attributed to Agatha Christie, Lucy Worsley demonstrates that she did not say it: *Agatha Christie: An Elusive Woman* (Pegasus Crime, 2022), p. 298.

7 **"looks backward rather than forward"**: May Sarton, *At Seventy* (W. W. Norton, 1984), pp. 9–10.

8 **the younger woman she had been**: Simone de Beauvoir, *Old Age*, translated by Patrick O'Brian (André Deutsch and Weidenfeld and Nicolson, 1972), p. 289.

8 **can dispense a jolt**: Kathleen Woodward, "The Mirror Stage of Old Age," in *Memory and Desire: Aging—Literature—Psychoanalysis*, edited by Kathleen Woodward and Murray M. Schwartz (Indiana University Press, 1986), pp. 97–113, at 109, 110.

8 **"but not in themselves"**: Louise Glück, "Visitors from Abroad," in *Faithful and Virtuous Night* (Farrar, Straus and Giroux, 2014), p. 22.

8 **"bodies are old, we are not"**: Woodward, "The Mirror Stage of Old Age," p. 104.

8 **"I can't get around to believing it"**: Simone de Beauvoir, quoted in Deirdre Bair, *Simone de Beauvoir: A Biography* (Summit Books, 1990), p. 541.

8 **"the wish to grow younger"**: Vivian Gornick, *The Odd Woman and the City: A Memoir* (Farrar, Straus and Giroux, 2015), p. 131; Erica Jong, *Fear of Dying* (St. Martin's Press, 2015), p. 155.

NOTES

9 "is already dead around you": Rebecca West, "There Is Nothing Like a Dame," *Vogue*, February 1983, p. 292.

10 "goals that demand more tenacity": Angela Duckworth, *Grit: The Power of Passion and Perseverance* (Scribner's, 2016), pp. 89, 85.

10 "Old age is not for sissies": See Bette Davis, interviewed by Barbara Walters on *Lifetime*, 1987, YouTube video, https://www.youtube.com/watch?v=jJn-eaL5rpg. The radio and television personality Art Linkletter recycled the quote in the title of his bestseller *Old Age Is Not for Sissies* (1988).

10 "someone who's got the will to live": Agatha Christie, *Poirot Loses a Client* (1937) (Bantam, 1985), p. 54.

10 "We need to be tough to age well": John Halliday, introduction to Halliday, *Don't Bring Me No Rocking Chair*, pp. 12–18, at 13.

10 "It's dogged as does it": Anthony Trollope, *The Last Chronicle of Barset* (1867) (Oxford University Press, 2015), pp. 539, 546.

10 "cushioned by financial security": Lively, *Ammonites and Leaping Fish*, pp. 34–35.

11 "most cherished principles of 'femininity'": Carolyn G. Heilbrun, *Writing a Woman's Life* (Ballantine Books, 1989), p. 126.

11 "can do what you want": Gloria Steinem, "At 81, Feminist Gloria Steinem Finds Herself Free of the 'Demands of Gender,'" interview with Terry Gross, *Fresh Air*, NPR, 26 October 2015, https://www.npr.org/2015/10/26/451862822/at-81-feminist-gloria-steinem-finds-herself-free-of-the-demands-of-gender.

11 more expansive forms of expression: Elizabeth Cady Stanton, "The Pleasures of Age," an address delivered on her seventieth birthday, 12 November 1885, mss41210, box 6, reel 4, Elizabeth Cady Stanton papers, Library of Congress, https://www.loc.gov/resource/mss41210.mss41210-004_00195_00202/?r=-0.544,-0.009,2.087,0.945,0.

11 "no longer objects of desire": Isabel Allende, *The Soul of a Woman* (Ballantine, 2021), p. 38.

15 published her autobiography in her nineties: See Claudia Kalb, *Spark: How Genius Ignites, from Child Prodigies to Late Bloomers* (National Geographic, 2021).

16 "the patron saint of late bloomers": Richard Lacayo, *Last Light: How Six Great Artists Made Old Age a Time of Triumph* (Simon & Schuster, 2022), p. 277.

16 "until the end of our lives": Rich Karlgaard, *Late Bloomers: The Hidden Strengths of Learning and Succeeding at Your Own Pace* (Broadway Books, 2019), p. 76.

16 narrates as she lives it: Kieran Setiya, *Life Is Hard: How Philosophy Can Help Us Find Our Way* (Riverhead Books, 2022), pp. 96–99. See also Stephen Katz, "Creativity Across the Life Course? Titian, Michelangelo, and Older Artist Narratives," in *Cultural Aging*, edited by Stephen Katz and Erin Campbell (University of Toronto Press, 2005), pp. 102–7.

18 "what anyone says about you": Agatha Christie, quoted in Janet Morgan, *Agatha Christie: A Biography* (Collins, 1984), p. 314.

18 good example for the children: Jenny Joseph, "Warning," in *Selected Poems* (Bloodaxe Books, 1992), p. 42.

20 **a security blanket or a stuffed animal:** Kathleen Woodward analyzes the transitional object of an aged Samuel Beckett character in *Aging and Its Discontents: Freud and Other Fictions* (Indiana University Press, 1991), pp. 135–45.

20 **"my transitional object into the grave":** Alice Elliott Dark, *Fellowship Point* (Scribner, 2022), pp. 80, 575.

20 **"second childishness":** William Shakespeare, *As You Like It.* 2.7.164, in *The Norton Shakespeare*, general editor Stephen Greenblatt, 2nd ed. (W. W. Norton, 2008), p. 1648.

21 **"I could do as I liked":** Alice Neel, quoted in Patricia Hills, *Alice Neel* (Harry N. Abrams, 1983), p. 11.

21 **a reality of its own:** Elizabeth Gilbert discusses the vagaries of inspiration throughout *Big Magic: Creative Living Beyond Fear* (Riverhead Books, 2015); see especially pp. 64–66 on the poet Ruth Stone.

22 **"an occasion for 'unselfing'":** Iris Murdoch, *The Sovereignty of Good* (Schocken Books, 1971), pp. 89, 84.

22 **"realism is to be connected with virtue":** Murdoch, *The Sovereignty of Good*, p. 84.

22 **stress, infections, injuries, and chronic conditions:** Gene D. Cohen, *The Mature Mind: The Positive Power of the Aging Brain* (Basic Books, 2005), pp. 175–82.

23 **"it might be worth trying":** Ursula K. Le Guin, "Introducing Myself" (1992), in *The Wave in the Mind: Talks and Essays on the Writer, the Reader, and the Imagination* (Shambhala, 2004), pp. 3–7, at 7.

23 **"We have no role models":** Harriet Beecher Stowe, *Uncle Tom's Cabin* (1852; reprint, Dover, 2005), p. 114; Betty Friedan, *The Fountain of Age* (Simon & Schuster, 1993), p. 607.

23 **"neither wise nor prudent":** Hannah Arendt, "Isak Dinesen," in *Men in Dark Times* (Harcourt, Brace & World, 1968), pp. 95–109, at 109.

24 **"a smaller set of goals":** Laura Carstensen, *A Long Bright Future: An Action Plan for a Lifetime of Happiness, Health, and Financial Security* (Broadway Books, 2009), p. 17.

25 **"she was going to swim":** Juan Hamilton, quoted in Jo Ann Lewis, "The War over O'Keeffe: The Artist's Heir, Juan Hamilton, and the Legal Wrangling That Followed Her Death," *Washington Post*, 2 March 1987, https://www.washingtonpost.com/archive/lifestyle/1987/03/03/the-war-over-okeefe/70e6fdc5-123f-457e-bb84-a0630a9418a1/.

25 **"for me but to go on?":** Martha Graham, *Blood Memory* (Doubleday, 1991), p. 276.

25 **"in fact and at last, free":** Toni Morrison, *The Bluest Eye* (1970; reprint, Alfred A. Knopf, 2000), p. 139.

Section I

28 **"your singular, aspirant song":** Charlie Smith, "The Meaning of Birds," in *Indistinguishable from the Darkness* (W. W. Norton, 1990), pp. 83–84.

Chapter 1: George Eliot

30 **"he preferred death to intercourse":** Kathryn Hughes, *George Eliot: The Last Victorian* (Farrar, Straus and Giroux, 1999), p. 341.

30 **George Eliot's decrepitude:** For a fictionalized version of the misogynistic interpretation of the marriage, see Terence de Vere White's novel *Johnnie Cross* (1983).

31 **"make life less difficult to each other?":** George Eliot, *Middlemarch: A Study of Provincial Life* (1871–72) (Oxford University Press, 1998), p. 691.

33 **"to a putrefying carcase":** George Eliot to Charles Bray, 11 June 1848, in *The George Eliot Letters*, edited by Gordon S. Haight, 7 vols. (Yale University Press, 1954–55), 1:333.

33 **"Only—they weren't married":** Phyllis Rose, *Parallel Lives: Five Victorian Marriages* (Vintage, 1984), p. 221.

34 **"most clever and entertaining":** Henry James, quoted in Rosemary Ashton, *G. H. Lewes: A Life* (Clarendon Press, 1991), p. 275.

34 **guessed that he was dying:** John Cross, *George Eliot's Life as Related in Her Letters and Journals*, 3 vols. (Jefferson Press, 1885), 3:271.

34 **"*not* a story":** George Lewes to John Blackwood, 9 April 1879, in *George Eliot Letters*, 7:78.

34 **George Eliot's persona or mask:** Rosemarie Bodenheimer discusses critics who view Theophrastus as Eliot's mouthpiece versus those who take him to be a fully realized character in "George Eliot's Last Stand: *Impressions of Theophrastus Such*," *Victorian Literature and Culture* 44 (2016): 607–21.

35 **"such a type who . . . ":** Nancy Henry, introduction to *Impressions of Theophrastus Such*, by George Eliot (University of Iowa Press, 1994), pp. vii–xxxviii, at xviii.

35 **George Eliot's mouthpiece:** The volume we read may not be the complete product Eliot had in mind: "I wish to add a good deal, but of course I can finish nothing now, until Mr. Lewes is better." Eliot to John Blackwood, 22 November 1878, and Eliot to John Blackwood, 25 November 1878, in *George Eliot Letters*, 7:83, 88 (quotation).

36 **"impossible to satisfy an author":** Eliot to John Cross, 6 November 1877, in *George Eliot Letters*, 6:410.

36 **"of exclusivity and elitism":** Henry, introduction to *Theophrastus Such*, pp. xi, xiii.

37 **set the intellectual establishment straight:** Eliot, *Theophrastus Such*, p. 30.

37 **"what we call the constitution":** Eliot, *Theophrastus Such*, pp. 37, 40.

37 **"ailments that come of small authorship":** Eliot, *Theophrastus Such*, p. 121.

38 **"the battle would be to the strong":** Eliot, *Theophrastus Such*, pp. 126, 128.

38 **"non-acknowledgment of indebtedness":** Eliot, *Theophrastus Such*, p. 91.

38 **a critique of anthropocentrism:** See S. Pearl Brilmyer, "'The Natural History of My Inward Self': Sensing Character in George Eliot's *Impressions of Theophrastus Such*," *PMLA* 129, no. 1 (January 2014): 35–51.

39 **supersede human beings:** Eliot, *Theophrastus Such*, p. 138.

39 **"grand sequence of things":** Eliot, *Theophrastus Such*, p. 139.

39 **"more powerful unconscious race":** Eliot, *Theophrastus Such*, p. 141.

NOTES

39 "and the abysmally ignorant": Eliot, *Theophrastus Such*, p. 143.
40 anti-Semitic stereotypes: On Eliot's relationship to the Jews, see Gertrude Himmelfarb, *The Jewish Odyssey of George Eliot* (Encounter Books, 2009).
40 "we who have punished others": Eliot, *Theophrastus Such*, p. 146.
40 "a new exile and a new dispersion": Eliot, *Theophrastus Such*, pp. 151–52.
41 "their delivery of our language": Eliot, *Theophrastus Such*, pp. 153, 158, 159.
41 "one among the nations": Eliot, *Theophrastus Such*, pp. 155, 163.
41 "I counted as nothing": George Eliot, *Daniel Deronda* (1876) (Oxford University Press, 2009), pp. 540, 541, 544.
42 establishment of a Jewish homeland: Edward W. Said, *The Question of Palestine* (Vintage, 1992), pp. 63–66.
42 "closer companionship with death": Eliot to Mrs. Edward Burne-Jones, 18 November 1878, and Barbara Bodichon, 25 November 1878, in *George Eliot Letters*, 7:78, 89.
43 "Your loving but half dead Marian": Eliot to Barbara Bodichon, 7 January 1879, in *George Eliot Letters*, 7:97.
43 "a new acquaintance with grief": Eliot to John Cross, 7 February 1879, in *George Eliot Letters*, 7:104, 105, 106.
43 "My appetite for life is gone": Eliot to François d'Albert-Durade, 9 March 1879, in *George Eliot Letters*, 7:115.
43 "[how dead the world seems!]": *The Journals of George Eliot*, edited by Margaret Harris and Judith Johnston (Cambridge University Press, 1998), pp. 154–56.
43 "Ailing and in constant pain": *Journals of George Eliot*, pp. 160, 162.
44 "but it comes slowly": Eliot to Harriet Beecher Stowe, 10 April 1879, in *George Eliot Letters*, 7:137.
44 "Ill and in bed all day": *Journals of George Eliot*, pp. 174, 178.
44 "the rate of a pint bottle daily": Eliot to Charles Lee Lewes, 7 July 1879, in *George Eliot Letters*, 7:183.
44 "Joy came in the evening": *Journals of George Eliot*, pp. 179, 183.
44 love letter to John Cross: Eliot to John Cross, 16 October 1879, in *George Eliot Letters*, 7:214–16, quotations at 216.
44 "Meditation on difficulties": *Journals of George Eliot*, p. 184.
45 "It was a renovation of life": Cross, *George Eliot's Life*, 3:292, 359.
45 "Bester Mann!": Eliot to John Cross, 24 December 1879, in *George Eliot Letters*, 7:239.
45 "My marriage decided": *Journals of George Eliot*, p. 202.
45 "*more loving and trustful*": Eliot to Eleanor Cross, 13 April 1880, in *George Eliot Letters*, 7:259.
46 "under which I still sit amazed": Eliot to Georgiana Burne-Jones, 5 May 1880, in *George Eliot Letters*, 7:269.
46 "you have [a] new friend": Barbara Bodichon to George Eliot, 8 May 1880, in *George Eliot Letters*, 7:276.
46 "tide is bearing me along": Emily Brontë, quoted in *Journals of George Eliot*, p. 188.
46 "a great deal of exercise without fatigue": John Walter Cross to Mrs. Elma Stuart, 11 May 1880; Eliot to Charles Lee Lewes, 12 May 1880; and Eliot to Mrs. Elma Stuart, 18 May 1880, in *George Eliot Letters*, 7:276, 277, 281.

46 "never seen her so strong in health": Cross, *George Eliot's Life*, 3:338.
46 "*I should have become very selfish*": Eliot to Charles Lee Lewes, 21 May 1880, in *George Eliot Letters*, 7:286.
47 "which seemed then hardly possible": Eliot to Florence Nightingale Cross, 25 May 1880, in *George Eliot Letters*, 7:288, 289.
47 **congratulations on the marriage from her brother**: Eliot to Florence Nightingale Cross, 25 May 1880, in *George Eliot Letters*, 7:290.
47 "*the spring seems to have arisen again*": Eliot to Mrs. Richard Congreve, 10 June 1880, in *George Eliot Letters*, 7:299.
47 "**Quiet night, without chloral**": *Journals of George Eliot*, p. 207.
47 **Italian newspapers covered the event**: See Brenda Maddox, *George Eliot: Novelist, Lover, Wife* (Harper Press, 2009), pp. 215–17.
47 "the lack of muscular exercise": Cross, *George Eliot's Life*, 3:331; Eliot to Mrs. Elma Stuart, 27 June 1880, in *George Eliot Letters*, 7:305.
47 "with a miraculous tenderness": Eliot to Charles Lee Lewes, 7 October 1880, in *George Eliot Letters*, 7:333.
48 "a wife nursing a husband": Eliot to Mrs. Elma Stuart, 13 October 1880, and Barbara Bodichon, 7 November 1880, in *George Eliot Letters*, 7:330, 336.
48 "House we meant to be so happy in": Cross, *George Eliot's Life*, 3:349, 354.
48 "not fitted to stand alone": Gordon S. Haight, *George Eliot, a Biography* (Oxford University Press, 1968), p. 530.
49 "he would never leave her": Dinitia Smith, *The Honeymoon* (Other Press, 2016), p. 196.
49 "Cross was 'a Nancy boy'": Smith, *The Honeymoon*, p. 305.
49 "she was ugly AND horny!": Lena Dunham, Twitter, 15 September 2013, 1:18 p.m., https://twitter.com/lenadunham/status/379293041892134912. Quoted in Rebecca Mead, "George Eliot's Ugly Beauty," *New Yorker*, 19 September 2013, https://www.newyorker.com/books/page-turner/george-eliots-ugly-beauty.
50 **Ruth wants "a time machine"**: Cynthia Ozick, "Puttermesser Paired" (1990), in *The Puttermesser Papers* (Knopf, 1997), pp. 105–65, at 111, 117.
50 **making Johnny "into a copyist"**: Ozick, "Puttermesser Paired," pp. 132, 144, 145.
50 "**Lewes had inspired him to it**": Ozick, "Puttermesser Paired," pp. 151, 154, 157.
50 "a copyist, a copyist!": Ozick, "Puttermesser Paired," pp. 161, 162, 165.
50 "a different thing altogether": Ozick, "Puttermesser Paired," p. 125.
52 "most practical step she could have taken": Rosemarie Bodenheimer, *The Real Life of Mary Anne Evans: George Eliot, Her Letters and Fiction* (Cornell University Press, 1994), p. 115.
52 "my wife would have wished to be omitted": Cross, *George Eliot's Life*, 1:vi.
53 "a better more loving creature": Eliot to Barbara Bodichon, 29 May–1 June 1880, in *George Eliot Letters*, 7:294.

Chapter 2: Colette

56 "Art imitates life": Oscar Wilde, "The Decay of Lying" (1891), in *Oscar Wilde*, edited by Isobel Murray (Oxford University Press, 1989), p. 228.
56 "one holds it in one's arms?": Colette's question to the actress Margue-

rite Moreno is quoted in Judith Thurman, *Secrets of the Flesh: A Life of Colette* (Alfred A. Knopf, 1999), p. 305.

56 **"from the child to the parent"**: Thurman, *Secrets of the Flesh*, p. 307.

58 **addressed sexual politics**: In a 1910 interview, Colette said, "You know what the suffragettes deserve? The whip and the harem" (quoted in Thurman, *Secrets of the Flesh*, p. xv). Toward the end of her life, Colette told the visiting author Glenway Wescott that *The Pure and the Impure* was her "best book": see "A Call on Colette and Goudeket," in Wescott's *Images of Truth: Remembrances and Criticism* (Harper & Row, 1962), 1964), pp. 142–48, at 146.

59 **"naked in the morning on her ermine rug"**: Colette, *Chéri*, in *"Chéri" and "The Last of Chéri,"* translated by Roger Senhouse (Farrar, Straus and Giroux, 1951), pp. 1–154, at 8, 35.

59 **"she had hurt him to the quick"**: Colette, *Chéri*, pp. 35, 7, 24, 30–31.

59 **"someone definitely not young"**: Glenway Wescott, "An Introduction to Colette," in *Images of Truth*, pp. 86–141, at 105.

59 **"and the size of a belly"**: Colette, *Chéri*, p. 56.

60 **"followed by a dry spell"**: Colette, *Chéri*, pp. 133, 136, 145.

60 **"everything you lack"**: Colette, *Chéri*, pp. 159, 153, 152.

60 **"in common with that crazy woman"**: Colette, *Chéri*, p. 154.

60 **"surrendered to that protective influence"**: Bertrand de Jouvenel, quoted in Thurman, *Secrets of the Flesh*, pp. 295, 292.

61 **"failed to deflower him"**: Thurman, *Secrets of the Flesh*, p. 296.

61 **"let him go brown in the sun"**: Colette's letter to the actress Marguerite Moreno is quoted in Geneviève Dormann, *Colette: A Passion for Life* (Abbeville Press, 1985), p. 230. Her descriptions "leopard cub" and "great greyhound of a boy" appear in a letter to Moreno and in a conversation of her friend Jeannie Malige with Joanna Richardson, both quoted in Richardson's *Colette* (Franklin Watts, 1984), p. 88.

61 **"demanding, voracious, expert, and rewarding"**: Thurman, *Secrets of the Flesh*, p. 296.

61 **a sort of trademark**: Claude Francis and Fernande Gontier, *Creating Colette*, vol. 2, *From Baroness to Woman of Letters, 1912–1954* (Steerforth Press, 1998), pp. 52–53.

61 **"her initiation of Bertrand"**: Richardson, *Colette*, p. 93.

62 **apartment of one of Colette's friends**: Richardson, *Colette*, p. 93.

62 **"all of Philippe's composure"**: Colette, *Green Wheat*, translated by Zack Rogow (Sarabande Books, 2004), p. 48.

62 **"how true that really is"**: Colette, *Green Wheat*, p. 49.

62 **"commanding she-devil"**: Colette, *Green Wheat*, pp. 66, 77.

63 **"my master"**: Colette, *Green Wheat*, p. 135.

63 **"I wish he'd kick the bucket!"**: Colette, letter to Hélène Picard, quoted in Richardson, *Colette*, p. 110.

63 **"Colette wrote under my eyes"**: Maurice Goudeket, *Close to Colette: An Intimate Portrait of a Woman of Genius* (Farrar, Straus and Cudahy, 1957), p. 51.

64 **"fat in every part of her body"**: Colette, *The Last of Chéri*, in *"Chéri" and "The Last of Chéri,"* pp. 155–296, at 216.

64 **"virile and happy in that state"**: Colette, *The Last of Chéri*, p. 223.

NOTES

64 **how she might come to look:** At fifty-two Colette "radiated physical pleasure, love, passion, and sensuality," according to Francis and Gontier, *Creating Colette*, 2:89.

64 **"held back by her, forever":** Wescott, "An Introduction to Colette," pp. 103–4.

65 **"going to marry that woman":** Goudeket, *Close to Colette*, p. 6.

65 **known as "Monsieur Colette":** Maurice Goudeket, *The Delights of Growing Old*, translated by Patrick O'Brian (Farrar, Straus and Giroux, 1966), p. 155.

65 **"It's so extraordinary":** Colette, *Break of Day*, translated by Enid McLeod (London: Secker and Warburg, 1961), pp. 34, 112.

65 **"needed for thirty years: love":** Colette, *Break of Day*, p. 112.

66 **"those which were forbidden":** Bertrand de Jouvenel, "Colette" (1954), in *Time and Tide Anthology*, edited by Anthony Lejeune (Andre Deutsch, 1956), pp. 275–78, at 275.

67 **"treat *sadly* of sexual pleasure":** Colette, *The Pure and the Impure*, translated by Herma Briffault (New York Review of Books, 2000), p. 26.

68 **"a melodious and merciful lie":** Colette, *The Pure and the Impure*, pp. 8, 18.

68 **"more ashamed of the truth than the lie":** Colette, *The Pure and the Impure*, pp. 22, 24.

68 **"bitches" or "she-devils":** Colette, *The Pure and the Impure*, pp. 28, 27, 32.

68 **"fall, one misstep after another":** Colette, *The Pure and the Impure*, pp. 45, 43.

68 **"solitude, and vain flight":** Colette, *The Pure and the Impure*, pp. 55, 56, 58.

69 **encountered in various social settings:** Colette, *The Pure and the Impure*, pp. 70, 75.

69 **adopted clever working-class girls:** Colette, *The Pure and the Impure*, p. 73.

69 **"imitate worst is a man's stride":** Colette, *The Pure and the Impure*, p. 76.

69 **"a woman pretending to be a man?":** Colette, *The Pure and the Impure*, pp. 110, 107.

70 **"a woman's explicit need":** Colette, *The Pure and the Impure*, pp. 71, 77.

70 **"come from too far away":** Colette, *The Pure and the Impure*, p. 87.

70 **"enamels, lacquers, fabrics...":** Colette, *The Pure and the Impure*, pp. 97, 89.

70 **"but it gains on one":** Colette, *The Pure and the Impure*, pp. 99, 100, 101, 102.

71 **"upon its puny counterfeit":** Colette, *The Pure and the Impure*, p. 139.

71 **"finding fault with men":** Colette, *The Pure and the Impure*, p. 147.

71 **remains a "puny counterfeit":** See Sigmund Freud, "Femininity" (1933), [translated by W. J. H. Sprott,] reprinted in *On Freud's "Femininity,"* edited by Leticia Glocer Fiorini and Graciela Abelin-Sas Rose (Karnac, 2010), pp. 3–31, at 20–23.

71 **"predictable periods of chastity":** Colette, *The Pure and the Impure*, p. 117.

71 **the Ladies of Llangollen:** The hope for a more egalitarian model of female partnerships is raised by Amalia X, who has slept with both men and women: "when a woman remains a woman, she is a complete human being. She lacks nothing, even insofar as her *amie* is concerned" (Colette, *The Pure and the Impure*, p. 107).

71 **"wheat caught in a head of hair":** Colette, *The Pure and the Impure*, pp. 126, 119.

72 **"would have her breasts amputated":** Colette, *The Pure and the Impure*, pp. 125, 133, 138.

72 **"the certainty of an exceptional death"**: Colette, *The Pure and the Impure*, pp. 141, 140, 146.
72 **"strangled a Turkish-bath attendant"**: Colette, *The Pure and the Impure*, pp. 146, 144–45.
72 **often involve working-class men**: See Colette's accounts in *The Pure and the Impure* about "a seventeen-year-old butcher boy" in "a black Chantilly dress" (p. 148) and a workman in "a woman's chemise" (p. 161), which both end in suicides.
72 **"to acknowledge its eternal character"**: Colette, *The Pure and the Impure*, p. 156.
72 **"etiquette of survivors" in friendships**: Colette, *The Pure and the Impure*, pp. 164, 165, 169.
73 **prefer "passion to goodness"**: Colette, *The Pure and the Impure*, p. 172.
73 **"a kind of gymnast's purgatory"**: Colette, *The Pure and the Impure*, p. 175.
73 **"oftener than one might think"**: Colette, *The Pure and the Impure*, pp. 181, 182–83, 183.
73 **"Mental hermaphroditism"**: Colette, *The Pure and the Impure*, p. 62.
73 **forthcoming appearance of *Mein Kampf***: Francis and Gontier, *Creating Colette*, 2:197–98.
74 **"the grey of the lips . . ."**: Colette, *The Evening Star: Recollections*, translated by David Le Vay (Bobbs-Merrill, 1973), pp. 20, 21.
75 **her solicitous "best friend"**: Colette, *The Evening Star*, p. 12.
75 **view "near-immobility" as a "gift"**: Colette, *The Evening Star*, p. 11.
75 **"a little linen, the few letters"**: Colette, *The Evening Star*, p. 95.
76 **"the pistons of a train"**: Colette, *The Evening Star*, pp. 102, 139.
76 **"one who is easily amused"**: Colette, *The Evening Star*, pp. 118, 127.
76 **"And then I've married a saint"**: Colette, letter to Claude Farrère, quoted in Richardson, *Colette*, p. 216.
77 **"it's as well to accept it"**: Colette, *The Evening Star*, p. 11.
77 **"our Gigi for America"**: Colette, quoted in Goudeket, *Close to Colette*, p. 222.
77 **"like a boy in skirts"**: Colette, *Gigi*, translated by Roger Senhouse, in *"Gigi" and "The Cat"* (Penguin, 1953), pp. 7–57, at 7, 49, 9.
78 **tabloid accounts of laudanum**: Colette, *Gigi*, pp. 49, 55.
79 **"There is no other name"**: Colette, *Gigi*, p. 8.
79 **"looking at younger, finer women"**: Simone de Beauvoir to Nelson Algren, 6 March 1948, in *A Transatlantic Love Affair: Letters to Nelson Algren*, compiled and annotated by Sylvie Le Bon de Beauvoir (New Press, 1998), p. 180.
79 **"and talking about it"**: Colette, quoted in Richardson, *Colette*, pp. 225, 226.
80 **"at last happy and released"**: Colette, *The Evening Star*, p. 70.
80 **"my old woman's wiles"**: Colette, *The Blue Lantern*, translated by Roger Senhouse (1963; reprint, Greenwood, 1972), pp. 90, 91, 92, 39.
80 **"would not otherwise have acquired"**: Goudeket, *The Delights of Growing Old*, pp. 156–57.
80 **what she called "my virility"**: Thurman, *Secrets of the Flesh*, pp. 470–71.
80 **"'and he was here with me'"**: Excerpt from the late memoirs in Colette, *Earthly Paradise: An Autobiography*, edited by Robert Phelps (Farrar, Straus and Giroux, 1966), p. 501.

80 **"are half a century old"**: Colette, *The Evening Star*, p. 143.
80 **"'To be continued...'"**: Colette, *The Blue Lantern*, p. 161.
80 **"made her living by her pen"**: Erica Jong, "Viva Colette!," in *The Colette Omnibus* (Nelson Doubleday, 1974), pp. vii–ix, at vii.
80 **"Dear Colette"**: Erica Jong, "Dear Colette," in *Becoming Light: Poems New and Selected* (HarperCollins, 1999), pp. 172–74.

Chapter 3: Georgia O'Keeffe

84 **"speak—so I must keep on"**: Georgia O'Keeffe, *Georgia O'Keeffe* (Viking Press, 1976), n.p.
84 **"a woman on paper!"**: Alfred Stieglitz, quoted in Anita Pollitzer, *A Woman on Paper: Georgia O'Keeffe* (Simon & Schuster, 1988), p. 48.
85 **"Georgia O'Keeffe is the proof of it"**: Alfred Stieglitz, quoted in Laurie Lisle, *Portrait of an Artist: A Biography of Georgia O'Keeffe* (University of New Mexico, 1986), p. 119.
85 **"She's a person in her own right"**: Georgia O'Keeffe and Alfred Stieglitz, quoted in Lisle, *Portrait of an Artist*, p. 119.
87 **"telling the truth, it is sharp"**: O'Keeffe's comment is recorded by C. S. Merrill in *Weekends with O'Keeffe* (University of New Mexico Press, 2010), p. 144.
87 **"personal questions" he put to her girlfriends:** Georgia O'Keeffe, introduction to *Georgia O'Keeffe: A Portrait by Alfred Stieglitz* (Metropolitan Museum of Art New York, distributed by Viking Press, 1978), n.p.
88 **"I only knew her in sections"**: Florine Stettheimer, quoted in Benita Eisler, *O'Keeffe and Stieglitz: An American Romance* (Doubleday, 1991), p. 237.
88 **"a newspaper personality"**: Henry McBride, quoted in Roxana Robinson, *Georgia O'Keeffe: A Life* (Harper & Row, 1989), p. 240.
88 **"a great deal of fuss"**: O'Keeffe, introduction to *Georgia O'Keeffe: A Portrait by Alfred Stieglitz*.
88 **"the quickly drawn breath—..."**: Georgia O'Keeffe to Alfred Stieglitz, 16 May 1922, in *My Faraway One: Selected Letters of Georgia O'Keeffe and Alfred Stieglitz*, vol. 1, *1915–1933*, edited by Sarah Greenough (Yale University Press, 2011), pp. 333–34, at 334.
88 **"sniffer at the value of a secret"**: Robinson, *Georgia O'Keeffe*, p. 240.
89 **with Stieglitz's and O'Keeffe's approval:** See Eisler, *O'Keeffe and Stieglitz*, p. 278.
89 **"to some extent, his virility"**: Sarah Greenough, introduction to O'Keeffe and Stieglitz, *My Faraway One*, pp. vii–xiv, at xiv.
89 **"The portrait is a self-portrait"**: Janet Malcolm, "Photography: Artists and Lovers," *New Yorker*, 12 March 1978, pp. 118–20, at 118.
91 **"see of the flower—and I don't"**: Georgia O'Keeffe, *Georgia O'Keeffe* (Viking Press, 1976), text facing plates 23, 24. O'Keeffe is quoting herself from the catalogue of her 1939 exhibition at An American Place.
91 **"the responsibility of self-realization"**: Richard Whelan, *Alfred Stieglitz: A Biography* (Little, Brown, 1995), p. 484; he is quoting a 1927 article about O'Keeffe's speech by Francis O'Brien in *The Nation*.

NOTES

91 **women of all classes were oppressed:** Hunter Drohojowska-Philp, *Full Bloom: The Art and Life of Georgia O'Keeffe* (W. W. Norton, 2004), pp. 317–78.

91 **stop opposing the Equal Rights Amendment:** Georgia O'Keeffe to Eleanor Roosevelt, 10 February 1944, in Jack Cowart and Juan Hamilton, *Georgia O'Keeffe: Art and Letters*, edited by Sarah Greenough (National Gallery of Art, 1987), p. 235.

91 **"only people who ever helped me were men":** O'Keeffe, quoted in Robinson, *Georgia O'Keeffe*, p. 509.

92 **"be out of her sight":** Dorothy Norman to Stieglitz, 19 December 1928, quoted in O'Keeffe and Stieglitz, *My Faraway One*, p. 380.

92 **opened vistas for O'Keeffe:** In *O'Keeffe and Stieglitz*, Eisler reads Rebecca Strand's letters from the 1929 Taos summer as an expression of lesbian love, but most other biographers do not.

92 **"will be Georgia O'Keeffe":** Stieglitz to O'Keeffe, 6 July 1929, in O'Keeffe and Stieglitz, *My Faraway One*, pp. 457–62, at 457, 459, 460.

93 **"I'm willing to die alone":** Stieglitz to O'Keeffe, 27 July 1929, in O'Keeffe and Stieglitz, *My Faraway One*, pp. 496–98, at 496.

93 **"S.W." (for Southwest):** Carolyn Burke, *Foursome: Alfred Stieglitz, Georgia O'Keeffe, Paul Strand, Rebecca Salsbury* (Alfred A. Knopf, 2019), pp. 205, 223.

93 **"if I cannot be me":** O'Keeffe to Stieglitz, 9 July 1929, in O'Keeffe and Stieglitz, *My Faraway One*, p. 471.

93 **"I will never get rid of":** O'Keeffe, quoted in Burke, *Foursome*, p. 235.

93 **"helping him to function in his way":** O'Keeffe, quoted in Drohojowska-Philp, *Full Bloom*, p. 319.

93 **"problems and situations you cant help":** O'Keeffe to Dorothy Brett, early April 1930, in Cowart and Hamilton, *Georgia O'Keeffe: Art and Letters*, pp. 200–201.

94 **"I make love":** Stieglitz, quoted in Whelan, *Alfred Stieglitz*, p. 403.

94 **"displayed in the role of superseded wife":** Eisler, *O'Keeffe and Stieglitz*, p. 428.

94 **"quite empty" or "vacant":** O'Keeffe to Stieglitz, 9 November 1932 and 10 November 1932, in O'Keeffe and Stieglitz, *My Faraway One*, pp. 468–71, at 471.

94 **creative activities like writing or painting:** See Charlotte Perkins Gilman's story "The Yellow Wallpaper" (1892) and her autobiography, *The Living of Charlotte Perkins Gilman: An Autobiography* (1935).

95 **"I like you very much Georgia":** Frida Kahlo's 1 March 1933 letter to O'Keeffe is quoted in Sharyn Rohlfsen Udall, *Carr, O'Keeffe, Kahlo: Places of Their Own* (Yale University Press, 2000), p. 287.

95 **"on account of her weakness":** Frida Kahlo to Clifford and Jean Wight, 11 April 1933, in *Frida by Frida: Selections of Letters and Texts*, edited by Raquel Tibol (México Editorial RM, 2006), p. 129. Celia Stahr discusses the two artists' relationship in *Frida in America: The Creative Awakening of a Great Artist* (St. Martin's Press, 2020), pp. 180–89, 276–78, 285); Udall considers this comment "a boastful exaggeration of their closeness" (*Carr, O'Keeffe, Kahlo*, p. 287).

95 **and she read *Cane*:** O'Keeffe to Stieglitz, 19 December 1933, in O'Keeffe and Stieglitz, *My Faraway One*, p. 735.

95 **"even the duck missed you"**: O'Keeffe to Jean Toomer, 3 January 1934, in Cowart and Hamilton, *Georgia O'Keeffe: Art and Letters*, p. 216.

96 **"I like it that it stands as it is"**: O'Keeffe's letters to Toomer, quoted in Cynthia Earl Kerman and Richard Eldridge, *The Lives of Jean Toomer: A Hunger for Wholeness* (Louisiana State University Press, 1987), pp. 213–14.

96 **"for now I need it that way"**: O'Keeffe's letters to Toomer, quoted in Earl Kerman and Eldridge, *The Lives of Jean Toomer*, p. 214.

96 **"the less powerful get an adjective"**: Gloria Steinem, "In Defense of the 'Chick-Flick,'" *AlterNet*, 6 July 2007, https://www.alternet.org/2007/07/gloria_steinem_in_defense_of_the_chick_flick.

96 **"I like being first"**: O'Keeffe, quoted in Robinson, *Georgia O'Keeffe*, p. 377.

97 **"if it had been possible for them"**: O'Keeffe, *Georgia O'Keeffe*, text facing plate 58.

98 **"bleached, unburied bones"**: D. H. Lawrence, *St. Mawr* (Alfred A. Knopf, 1925), p. 212.

98 **"kin to what the male can give me"**: O'Keeffe to Stieglitz, 20 November 1932, in O'Keeffe and Stieglitz, *My Faraway One*, p. 663.

98 **"a wild spirit" accessible in the desert**: Lawrence, *St. Mawr*, pp. 217, 221.

99 **"I hate it," he told a reporter**: Stieglitz, quoted in Eisler, *O'Keeffe and Stieglitz*, p. 467.

100 **"most famous and successful woman artist"**: *Life* article, quoted in Drohojowska-Philp, *Full Bloom*, p. 374.

100 **"including weekends, from morning until night"**: Stieglitz, quoted in Dorothy Norman, *Alfred Stieglitz: An American Seer* (Aperture, 1990), p. 183.

100 **laudatory essays about Stieglitz**: In his biography of Stieglitz, Whelan claims that the publication of Dorothy Norman's *Dualities* in 1933 "marked the end of her romance with Stieglitz," though they remained friends (*Alfred Stieglitz*, p. 544).

100 **"18 miles from a post office and it is good"**: O'Keeffe to Ettie Stettheimer, 15 August 1940, in Cowart and Hamilton, *Georgia O'Keeffe: Art and Letters*, p. 230.

101 **pineapple plant did she comply**: Theresa Papanikolas, "Georgia O'Keeffe in Hawai'i," in *Georgia O'Keeffe: Visions of Hawai'i*, edited by Joanna L. Groarke and Theresa Papanikolas (New York Botanical Garden, 2018), pp. 11–23, at 20–21.

101 **a remote, autonomous trailblazer**: See Wanda M. Corn, *Georgia O'Keeffe: Living Modern* (Delmonico Books Prestel, 2017).

102 **"reaching out to the sky and holding it"**: O'Keeffe, *Georgia O'Keeffe*, text facing plate 85.

102 **"like a mile of elephants"**: O'Keeffe, *Georgia O'Keeffe*, text facing plate 59.

102 **"extricate themselves from their shell"**: Catherine Millet, "Georgia O'Keeffe: A Heroine for D. H. Lawrence," in *Georgia O'Keeffe*, edited by Marta Ruiz del Árbol (Museo Nacional Thyssen-Bornemisza, 2021), pp. 94–91, at 90.

102 **no longer register as landscapes**: On O'Keeffe's commitment to abstraction, see Barbara Buhler Lynes, "Georgia O'Keeffe and New Mexico: A Sense of Space," in Barbara Buhler Lynes, Lesley Poling-Kempes, and Fred-

erick W. Turner, *Georgia O'Keeffe and New Mexico: A Sense of Place* (Georgia O'Keeffe Museum, 2004), pp. 11–58, at 13.

102 **"big far beyond my understanding"**: O'Keeffe, *Georgia O'Keeffe*, text facing plate 100.

102 **how to make whole-grain breads**: See Robyn Lea, *Dinner with Georgia O'Keeffe: Recipes, Art and Landscape* (Assouline, 2017).

103 **"all ready to be put down the next day"**: O'Keeffe, *Georgia O'Keeffe*, text facing plate 102.

103 **Robinson has suggested:** Robinson, *Georgia O'Keeffe*, p. 469.

103 **"Soldiers of the Cross"**: From the hymn "We Are Climbing Jacob's Ladder," in *Hymns for the Family of God*, compiled by Fred Bock (Paragon Associates, 1976), p. 488.

104 **to glimpse the flat-topped mesa:** Drohojowska-Philp, *Full Bloom*, p. 527. The documentary is *Georgia O'Keeffe* (Thirteen/WNET, 1971).

104 **"captured the national imagination"**: Corn, *Georgia O'Keeffe: Living Modern*, p. 182.

104 **"come in behind me as I worked"**: O'Keeffe, *Georgia O'Keeffe*, one page preceding plate 106.

104 **"it still hangs in Chicago"**: O'Keeffe, *Georgia O'Keeffe*, one page following plate 106.

104 **almost twenty pounds:** Barbara Buhler Lynes, *Georgia O'Keeffe: Catalogue Raisonné*, 2 vols. (Yale University Press, 1999).

105 **recordings of Beethoven's piano sonatas:** Juan Hamilton, "In O'Keeffe's World," in Cowart and Hamilton, *Georgia O'Keeffe: Art and Letters*, pp. 7–12, at 8.

105 **"what was said about them"**: O'Keeffe, introduction to *Georgia O'Keeffe*, n.p.

106 **"nobody's business but my own"**: O'Keeffe, *Georgia O'Keeffe*, text facing plates 1, 12, 12–13.

106 **he had changed his will:** Dorothy Norman reportedly said, "Stieglitz told me that he had to take me out of the will. In one will, he left it to me to carry out his wishes. In fact, O'Keeffe apportioned them according to her wishes" (quoted in Drohojowska-Philp, *Full Bloom*, p. 424).

106 **likened to "a palette knife"**: O'Keeffe, quoted in Drohojowska-Philp, *Full Bloom*, p. 523.

106 **"weak or less than she is"**: Merrill, *Weekends with O'Keeffe*, p. 147.

107 **"enhanced the artist's last years immeasurably"**: Drohojowska-Philp, *Full Bloom*, p. 527.

107 **acknowledged his marriage to someone else:** See Robinson, *Georgia O'Keeffe*, 556; David Johnston, "Portrait of the Artist and the Young Man: Why a Once-Impoverished Potter Is Giving Up Georgia O'Keeffe Inheritance," *Los Angeles Times*, 23 July 1987, https://www.latimes.com/archives/la-xpm-1987-07-23-vw-5598-story.html.

107 **for her companion:** *A Day with Juan*: Lynes, *Georgia O'Keeffe: Catalogue Raisonné*, 2: plates 1625–31.

108 **"He is my eyes and my ears"**: Hamilton, quoting O'Keeffe as he is quoted in Charlotte Cowles, "Georgia O'Keeffe's Younger Man," *Harper's Bazaar*, 24 February 2016, https://www.harpersbazaar.com/culture/features/a14033/georgia-okeeffe-0316/.

NOTES

108 **"an upward bound feeling"**: Hamilton, "In O'Keeffe's World," p. 11.
108 **"fading away"**: Barbara Rose, "Georgia O'Keeffe's Late Paintings," *Artforum*, November 1970, https://www.artforum.com/features/georgia-okeeffes-late-paintings-213636/.
108 **whitish bands of blues in the distance:** Lynes, *Georgia O'Keeffe: Catalogue Raisonné*, 2:1460, 1573, 1581, 1618.
108 **"smallness and pettiness if more people flew"**: O'Keeffe, letter to Maria Chabot, November 1941, in Cowart and Hamilton, *George O'Keeffe: Art and Letters*, p. 231.
109 **"'want to create is still there'"**: Árbol, ed., *Georgia O'Keeffe*, p. 236.
109 **"the Rothko Chapel in Houston"**: Merrill, *Weekends with O'Keeffe*, p. 183. See also Adato's documentary *Georgia O'Keeffe*, which films O'Keeffe viewing Rothko's work with Hamilton.

Section II: Mavericks

111 **"its agitating and inquiring force"**: Mary Oliver, "Habits, Differences, and the Light That Abides," in *Long Life: Essays and Other Writings* (Da Capo Press, 2004), pp. 10–13, at 12.
111 **"pleasant contacts with the world"**: M. F. K. Fisher, *Sister Age* (Alfred A. Knopf, 1983), p. 235.
112 **"those who build them again are gay"**: William Butler Yeats, "Lapis Lazuli," in *Yeats's Poetry, Drama, and Prose*, edited by James Pethica (W. W. Norton, 2000), p. 115.

Chapter 4: Isak Dinesen

114 **"life closed twice before its close"**: Emily Dickinson, "My life closed twice before its close" (1896), in *The Complete Poems of Emily Dickinson*, edited by Thomas H. Johnson (Little, Brown, 1961), pp. 702–3, at 702.
115 **syphilis as "bad as a trooper's"**: The physician is quoted in Judith Thurman, *Isak Dinesen: The Life of a Storyteller* (St. Martin's Press, 1982), p. 136.
115 **"in order to become a Baroness"**: Isak Dinesen to Thomas Dinesen, 5 September 1926, quoted in Thurman, *Isak Dinesen*, p. 140.
115 **moral duties hamper his spontaneity:** See Isak Dinesen, "On Mottoes of My Life" (1960), in her *Daguerreotypes and Other Essays*, translated by P. M. Mitchell and W. D. Paden (University of Chicago Press, 1979), pp. 1–15, at 6–7.
115 **could not physically bring to term:** According to Thurman (*Isak Dinesen*, p. 208), this was probably the second miscarriage suffered by Dinesen. Else Cederborg believes that Dinesen may have been trying "to lure" Finch Hatton "into a marriage by pretending to be pregnant": "Introduction: Karen Blixen—Her Life and Writings," in *On Modern Marriage and Other Observations*, by Isak Dinesen (St. Martin's Press, 1986), pp. 1–31, at 9.
115 **"between Copenhagen and Elsinore"**: Isak Dinesen, "Rungstedlund: A Radio Address" (1958), in *Daguerreotypes and Other Essays*, pp. 195–218, at 197.
116 ***Mein Kampf*** **to the Qu'ran:** Isak Dinesen, "Letters from a Land at War," in *Daguerreotypes and Other Essays* (1948), pp. 88–137, at 103, 109.

- 116 **"long hiatus of fifteen years"**: Robert Langbaum, *Isak Dinesen's Art: The Gayety of Vision* (University of Chicago Press, 1978), p. 44.
- 117 **Dinesen likened herself to Scheherazade**: See Isak Dinesen, "The Deluge of Norderney," in *Seven Gothic Tales* (Modern Library, 1934), pp. 1–79, at 79, and Hannah Arendt's foreword, "Isak Dinesen, 1885–1962," in Dinesen, *Daguerreotypes and Other Essays*, pp. vii–xxv, at xiv.
- 117 **Bôhème, Sober Truth**: Thurman, *Isak Dinesen*, p. 407.
- 117 **was called Little Devil**: Olga Anastasia Pelensky, *Isak Dinesen: The Life and Imagination of a Seducer* (Ohio University Press, 1991), p. 156.
- 118 **likened the story to *Sunset Boulevard* (1950)**: "The Baroness—Isak Dinesen's Final Affair," *New Yorker*, 7 September 2017, https://www.newyorker.com/goings-on-about-town/theatre/the-baroness-isak-dinesens-final-affair-2.
- 118 **"three-fourths of my spirit remain with you"**: Thorkild Bjørnvig, *The Pact: My Friendship with Isak Dinesen*, translated by Ingvar Schousboe and William Jay Smith (Louisiana State University Press, 1983), pp. 27, 26.
- 118 **induct her protégé into visionary artistry**: See Isak Dinesen, "The Cloak," in *Last Tales* (Random House, 1957), pp. 27–44, as well as Bjørnvig, *The Pact*, pp. 139–43. The story focuses on the mentee, revealing little about the interiority of the mentor.
- 119 **"the sexual part of it, at an early age"**: Bjørnvig, *The Pact*, p. 62. Aage Henriksen recounts a similar story in *Isak Dinesen/Karen Blixen: The Work and the Life* (St. Martin's Press, 1988), pp. 126–27.
- 119 **William Blake called "the Devil's party"**: William Blake, *The Marriage of Heaven and Hell* (1790–93) (1906; reprint, Floating Press, 2014), p. 7. Sara Stambaugh discusses Dinesen's relationship to God, Satan, and witches throughout *The Witch and the Goddess in the Stories of Isak Dinesen: A Feminist Reading* (UMI Research Press, 1988).
- 119 **"a crime of sublime intent and motive"**: Bjørnvig, *The Pact*, pp. 162, 126.
- 119 **"would constitute an unbreakable covenant"**: Bjørnvig, *The Pact*, pp. 113, 130.
- 120 **"how fit and plump you have become"**: Bjørnvig, *The Pact*, pp. 62, 59–60.
- 120 **"must be possessed by the devil"**: Dinesen, "Daguerreotypes" (1951), in *Daguerreotypes and Other Essays*, pp. 16–63, at 33.
- 120 **"strike the Magister on his head!"**: Bjørnvig, *The Pact*, pp. 28, 31. "Magister" is the holder of a Danish advanced academic degree, and, according to Bjørnvig's translator, Dinesen often referred to him by this title.
- 120 **"frailer but the same, the same"**: Bjørnvig, *The Pact*, pp. 136, 52, 77.
- 121 **"yet another formula for our pact"**: Bjørnvig, *The Pact*, pp. 54, 102–3.
- 121 **"a problem for Karen Blixen to take nourishment"**: Clara Svendsen, in *The Life and Destiny of Isak Dinesen*, photographs collected and edited by Frans Lassou, text by Svendsen (Random House, 1970), p. 183. In Eugene Walter's 1956 interview, Dinesen explains that she had been in a nursing home, preparing for death: "Isak Dinesen, The Art of Fiction No. 14," *Paris Review*, no. 14 (Autumn 1956), https://www.theparisreview.org/interviews/4911/the-art-of-fiction-no-14-isak-dinesen.
- 121 **"no one expected her to live through"**: Svendsen, in *The Life and Destiny of Isak Dinesen*, p. 214.

NOTES

122 **died in an opera house fire:** Isak Dinesen, "Echoes," in *Last Tales*, pp. 153–90, at 153.
122 **"will not be heard again":** Dinesen, "Echoes," pp. 188, 189.
122 **"He will not escape me":** Dinesen, "Echoes," p. 172.
122 **who manipulates people like puppets:** Thurman (*Isak Dinesen*, p. 359) considers the tale "prophetic" because Dinesen composed it before failing with Bjørnvig. "The Immortal Story" appears in *Anecdotes of Destiny* (Random House, 1958), pp. 155–231.
123 **sitting alone, surrounded by mirrors:** See James Naremore, *The Magic World of Orson Welles*, 3rd ed., Centennial Anniversary Edition (University of Illinois Press, 2015), pp. 265–72.
123 **"within this old hand of mine":** Dinesen, "The Immortal Story," pp. 173, 214–15.
123 **"never loved anybody till I met you":** Dinesen, "The Immortal Story," p. 224.
123 **"a new voice in the house":** Dinesen, "The Immortal Story," pp. 226, 231.
124 **"long ago. But where?":** Dinesen, "The Immortal Story," pp. 160–61, 271.
124 **"the devil is masculine":** Dinesen, "Daguerreotypes," pp. 33, 35.
125 **"she triumphantly became her whole self":** Dinesen, "The Cardinal's First Tale," in *Last Tales*, pp. 3–26, at 5, 7.
125 **"In the beginning was the story":** Dinesen, "The Cardinal's First Tale," p. 24.
125 **(whose name derives from Dionysos):** On the derivation of the name Dinesen, see Cederborg, "Introduction: Karen Blixen—Her Life and Writings," p. 14.
126 **"in comparison with the world of witchcraft":** Dinesen, "The Caryatids: An Unfinished Gothic Tale," in *Last Tales*, pp. 107–51, at 133, 150.
127 **journey to the remote country convent:** Dinesen, "The Blank Page," in *Last Tales*, pp. 99–105, at 104. I am drawing here on my essay "'The Blank Page' and the Issues of Female Creativity," in *Writing and Sexual Difference*, edited by Elizabeth Abel (University of Chicago Press, 1982), pp. 73–93.
127 **"'in the end, silence will speak'":** Dinesen, "The Blank Page," p. 100.
128 **"and of all storytelling women!":** Dinesen, "The Blank Page," p. 104.
128 **she would have "been lost":** Dinesen, "Tales of Two Old Gentlemen," in *Last Tales*, pp. 63–72, at 68, 69, 70.
128 **extraordinary "energy to satisfy longing":** Dinesen, "Tales of Two Old Gentlemen," pp. 70, 70–71.
128 **"at the complexity of the Universe":** Dinesen, "Tales of Two Old Gentlemen," pp. 71, 72.
129 **nostalgic portraits of her servants:** Isak Dinesen, *Shadows on the Grass* (Random House, 1961).
129 **"with a leg and a half in the grave":** Dinesen to Robert Haas, 23 August 1957, quoted in Thurman, *Isak Dinesen*, p. 404.
129 **heavy metal poisoning (produced by syphilis treatments):** See Kaare Weismann, "Neurosyphilis, or Chronic Heavy Metal Poisoning: Karen Blixen's Lifelong Disease," *Sexually Transmitted Diseases* 22, no. 3 (May–June 1995): 137–44. Deborah Hayden associates the symptoms with syphilis in *Pox: Genius, Madness, and the Mysteries of Syphilis* (Basic Books, 2003), pp. 229–38.

- 129 **"fooling herself and her public"**: Linda Donelson, *Out of Isak Dinesen in Africa: The Untold Story* (Coulsong List, 1995), pp. 347, 355.
- 129 **dreaming that he drank but awakening faint**: Isak Dinesen, "Tempests," in *Anecdotes of Destiny*, pp. 71–151, at 148.
- 130 **Malli evolves into "a lioness"**: Dinesen, "Tempests," p. 83.
- 130 **"distrust—and our dire loneliness"**: Dinesen, "Tempests," p. 146.
- 130 **would hurt those she loved**: Guilt solidified Dinesen's identification with the heroes of Byron. See her late tale "Second Meeting," in *Carnival: Entertainments and Posthumous Tales* (University of Chicago Press, 1977), pp. 327–38.
- 131 **convinced her that she was contagious**: Dinesen circuitously ponders the link between love, desire, and disease in "The Cardinal's Third Tale," in *Last Tales*, pp. 73–98.
- 131 **God's or the Devil's handiwork**: See chapters 2 and 3 in Joan Jacobs Brumberg, *Fasting Girls: The History of Anorexia Nervosa* (Vintage, 2000), pp. 43–99.
- 132 **"God had cast me from Heaven"**: William Luce, *Lucifer's Child* (Samuel French Theater Bookshop, 1992), p. 51. The play was directed by Tony Abatemarco.
- 132 **had been arrested as a Pétroleuse**: Isak Dinesen, "Babette's Feast," in *Anecdotes of Destiny*, pp. 23–68, at 24.
- 133 **will be "a witches' sabbath"**: Dinesen, "Babette's Feast," pp. 45, 46.
- 133 **"would wring a word from their lips"**: Dinesen, "Babette's Feast," pp. 46–47.
- 133 **"to thy pleading child for food?"**: Dinesen, "Babette's Feast," p. 50.
- 134 **"Time itself had merged into eternity"**: Dinesen, "Babette's Feast," pp. 57, 58, 61.
- 134 **"artist that God meant you to be!"**: Dinesen, "Babette's Feast," p. 68.
- 134 **"sentinel before our lovers' paradise!"**: Isak Dinesen, *Ehrengard* (Random House, 1963), pp. 3, 27–28, 28.
- 134 **"irresistible Don Juan of his age"**: Dinesen, *Ehrengard*, p. 10.
- 135 **"fallen, broken and lost"**: Dinesen, *Ehrengard*, pp. 36, 54, 57.
- 135 **"in consent and surrender!"**: Dinesen, *Ehrengard*, pp. 66, 67, 69.
- 135 **"like a transparent crimson veil"**: Dinesen, *Ehrengard*, p. 109.
- 136 **"Clara went to live in Copenhagen"**: Thurman, *Isak Dinesen*, p. 365.
- 136 **Clara Svendsen as her Sancho Panza**: William Jay Smith, introduction to Bjørnvig, *The Pact*, pp. 3–15, at 11.
- 136 **"referring to a page of paper or a book"**: Smith, introduction to Bjørnvig, *The Pact*, p. 7.
- 136 **"god knows where or when"**: Hannah Arendt, quoted in Elizabeth Young-Bruehl, *Hannah Arendt: For Love of the World* (Yale University Press, 1982), pp. 18–19.
- 136 **"horrid old witch, a real Memento Mori"**: Dinesen, letter to Violet Trefusis, n.d., quoted in Thurman, *Isak Dinesen*, p. 442.
- 136 **a portrait of Denys Finch Hatton**: Svendsen, in *The Life and Destiny of Isak Dinesen*, p. 220. In an introduction to the volume, Frans Lasson states that Dinesen "did not mention" the photograph (pp. 13–15, at 15).
- 137 **"suddenly the work will finish itself"**: Dinesen, quoted in Glenway Wescott, "Isak Dinesen, the Storyteller," in *Images of Truth*, pp. 149–63, at 162.

137 **"most powerful creatures in the whole world"**: Isak Dinesen, "The Monkey," in *Seven Gothic Tales*, pp. 106–94, at 119.

137 **"or tell a story about them"**: Dinesen, quoted in Hannah Arendt, "Isak Dinesen," in *Men in Dark Times* (Harcourt, Brace & World, 1968), pp. 95–109, at 104.

Chapter 5: Marianne Moore

140 **a black hat, and pointy black shoes**: Elizabeth Bishop, "Invitation to Miss Marianne Moore," in *The Complete Poems, 1927–1979* (Farrar, Straus and Giroux, 1983), pp. 82–83.

140 **"I do seem at least to be awake, don't I?"**: Moore, quoted in Jane Howard, "Leading Lady of U.S. Verse," *Life*, 13 January 1967, pp. 37–44, at 42.

141 **a second parental figure materialized**: Linda Leavell, *Holding on Upside Down: The Life and Work of Marianne Moore* (Farrar, Straus and Giroux, 2013), p. 45.

142 **the poet's "delicate appetite"**: Leavell, *Holding on Upside Down*, p. 163.

142 **mother and daughter continued to share a bed**: Leavell, *Holding on Upside Down*, p. 252.

142 **decline from her modernist publications**: The exceptions are Laurence Stapleton, *Marianne Moore, the Poet's Advance* (Princeton University Press, 1978); Margaret Holley, *The Poetry of Marianne Moore: A Study in Voice and Value* (Cambridge University Press, 1987); and Cristanne Miller, *Marianne Moore: Questions of Authority* (Harvard University Press, 1995). Elizabeth Gregory's book was the first to explore the late poetry in full detail: *Apparition of Splendor: Marianne Moore Performing Democracy Through Celebrity, 1952–1970* (University of Delaware Press, 2021).

143 **what she called "straight writing"**: Grace Schulman, "Conversations with Marianne Moore," *Quarterly Review of Literature* 16, nos. 1–2 (1969): 154–71, at 164.

143 **"show an affirming flame"**: W. H. Auden, "September 1, 1939," in *W. H. Auden: Selected Poems* (Vintage International, 2007), p. 97. Moore quotes this phrase in "W. H. Auden" (1952), in *The Complete Prose of Marianne Moore*, edited by Patricia C. Willis (Viking Press, 1986), pp. 459–72, at 471.

143 **"plain American which cats and dogs can read"**: Marianne Moore, "England" (1920), in *The Complete Poems of Marianne Moore* (Macmillan/Viking, 1967), pp. 46–47, at 46. Throughout, with the exception of "Poetry," I will refer to verse in this edition because it remains the most accessible.

143 **gift of a tangible paper nautilus**: On the gift, see Elizabeth Bishop, "Efforts of Affection: A Memoir of Marianne Moore," in *Prose*, edited by Lloyd Schwartz (Farrar, Straus and Giroux, 2011), pp. 117–40, at 126, and Marianne Moore to Louise Crane, 21 February 1937, in *The Selected Letters of Marianne Moore*, edited by Bonnie Costello with Celeste Goodridge and Cristanne Miller (Alfred A. Knopf, 1997), p. 381.

144 **"strong enough to trust to"**: Marianne Moore, "Paper Nautilus," in *The Complete Poems*, pp. 121–22, at 122.

144 **"the strong over- / comes itself"**: Marianne Moore, "Nevertheless," in *The Complete Poems*, pp. 125–26, at 126.

144 **"that handicap is proficiency"**: Marianne Moore, "Compactness Compacted" (1941), in *The Complete Prose*, pp. 367–69, at 369.
145 **by later critics and by the poet herself**: Helen Vendler represents the dismissive view in "Marianne Moore," in her *Part of Nature, Part of Us: Modern American Poets* (Harvard University Press, 1980), pp. 59–76, at 61.
145 **"war is intolerable and unjust"**: Marianne Moore, interview with Donald Hall, in *A Marianne Moore Reader* (Viking Press, 1961), pp. 253–73, at 261.
145 **"feel 'superior' in sundry ways"**: Moore to John Warner Moore, 19 November 1939, in *Selected Letters*, pp. 394–95, at 395.
145 **echoes throughout its eight stanzas**: For quotations from Marianne Moore's "In Distrust of Merits," see *The Complete Poems*, pp. 136–38.
146 **a slain soldier inspired her**: Stapleton, *Marianne Moore, the Poet's Advance*, p. 134.
147 **"vegetable iron, brewers' yeast"**: Moore to Ezra Pound, 31 July 1946, and to Bryher, 29 October 1946, in *Selected Letters*, pp. 461–62, at 461; 462–63, at 462.
147 **"rashes and kidney trouble and pains"**: Bryher, letter to H.D., quoted in Charles Molesworth, *Marianne Moore: A Literary Life* (Northeastern University Press, 1990), p. 323.
147 **had begun destroying their papers**: According to most of Moore's biographers, the decision to destroy letters was made because her brother's wife was jealous about his intimacy with his family.
147 **"exhausted and beyond her sixty years"**: Leavell, *Holding on Upside Down*, p. 334.
147 **"impatience with imprecision"**: Marianne Moore, foreword to *The Fables of La Fontaine*, translated by Moore (Viking Press, 1964), pp. ix–x, at x.
147 **"One's skin creeps when poets persevere"**: Selections from *The Fables of La Fontaine*, in *A Marianne Moore Reader*, pp. 95–120, at 95, 97, 109, 110.
148 **"told too little than too much"**: Marianne Moore, "Feeling and Precision" (1944), in *The Complete Prose*, pp. 396–402, at 396; "Humility, Concentration, and Gusto" (1949), in *The Complete Prose*, pp. 420–26, at 422.
148 **"eloquent by reason of the not said"**: Marianne Moore, "Impact, Moral and Technical; Independence versus Exhibitionism; and Concerning Contagion" (1951), in *The Complete Prose*, pp. 433–37, at 435.
149 **its original five stanzas in *Collected Poems***: Marianne Moore, "Poetry," in *Collected Poems* (Macmillan, 1951), pp. 40–41. Bonnie Hoingsblum discusses all variants of the poem in "Marianne Moore's Revisions of 'Poetry,'" in *Marianne Moore: Woman and Poet*, edited by Patricia C. Willis (National Poetry Foundation, 1990), pp. 520–610.
150 **the "verbal bravura" in Auden's verse**: Moore, "Impact, Moral and Technical," p. 436.
150 **he admitted stealing from her**: W. H. Auden, review of *Nevertheless* in *New York Times Book Review*, 15 October 1944; reprinted in *The Critical Response to Marianne Moore*, edited by Elizabeth Gregory (Praeger, 2003), pp. 136–38, at 138.
150 **"'inclusions are intentions'"**: Bonnie Costello, *Marianne Moore: Imaginary Possessions* (Harvard University Press, 1981), p. 25.

150 **Mongoose Civique, and Utopian Turtletop:** Moore to Robert B. Young, 28 November–26 December 1955, in *A Marianne Moore Reader*, pp. 220–22.

151 **"When you got it—flaunt it":** Howard, "Leading Lady of U.S. Verse"; Benjamin Kahan includes a photograph and the complete text of the Braniff ad in *Celibacies: American Modernism and Sexual Life* (Duke University Press, 2013), pp. 75–78.

151 **"Tom Fool at Jamaica":** Marianne Moore, "Tom Fool at Jamaica," in *The Complete Poems*, pp. 162–63.

152 **"look their best when caring least":** Marianne Moore, foreword to *A Marianne Moore Reader*, pp. xiii–xviii, at xvi.

152 **"Hometown Piece for Messrs. Alston and Reece":** Marianne Moore, "Hometown Piece for Messrs. Alston and Reece," in *The Complete Poems*, pp. 182–84.

153 **"the Brooklyn Dodgers' clubhouse":** Roscoe McGowen, "Team-Mates' Vigorous Congratulations Tire Podres More Than Mound Work," *New York Times*, 5 October 1955.

153 **teaching in the Carlisle Indian School:** See Robert Cantwell, "The Poet, the Bums and the Legendary Red Men," *Sports Illustrated: Vault*, 15 February 1960, https://vault.si.com/vault/1960/02/15/the-poet-the-bums-and-the-legendary-red-men, as well as Siobhan Phillips, "The Students of Marianne Moore: Reading the Ugly History of the Carlisle Indian Industrial School, Where the Poet Taught," Poetry Foundation, 14 March 2017, https://www.poetryfoundation.org/articles/92768/the-students-of-marianne-moore.

153 **"Blessed Is the Man":** Marianne Moore, "Blessed Is the Man," in *The Complete Poems*, p. 173.

154 **"A Poem on the Annihilation of Ernie Terrell":** Danny Heitman, "When Muhammad Ali Wrote a Poem with Marianne Moore," *Humanities* 37, no. 2 (Spring 2016), https://www.neh.gov/humanities/2016/spring/feature/when-muhammad-ali-wrote-poem-marianne-moore.

154 **"He is a smiling pugilist":** Marianne Moore, record jacket for *I Am the Greatest!* (1963), in *The Complete Prose*, pp. 659–60, at 660.

154 **"he invariably would croak, 'Evermore'":** Marianne Moore, "My Crow, Pluto—A Fantasy" (1961), in *The Complete Prose*, pp. 556–58, at 557.

154 **"fired my imagination with gratitude":** Marianne Moore, "Profit Is a Dead Weight" (1963), in *The Complete Prose*, pp. 568–71, at 569, 570.

154 **"the most famous Negro woman poet in America":** John Lindsay and Langston Hughes, quoted in Harry Gelroy, "Marianne Moore Wins Gold Medal," *New York Times*, 14 April 1967.

154 **"I like New York best":** Marianne Moore, "Crossing Brooklyn Bridge at Twilight" (1967), in *The Complete Prose*, pp. 610–12, at 612.

155 **save the Walt Whitman building from demolition:** On this and other acts of preservation, see Bette Stoltz and M. M. Graff, "Marianne Moore," New York Preservation Archive Project, https://www.nypap.org/preservation-history/marianne-moore.

155 **"Carnegie Hall: Rescued" (1960):** Marianne Moore, "Carnegie Hall: Rescued," in *The Complete Poems*, pp. 229–30.

155 **"The Camperdown Elm":** Marianne Moore, "The Camperdown Elm," in *The Complete Poems*, p. 242.

156 **an address to which money can be sent:** Moore, "Crossing Brooklyn Bridge at Twilight," p. 611.

156 **this image of old age:** Elizabeth Gregory makes this point in "'Still Leafing': Celebrity, Confession, Marianne Moore's 'The Camperdown Elm,' and the Scandal of Age," *Journal of Modern Literature* 35, no. 3 (March 2012): 51–76.

156 **"Granite and Steel":** Marianne Moore, "Granite and Steel," in *The Complete Poems*, p. 205.

156 **"who mastered calculus and engineering":** Marianne Moore, "Brooklyn from Clinton Hill" (1960), in *The Complete Prose*, pp. 539–47, at 544.

157 **"filament united by stress":** Moore, "Brooklyn from Clinton Hill," p. 544.

157 **"The Arctic Ox (or Goat)":** Marianne Moore, "Poetry" and in "The Arctic Ox (or Goat)," in *The Complete Poems*, pp. 36, 77.

158 **"altered the terms of media mythmaking":** Hilton Kramer, "Freezing the Blood and Making One Laugh," *New York Times*, 15 March 1981; reprinted in Gregory, *The Critical Response to Marianne Moore*, p. 230.

158 **alienation from conventional gender roles:** Sandra M. Gilbert, "Marianne Moore as Female Female Impersonator," in *Marianne Moore: The Art of a Modernist*, edited by Joseph Parisi (UMI Research Press, 1990), pp. 27–48, as well as Sandra M. Gilbert and Susan Gubar, *Letters from the Front*, vol. 3 of *No Man's Land: The Place of the Woman Writer in the Twentieth Century* (Yale University Press, 1994), especially pp. 93–111.

159 **Lamb said smiling:** Moore, foreword to *A Marianne Moore Reader*, p. xiii.

159 **the "senile sublime":** Eve Kosofsky Sedgwick, *Touching Feeling: Affect, Pedagogy, Performativity* (Duke University Press, 2003), p. 24. Sedgwick attributes the term to her colleague Barbara Herrnstein Smith.

159 **"since you are aware of doing it":** Moore to Hildegarde Watson, 3 December 1967, quoted by the editors in Moore's *Selected Letters*, p. 491.

159 **"Does any of it apply?":** Marianne Moore, foreword to *The Absentee: A Comedy in Four Acts, Based on Maria Edgeworth's Novel of the Same Name* (House of Books, 1962), pp. iii–iv, at iii, iv.

159 **"answer with a reluctant 'no'":** Molesworth, *Marianne Moore: A Literary Life*, p. 371.

160 **"Who would you rather be except Shakespeare?":** Marianne Moore, quoted in Winthrop Sargeant, "Humility, Concentration, and Gusto," *New Yorker*, 16 February 1957, pp. 38–77, at 48, 49.

160 **and preserved her privacy:** Donald Hall also notes "her wandering consequent-inconsequent responses" in *Their Ancient Glittering Eyes: Remembering Poets and More Poets* (Ticknor & Fields, 1992), p. 160.

161 **she provides "instances of impersonalism":** Marianne Moore, "If a Man Die" (1932), in *The Complete Prose*, pp. 279–85, at 283, 284. Cristanne Miller discusses Moore's investment in "gender neutrality" in *Marianne Moore: Questions of Authority*, pp. 100–103.

161 **"the non-binary self-view she'd held all along":** Gregory, *Apparition of Splendor*, p. 23.

161 **"delicate re-incarnation of Paul Revere"**: Elizabeth Bishop, quoted in Leavell, *Holding on Upside Down*, p. 349.

161 **"and they are all terrified of her"**: Hall, *Their Ancient Glittering Eyes*, p. 154.

162 **"Washington Saves His Army at Brooklyn"**: Moore, "Brooklyn from Clinton Hill," 546.

162 **" 'They're so nutritious' "**: Hall, *Their Ancient Glittering Eyes*, pp. 165, 166.

162 **"but is in the same category"**: Marianne Moore, "Dress and Kindred Subjects" (1965), in *The Complete Prose*, pp. 596–600, at 597.

162 **"have an influence on what we wear"**: Marianne Moore, "Of Beasts and Jewels" (1963), pp. 573–74, at 573.

162 **with the songwriter Lou Reed:** John Leland, "Tragedy, Peyote, Beat Poets, Yoko Ono," *New York Times*, 24 March 2023, https://www.nytimes.com/2023/03/24/nyregion/east-village-history-townhouse.html.

163 **Our best pencils / write like that:** Marianne Moore, "Velvet Mat," in *New Collected Poems*, edited by Heather Cass White (Farrar, Straus and Giroux, 2017), p. 420.

163 **"poetry of praise in an age of anxiety"**: Molesworth, *Marianne Moore: A Literary Life*, p. 411.

163 **the "tranquilized Fifties"**: Robert Lowell, "Memories of West Street and Lepke," in *Robert Lowell: Selected Poems*, expanded ed. (Farrar, Straus and Giroux, 2006), p. 129.

163 **"worms and germs and spiritual flatness"**: From Marianne Moore's letter of 1961 assessing Plath as a candidate for a Guggenheim award, quoted in Vivian R. Pollak, "Moore, Plath, Hughes, and 'The Literary Life,'" *American Literary History* 17, no. 1 (Spring 2005): 95–117, at 107.

163 **"go with you, remember. Do I have to?"**: Moore to Allen Ginsberg, 4 July 1952, in *Selected Letters*, pp. 499–501, at 499.

164 **"make *you* too tired to work"**: Moore to Ginsberg, 4 July 1952, p. 501.

164 **"affirm or die"**: Moore to Ginsberg, 4 July 1952, p. 501.

Chapter 6. Louise Bourgeois

166 **worn for a *Vogue* photoshoot:** See Deborah Wye, *Louise Bourgeois* [exhibition catalogue] (Museum of Modern Art, 1982), back cover; Carter Ratcliff, "People Are Talking About: Louise Bourgeois: Sculptor," *Vogue*, October 1980, pp. 342–43, 375–77.

166 **"the art world's favorite naughty old lady"**: Joan Acocella, "The Spider's Web: Louise Bourgeois and Her Art," *New Yorker*, 27 January 2002, https://www.newyorker.com/magazine/2002/02/04/the-spiders-web.

167 **"was inspired by my early life"**: Louise Bourgeois, "Child Abuse," *Artforum* 21, no. 4 (December 1982), https://www.artforum.com/print/198210/child-abuse-35538.

167 **led to suicide attempts:** Robert Storr, *Intimate Geometries: The Art and Life of Louise Bourgeois* (Monacelli Press, 2016), p. 64.

167 **she missed friends like Colette:** Bourgeois's letters to Colette can be read in Louise Bourgeois, *Destruction of the Father, Reconstruction of the Father: Writings and Interviews, 1923–1997*, edited by Marie-Laure Bernadac and Hans-Ulrich Obrist (MIT Press, 1998), pp. 29–39.

- 167 **especially the surrealists:** On Bourgeois's later distancing herself from the surrealists' misogyny, see Barbara Rose, "Sex, Rage & Louise Bourgeois," *Vogue*, September 1987, pp. 764–65, 824–26, at 824.
- 167 **"gargled" with words:** Louise Bourgeois, "Self-Expression Is Sacred and Fatal," in *Destruction of the Father, Reconstruction of the Father*, pp. 222–30, at 229; Storr, *Intimate Geometries*, p. 501.
- 168 **a "small miracle":** "Louise Bourgeois," the 1986 interview conducted by Robert Storr and included in his *Interviews on Art*, edited by Francesca Pietropaolo (HENI Publishing, 2017), pp. 35–60, at 45.
- 168 **devouring the oppressive patriarch:** Lucy R. Lippard, "Louise Bourgeois: From the Inside Out," in *From the Center: Feminist Essays on Women's Art* (E. P. Dutton, 1976), pp. 238–49, at 240, 242.
- 168 **"icon of the growing women's movement":** Storr, *Intimate Geometries*, p. 362.
- 169 **documentary film about Louise Bourgeois:** Amei Wallach and Marion Cajori, *Louise Bourgeois: The Spider, the Mistress and the Tangerine* (Zeitgeist Films, 2008). At the time of this writing, the documentary is available on YouTube, https://www.youtube.com/watch?v=IijPyKo3hOg.
- 169 **"The little creature was just a girl":** This same episode, when combined with Bourgeois's jealousy of the English nanny, is said to exhibit "a textbook *Oedipal* complex": Paul Verhaeghe and Julie De Ganck, "Beyond the Return of the Repressed: Louise Bourgeois's Chthonic Art," in *Louise Bourgeois: The Return of the Repressed*, vol. 1, edited by Philip Larratt-Smith and Elisabeth Bronfen (Violette, 2012), pp. 115–25, at 117. The cutting of the tangerine also appears in a YouTube video in an episode that ends with Bourgeois laughing: "Louise Bourgeois Peels a Tangerine," ZCS Films, YouTube video, 17 February 2013, https://www.youtube.com/watch?v=M2mx1gZqh1E.
- 170 **a symbolic replacement for it:** Sigmund Freud, "Femininity" (1933), [translated by W. J. H. Sprott,] reprinted in *On Freud's "Femininity,"* edited by Leticia Glocer Fiorini and Graciela Abelin-Sas Rose (Karnac, 2010), pp. 3–31, especially 21–22 ("penis-envy"), 24 (on the baby/doll as a replacement for the penis).
- 170 **"cutting off the limbs with a knife":** Bourgeois, quoted in Jan Greenberg and Sandra Jordan, *Runaway Girl: The Artist Louise Bourgeois* (Harry N. Abrams, 2003), p. 16.
- 170 **"my need to be violent and physical":** Bourgeois, quoted in Rose, "Sex, Rage & Louise Bourgeois," p. 826.
- 170 **"dolls of bread/pain":** Greenberg and Jordan, *Runaway Girl*, pp. 16–17.
- 170 *Femme Couteau* (**Knife Woman,** 1969/70): Wye, *Louise Bourgeois*, plate 109.
- 170 **"the weapon of the aggressor":** Bourgeois, quoted in Dorothy Seiberling, "The Female View of Erotica," *New York Magazine*, 11 February 1974, pp. 54–58, at 56.
- 170 **"like a baby, have it as a doll":** Bourgeois, quoted in Lippard, *From the Center*, p. 243.
- 171 **"My religion is psychoanalysis":** Bourgeois, quoted in Paul Gardner, *Louise Bourgeois* (Universe, 1994), p. 44.
- 171 **"the art of hanging in there":** Bourgeois, "Self-Expression Is Sacred and Fatal," p. 222.

NOTES

171 **"I slit her throat"**: Bourgeois, quoted in Jerry Gorovoy and Pandora Tabatabai Asbaghi, *Louise Bourgeois: Blue Days and Pink Days* (Fondazione Prada, 1997), n.p.

171 **in overlapping pieces of canvas**: Storr, *Intimate Geometries*, p. 739.

172 **"dolls of loss and mortality"**: Siri Hustvedt, "The Places That Scare You," 5 October 2007, *The Guardian*, https://www.theguardian.com/books/2007/oct/06/art/. Also see Hilary Robinson, *Reading Art, Reading Irigaray: The Politics of Art by Women* (I. B. Tauris, 2006), p. 144.

173 **"kill someone, or kill herself"**: Jerry Gorovoy, quoted in Deborah Wye, *Louise Bourgeois: An Unfolding Portrait* (Museum of Modern Art, 2017), p. 199.

173 **conjuring anatomical specimens**: Images of the figures mentioned in this paragraph appear in Storr, *Intimate Geometries*, pp. 598, 599, 610, 739, 615, 614.

173 **"some mass misogynist atrocity of our time"**: Linda Nochlin, "Old-Age Style: Late Louise Bourgeois" (2008), reprinted in *Women Artists: The Linda Nochlin Reader*, edited by Maura Reilly (Thames & Hudson, 2015), pp. 383–94, at 386.

173 **mother's plea or the baby's or both**: Images of the figures mentioned in this paragraph appear in Storr, *Intimate Geometries*, pp. 643, 532, 644.

174 **(*Endless Pursuit*, 2000)**: Images of the figures mentioned in this paragraph appear in Storr, *Intimate Geometries*, pp. 611, 530, 713.

174 **"boiled, wrung out, skinned and hanged"**: Robin Bernstein, *Racial Innocence: Performing American Childhood and Race from Slavery to Civil Rights* (New York University Press, 2011), p. 193.

174 **"But then comes the reparation and exorcism"**: Bourgeois, quoted in Greenberg and Jordan, *Runaway Girl*, p. 17.

175 **"because they have no access to a cure"**: Louise Bourgeois, "Freud's Toys," *Artforum* 28, no. 5 (January 1990), https://www.artforum.com/print/199001/freud-s-toys-34249.

175 **"less tiring to be loving than to be fighting"**: Storr interview, "Louise Bourgeois," p. 47.

175 **"less than thirty-five or forty"**: Bourgeois, quoted in Gorovoy and Asbaghi, *Louise Bourgeois: Blue Days and Pink Days*, n.p.

175 **"I truly like only the people who help me"**: Bourgeois, in "The Interview," by Donald Kuspit, in *Bourgeois* (Vintage, 1988), pp. 19–82, at 72.

176 **she had been afraid to show her work**: Jerry Gorovoy, "The Louise Bourgeois I Knew," *The Guardian*, 11 December 2010, https://www.theguardian.com/theobserver/2010/dec/12/louise-bourgeois-obituary-by-jerry-gorovoy.

176 **Bourgeois called him "the pacifier"**: Jerry Gorovoy, quoted in Katy Diamond Hamer's interview, "Assistant for 30 Years: Life with Louise Bourgeois," *Vulture*, 18 December 2014, https://www.vulture.com/2014/12/life-with-louise-bourgeois.html.

176 **artwork that students brought her for critique**: Arthur Lubow, "A Look Inside the Louise Bourgeois House, Just How She Left It," *New York Times*, 20 January 2016, https://www.nytimes.com/2016/01/24/arts/design/a-look-inside-louise-bourgeoiss-home-just-how-she-left-it.html.

176 **each session "ends in tears"**: Ingela Lind describes eighty-six-year-old

Bourgeois in "Meet Louise Bourgeois," *Louise Bourgeois "Maman,"* edited by Marika Wachtmeister (Atlantis, 2007), pp. 17–32, at 17. The young artist is quoted in *Louise Bourgeois*, edited by Frances Morris (Tate Publishing, 2007), p. 285.

176 **"all at the same time"**: Bera Nordal, "Louise Bourgeois: My Body Is My Sculpture," in Wachtmeister, *Louise Bourgeois "Maman,"* pp. 103–15, at 105–6.

176 **"self-selected, self-involved interlocutors"**: Storr, *Intimate Geometries*, p. 698.

177 **"space which you enter and walk around in"**: Bourgeois, quoted in Greenberg and Jordan, *Runaway Girl*, p. 56.

177 **flashbacks from the artist's childhood traumas:** Siri Hustvedt summarizes the ways in which such critics as Donald Kuspit, Philip Larratt-Smith, Paul Verhaeghe and Julie De Ganck, Juliet Mitchell, and Magnon Nixon used the artist's child abuse story to frame her art: see "Both-And," in *Mothers, Fathers, and Others* (Simon & Schuster, 2021), pp. 195–224, at 196–97.

178 ***Cell I*** (1991, 83 × 96 × 108 in.): Image in Storr, *Intimate Geometries*, p. 513.

178 **died in 1960 at forty-seven:** On Bourgeois's ambivalence and guilt about her brother, see Juliet Mitchell, "Love and Hate, Girl and Boy," *London Review of Books*, 6 November 2014, https://pugpig.lrb.co.uk/the-paper/v36/n21/juliet-mitchell/love-and-hate-girl-and-boy.

178 **"how psychologically fragile she was"**: Jerry Gorovoy, quoted in Wye, *Louise Bourgeois: An Unfolding Portrait*, p. 196.

179 ***Red Room (Parents)*** **and** ***Red Room (Child)***: Images in Storr, *Intimate Geometries*, pp. 573, 570.

180 **"the father, or just a friend"**: Louise Bourgeois, 1994 interview with Nena Dimitrijevic, reprinted in Morris, *Louise Bourgeois*, p. 170.

180 **dangling before a mirror:** Images of the figures mentioned in this paragraph appear in Storr, *Intimate Geometries*, pp. 569, 567, 601, 709.

180 **"I'm a prisoner of my memories"**: Louise Bourgeois, "Arena," edited transcript of interview from the 1993 British television documentary directed by Nigel Finch, in *Destruction of the Father, Reconstruction of the Father*, pp. 253–62, at 257.

181 **code for menstrual cycles in her diary:** Ulf Küster discusses the code word "Maman" in the context of Spiders in *Louise Bourgeois* (Hatje Cantz, 2011), p. 29.

181 **"a defense against evil"**: Bourgeois, quoted in Storr, *Intimate Geometries*, pp. 545–46.

181 **"A spider sewed at night"**: Emily Dickinson, "A Spider Sewed at Night" (1891), in *The Complete Poems of Emily Dickinson*, edited by Thomas H. Johnson (Little, Brown, 1961), p. 511.

182 **noxious bugs, and a seismic joke:** A point made in "Louise Bourgeois, Spiderwoman," an episode of the BBC program *Imagine* that aired on 13 November 2007, YouTube video, 30 January 2021, https://www.youtube.com/watch?v=4VMWM2EbjIU.

182 **"live on, you wicked child"**: Ovid, *Metamorphoses* 6.193–94, translated and edited by Charles Martin (W. W. Norton, 2010), p. 147.

182 **"flesh and blood that he himself begot"**: Ovid, *Metamorphoses* 6.944–45, translated by Martin, p. 165.

- 183 **"are only matted"**: Freud, "Femininity," p. 28.
- 183 **"like a thread in a spider's web"**: Bourgeois, quoted in Morris, *Louise Bourgeois*, p. 50. See Walt Whitman, "A Noiseless, Patient Spider," in *Whitman: Poetry and Prose*, edited by Justin Kaplan (Library of America, 1982), pp. 564–65.
- 183 **"what the Turbine Hall needs"**: Lars Nittve, director's foreword to *Louise Bourgeois* [exhibition catalogue] (Tate Gallery Publishing, 2000), p. 5.
- 184 **within a protective glass bell jar**: Sheikha Al Mayassa bint Hamad bin Khalifa al Thani, foreword to *Louise Bourgeois: Conscious and Unconscious*, curated by Philip Larratt-Smith, 20 January–1 June 2012 (Bloomsbury Qatar Foundation Publishing, 2012), pp. 13–14.
- 184 **considered them "a family affair"**: Frances Morris, "A Family Affair," in the Tate exhibition catalog *Louise Bourgeois*, pp. 6–17, at 9.
- 185 **"namely, love, goodness and security"**: Melanie Klein, "Mourning and Its Relation to Manic-Depressive States" (1940), in *Love, Guilt, and Reparation and Other Works, 1921–1945* (Hogarth Press, 1975), pp. 344–69, at 345. According to Jerry Gorovoy, Bourgeois "loved [Klein's] *Guilt and Reparation* and *Narrative of a Childhood Analysis*. She also had *Envy and Gratitude: A Study of Unconscious Sources* in her library": email to author, 20 July 2023.
- 186 **a fabrication of her own making**: Wye, *Louise Bourgeois: An Unfolding Portrait*, p. 101.
- 186 **"got funnier as she got older"**: Hustvedt, "Both-And," p. 204.
- 187 **"the embryos visible in their stomachs"**: Küster, *Louise Bourgeois*, p. 8.
- 187 **he would have to look up to her**: Storr, *Intimate Geometries*, p. 8.
- 187 **"Bourgeois asked for paper and pencils"**: Wye, *Louise Bourgeois: An Unfolding Portrait*, p. 34.
- 187 **"performer in front of the camera"**: Alex Van Gelder, *Mumbling Beauty: Louise Bourgeois* (Thames & Hudson, 2015), n.p.
- 188 *The Last Climb* (151½ × 157½ × 118 in.): Image in Storr, *Intimate Geometries*, p. 741.
- 188 **"There's this escape"**: Jerry Gorovoy, quoted in Rachel Small, "Louise Bourgeois's Psychological Turmoil in Cells," *Interview Magazine*, 23 September 2015, https://www.interviewmagazine.com/art/louise-bourgeois-garage-museum-of-contemporary-art.

Section III: Sages

- 190 **"no such thing as Black America"**: See Nell Painter's interview with Carol Jenkins, "Through a Painter's Eye with Nell Painter," *Black America*, CUNY TV, 26 April 2017, YouTube video, uploaded 10 May 2017, https://www.youtube.com/watch?v=I_b6qwX9f0c.
- 191 **"sap of ideas and thoughts was rising in you"**: Agatha Christie, *An Autobiography* (Collins, 1977), p. 520.

Chapter 7: Mary Lou Williams

- 195 **hiring herself out for performances**: These are the biographical facts that Mary Lou Williams repeated in countless interviews: Deanna Witkowski, *Mary Lou Williams: Music for the Soul* (Liturgical Press, 2021), p. 7.

NOTES

195 **"unlike most women at the time"**: Tammy L. Kernodle, *Soul on Soul: The Life and Music of Mary Lou Williams* (2004; reprint, University of Illinois Press, 2020), p. 26.

195 **"get away from fear, alcoholism, fights"**: Williams, quoted in Linda Dahl, *Morning Glory: A Biography of Mary Lou Williams* (University of California Press, 2001), p. 28.

195 **"heavy like a man" would attract audiences:** Dahl, *Morning Glory*, p. 44.

195 **"roaring like a crazy man"**: Mary Lou Williams, "My Life with the Kings of Jazz," *Melody Maker*, April–June 1954; reprinted in Max Jones, *Talking Jazz* (W. W. Norton, 1988), pp. 178–207, at 184.

195 **"'but she sure can play'"**: Williams, quoted in Barbara Rowes, "From Duke Ellington to Duke University," *People*, 12 May 1980, pp. 73–77, at 74.

196 **she managed to record two original pieces:** Farah Jasmine Griffin comments on the incidents in the television documentary *Mary Lou Williams: The Lady Who Swings the Band* (dir. Carol Bash, NBPC and IYVS, 2015). See also Griffin, *Harlem Nocturne: Women Artists and Progressive Politics During World War II* (Basic Civitas, 2013), and Daphne A. Brooks, *Liner Notes for the Revolution: The Intellectual Life of Black Feminist Sound* (Belknap Press of Harvard University Press, 2021), p. 97.

196 **to make her name less common:** Williams, "My Life with the Kings of Jazz," p. 190.

196 **"and that was about a month"**: Williams, quoted in Phyl Garland, "The Lady Lives Jazz: Mary Lou Williams Remains as a Leading Interpreter of the Art," *Ebony*, October 1979, pp. 56–64, at 60. "I've never had a deep love" except for the music, she explains in Joanne Burke's documentary *Music on My Mind* (Blue Lion Film, 1990).

197 **"at 33, she is already a veteran"**: "No Kitten on the Keys," *Time*, 26 July 1943, https://content.time.com/time/subscriber/article/0,33009,802919,00.html.

197 **emerging generation of bebop artists:** Freddi Washington, "Music Can Help Youth," *The People's Voice*, 1 June 1946, p. 2.

197 **feasts at 6 a.m.:** Williams describes these sessions in a PBS documentary hosted by Billy Taylor, *Swingin' in the Blues—Goin' to KC* (1981), where she can be seen playing toward the very end of her life.

197 **"her need to grow as a musician"**: Linda Dahl, *Stormy Weather: The Music and Lives of a Century of Jazzwomen* (Limelight Editions, 1996), p. 65.

197 **a source of guilt, according to Dahl:** Dahl, *Morning Glory*, p. 204.

198 **ban against American musicians performing there:** Williams discusses the ban in an interview with Studs Terkel in 1978 ("Mary Lou Williams and Her Manager Father Peter O'Brien Discuss Williams's Career," broadcast 15 September 1978, WFMT, *Studs Terkel Radio Archive*, https://studsterkel.wfmt.com/programs/mary-lou-williams-and-her-manager-father-peter-obrien-discuss-williams-career). According to Kernodle (*Soul on Soul*, p. 155), Williams discovered that the ban was a "lie": jazz players, put in the same category as vaudeville performers, were unaffected by it.

199 **"ones J. P. Johnson composed"**: Williams, quoted in Gayle Murchison, "Mary Lou Williams's Hymn *Black Christ of the Andes (St. Martin de Porres)*:

Vatican II, Civil Rights, and Jazz as Sacred Music," *Musical Quarterly* 86, no. 4 (Winter 2002): 591–629, at 593.

199 **"Whoever got [to a reported killing] first took the body"**: Williams, "My Life with the Kings of Jazz," pp. 181, 183, 185, 187.

199 **"conditions were like in the slums of Harlem"**: Williams, "My Life with the Kings of Jazz," pp. 196, 205, 206.

199 **addiction that threatened to impoverish her**: Williams, "My Life with the Kings of Jazz," pp. 206–7. Throughout Harlem, Williams became known as a "poker chump" (Witkowski, *Mary Lou Williams*, p. 38).

200 **"and I'm in Europe yet"**: Williams, "My Life with the Kings of Jazz," p. 207.

200 **"I had been doing was no good"**: Mary Lou Williams, "What I Learned from God About Jazz," *Sepia*, April 1958, pp. 57–60, at 57.

200 **"badness" she could hear in her own music**: Williams, quoted in "Jazz: The Prayerful One," *Time*, 21 February 1964, https://content.time.com/time/subscriber/article/0,33009,870827,00.html.

200 **"trying to make contact with God"**: Williams, "What I Learned from God About Jazz," p. 57.

201 **"and turned it off again"**: Williams, quoted in Michael Scott Alexander, *Making Peace with the Universe: Personal Crisis and Spiritual Healing* (Columbia University Press, 2020), p. 153. He cites Thomas Albright, "Mary Lou—a Heritage That's Strictly American," *World Sunday*, 1 May 1977.

201 **excessive drinking did him in**: Whitney Balliett, "Out Here Again," *New Yorker*, 2 May 1964; reprinted in Whitney Balliett, *American Musicians: Fifty-Six Portraits in Jazz* (Oxford University Press, 1986), pp. 96–107, at 101.

201 **"as children of God"**: Williams, "What I Learned from God About Jazz," p. 58.

201 **calling her "Reverend Williams"**: John S. Wilson, "Mary Lou Williams Takes Her Jazz Mass to Church," *New York Times*, 9 February 1975, https://www.nytimes.com/1975/02/09/archives/mary-lou-takes-her-jazz-mass-to-church.html.

201 **as a crazed "witch" . . . "like a monk"**: Dahl, *Morning Glory*, p. 256; Balliett, "Out Here Again," p. 107.

202 **a sort of halfway house**: Tammy Kernodle, "A Woman's Place: The Importance of Mary Lou Williams's Harlem Apartment," NPR Music, 12 September 2019.

202 **"the greatest musical sounds"**: Williams, quoted in Alexander, *Making Peace with the Universe*, p. 162.

202 **"you've got to pray"**: Williams, "What I Learned from God About Jazz," p. 60.

203 **chromatically altered ninths and thirteenths**: Murchison, "Mary Lou Williams's Hymn *Black Christ of the Andes (St. Martin de Porres)*," p. 606.

203 **to create a "gliding effect"**: Gayle Murchison, quoted by Fr. Peter F. O'Brien, S.J., in the liner notes of *Mary Lou Williams Presents Black Christ of the Andes* (Smithsonian Folkways Recordings, 2004), p. 19.

203 **"Mary Lou had while praying"**: Alexander, *Making Peace with the Universe*, p. 166.

203 **to a "shepherd staff"**: The cantata's words are quoted from *Mary Lou Williams Presents Black Christ of the Andes*.

205 **hid behind the coats in the cloakroom:** Witkowski, *Mary Lou Williams*, p. 62.
205 **"ALL 'WHO DIG THE SOUNDS'":** The entirety of "Jazz for the Soul" is reprinted in O'Brien's liner notes for *Mary Lou Williams Presents Black Christ of the Andes*, pp. 11–12.
206 **like a "little boy":** Dahl, *Morning Glory*, pp. 284–85.
206 **"I try to touch people's spirits":** "Jazz: The Prayerful One."
206 **"*I was finally home*":** O'Brien, liner notes for *Mary Lou Williams Presents Black Christ of the Andes*, p. 4.
206 **"Mary Lou and saving jazz":** Peter O'Brien, quoted in Dahl, *Morning Glory*, p. 314.
207 **"she would have to Blacken the faith":** Randal Maurice Jelks, *Faith and Struggle in the Lives of Four African Americans: Ethel Waters, Mary Lou Williams, Eldridge Cleaver, and Muhammad Ali* (Bloomsbury Academic, 2019), pp. 69, 80.
208 **"I'd shift to theory":** Williams, quoted in Wilson, "Mary Lou Williams Takes Her Jazz Mass to Church."
208 **"another mass for the peace of the world":** Williams, quoted in Dahl, *Morning Glory*, pp. 303, 306.
209 **women cannot perform a liturgical office:** "Tra Le Sollecitudini" (Instructions on Sacred Music) is discussed by Anthony Ruff, OSB, in *Sacred Music and Liturgical Reform: Treasures and Transformations* (Hillenbrand Books, 2007), pp. 272–96.
209 **protested with placards:** "No Jazz!": Wilson, "Mary Lou Williams Takes Her Jazz Mass to Church."
209 **"from the kitchen to the piano":** Peter O'Brien, quoted in Brian Q. Torff, "Mary Lou Williams: A Woman's Life in Jazz," in *Perspectives on American Music Since 1950*, edited by James R. Heintze (Garland, 1999), pp. 153–203, at 198.
209 **changes made with many musicians:** Mary Lou Williams, *Mary Lou's Mass* (Smithsonian Folkways Recordings, 2005). On the evolution of *Mary Lou's Mass*, see Charles Wilkins Pickeral's PhD dissertation, "The Masses of Mary Lou Williams: The Evolution of a Liturgical Style" (Texas Tech University, 1998).
209 **"an encyclopedia of black music":** Hubert Saal, "The Spirit of Mary Lou," *Newsweek*, 20 December 1971, p. 67.
211 **with complex jazz harmonies:** See "The Business of Jazz: The Musical Artistry of Mary Lou Williams," 1977, from Kennedy Center Education Digital Learning, YouTube video, uploaded 26 March 2019, https://www.youtube.com/watch?v=UA4vp9AB_Oo.
211 **"a loving and caring exercise":** Torff, "Mary Lou Williams," p. 155.
212 **he showcased his dance rendition of it:** Parts of Alvin Ailey's production of *Mary Lou's Mass* can be seen online on the Alvin Ailey American Dance Theater's official website, at https://www.alvinailey.org/performances/repertory/mary-lous-mass.
212 **"colleges and churches around the country":** Witkowski, *Mary Lou Williams*, p. 96.
212 **"That's what we need":** Williams and Cardinal Cooke, quoted in Wilson, "Mary Lou Williams Takes Her Jazz Mass to Church."
213 **"But no sex":** O'Brien, quoted in Dahl, *Morning Glory*, p. 320.

214 **"our only original American art form"**: Williams, quoted in "Jazz Goes to Church," *Ebony*, April 1966, pp. 77–80, at 80.

214 **from her great-grandparents**: "By the time I was eight years old, I had heard so many tales of how the slaves were mistreated.... Both my [fair] great-grandparents told stories about how the slaveowners on the two different farms on which they were raised used to put them in the sun to parch their skin black to escape guilt and the neighbors' talk. It was a question of easing guilty consciences": Arnold Shaw, "Mary Lou Williams," in his collection of interviews, *The Street That Never Slept: New York's Fabled 52d Street* (Coward, McCann and Geoghegan, 1971), pp. 221–24, at 222, 223.

214 **"completeness of American music's evolution"**: Torff, "Mary Lou Williams," p. 178.

214 **legally park at 6 or 7 a.m.**: Torff, "Mary Lou Williams," pp. 177, 180.

215 **"I have played through all the eras of Jazz"**: All quotations from *The History of Jazz* (Folkways Records, 1978) are drawn from this record. Williams began recording tracks for this album in 1970.

215 **"love we have for one another musically"**: Mary Lou Williams, liner notes for Mary Lou Williams and Cecil Taylor, *Embraced* (Pablo Records, 1978).

215 **"'making people sick all over town'"**: Williams, quoted in "Jazz: The Prayerful One."

216 **"get a word in edgewise"**: Witkowski, *Mary Lou Williams*, p. 121.

216 **than her earlier renditions of it**: Richard Brody, "A Hidden Hero of Jazz," *New Yorker*, 21 September 2015, https://www.newyorker.com/culture/richard-brody/a-hidden-hero-of-jazz; Phyl Garland, "Sounds," *Ebony*, October 1974, p. 30; Tammy Kernodle, "Five Minutes That Will Make You Love Mary Lou Williams," *New York Times*, 5 April 2023.

216 **"I'm playing my buns off"**: Williams, quoted in Dahl, *Morning Glory*, p. 350.

216 **"*That* woulda got them!"**: Garland, "The Lady Lives Jazz," p. 58.

217 **the initials of her own name!**: Kernodle, *Soul on Soul*, p. 265.

218 **"blacks under forty can't play it at all"**: Williams, quoted in Torff, "Mary Lou Williams," p. 173.

218 **"in order to internalize the music"**: Torff, "Mary Lou Williams," p. 183.

218 **Count Basie, or Dizzy Gillespie**: Rowes, "From Duke Ellington to Duke University," p. 77.

218 **"by saying 'Play the note'"**: Williams and O'Brien, quoted in Torff, "Mary Lou Williams," pp. 183, 200.

218 **"right here in my mind. It saves me"**: Williams, quoted in Rowes, "From Duke Ellington to Duke University," p. 77.

218 **"a very good ending, very good"**: O'Brien, quoted in Torff, "Mary Lou Williams," p. 200.

219 **"put her in Harlem Hospital. It worked"**: O'Brien, quoted in Torff, "Mary Lou Williams," p. 200.

219 **"what the music really is: love"**: Mary Lou Williams, in Nina Winter, "Mary Lou Williams," in *Interview with the Muse: Remarkable Women Speak on Creativity and Power* (Moon Books, 1978), pp. 146–49, at 148.

220 **"'Mary, you'll do that one day'"**: Williams, "My Life with the Kings of Jazz," p. 179.

220 **Norma Teagarden, Melba Liston:** Williams's liner notes to the record *Jazz Women* are discussed in Mary Unterbrink, *Jazz Women at the Keyboard* (McFarland, 1983), pp. 47–48.
220 **"and only men can play jazz":** The editor of *Downbeat Magazine*, quoted in the Discussion Guide of *The Girls in the Band*, dir. Judy Chaikin (Virgil Films, 2014), College Version DVD, p. 7.

Chapter 8: Gwendolyn Brooks

222 **"I would have died a 'Negro' fraction":** Gwendolyn Brooks, *Report from Part One*, prefaces by Don L. Lee and George Kent (Broadside Press, 1972), p. 45.
222 **"DARK . . . was the failings of failings":** Brooks, *Report from Part One*, pp. 56, 57.
222 **one White, one Black, and one mixed:** Angela Jackson, *A Surprised Queenhood in the New Black Sun: The Life and Legacy of Gwendolyn Brooks* (Beacon Press, 2017), pp. 6–7.
223 **deemed three-fifths of a person:** Patrick Rael, "A Compact for the Good of America? Slavery and the Three-Fifths Compromise," *Black Perspectives*, 19 December 2016, https://www.aaihs.org/a-compact-for-the-good-of-america-slavery-and-the-three-fifths-compromise/.
223 **anyone to whom it spoke:** Brooks argued that her "poetry is for anybody who wants to take the time to consult it"; Kevin Bezner, "A Life Distilled: An Interview with Gwendolyn Brooks" (1986), in *Conversations with Gwendolyn Brooks*, edited by Gloria Wade Gayles (University Press of Mississippi, 2003), pp. 117–24, at 120. See in the same volume Rebekah Presson, "Interviews with Gwendolyn Brooks" (1988), pp. 133–39, at 138.
224 **less widely circulated and reviewed:** Brooks herself noted this point. See "Gwendolyn Brooks," Poetry Foundation, https://www.poetryfoundation.org/poets/gwendolyn-brooks.
224 **"the kindergarten of new consciousness":** Brooks, *Report from Part One*, pp. 84, 86.
224 **debilitating consequences of racism:** In 1983 Brooks defended the militancy of her early publications. See Claudia Tate, "Interview with Gwendolyn Brooks" (1983), in Gayles, *Conversations with Gwendolyn Brooks*, pp. 104–10, at 106–7.
224 **"his power back again":** Gwendolyn Brooks, "The Anniad," in *The Essential Gwendolyn Brooks*, edited by Elizabeth Alexander (Library of America, 2005), p. 41; this is the most widely available collection of Brooks's poems.
225 **pay the electricity bill:** See Brooks's 1986 interview by E. Ethelbert Miller, a poet and the director of Howard University's African American Resource Center, and Alan Jabbour, the head of the Library of Congress's American Folklore division, "A Conversation with Gwendolyn Brooks," *The Writing Life*, HoCoPoLitSo, YouTube video, uploaded 15 October 2012, https://www.youtube.com/watch?v=UVZ6KTLN7O8.
225 **"We Real Cool":** Gwendolyn Brooks, "We Real Cool," in *The Essential Gwendolyn Brooks*, pp. 60–61.
225 **Elizabeth Alexander points out:** Elizabeth Alexander, introduction to *The Essential Gwendolyn Brooks*, pp. xiii–xxvi, at xxi.

225 **"Bronzeville Woman in a Red Hat":** Gwendolyn Brooks, "Bronzeville Woman in a Red Hat," in *The Essential Gwendolyn Brooks*, p. 75.
226 **"rarely touched upon by standard texts":** Brooks, *Report from Part One*, pp. 81, 82.
226 **his deliberately fragmented dreamscape:** Brooks had earlier started work on a prose composition about the Mecca, but she took it up in verse after suffering "a mild heart attack, followed by influenza" in 1966. D. H. Melhem, *Gwendolyn Brooks: Poetry and the Heroic Voice* (University Press of Kentucky, 1987), p. 154.
227 **"pigeon feathers, and cigarette butts":** Katherine Dunham, *A Touch of Innocence: Memoirs of Childhood* (1959; reprint, University of Chicago Press, 1994), p. 46.
227 **Toni Cade Bambara noted:** Toni Cade Bambara, review of Brooks's *Report from Part I*, *New York Times Book Review*, 7 January 1973, pp. 1, 10, at 1.
227 **"some say two thousand)":** Brooks, *Report from Part One*, p. 190.
228 **"Mecca was on this wise":** Gwendolyn Brooks, "In the Mecca," in *In Montgomery and Other Poems* (Third World Press, 2003), pp. 105–40, at 108.
228 **"'WHERE PEPITA BE?'":** Brooks, "In the Mecca," p. 118.
229 **that she "squishied":** Brooks, "In the Mecca," p. 120.
229 **"A lariat of questions":** Brooks, "In the Mecca," p. 125.
229 **"heel-grind that soft breast":** Brooks, "In the Mecca," p. 130.
229 **the Black Power/Arts movements:** See, for example, Cheryl Clarke, *"After Mecca": Women Poets and the Black Arts Movement* (Rutgers University Press, 2005), pp. 38–41, 43–45, as well as D. H. Melhem, "*In the Mecca*," in *On Gwendolyn Brooks: Reliant Contemplation*, edited by Stephen Caldwell Wright (University of Michigan Press, 1996), pp. 161–81.
230 **"with roaches" under his bed:** Brooks, "In the Mecca," p. 130.
231 **"chopped chirpings oddly rising":** Brooks, "In the Mecca," p. 140.
231 **"changes are in the Mecca book":** Brooks, quoted in George E. Kent, *A Life of Gwendolyn Brooks* (University Press of Kentucky, 1990), p. 233.
231 **letter recommending her for the Pulitzer Prize:** See Major Jackson, "Pulitzer Jury Report: February 1950," in *The Whiskey of Our Discontent: Gwendolyn Brooks as Conscience and Change Agent*, edited by Quraysh Ali Lansana and Georgia A. Popoff (Haymarket Books, 2017), pp. 169–84, at 178.
232 **"the Gwendolyn Brooks Workshop":** Haki Madhubuti, quoted in Lita Hooper, *The Art and Life of Haki R. Madhubuti* (Third World Press, 2007), p. 77.
232 **"logic, illogic, zeal, construction":** Gwendolyn Brooks, "Gwendolyn Brooks" (1984), an interview with herself reprinted in Gayles, *Conversations with Gwendolyn Brooks*, pp. 111–16, at 113.
232 **"to lift the men up, to *heroize* them":** Brooks, quoted in Gloria T. Hull and Pasey Gallagher, "Update on 'Part One': An Interview with Gwendolyn Brooks," *CLA Journal* 1, no. 1 (September 1977): 19–40, at 36.
233 **appended to its title poem:** Gwendolyn Brooks, "Riot," in *The Essential Gwendolyn Brooks*, pp. 100–101.
233 **wrecked self-esteem in the Black community:** Gwendolyn Brooks, "The Life of Lincoln West," in *The Essential Gwendolyn Brooks*, pp. 106–11.
234 **as Brooks sometimes suggested?:** See Bezner, "A Life Distilled," p. 117; Presson, "Interviews with Gwendolyn Brooks," p. 133; and Gwendolyn Brooks, *Report from Part Two* (Third World Press, 1996), p. 57.

235 "Where are the young folks that's buildin'?": Gwendolyn Brooks, "In Montgomery," in *In Montgomery and Other Poems*, pp. 1–28, at 21, 16.
235 "some degree of free time for him": Brooks, *Report from Part One*, p. 144.
236 "personal shapings not possible before": Brooks, *Report from Part One*, p. 58.
236 he was "an integrationist": Brooks, *Report from Part One*, p. 178.
236 "get some attention before he does": Brooks, *Report from Part One*, pp. 179, 180.
236 "Shorthand Possible": Gwendolyn Brooks, "Shorthand Possible," in *The Essential Gwendolyn Brooks*, p. 124.
237 "equal pay just as white women should": Brooks, *Report from Part One*, p. 180.
237 "I thought that was interesting": Brooks, *Report from Part One*, pp. 85–86.
237 "I am essentially an essential African": Brooks, *Report from Part One*, pp. 175, 176, 45. See Annette Debo, "Signifying 'Afrika': Gwendolyn Brooks' Later Poetry," *Callaloo* 29, no. 1 (Winter 2006): 168–81.
237 "factories, prisons, the consulate": Brooks, *Report from Part One*, pp. 177, 183.
238 "from the chaff, comes to meet you . . .": Brooks, *Report from Part One*, p. 204.
238 a "religion of kindness": Madhubuti, quoted in Hooper, *The Art and Life of Haki R. Madhubuti*, pp. 94, 86.
238 "they are blackening English": Gwendolyn Brooks, introduction to *Jump Bad: A New Chicago Anthology*, edited by Brooks (Broadside, 1972), pp. 11–12, at 12.
238 "frivolous—perilously innocent": Gwendolyn Brooks, Keorapetse Kgositsile, Haki R. Madhubuti, and Dudley Randall, *A Capsule Course in Black Poetry Writing* (Broadside Press, 1975), p. 4.
238 "ideas that are like my own": Brooks, quoted in Hull and Gallagher, "Update on 'Part One,'" p. 35.
238 for those in elementary school: For Brooks's involvement with school-age poets, see Rachel Conrad, *Time for Childhoods: Young Poets and Questions of Agency* (University of Massachusetts Press, 2020), pp. 48–84.
239 "To Those of My Sisters Who Kept Their Naturals": Gwendolyn Brooks, "The Boy Died in My Alley" and "To Those of My Sisters Who Kept Their Naturals," in *The Essential Gwendolyn Brooks*, pp. 114–15, 120–21.
239 "from vomit, and from tainted blood": Gwendolyn Brooks, *Winnie* (World Press, 1991), p. 15.
239 "Jane Addams": Gwendolyn Brooks, "Jane Addams," in *In Montgomery*, pp. 68–69.
239 receive "cookies and cocoa": Gwendolyn Brooks, "After School," in *Children Coming Home* (David Company, 1991), unpaginated opening poem.
240 "hoping to change the hearts of white people": Gwendolyn Brooks, in Haki Madhubuti, "Interview with Gwendolyn Brooks," *Black Books Bulletin: Words Work* 1 (July/August 1991): 3–4, at 4.
240 where they dare not sleep: Gwendolyn Brooks, "The Coora Flower," in *Children Coming Home*, p. 1.
240 where Brooks had interacted with them: Jackson, *A Surprised Queenhood in the New Black Sun*, p. 196.
240 "Uncle Seagram," in a filmed interview: "Lincoln Academy 1997 Interview Gwendolyn Brooks," YouTube video, uploaded by Lincoln Academy of

Illinois, 11 September 2015, https://youtu.be/lsZJZPm7pt0. For "Uncle Seagram," see Brooks, *Children Coming Home*, p. 7.

241 **"Black But Not Very"**: Gwendolyn Brooks, "Song: White Powder" and "Black But Not Very," in *Children Coming Home*, pp. 10, 13.
241 **"I'll Stay"**: Gwendolyn Brooks, "I'll Stay," in *Children Coming Home*, p. 20.
242 **"My Mother"**: Gwendolyn Brooks, "My Mother," in *Report from Part Two*, p. 31.
242 **"Keziah's Health Book"**: Keziah Wims Brooks, in Brooks, *Report from Part Two*, pp. 35–38.
242 **"The total was 746 words"**: Brooks, *Report from Part Two*, p. 39.
243 **"YOU AmeriCAINE!"**: Brooks, *Report from Part Two*, pp. 48, 51.
243 **always be viewed as Americans**: D. H. Mehlem's interview "Gwendolyn Brooks: Humanism and Heroism" (1990), in Gayles, *Conversations with Gwendolyn Brooks*, pp. 149–54, at 150.
243 **"Friends Today—Enemies Tomorrow"**: Brooks, *Report from Part Two*, p. 52.
243 **"when the library is closed?"**: Brooks, *Report from Part Two*, p. 14.
243 **"would have made more sense to him"**: Brooks, *Report from Part Two*, pp. 19, 20.
244 **"everyone was of the same hue"**: Brooks, *Report from Part Two*, pp. 58, 59.
244 **"brilliant, informed, managed, sane"**: Brooks, *Report from Part Two*, pp. 55, 57.
244 **"etc. etc. etc., in agitated spew"**: Brooks, *Report from Part Two*, pp. 63, 64.
245 **"hosts of the Boston Tea Party"**: Brooks, *Report from Part Two*, pp. 64, 65.
245 **"never worked so hard in my life!"**: Brooks, *Report from Part Two*, pp. 77, 78.
245 **"ALL WHITE CRITICS NON-SPUNKY!"**: Brooks, *Report from Part Two*, pp. 86, 94.
246 **"wild OR to an unwilling courtesy.)"**: Brooks, *Report from Part Two*, pp. 105, 106.
246 **"(Oh, mighty Drop.)"**: Brooks, *Report from Part Two*, p. 128.
246 **"insults without including curse words"**: Quraysh Ali Lansana, quoted in Jackson, *A Surprised Queenhood in the New Black Sun*, p. 196.
246 **"though gracious and playful as always"**: Quraysh Ali Lansana, "No Waste: Gwendolyn Brooks's Last Workshop," in *Gwendolyn Brooks and Working Writers*, edited by Jacqueline Imani Bryant (Third World Press, 1967), pp. 61–67, at 62–63, 67.
247 **"Nora placed a pen in her hand"**: Jackson, *A Surprised Queenhood in the New Black Sun*, p. 182.
247 **initiated with "We Real Cool"**: Madhubuti, "Interview with Gwendolyn Brooks," p. 4.
247 **the Golden Shovel form was born**: Terrance Hayes, foreword to *The Golden Shovel Anthology: New Poems Honoring Gwendolyn Brooks*, edited by Peter Kahn, Ravi Shankar, and Patricia Smith (University of Arkansas Press, 2017), pp. xxvii–xxix, at xxix.

Chapter 9: Katherine Dunham

250 **"the Beyoncé before Beyoncé"**: The comment is made by the Dunham-trained dancer Heather Beal in "How Katherine Dunham and Dance from the African Diaspora Changes Lives," *If Cities Could Dance*, KQED Arts, 23 June 2021, YouTube video, https://www.youtube.com/watch?v=7k7SLEaTh7U.

NOTES

250 **originated in a Nigerian wrestling match:** Katherine Dunham, writing as Kaye Dunn, "L'Ag'ya of Martinique," *Esquire*, November 1939; reprinted in *Kaiso! Writings by and About Katherine Dunham*, edited by Vèvè A. Clark and Sara E. Johnson (University of Wisconsin Press, 2005), pp. 201–7, at 201.

250 **the groups she led in Chicago:** First, Dunham had to divorce Jordis McCoo, a fellow dancer. On the marriage with Pratt, see Joanna Dee Das, *Katherine Dunham: Dance and the African Diaspora* (Oxford University Press, 2017), pp. 98–99.

250 **the shimmy, and the black bottom:** On *Tropics and Le Jazz Hot*, see Susan Manning, *Modern Dance, Negro Dance* (University of Minnesota Press, 2004), pp. 142–53, as well as Wendy Perron, "Katherine Dunham: One-Woman Revolution," *Dance Magazine*, August 2000, pp. 42–45, 74.

251 **Lena Horne, and Fats Waller:** On Dunham's resistance to stereotypes in *Stormy Weather*, see Daphne Lamothe, *Inventing the New Negro: Narrative, Culture, and Ethnography* (University of Pennsylvania Press, 2008), p. 139; Shane Vogel, "Performing 'Stormy Weather': Ethel Waters, Lena Horne, and Katherine Dunham," *South Central Review* 25, no. 1 (Spring 2008): 93–113; and Hannah Durkin, *Josephine Baker and Katherine Dunham: Dances in Literature and Cinema* (University of Illinois Press, 2019), pp. 159–67.

251 **"and in Rome—art!":** Dunham's words appear in the headnote to her essay "Thesis Turned Broadway" (1941), in *Dance in America: A Reader's Anthology*, edited by Mindy Aloff (Library of America, 2018), p. 258. For the rumor about her legs being insured, see Ruth Beckford, *Katherine Dunham: A Biography* (Marcel Dekker, 1979), p. 105.

251 **stereotypically "racy" productions:** Katherine Dunham, in "Divine Drumbeats—Katherine Dunham & Her People," *Great Performances*, WNET New York, 24 March 1980, YouTube video, 14 May 2022, https://youtu.be/Z_pUzS9chh4.

251 **until the theater desegregated:** "Katherine Dunham on Overcoming 1940s Racism | Jacob's Pillow Dance," The Dunham Institute, Inc., 12 June 2022, YouTube video, https://youtu.be/fR5rsJwLe84. See also Katherine Dunham, "Comment to a Louisville Audience," in Clark and Johnson, *Kaiso!*, p. 255.

252 **canceled her troupe's visas:** Background on *Southland*'s reception appears in Katherine Dunham, "*Southland* Program: A Dramatic Ballet in Two Scenes," and Constance Valis Hill, "Katherine Dunham's *Southland*: Protest in the Face of Repression," both in Clark and Johnson, *Kaiso!*, pp. 341–44, 345–63. See also Joyce Aschenbrenner, *Katherine Dunham: Dancing a Life* (University of Illinois Press, 2002), p. 150.

252 **"foundations would not give it support":** Dunham, quoted in Beckford, *Katherine Dunham: A Biography*, p. 120.

252 **during a precarious lift:** Rishona Zimring, "Katherine Dunham's Chicago Stage: Crossing to Caribbean *Négritude*," *Feminist Modernist Studies* 1, no. 1–2 (2018): 52–73, at 52–53.

253 **"or of their own lives":** Terry Harnan, *African Rhythm—American Dance: A Biography of Katherine Dunham* (Alfred A. Knopf, 1974), p. 173.

253 **"her French-Canadian background":** Katherine Dunham, *A Touch of Innocence: Memoirs of Childhood* (1959; reprint, University of Chicago Press, 1994), p. 14.

253 **Requiescat in Pace**: Frank Edward Moorer, "Creating the Uncreated Features of My Face: The Social Self and Transcendence in Selected Black American and South American Autobiographies" (PhD diss., University of Iowa, 1991), p. 103.

254 **"so wild, so cruel, so filthy!"**: Bernard Berenson, quoted in Harnan, *African Rhythm*, p. 157. Marina Magloire discusses the voodoo craze in terms of primitivism in "An Ethics of Discomfort: Katherine Dunham's Vodou Belonging," *Small Axe* 23, no. 3 (2019): 1–17, at 5–7.

254 **"She's a law unto herself"**: A "woman journalist," quoted in Harnan, *African Rhythm*, p. 165.

254 **"she became a complete tyrant"**: James Haskins, *Katherine Dunham* (Coward, McCann & Geoghegan, 1982), p. 103.

254 **her mature personality as "authoritarian"**: Beckford, *Katherine Dunham: A Biography*, pp. 119, 109.

254 **"the 'near whites' against the 'all blacks'"**: Dunham, *A Touch of Innocence*, p. 35.

255 **"forerunners of the Broadway revue"**: Dunham, *A Touch of Innocence*, pp. 54, 58, 59.

255 **into Chicago during the Great Migration**: Katherine Dunham discussed this "influx" in "Katherine Dunham: My Childhood," National Visionary Project [@visionaryproject], YouTube video, uploaded 17 March 2010, https://youtu.be/4K72lC030Fw.

255 **"barriers set up against their darker brethren"**: Dunham, *A Touch of Innocence*, p. 62.

255 **"dedicated through blood for life"**: Dunham, *A Touch of Innocence*, pp. 177, 178, 179.

256 **knee squats of the Russian dance**: Dunham, *A Touch of Innocence*, pp. 187–88, 191, 194.

256 **"he mistook the Negro for a horse"**: Dunham, *A Touch of Innocence*, p. 197.

257 **"and squat like a *girl*"**: Dunham, *A Touch of Innocence*, p. 5.

258 **led to an early death**: Katherine Dunham, "Prologue: Excerpt from 'Minefields,'" in Clark and Johnson, *Kaiso!*, pp. 73–84, at 83.

258 **"contempt" for her stepmother**: Dunham, *A Touch of Innocence*, p. 256.

258 **"associated *unnaturally* with her own father"**: Dunham, *A Touch of Innocence*, pp. 265, 266.

258 **"a knowledge too long held off"**: Dunham, *A Touch of Innocence*, p. 270.

259 **"retreating farther and farther since childhood"**: Dunham, *A Touch of Innocence*, pp. 283, 285.

259 **"freedom from the parental vise"**: Dunham, *A Touch of Innocence*, p. 307.

259 **"except as part-time hired help"**: Dunham, *A Touch of Innocence*, p. 309.

259 **"feeling of freedom while dancing"**: Katherine Dunham, "Survival: Chicago After the Caribbean: Excerpt from 'Minefields,'" in Clark and Johnson, *Kaiso!*, pp. 85–124, at 106.

259 **feelings of isolation in childhood**: Dunham, in "Divine Drumbeats—Katherine Dunham & Her People."

260 **"I . . . lost my will to live"**: Martha Graham, *Blood Memory* (Doubleday, 1991), p. 237.

260 **in "an outdoor amphitheatre"**: Aschenbrenner, *Katherine Dunham: Dancing a Life*, pp. 158, 160.
260 **word for "having a good time"**: Beckford, *Katherine Dunham: A Biography*, p. 77.
261 **"hullabaloo of the music hall and nightclub"**: Allen Hughes, "Dance: Revue by Katherine Dunham," *New York Times*, 23 October 1962.
261 **"people from different tribal groups"**: Haskins, *Katherine Dunham*, p. 113.
261 **"springing movements of traditional *karate*"**: Aschenbrenner, *Katherine Dunham: Dancing a Life*, p. 161.
262 **"delinquency and poverty for many years"**: Haskins, *Katherine Dunham*, p. 118.
262 **storm trooper on a motorcycle**: Clark Mitze, "Dunham 'Faust' Gives SIU Exciting Evening," *St. Louis Globe-Democrat*, 15 February 1965, https://collections.carli.illinois.edu/digital/collection/sic_srcper/id/3809.
262 **"complexity of Caribbean color classifications"**: Katherine Dunham, *Island Possessed* (Doubleday, 1969), p. 4.
263 **"by slavery and/or colonialism"**: Dunham, *Island Possessed*, p. 60.
263 **stance was very difficult to sustain**: On the anthropologist-observer, see Kate Ramsey, "Melville Herskovits, Katherine Dunham, and the Politics of African Diasporic Dance Anthropology," in *Dancing Bodies, Living Histories: New Writings About Dance and Culture*, edited by Lisa Doolittle and Anne Flynn (Banff Centre Press, 2000), pp. 196–216.
263 **"all 'call,' all causes"**: Dunham, *Island Possessed*, pp. 60, 62, 65, 68.
264 **"obeisance to Damballa, the serpent"**: Dunham, *Island Possessed*, p. 99.
264 **"associated traits, and so forth"**: Dunham, *Island Possessed*, pp. 102, 104, 105–6.
264 **"my life, my brother's illness"**: Dunham, *Island Possessed*, pp. 109, 113, 34.
265 **"now a god dances in me"**: Dunham, *Island Possessed*, p. 117. See Nietzsche's *Thus Spoke Zarathustra* (1883–85), I.7.
265 **"mixed lightheadedness and well-being"**: Dunham, *Island Possessed*, pp. 129, 131.
265 **"but a part of everyone else"**: Dunham, *Island Possessed*, pp. 132, 135, 136.
265 **"in terms of unlimited control"**: Dunham, *Island Possessed*, pp. 136, 133.
266 **French bread brought to her by Fred**: Dunham, *Island Possessed*, p. 139.
267 **renditions could get commercially produced**: Shane Vogel argues that Dunham introduced "alienating" strategies "to disrupt the spectatorial pleasure in Caribbean alterity"; see *Stolen Time: Black Fad Performance and the Calypso Craze* (University of Chicago Press, 2018), p. 153.
267 **"that I *invaded* the Caribbean"**: Dunham, *Island Possessed*, p. 3.
268 **"my dancing had saved me from disgrace"**: Dunham, *Island Possessed*, pp. 234, 235.
268 **"superior in the social structure"**: Dunham, *Island Possessed*, p. 46.
268 **"*a country of which I really knew nothing*"**: Dunham, *Island Possessed*, pp. 46, 51, 53. In the 1983 preface to a revised edition of her 1947 monograph *Las danzas de Haiti*, Dunham stresses that "I have never been able to claim truthfully a knowledge of the *vodun*": Katherine Dunham, *Dances of Haiti* (Center for Afro-American Studies, University of California, Los Angeles, 1983), pp. ix–xiv, at ix–x.

NOTES

268 **"for such in a starving nation"**: Dunham, *Island Possessed*, pp. 222, 225. Harnan (*African Rhythm*, p. 182) suggests that Dunham could only hint at the horrors instigated by Duvalier's militia, the ruthless Tonton Macoute (Uncle Gunnysack).

269 **"and buried alive" many slaves**: Dunham, *Island Possessed*, pp. 236, 239, 242.

269 **"worming babies, and other clinic demands"**: Dunham, *Island Possessed*, pp. 244, 268.

269 **"munitions station" for Duvalier's political opponents**: Dunham, *Island Possessed*, p. 270.

270 **"pig cops started twisting my arm"**: Dunham, quoted in Associated Press, "Dunham Jailed Following Protest" (29 July 1967), in Clark and Johnson, *Kaiso!*, p. 418.

270 **"all those young men going up in flames"**: Haskins, *Katherine Dunham*, p. 117.

270 **"intensified by the riots, that I remained"**: Dunham, quoted in Gwen Mazer, "Katherine Dunham" (1976), in Clark and Johnson, *Kaiso!*, pp. 419–26, at 425.

270 **"in on a drumming class the next"**: Dunham, quoted in Haskins, *Katherine Dunham*, pp. 126, 127.

270 **"and can relate to other people"**: Dunham, quoted in Harnan, *African Rhythm*, p. 206.

271 **"my love of humanity and things of beauty"**: Dunham, quoted in Mazer, "Katherine Dunham," p. 421.

271 **"I have something to live for!"**: Dunham, quoted in Das, *Katherine Dunham: Dance and the African Diaspora*, p. 187.

271 **"Now I'll never leave"**: Dunham, quoted in Aschenbrenner, *Katherine Dunham: Dancing a Life*, p. 177.

271 **thoughts of the grandmothers**: Eugene Redmond, in "Dr. Eugene B. Redmond's Reflections of Katherine Dunham," at Lovejoy Library, Southern Illinois University Edwardsville, 28 September 2017, uploaded to YouTube 5 February 2018, https://www.youtube.com/watch?v=e7CjczCYqak.

271 **"universities without walls"**: Katherine Dunham, "Performing Arts Training Center as a Focal Point for a New and Unique College or School" (1970), in Clark and Johnson, *Kaiso!*, pp. 551–56, at 556.

271 **"whom or what we might meet or see!"**: Eugene Redmond, "Cultural Fusion and Spiritual Unity" (1976), in Clark and Johnson, *Kaiso!*, pp. 557–63, at 562.

272 **"the equivalent of those cafés in France"**: Eugene Redmond, quoted in Aschenbrenner, *Katherine Dunham: Dancing a Life*, p. 182.

272 **"whose formula is always kept secret"**: Beckford, *Katherine Dunham: A Biography*, p. 9.

272 **sundry as her foreign languages**: Redmond, in "Dr. Eugene B. Redmond's Reflections of Katherine Dunham."

272 **"alternative to violence and genocide"**: Dunham, "Performing Arts Training Center," p. 551.

272 **"through the Concentrated Employment Program"**: Das, *Katherine Dunham: Dance and the African Diaspora*, pp. 189–90.

NOTES

273 **"scalp-tingling power"**: "Music: From Rags to Rags," *Time*, 7 February 1972, pp. 89–90.

273 **"Beauty rubs off"**: Dunham, quoted in Barbara O'Connor, *Katherine Dunham: Pioneer of Black Dance* (Carolrhoda Books, 2000), p. 93.

273 **holding the rest of the body stationary**: See Albirda Rose, *Dunham Technique: "A Way of Life"* (Kendall/Hunt, 1990), and Eugene B. Redmond, "Choreo/Cosmo-Empress' Leg-a-cy Lands on East Saint Earth (Apropos Katherine Dunham)," *Drumvoices Revue* 8 (1998/1999): 18–21. Redmond reads the entire poem in "Dr. Eugene B. Redmond's Reflections of Katherine Dunham."

273 **toe and foot movements from Haiti**: Beckford, *Katherine Dunham: A Biography*, p. 51.

273 **"prayer in its deepest sense"**: Dunham, *Island Possessed*, p. 135.

273 **"the high priestess of the pelvic girdle"**: Martha Graham, quoted in Adam Bernstein, "Dancer Katherine Dunham; Formed Black Ballet Troupe," *Washington Post*, 23 May 2006, https://www.washingtonpost.com/archive/local/2006/05/23/dancer-katherine-dunham/bdd7b8a4-3bd3-4f64-8df9-e66a5d5e02d6/.

274 **"working under Miss Dunham"**: Dunham and Redmond, quoted in Aschenbrenner, *Katherine Dunham: Dancing a Life*, pp. 208, 194.

274 **"frame her well-structured face"**: Beckford, *Katherine Dunham: A Biography*, pp. 79–80.

274 **"powers—unless I have to"**: Alvin Ailey's recollection of Katherine Dunham's words, quoted in Alan M. Kriegman, "Dances Dynamic Duo" (1988), in Clark and Johnson, *Kaiso!*, pp. 591–94, at 592–93.

274 **"what I have done and researched"**: Dunham, quoted in Beckford, *Katherine Dunham: A Biography*, p. 129.

274 **and the exhibition of virtuosity**: See Katherine Dunham, "The Anthropological Approach to Dance" (1942), in Clark and Johnson, *Kaiso!*, pp. 508–513, at 510.

275 **potshots at her rival in anthropology**: See Das, *Katherine Dunham: Dance and the African Diaspora*, pp. 41–42, as well as Durkin, *Josephine Baker and Katherine Dunham*, pp. 57–68.

275 **"or in later years, vodka"**: Dunham, "Survival," p. 93.

275 **"people you came from, your roots"**: Katherine Dunham, interview with Anne-Marie Berger in October 2005, for "Katherine Dunham," *Living St. Louis*, Nine PBS, YouTube video, uploaded 20 September 2007, https://www.youtube.com/watch?v=7vyx6ue7K6o.

275 **move her to New York City**: Bernstein, "Dancer Katherine Dunham"; Aschenbrenner, *Katherine Dunham: Dancing a Life*, p. 230.

275 **"to create a desire to be alive"**: Dunham, quoted in Jack Anderson, "Katherine Dunham, Dance Icon, Dies at 96," *New York Times*, 23 May 2006, https://www.nytimes.com/2006/05/23/arts/dance/23dunham.html.

275 **"will not blow out your inner candle"**: Ruby Streate, artistic director of the Katherine Dunham Children's Workshop, in "How Katherine Dunham and Dance from the African Diaspora Changes Lives."

276 **"you have the same spirit"**: Katherine Dunham, "90th Birthday Interview

with Empress Katherine Dunham," with Eugene B. Redmond, *Drumvoices Revue* 8 (1998/1999): 10–16, at 16.

276 **"Born again Civil-warrior"**: Redmond, "Choreo/Cosmo-Empress' Leg-a-cy Lands on East Saint Earth," p. 18.

Conclusion: Inventive Endgames in Our Times

278 **"That ebb and flow by th' moon"**: William Shakespeare, *King Lear*, 5.3.8–19, in *The Norton Shakespeare*, general editor Stephen Greenblatt, 2nd ed. (W. W. Norton, 2008), p. 2475.

279 **"I know that it can bring me joy"**: Emma Thompson, quoted in John Lahr, "Acting Up: Emma Thompson's Third Act," *New Yorker*, 14 November 2022, pp. 52–63, at 54.

279 **elderly women posing in natural settings**: See Jocelyn Lee's book *Sovereigns* (Minor Matters, 2020), as well as Margaret Talbot's essay "Jocelyn Lee's Older Women in the Nude," *New Yorker*, 1 November 2021, https://www.newyorker.com/culture/photo-booth/jocelyn-lees-older-women-in-the-nude, and an online collection of some of the images at the Minor Matters website, https://minormattersbooks.com/products/sovereign-by-jocelyn-lee.

280 **telling the truth about the female body?**: Virginia Woolf, "Professions for Women" (1942), in *The Norton Anthology of Literature by Women: The Traditions in English*, edited by Sandra M. Gilbert and Susan Gubar, 3rd ed., 2 vols. (W. W. Norton, 2007), 2:244–47, at 247.

280 **"become what I have loved"**: Sharon Olds, "Ode to Stretch Marks," in *Odes* (Alfred A. Knopf, 2016), pp. 82–83.

280 **taste of a bowl of soup**: Sam Anderson, "Sex, Death, Family: Sharon Olds Is Still Shockingly Intimate," *New York Times Magazine*, 12 October 2022, https://www.nytimes.com/2022/10/12/magazine/sharon-olds-poetry.html.

281 **"best / who loves you best"**: Sharon Olds, "Crazy Sharon Talks to the Bishop" and "The Preparing," in *Balladz* (Alfred A. Knopf, 2022), pp. 74–75, at 74; 164–65, at 164.

281 **"ash and dispersed chemicals"**: Fleur Adcock, "Match Girl," "Nominal Aphasia," "Walking Stick," "Macular Degeneration," and "Having Sex with the Dead," in *Glass Wings* (Bloodaxe Books, 2013), pp. 21, 23, 24, 25, 28.

281 **"kiss his sweet explaining lips"**: Grace Paley, "Here," in *Begin Again: Collected Poems* (Farrar, Straus and Giroux, 2000), p. 177.

281 **"The other, I agree"**: Adrienne Rich, "Memorize This," in *Collected Poems 1950–2012* (W. W. Norton, 2016), p. 943.

282 **"but it might be worth trying"**: Ursula K. Le Guin, "Introducing Myself," in *The Wave in the Mind: Talks and Essays on the Writer, the Reader, and the Imagination* (Shambhala, 2004), pp. 3–7, at 7.

282 **"her fertility would be sacramental"**: Leonora Carrington, quoted in Joanna Moorhead, *The Surreal Life of Leonora Carrington* (Virago, 2017), p. 241.

282 **with the survival of the planet**: Leonora Carrington, "Female Human Animal" (1970), in *Leonora Carrington: What She Might Be*, by Salomon Grimberg (Dallas Museum of Art, 2008), pp. 11–15, at 12–13.

282 **Remedios Varo as radical old ladies:** According to Joanna Moorhead, *The Hearing Trumpet* was composed in 1950: see "Surreal Friends in Mexico," in Stefan van Raay, Joanna Moorhead, and Teresa Arcq, with contributions by Sharon-Michi Kusunoki and Antonio Rodriguez Rivera, *Surreal Friends: Leonora Carrington, Remedios Varo and Kati Horna* (Ashgate/Lund Humphries in association with Pallant House Gallery, 2010), pp. 70–97, at 94. In her introduction to a reprinted edition of the novel, the novelist Ali Smith mentions this same date and also another source that suggests it was first written in the early 1960s: introduction to Carrington, *The Hearing Trumpet* (Penguin Books, 2005), pp. v–xv, at x.

283 **"the revengeful Father God":** Leonora Carrington, *The Hearing Trumpet*, with illustrations by Pablo Weisz Carrington (1976; reprint, New York Review of Books, 2020), pp. 9, 13, 181.

283 **"there is little hope for civilization":** Whitney Chadwick, quoted in Susan L. Aberth, *Leonora Carrington: Surrealism, Alchemy and Art* (Lund Humphries, 2004), p. 126.

283 **"decorative ridges worn as a badge of honour":** Aberth, *Leonora Carrington: Surrealism, Alchemy and Art*, p. 126.

283 **"rape, torture, assassination":** Toni Morrison, "The Nobel Lecture in Literature," in *Mouth Full of Blood: Essays, Speeches, Meditations* (Vintage, 2019), pp. 102–9, at 102, 103, 105.

284 **"waist deep in the toxin of your past?":** Morrison, "The Nobel Lecture in Literature," pp. 107, 108.

284 **"this thing we have done—together":** Morrison, "The Nobel Lecture in Literature," p. 109.

284 **her mother's beautiful singing voice:** Toni Morrison, "The Last Interview," with Alain Elkann (2018), in *Toni Morrison: The Last Interview and Other Conversations*, edited by Nikki Giovanni (Melville House, 2020), pp. 123–70, at 160.

284 **"writing, for me, is the big protection":** Toni Morrison, "'I Regret Everything': Toni Morrison Looks Back on her Personal Life," interview with Terry Gross, *Fresh Air*, NPR, 24 August 2015, https://www.npr.org/2015/08/24/434132724/i-regret-everything-toni-morrison-looks-back-on-her-personal-life.

285 **"everyone needs one of those places":** Toni Morrison, "The Greatest Lesson Toni Morrison Learned at 80," interview with Oprah Winfrey, *The Oprah Winfrey Show*, OWN, 13 May 2011, https://www.oprah.com/own-oprahshow/the-greatest-lesson-toni-morrison-learned-at-80.

285 **"comfort her in old age":** Toni Morrison, *God Help the Child* (Vintage, 2015), p. 159.

286 **images instead of the numbers of Sudoku:** Faith Ringgold, "Meet Faith Ringgold: 86-Year-Old App Developer," interview with Maryjane Fahey, AARP, 23 January 2017, https://videos.aarp.org/detail/video/5288952675001/meet-faith-ringgold:-86-year-old-app-developer. See also Amel Mukhtar, "88-Year-Old Faith Ringgold: 'There Is Power in Ageing,'" *British Vogue*, 8 July 2017, https://www.vogue.co.uk/article/faith-ringgold-exhibition-serpentine-gallery-interview.

286 **"I've got so much more to do"**: Faith Ringgold, quoted in "Faith Ringgold's Art of Fearlessness and Joy," *CBS Sunday Morning*, 11 July 2021, YouTube video, https://www.youtube.com/watch?v=IZ-VvOep2D8&ab_channel=CBSSundayMorning, and in Bob Morris, "Faith Ringgold Will Keep Fighting Back," *New York Times*, 11 June 2020, https://www.nytimes.com/2020/06/11/arts/design/faith-ringgold-art.html?searchResultPosition=1.

286 **"so many things I want to express"**: Yayoi Kusama, *Infinity Net: The Autobiography of Yayoi Kusama*, translated by Ralph McCarthy (Tate Publishing, 2002), pp. 229, 227.

286 **"human beings" into "radiance"**: Kusama, *Infinity Net*, p. 229.

286 **"the infinite existence of electronic polka-dots"**: Yayoi Kusama, "Yayoi Kusama Interview: Earth Is a Polka Dot," interview with Christian Lund, translated by Nami Yamamoto, *Louisiana Channel*, Louisiana Museum of Art, February 2011, YouTube video, uploaded 8 January 2015, https://www.youtube.com/watch?v=21NrNdse7nI. Also see Heather Lenz's full-length documentary *Kusama—Infinity* (Magnolia Pictures, 2018).

286 **the "vitality" of "Eternity"**: Yayoi Kusama, "Aftermath of Obliteration of Eternity," The Museum of Fine Arts, Houston, https://www.mfah.org/exhibitions/galleries/kusama-aftermath-obliteration-eternity.

287 **"fragility, of our natural environment"**: Kate Flint, "In Dandelions and Fireflies, Artists Try to Make Sense of Climate Change," *The Conversation*, 11 September 2019, https://theconversation.com/in-dandelions-and-fireflies-artists-try-to-make-sense-of-climate-change-112755.

287 **anti-censorship activism around the world**: "The Unburnable Book: Margaret Atwood's *The Handmaid's Tale*," Penguin Random House, 23 May 2022, YouTube video, https://www.youtube.com/watch?v=zpsMsAMY4eM. See the subsequent press release, "Fireproof Edition of Margaret Atwood's *The Handmaid's Tale* Sells for $130,000 at Auction, with Proceeds to Benefit PEN America," PEN America, 8 June 2022, https://pen.org/press-release/fireproof-edition-of-margaret-atwoods-the-handmaids-tale-sells-for-130000-at-auction-with-proceeds-to-benefit-pen-america/.

287 **"worrying and being afraid?"**: Margaret Atwood, quoted in Charles Arrowsmith, "In 'Burning Questions,' Margaret Atwood Ponders an Astonishing Array of Subjects," *Washington Post*, 26 February 2022, https://www.washingtonpost.com/books/2022/02/26/margaret-atwood-burning-questions-review/, and in "Roll Up Your Sleeves, Girls," interview with Cheryl Strayed, *Sugar Calling*, New York Times podcast, 8 April 2020, https://www.nytimes.com/2020/04/08/podcasts/sugar-calling-margaret-atwood-coronavirus.html.

287 **depicts the artist's antic hilarity**: Lorraine Candy, "Margaret Atwood Interview: *The Handmaid's Tale* Author Talks Love and Loss Ahead of New Book *The Testaments*," *The Times*, 8 September 2019, https://www.thetimes.co.uk/article/margaret-atwood-interview-the-handmaid-s-tale-author-talks-love-and-loss-ahead-of-new-book-the-testaments-bdl5k29fc.

287 **"the silver tsunami"**: On the silver tsunami, see, for example, Jason Horowitz, "The Double Whammy Making Italy the West's Fastest-

Shrinking Nation," *New York Times*, 30 January 2023, https://www.nytimes.com/2023/01/30/world/europe/italy-birthrate.html.

287 **"HURRY UP PLEASE IT'S TIME":** Margaret Atwood, "Torching the Dusties," in *Stone Mattress: Nine Tales* (Doubleday, 2014), pp. 225–68, at 257, 262.

287 **Jane Goodall's book subtitles:** Jane Goodall and Douglas Abrams with Gail Hudson, *The Book of Hope: A Survival Guide for Trying Times* (Celadon, 2021).

288 **"give the world a formidable shake":** Isabel Allende, *The Soul of a Woman* (Ballantine, 2021), p. 83.

288 **"I still can paint, I still can draw":** Luchita Hurtado, "Conversations: The Painter and the Planetarian: Luchita Hurtado," interview with Andrea Bowers, *Ursula*, no. 2 (2019), https://www.hauserwirth.com/ursula/24258-painter-planetarian-luchita-hurtado/.

288 **"live it to the fullest":** Annie Ernaux, quoted in Alexandra Schwartz, "Annie Ernaux Turns Memory into Art," *New Yorker*, 14 November 2022, https://www.newyorker.com/magazine/2022/11/21/annie-ernaux-turns-memory-into-art.

289 **scholars like Edward Said and Kenneth Clark:** Edward Said, *On Late Style: Music and Literature Against the Grain* (Vintage, 2007); Kenneth Clark, "The Artist Grows Old" [1970 Rede Lecture], in *Moments of Vision* (John Murray, 1972), pp. 160–80.

290 **"what I think people want to hear":** M. F. K. Fisher, "M. F. K. Fisher: Essayist" (1990), interview with Bill Moyers, in *Conversations with M. F. K. Fisher*, edited by David Lazar (University Press of Mississippi, 1992), pp. 167–77, at 167.

290 **"then they don't like it":** Maxine Kumin, interview with Diana Hume George, in George's "'Keeping Our Working Distance': Maxine Kumin's Poetry of Loss and Survival," in *Aging and Gender in Literature: Studies in Creativity*, edited by Anne M. Wyatt-Brown and Janice Rossen (University of Virginia Press, 1993), pp. 314–38, at 335.

290 **"than would otherwise be the case":** David W. Galenson, *Old Masters and Young Geniuses: The Two Life Cycles of Artistic Creativity* (Princeton University Press, 2006), p. 184.

291 **vulnerable to physical and mental problems:** Dana Goldstein and Robert Gebeloff, "As Gen X and Boomers Age, They Confront Living Alone," *New York Times*, 27 November 2022, https://www.nytimes.com/2022/11/27/us/living-alone-aging.html.

291 **rob the elderly of their autonomy:** See Atul Gawande, *Being Mortal: Medicine and What Matters in the End* (Henry Holt, 2014), chaps. 4, 5.

291 **supplied or paid by the collective:** On ADUs, see Paula Span, "Senior Housing That Seniors Actually Like," *New York Times*, 29 January 2023, https://www.nytimes.com/2023/01/29/health/elderly-housing-adu.html.

291 **"the coital imperative":** Jane Gallop discusses this term in *Sexuality, Disability, and Aging: Queer Temporalities of the Phallus* (Duke University Press, 2019), pp. 85–91.

293 **"than it ever has been before":** Agatha Christie, *An Autobiography* (Collins, 1977), pp. 520–21, 521.

NOTES

295 **"a result of good work habits"**: Twyla Tharp with Mark Reiter, *The Creative Habit: Learn It and Use It for Life* (Simon & Schuster, 2003), p. 7.

295 **"the actual reality of your life"**: Joyce Carol Oates, "Joyce Carol Oates Figured Out the Secret of Immortality," interview with David Marchese, *New York Times Magazine*, 16 July 2023, https://www.nytimes.com/interactive/2023/07/16/magazine/joyce-carol-oates-interview.html.

296 **"social, political, intellectual and creative work"**: Edith Wharton, *A Backward Glance: An Autobiography* (1934; reprint, Simon & Schuster, 1998), p. xix; Simone de Beauvoir, *The Coming of Age*, translated by Patrick O'Brian (G. P. Putnam's Sons, 1972), p. 540.

296 **retiring earlier now than ever before:** Carstensen, *A Long Bright Future*, p. 27.

296 **"*diffuse work across the life span*"**: Carstensen, *A Long Bright Future*, pp. 67, 69.

296 **"I have no time to spare"**: Ursula K. Le Guin, "In Your Spare Time," in *No Time to Spare: Thinking About What Matters* (Houghton Mifflin Harcourt, 2017), pp. 3–7, at 7.

297 **"spatially, temporally, spiritually, you name it"**: Ross Gay, *Inciting Joy: Essays* (Algonquin Books of Chapel Hill, 2022), p. 111.

297 **"fall apart, and finally die"**: M. F. K. Fisher, *Last House: Reflections, Dreams, and Observations, 1943–1991* (Pantheon Books, 1995), pp. 278, 277, 275.

298 **"almost unbearably boring grandparents"**: Fisher, *Last House*, pp. 279, 280.

299 **"opposite of depression is expression"**: Edith Eger, *The Gift* (Scribner, 2020), p. 29.

299 **"being rather than doing"**: This is Atul Gawande's take (*Being Mortal*, p. 94) on the psychological suppositions of Abraham Maslow.

300 **"and so on than men seem to do"**: Fisher, *Last House*, p. 276.

300 **the greatest proportion of suicides:** Men over the age of seventy-five have the highest suicide rate of all age groups. See "Health Disparities in Suicide," Centers for Disease Control and Prevention, 16 May 2024, https://www.cdc.gov/suicide/disparities/?CDC_AAref_Val=https://www.cdc.gov/suicide/facts/disparities-in-suicide.html.

301 **living on the cusp of the precipice:** For virtually every disease, there are online support groups for patients and caregivers. There are also activist digital networks such as Elder Networking, the Transition Network, the Diverse Elders Coalition, Third Act, or CoGenerate.org (which used to be Encore.org).

301 **"only the how and the when"**: Kathryn Schulz, *Lost & Found* (Random House, 2022), p. 225.

302 **"entering upon the fullness of our being"**: Dorothy Richardson, "Old Age," in *Adam International Review* 31 (1966): 25–26, at 26. I have added commas in the passages quoted to facilitate understanding.

302 **"the lightest footed dance of all"**: Richardson, "Old Age," p. 26.

302 **"reach out to beauty everywhere"**: Joan M. Erikson's essay "Gerotranscendence" appears in a book that is attributed to Erik H. Erikson: *The Life Cycle Completed* (W. W. Norton, 1998), pp. 123–29, at 127. See also Lars Tornstam, *Gerotranscendence: A Developmental Theory of Positive Aging* (Springer, 2005).

303 **"for the first time: everything a wonder"**: Doris Lessing, "Old," in *Time Bites: Views and Reviews* (Fourth Estate, 2004), pp. 215–16, at 215, 216.

303 **"my body deteriorates, my soul rejuvenates"**: Allende, *The Soul of a Woman*, p. 94.

Illustration Credits

29	Supplied by Llyfrgell Genedlaethol Cymru / National Library of Wales.
55	Getty Images / Keystone-France.
83	William Clift, "Georgia O'Keeffe and Juan Hamilton, Abiquiu, New Mexico." 1983.
113	Bettmann, "Countess Karen Blixen Relaxes with Cigarette." 1959.
139	AP Photo/ John Lindsay. 1966.
165	© Oliver Mark.
193	© David M. Rubenstein Rare Book and Manuscript Library, Duke University.
221	Courtesy of Gabrielle Speaks / The Daily Cardinal.
249	AP Photo / Stephen Chernin. 2006.

Index

Page numbers in *italics* refer to illustrations.

Aberth, Susan L., 283
Abiquiu, N.M., 101–2, 106
Abramovic, Marina, 15
Adams, Ansel, 103
Adato, Perry Miller, 103, 107
Adcock, Fleur, 15, 281, 291
Addams, Jane, 239
After the Stroke (Sarton), 14
age-gap romance, 28, 52, 56, 64–65, 77
agoraphobia, 19, 94, 98, 177, 293
Ailey, Alvin, 211–12, 275
Alexander, Elizabeth, 164, 225
Alexander, Michael Scott, 203
Ali, Muhammad (Cassius Clay), *139*, 153–54
Allen, Geri, 219
Allende, Isabel, 11, 15, 288, 303
alliances with younger companions, 2, 17, 27–28, 290–91; *See also* Bourgeois, Louise/ and Jerry Gorovoy; Colette/and Maurice Goudeket; Colette/ *Last of Chéri*; Dinesen,

Isak/and Thork- ild Bjornvig; Eliot, George/and John Cross; O'Keeffe, Geor- gia/and Jean Toomer
Altman, Robert, 219
Alvarez, Julia, 15
American Dance Theater, 212
American Place, An (gal- lery), 93
Anastasio (fictional charac- ter), 125
Anderson Galleries, 88
Angelou, Maya, 7, 164, 190
anorexia, 70, 117, 131, 293
Anyone Can Fly Founda- tion, 285
Anzaldúa, Gloria, 13–14
Apfel, Iris, 294
Apollo Theater (Harlem, New York City), 261
Arachne (mythological char- acter), 182
Arendt, Hannah, 23, 136
Ariel (Plath), 12
Armstrong, Lil, 220
Armstrong, Louis, 196, 200
Armstrong, Lucille, 201
Arroyo, Luis, 153
Asch, Moe, 197, 215

Aschenbrenner, Joyce, 260
At Eighty-Two (Sarton), 14
Athena (mythological char- acter), 182
Atkinson, Ted, 151–52
Atlantic Monthly, 142
At Seventy (Sarton), 7
Atwood, Margaret, 6, 15, 22, 287
Auden, W. H., 143, 147, 150
August, Bille, 121
Austen, Jane, 13
Austin, Lovie, 220
Autobiography of Malcolm X, The, 232

Baca, Judy, 15
Bach, Johann Sebastian, 209
Baker, Harold "Shorty," 196
Baker, Josephine, 14, 190
Baldwin, James, 232
Balladz (Olds), 280
Bambara, Toni Cade, 227
Bancroft Library, 246
Banks, Bob, 209
Bara, Theda, 256
Baraka, Imamu Amiri (LeRoi Jones), 226, 237
Barber of Seville, 34
Barney, Natalie, 56

357

INDEX

Baroness, The (Krebs), 118
Basie, Count, 218
Battle, Kathleen, 284
Beach, Amy, 14
Beauvoir, Simone de, 7–9, 79, 296
Beethoven, Ludwig von, 3, 209
Belafonte, Harry, 275
Belbeuf, Marquise de ("Missy," "Max"), 57, 61, 69
Bel Canto Foundation, 202
Benglis, Lynda, 15
Berenson, Bernard, 253, 271
Bernstein, Leonard, 209
Berra, Yogi, 24
Berry, Gladys, 146
Bible, The (film), 261
Bishop, Elizabeth, 140, 155, 157, 161
Bjørnvig, Thorkild, 118–22
Black Academy of Arts and Letters, 298
Black nationalism, 224, 231
Black Power/Arts movements, 222, 225, 229, 232, 262
Black Protestantism, 206–9
Blackstone Rangers, 226, 232
Blackwood, John, 34
Blake, Eubie, 3, 152
Blake, William, 119
Blakely, Henry, Jr., 222–23, 243, 246
Blakely, Nora Brooks, 224, 241, 243, 247
Blanco, Richard, 164
Blixen, Karen, *see* Dinesen, Isak
Blixen-Finecke, Bror von, 114–15
"Bloody Sundays" (salon), 176
Blue Flower, The (Fitzgerald), 16
Blue Moon cabaret, 256
Bly, Robert, 244
Bodenheimer, Rosemarie, 52
Bodichon, Barbara, 43, 46, 53

Boeuf sur le Toit, Le (The Ox on the Roof), 200
Bop City, 200
Boulanger, Nadia, 14
Bourgeois, Louise, 111–12, 165, 165–88
 on aging process, 177–78, 180–81
 agoraphobia, 168
 Arch of Hysteria, 180
 brother, 178
 Cell (Choisy), 180
 Cell I, 178
 Cells (dollhouses), 175, 177–85, 188
 Cell XXVI, 180
 "Child Abuse" (essay), 170
 and Colette, 167
 Couple, 174
 death, 168
 death of son, 180
 deserted spaces, 180
 The Destruction of the Father, 170–71, 182
 documentary film, 169
 Do Not Abandon Me, 173, 187
 drawings and paintings, 187
 early life, 166–67
 Endless Pursuit, 174
 English nanny, 166, 171
 fabric books and figures, 172–75, 186
 Femme Couteau (Knife Woman), 170–72
 Femme Maison (Woman House), 167
 Fillette (Little Girl), 166, 168, 170
 French Legion of Honor medal, 187
 health, 293
 I Do, I Undo, I Redo, 184–85
 Lairs (sculptures), 167
 The Last Climb, 188
 Le Repas du Soir (The Evening Meal; The Destruction of the Father), 168
 Louise Bourgeois: An Unfolding Portrait

(MoMA exhibit), 166, 185
 midlife, 167
 Ode a la Bievre (Ode to the River Bievre), 186
 Ode a la Mere (book), 181
 Ode a l'Oubli (Ode to Memory), 186
 parents, 166–67, 169–72, 181
 phallic creations, 166, 168, 170, 172
 photographs, 187–88
 "*poupees de pain*" ("dolls of bread/pain"), 170, 172–74, 185
 Precious Liquids, 180
 Red Room (Child), 179–80
 Red Room (Parents), 179–80
 Self-Portrait, 187
 She-Fox, 171
 Single III, 174
 Spider (Cell), 182–83
 spider sculptures, 181–83
 "Spider Woman," 182
 Spiral Woman, 171, 187
 Three Horizontals, 173
 "Toi et Moi," 184
 works in old age, 185–86
Bradford, Walter, 226, 232, 238
Brahms, Johannes, 209
Brando, Marlon, 251
breast milk, 184–85
Brett, Dorothy, 92–93
Britten, Benjamin, 209
Broadside Press, 232
Broadway, 260
Brody, Richard, 216
Brontë, Charlotte, 13, 32
Brontë, Emily, 13, 46
Brooklyn Academy of Music, 151
Brooklyn Bridge, 156–57
Brooklyn Institute of Arts and Sciences, 151
Brooklyn Museum, 181
Brooklyn Navy Yard, 142
Brooks, Gwendolyn, 189–90, 221, 221–47
 "After School," 239
 "The Anniad," 224

INDEX

Annie Allen, 224
The Bean Eaters, 224–25
Beckonings, 239
Blackstone Rangers, 226
"The Boy Died in My Alley," 239
Bronzeville Boys and Girls, 240
"Bronzeville Woman in a Red Hat," 233
A Capsule Course in Black Poetry Writing, 238
Children Coming Home, 239–40
"The Coora Flower," 240
daughter, *See* Blakely, Nora Brooks
and Katherine Dunham, 227
early life, 222
Family Pictures, 233
"Family Pictures," 246
"Gay Chaps at the Bar," 224
health, 235, 246–47, 293
"I'll Stay," 241
"In Ghana," 243
"In Montgomery," 235
"In the Mecca" (poem), 226–31
Jump Bad, 238
"Keziah's Health Book," 242
"The Life of Lincoln West," 233–34, 244
marriage, 231, 236–37; *See also* Blakely, Henry, Jr.
Maud Martha, 224
In the Mecca (book), 226, 231
In Montgomery and Other Poems, 247
"My Mother," 242
National Medal of the Arts, 246
as Poet Laureate of the United States, 241
poetry workshops, 226
race and racism, 222–26, 231–34, 237, 239–45
radicalization, 231–35

Report from Part One, 235–38
Report from Part Two, 241–43, 246
Riot, 232–33
"Shorthand Possible," 236
A Street in Bronzeville, 224
"To Those of My Sisters Who Kept Their Naturals," 239
"Uncle Seagram," 240
Very Young Poets, 238
"Warpland," 232
"We Real Cool," 225, 238, 247
Winnie, 239
The World of Gwendolyn Brooks, 231
Young Poets Primer, 238
Brooks, Keziah, 241–42
Brown, Oscar, Jr., 226
Browning, Elizabeth Barrett, 13
Browning, Robert, 34
Bry, Doris, 103, 106
Bryant, William Cullen, 155
Bryher (Annie Winifred Ellerman), 141–42, 147
Bryn Mawr College, 141
Brynner, Yul, 153
building preservation, 156
Burne-Jones, Georgiana, 46
Bush, George H. W., 250
Butcher (Oates), 15
Butler, Eleanor, 71–72
Byron, Lord, 119

Cabrini-Green Housing Projects, 240
Café Society, 197, 199, 212
Campanella, Roy, 153
Camperdown Foundation, 164
Canada, 90
Cane (Toomer), 95
Cape Coast of Africa, 242–43
Capossela, Frederic, 151
Capote, Truman, 160
Carlyle, Una Mae, 220
Carnegie Hall, 197, 215–16
Carnival of Losses, A (Hall), 9

Carrington, Leonora, 3, 14, 20, 282–83
Carroll, Lewis, 163
Carstensen, Laura L., 24, 296
Cassatt, Mary, 96
Catholicism, 202, 204, 207, 220
Catholic Worker (publication), 212
Cervantes, Lorna Dee, 245
Chabot, Maria, 101, 103, 106, 108
Chadwick, Whitney, 283
Charles Clay (fictional character), 122–23
Chevalier, Maurice, 77
Chicago, Ill., 196, 225–26, 243, 250, 255, 258–59
Chicago, Judy, 15
Chicago Defender, 222
Chicana artists, 13
Child, Julia, 14
Chopin, Kate, 13
Christie, Agatha, 7, 10, 14, 15, 18, 190–91, 292
Circe (mythological character), 156
Cisneros, Sandra, 245
City College (New York City), 225
Clark, Kenneth, 289
Clay, Cassius (Muhammad Ali), *139,* 153–54
Cliff, Michelle, 281
Clifton, Lucille, 190
Clinton, Bill, 246
Coca, Imogene, 197
Cocteau, Jean, 79
Cole, Thomas, 155
Colette, 27–28, *55,* 55–81
The Blue Lantern, 80
and Louise Bourgeois, 167
Break of Day, 65
changing styles, 289
Cheri, 57–60
Claudine, 57
"Dear Colette" (Jong), 80–81
death and legacy, 80–81
Gigi, 58, 76–79

359

Colette (*continued*)
and Maurice Goudeket, *See* Goudeket, Maurice
Green Wheat (Ripening Seed), 57, 61–63
health, 61, 76, 79, 293
on homosexuality, 71–72
and Bertrand de Jouvenel (stepson), 56–58, 60–66
Julie de Carneilhan, 74
The Last of Cheri, 57, 63–64
later life, 79–80
The Pure and the Impure, *See Pure and the Impure, The* [Colette]
Ripening Seed (Green Wheat), 57, 61–63
self-mythologizing, 294
on sexual pleasure, 66–68
Those Pleasures, See Pure and the Impure, The [Colette]
Colette, Sidonie-Gabrielle, *see* Colette
Coltrane, John, 213, 218
Columbia College (Chicago, Ill.), 225
Columbia University, 209
Confucius, 148, 154
Congreve, William, 17
Cooke, Terence, 212
Cookery (restaurant), 212, 215
Crane, Hart, 157
"Crazy Sharon Talks to the Bishop" (Olds), 280
Cross, John, 30–32, 42–49, 51–53
George Eliot: A Life, 46–47
George Eliot's Life as Related in Her Letters and Journals, 52
Cross, Mary Ann, *see* Eliot, George
Cross, Willie, 47
Crowley, John, 202, 203

Dahl, Linda, 197
Damballa (snake), 264, 267, 276

Dante, 45
Dante Alighieri, 160
Dark, Alice Elliott, 20
Das, Joanna Dee, 272
David Company, 239, 240
Davis, Adele, 102
Davis, Miles, 201, 213
Day, Dorothy, 14, 212
de Amaral, Olga, 15
Dean, James, 251
"Dear Colette" (Jong), 80–81
Death in Venice (Mann), 49
Demeter (mythological character), 227–28
Denmark, 115
Desdemona (Morrison), 284
Detroit Tigers, 153
Dial magazine, 142
Dickens, Charles, 5
Dickinson, Emily, 13, 114, 181, 242
Didion, Joan, 14, 280
Dinesen, Isak, 111–37, *113*
"A Country Tale," 126
Anecdotes of Destiny, 116
Angelic Avengers, 116
appearance, 114, 116
"Babette's Feast," 132–34
"The Blank Page," 126–28
"The Cardinal's First Tale," 125–26
"The Caryatids," 126
changing styles, 289
and the Devil, 118–21, 124, 131–32
doyenne role, 118
"Echoes," 121–22
Ehrengard, 117, 134–36
health, 115–16, 121, 129–32, 293
"The Immortal Story," 122–24
Last Tales, 116, 121, 125, 128
midlife, 116
and Marianne Moore, 153
Out of Africa, 115–16
post-sexual life, 292
on post-sexual life, 124, 130, 134, 136

self-mythologizing, 132, 294
Seven Gothic Tales, 116
on single women, 120
"Tales of Two Old Gentlemen," 128
"Tempests," 129–30
Winter's Tales, 116
Dinesen, Wilhelm, 114
Dionysus, 125–26
Disabilities, 2, 8, 22, 123, 132, 281, 293
Don Juan (fictional character), 68–69, 74, 134–35
Dorsey, Tommy, 196
Draper, Ruth, 160
Drohojowska-Philp, Hunter, 107
Du Bois, W. E. B., 232
Duckworth, Angela, 9
Ducrot, Isabella, 15
Dudley Randall, 226
Duke University, 217–18
Dunham, Albert, 255, 257–58
Dunham, Katherine, 189–90, *249*, 249–76; *See also* Katherine Dunham Museum
Aida, 261
and anthropology, 267–68
arrest of, 270
as artist-in-residence, 261
Bal Negre, 251
Bamboche!, 260–61
and Gwendolyn Brooks, 227
Cabin in the Sky, 250
Carib Song, 251
as choreographer, 260
death, 275
early life, 253–56
family, 252, 254–55, 257–58, 261, 269, 275
Faust (opera), 262
Green Mansions (film), 251
health, 252, 262, 275, 293
honors and recognition, 275
hunger strike, 250
Island Possessed, 252, 262, 264, 266–69, 273

INDEX

Le Jazz "Hot," 250
L'Ag'Ya (ballet), 250
"The Magic of Katherine Dunham" (Ailey), 275
marriage to John Pratt, *See* Pratt, John
midlife, 256
"Minefields," 275
Minnehaha, 255
Ode to Taylor Jones, 272
race and racism, 251, 256, 262, 266, 268–70
Requiescat in Pace, 253
"Rites of Spring," 251
self-presentation, 294
Southland, 252
Stormy Weather (film), 250–51
teaching, 267, 270–75
A Touch of Innocence, 252–54, 256–57–259
Treemonisha (Joplin) as choreographer, 272
Tropical Revue, 251
Tropics, 250
and Mary Lou Williams, 197
Dunham, Lena, 49
Dunham Company, 260, 261
Dunham School of Dance and Theater, 251, 252, 261
Dunham Technique, 273, 293
Durand, Asher Brown, 155
Durante, Jimmy, 163
Duvalier, François, 268
Dynamic Museum (Katherine Dunham Museum), 271, 273

Easton Foundation, 187
Edgeworth, Maria, 159
Eisenhower, Dwight David, 163
Eisler, Benita, 94
Eliot, George, 28, 28–53
Adam Bede, 31
on anti-Semitism, 289, 295
biographies, factual and fictional, 33, 46–52

and John Cross, 30–32, 42–49, 51–53
Daniel Deronda, 31, 34, 36, 41, 295
death, 30, 48
grieving, 43–44
Impressions of Theophrastus Such, See *Impressions of Theophrastus Such* [Eliot]
and Judaism, 40–42
and George Henry Lewes, 31–34, 42–43, 45–53
Middlemarch, 31, 34, 36
Mill on the Floss, The, 31
multiplicity of names, 31
pseudonyms, 33–35
Scenes from Clerical Life, 31
"Shadows of the Race," 38–39
"Silly Novels by Lady Novelists," 37
Eliot, T. S., 163
Elizabeth Arden (company), 100
Ellerman, Annie Winifred, 147
Ellerman, Annie Winifred (Bryher), 141–42, 147
Ellington, Duke, 194, 196, 205, 208, 210, 239
Elmhurst College (Elmhurst, Ill.), 225
Elmina Castle, 242
Emin, Tracey, 187
Emma Lazarus, 157
Encore (Sarton), 14
Endgame (Sarton), 14
Ephron, Delia, 5
Ephron, Nora, 279
Equal Rights Amendment, 91
Erikson, Joan, 302
Ernaux, Annie, 15, 288
Esquire, 163
Estimé, Dumarsais, 268
"Eternity" (Kusama), 286
Evans, Marian, *see* Eliot, George
Evans, Mary Ann, *see* Eliot, George

Evening Star, The, 79
Evers, Medgar, 232
Ewald, Johannes, 136

Fables (La Fontaine), 147
Fanon, Frantz, 232
Faust, 118
Fellowship Point (Dark), 20
Feminine Mystique, The (Friedan), 167
Finch Hatton, Denys, 114–15, 136
Fireflies on the Water (Kusama), 286–87
Fisher, M. F. K., 14, 111, 290, 297–98, 300
Fisk University Writers' Conference, 222, 223, 226, 237
Fitzgerald, Penelope, 14–16
Flint, Kate, 286
Folkways Records, 215
Ford, Edsel, 150
Fordham University, 212
Ford Motor Company, 150
Forerunner, The, 91
Frankenstein (Wollstonecraft), 12
Franklin, Aretha, 14
French Collection (Ringgold), 285
French Underground, 167
Freud, Sigmund, 167, 168, 183
Freudians, 91, 96
Friedan, Betty, 23, 167
Friendships
 of Colette, 71–72, 75
 of Marianne Moore, 141
 of Georgia O'Keeffe, 105
 of Mary Lou Williams, 197
Friends of Prospect Park, 156
Fromm, Erich, 271
Frost, Robert, 151, 164
Fuller, Margaret, 12–13

Galenson, David W., 290–91
Garland, Phyl, 216
Gauthier-Villars, Henry "Willy," 57

INDEX

Gay, Ross, 297
George Washington Monument, 107
"Gerotranscendence" (Erikson), 302
Ghost Ranch (New Mexico), 100–101
Gigi (Colette), 58, 76–79
Gigi (film), 77
Gigi (play), 78–79
Gilbert, Sandra, 158
Gillespie, Dizzy, 194, 197, 202, 205, 218
Gillespie, Lorraine, 201–2
Gilman, Charlotte Perkins, 91, 94
Ginsberg, Allen, 103, 163–64
Giovanni, Nikki, 232
Girls in the Band The (film), 220
Glück, Louise, 8
God Help the Child (Morrison), 285
Goethe, Johann Wolfgang von, 160
Gold, Michael, 91
Golden Shovel pool hall, 247
Goldwater, Robert, 166–68
Goodall, Jane, 15, 287
Good Luck to You, Leo Grande (film), 279
Goodman, Benny, 196
Gorman, Amanda, 164
Gornick, Vivian, 8
Gorovoy, Jerry, 173, 175–76, 178, 185–88
Gottschalk, Louis, 239
Goudeket, Maurice, 63, 65–67, 74–75, 80, 291
Gounod, Charles, 262
Graham, Martha, 14, 25, 260, 273
Grahame, Kenneth, 141
"Grand Night for Swinging, A," 216
Grant, Cary, 102
Great Day in Harlem, A (Kane), 194, 220
Great Depression, 67
Great Migration, 255

Greensward Foundation, 156
Gregory, Dick, 250
Gregory, Elizabeth, 161
Grey, Beryl, 14
Gringoire (newspaper), 74
Guggenheim Foundation, 147
Guggenheim Museum, 3

Habitation Leclerc (Haiti), 260, 262, 269
Haight, Gordon, 48
Hall, Donald, 8, 161–62
Halliday, John, 10
Hamilton, John "Juan," 105, 107, 291
Hancock, Mario, 202–3, 212
Handmaid's Tale, The (Atwood), 287
Hansberry, Lorraine, 13
Happiness Curve, The (Rauch), 6
Harjo, Joy, 15
Harlem Renaissance, 13
Harper & Row, 226, 231
Harper's Bazaar, 154
Harris, Julie, 132
Harvard University, 161
"Having Sex with the Dead" (Adcock), 281
Hawaiian Pineapple Company, 100–101
Hayes, Terrance, 247
H.D. (poet), 14, 141–42, 190
Hearing Trumpet, The (Carrington), 283
Heilbrun, Carolyn, 10
Hemingway, Ernest, 114
Hepworth, Barbara, 14
Hercules myth, 144
Herrera, Carmen, 14, 16
Herskovits, Melville, 267
Herzl, Theodor, 41
Hiller, Sara, 243
Hindemith, Paul, 209
"Hip Replacement Ode" (Olds), 280
Holliday, Billie, 153, 201, 208, 218
Honey and Rue (Morrison), 284

Honeymoon, The (Smith), 48
Hoover, J. Edgar, 252
Horne, Lena, 251
Howard, Elston, 153
Hughes, Langston, 154
Hurok, Sol, 251
Hurston, Zora Neale, 13, 232, 275
Hurtado, Luchita, 15, 288
Huston, John, 261
Hustvedt, Siri, 172, 186

I Am the Greatest (Clay), 154
Illinois Poet Laureate Awards, 235
Immortal Story, The (film), 123
Imperial War Lords, 270
Impressions of Theophrastus Such (Eliot), 31, 34–39, 42–44, 50, 53
Inferno (Dante), 45
Infinity Mirror Rooms (Kusama), 286
Infinity Net (Kusama), 286
"In Search of Zora Neale Hurston" (Walker), 13
"Introducing Myself" (Le Guin), 281–82
"Invitation to Miss Marianne Moore" (Bishop), 140
Isherwood, Christopher, 102–3

Jackson, Angela, 247
Jackson, Jesse, 250
Jacob's Pillow Dance Festival, 275
James, Henry, 34
Jane Eyre (fictional character), 32
"Jazz for the Soul" (handout), 205
Jenner Elementary School, 240
Jervis, Agnes, 32
"Jewish State" (Herzl), 41
Jews and Judaism, 40–42, 66, 74, 116
Jocasta, 27
John Cabot (fictional character), 233

INDEX

Johnson, J. P., 199
Jonas, Joan, 15
Jones, LeRoi (Imamu Amiri Baraka), 226, 237
Jong, Erica, 8, 15, 80, 244
Joplin, Scott, 272
Joseph, Jenny, 18
Jouvenel, Bertrand de, 56–58, 60–66
Jouvenel, Colette de, *see* Colette
Jouvenel, Henri de, 57, 63

Kahlo, Frida, 95
Kane, Art, 194, 220
Kansas City (film), 219
Kansas City, Mo., 195
Kapp, Jack, 196
Katherine Dunham Museum (Dynamic Museum), 271
Katz, Mercedes, 173, 185–86
Keillor, Garrison, 245
Kemble, Mrs., 34
Kennedy, Adrienne, 15
Kennedy, John F., 164
Kennedy Center Honors Award, 275
Kennedy-King College, 222
Kernodle, Tammy L., 195, 216
Killens, John O., 232
Kindred Spirits (Durand), 155
King, Martin Luther, Jr., 207–8, 211, 233, 235, 237, 239
King Lear (Shakespeare), 277–79
Kingston, Maxine Hong, 15
Kirk, Andy, 195–96
Kirstein, Lincoln, 153
Kitt, Eartha, 251
Klein, Melanie, 185
Knight, Etheridge, 232
Kramer, Hilton, 158
Krebs, Thor Bjørn, 118
Kron Flower (Carrington), 283
Kumin, Maxine, 14, 290
Kunitz, Stanley, 7
Kusama, Yayoi, 15, 22, 286

Küster, Ulf, 187
"Kyrie Eleison," 210

Lacan, Jacques, 167
Ladies of Llangollen, 71
La Fontaine, Jean de, 147
LaGuardia Airport, 155
Lansana, Quraysh Ali, 246
"Lapis Lazuli" (Yeats), 112
Lari, Yasmeen, 15
Larsen, Nella, 13
Latifah, Queen, 247
Lawrence, D. H., 92, 98
Lear, Edward, 163
Leavell, Linda, 141, 147
Lebovitz, Annie, 15
Lee, Don L. (Haki Madhubuti), 226
Lee, Jocelyn, 279
Le Guin, Ursula K., 14, 23, 281–82, 296
Lessing, Doris, 14, 302
Letters from the Hunt (W. Dinesen), 114
Leutze, Emanuel, 161
Levertov, Denise, 14, 190
Lewes, Charles, 43
Lewes, Marian, *see* Eliot, George
Library of Congress, 241, 245
Life magazine, 100, 151
Lindsay, John, 154
Lippard, Lucy, 168
Liston, Melba, 220
Liszt, Franz, 34
Little House in the Big Woods (Wilder), 15
Lively, Penelope, 7, 10, 15
Long Life (Oliver), 111
Loos, Anita, 78–79
López, Héctor, 153
Lorde, Audre, 190
Louis, Joe, 163
Louise Bourgeois: An Unfolding Portrait (MoMA exhibit), 166, 185
Lucas, Al, 197
Lucifer's Child (play), 132
Luhan, Mabel Dodge, 88, 92, 93
Lyne, Barbara Buhler, 104

MacLaine, Shirley, 251
Madhubuti, Haki (Don L. Lee), 226, 232, 238, 241, 245, 247
Madison Square Garden, 153
Magdalens, The (Carrington), 282
"Magic of Katherine Dunham, The" (Ailey), 275
Magritte, René, 98
Mailer, Norman, 153
Malcolm X, 232
Malli (fictional character), 130
Mandela, Winnie, 239
Mann, Thomas, 49
Mansfield, Katherine, 13
Mapplethorpe, Robert, 166
marginalization, 7–8
Marin, John, 87
Martin, David Stone, 213
Mary Lou Williams Foundation, 218–19
Mary Records, 209
Matin, Le (newspaper), 61
Matisse, Henri, 3
Matthew, St., 228
McCarthy, Mary, 14
McCullers, Carson, 136
McNair, Sylvia, 284
McPartland, Marian, 219
McQueen, Butterfly, 251
"Meaning of Birds, The" (Smith), 28
Mein Kampf (Hitler), 74, 116
Melody Maker, 199–200
Memoirs
 Gwendolyn Brooks, 235–37, 241
 Colette, 58, 75, 80, 293
 Joan Didion, 280
 Katherine Dunham, 227, 252–53, 257–59, 273
 Annie Ernaux, 288
 Martha Graham, 25
 Georgia O'Keeffe, 84, 99, 104–6, 108
 Nell Painter, 190
 Mary Lou Williams, 220
"Memorize This" (Rich), 281

INDEX

menopause, 11, 61, 98
Merton, Thomas, 103
Metropolitan Museum of Art, 88–89
Metropolitan Opera, 261
Michelangelo, 3
Midlife, 2, 293–94
 Louise Bourgeois, 167
 Isak Dinesen, 116
 Katherine Dunham, 256
 Georgia O'Keeffe, 90, 100
 Marianne Moore, 140, 142, 161
Millay, Edna St. Vincent, 151
Miller, Arthur, 136
Mingus, Charles, 213
Minnelli, Vincente, 77
Mitchell, Arthur, 153, 251
Molesworth, Charles, 159
MoMA, *See* Museum of Modern Art
Monk, Thelonious, 194, 197, 201
Monroe, Harriet, 142
Monroe, Marilyn, 136
Montejo, Manny, 153
Moore, Marianne, 111–12, *139*, 139–64
 The Absentee (play), 159
 "A Poem on the Annihilation of Ernie Terrell," 154
 appearance, 160–62
 "Arthur Mitchell," 153
 "Baseball and Writing," 153
 "Blessed Is the Man," 153
 Bollingen Prize, 148
 "Brooklyn from Clinton Hill," 154
 "The Camperdown Elm," 155
 "Carnegie Hall: Rescued," 155
 Collected Poems, 147–49
 commemorated on postage stamp, 162
 "Compactness Compacted," 148
 Complete Poems, 150, 155, 157–58
 "Crossing Brooklyn Bridge at Twilight," 155
 death, 164
 defense of poetry, 149
 and Isak Dinesen, 137, 153
 early life, 140–41
 editing of poems, 148
 "Feeling and Precision," 148
 "Granite and Steel," 156–57
 health, 142, 146, 293
 "Hometown Piece for Messrs. Alston and Reece," 152
 "Humility, Concentration, and Gusto," 148
 "In Distrust of Merits," 145–46
 "The Library Down the Street in the Village," 154–55
 Marianne Moore Reader, 150, 157–59
 midlife, 140, 142, 161
 "My Crow, Pluto—A Fantasy," 154
 National Book Award, 148
 "Nevertheless," 144
 Observations, 142
 "Old Amusement Park," 155
 "The Paper Nautilus," 143–44
 "Poetry," 148–50, 157–58
 "Profit Is a Dead Weight," 154
 Pulitzer Prize, 148
 on race and racism, 145, 152–53
 "Rescue with Yul Brynner," 153
 "Reticent Candor," 148
 Selected Poems, 142, 146, 148
 self-presentation, 160–62, 294
 and Alfred Stieglitz, 151
 "Tom Fool at Jamaica," 151–52
Moore, John Warner, 141–42
Moore, Mary Warner, 141–42
Morehouse College, 272
Morny, Mathilde de, 57
Morrison, Slade, 284
Morrison, Toni, 25, 190, 283–85
Mortality, awareness of, 5–11, 53, 295–96, 300–301
Moses, Anna Mary Robertson "Grandma," 15, 23
Moulin Rouge, 57
Mozart, Wolfgang Amadeus, 209
Mrs. Robinson Syndrome, 27
Murchison, Gayle, 203
Murdoch, Iris, 21–22, 190
Museum of Modern Art (MoMA), 18, 153, 166, 168, 170–71
"My Mamma Pinned a Rose on Me," 215

Nairobi, Kenya, 114
Nash, Ogden, 163
National Medal of the Arts, 246, 275
National Women's Party, 91
Nazis, 66, 116
"Necessary Angel, The" (Stevens), 160
Neel, Alice, 14, 21, 279
negritude, 268
"Negro fraction," 223, 225
Nevelson, Louise, 14, 16
Newcombe, Don, 153
New Mexico, 84, 90, 92, 96
Newport Jazz Festival (1957), 202
Newsweek, 209
New York City Ballet, 153
New Yorker magazine, 89, 142, 151, 153, 166
New York Herald Tribune, 152
New York Philharmonic, 197
New York Public Library, 155
New York Times, 152, 154, 164, 260–61

INDEX

New York Yankees, 153
Nietzsche, Friedrich, 265
Nobel Prize, 283, 288
Norcross, Mary, 141, 146
Norman, Dorothy, 91–92, 106
Norman, Jessye, 284
Northeastern Illinois State College, 225
Northwestern University, 267

Oates, Joyce Carol, 15, 295
Oberland, Cornelia Han, 14
O'Brien, Peter, 205–6, 208, 212–13, 217, 218–19
O'Brien, Tim, 5
O'Connor, Norman, 209
"Ode of Withered Cleavage" (Olds), 280
Odes (Olds), 280
"Ode to Stretch Marks" (Olds), 280
"Ode to Wattles" (Olds), 280
O'Keeffe, Georgia, 24–25, 27–28, 83, 83–109
 The Beyond, 108
 Black Place III, 101
 bone paintings, 97–98
 Cliffs Beyond Abiquiu, 101
 Closed Black Iris, 90
 Cow's Skull—Red, White and Blue, 97
 A Day with Juan, 107
 earth formations paintings, 101–2
 From the Far Away Nearby, 97
 Georgia O'Keeffe, 84, 105–7
 Georgia O'Keeffe: A Portrait of Alfred Stieglitz (Metropolitan Museum of Art), 88–89
 health, 94–95, 104, 293
 Jack in the Pulpit III (O'Keeffe), 90
 Ladder to the Moon, 103
 large-scale flower paintings, 90
 later life, 100–101
 midlife, 90, 100
 My Faraway One, 96

New Mexico work, 93
Open Clam Shell, 90
In the Patio I, 102
In the Patio IV, 102
Patio with Black Door, 102
Pelvis with Distance, 100
Pelvis with Moon, 100
Ram's Head with Hollyhock and Little Hills, 97
Red Hills and Sky, 101–2
Red Poppy, 90
75 Pelvis Series, Red with Yellow, 100
Sky Above Clouds IV, 104
Sky Above Clouds / Yellow Horizon and Clouds, 108–9
Sky with Flat White Cloud, 108
Sky with Moon, 108
and Alfred Stieglitz, *See* Stieglitz, Alfred
and Rebecca Strand, 91–92
Summer Days, 97–99
teaching, 86–87
and Jean Toomer, 95–96
White Patio with Red Door, 102
From the White Place, 101
"Old" (Lessing), 302–3
Old Age (Vieillesse, La) (Beauvoir), 7
Old in Art School (Painter), 190
Olds, Sharon, 15, 280, 291
Oliver, Mary, 14, 111
"On Aging" (Angelou), 7
Ovid, 182
Ox on the Roof, The (Boeuf sur le Toit, Le) (bar), 200
Ozick, Cynthia, 15, 49, 51

Pact, The (Bjørnvig), 118, 121
Paget, James, 45
Painter, Nell, 190
Paley, Grace, 14, 281, 291
Parker, Charlie, 194, 197, 200–201
Parker, Dorothy, 14

Passing (Larsen), 13
PATC (Performing Arts Training Center), 270–71
Patterson, Floyd, 154
Paul, Alice, 91
Paul VI, Pope, 208
Pencil Manufacturers Association, 162
Performing Arts Training Center (PATC), 270–71
Perrine, Laurence, 245
Phaedra, 27
Phèdre (Racine), 64
Philharmonic Hall, 205
Philomel (mythological character), 182
Picasso, Pablo, 3
Piñon, Nélida, 14
Pittsburgh, Pa., 194, 208
Pittsburgh Jazz Festival, 205
Pius X, Pope, 209
Plath, Sylvia, 12, 163
Plimpton, George, 153
Pochonet, Gérard, 200
Poet Laureate of Illinois, 231
Poetry magazine, 223
Poetry Society of America, 154
Poindexter, Annette, 255
Poitier, Sidney, 251
Pollitzer, Anita, 91, 103, 106
Ponsonby, Sarah, 71
Porres, Martin de, 203–5
post-traumatic stress disorder (PTSD), 178, 298
Pound, Ezra, 141, 147
Powell, Bud, 201
Pratt, John, 250–52, 254, 269, 273, 275
Pratt, Marie-Christine, 251
Price, Leontyne, 261
Primus, Pearl, 275
Prospect Park, New York City, 155–56, 164
Proust, Marcel, 70
PTSD (post-traumatic stress disorder), 178, 298
Public Enemy, 247

Pulitzer Prize, 222, 224–25
Pure and the Impure, The (Colette)
 aging, 72–73
 analysis of, 73–74
 faked orgasms, 67–68
 heterosexuality, 68–69
 homosexuality, 70–72
 place within Colette's writing, 66–67
 as treatise on desire, 58
Purgatorio (Dante), 45
Puttermesser, Ruth, 49
"Puttermesser Paired" (Ozick), 49

Queen Latifah, 247
Quicksand (Larsen), 13
Quiltuduko (app), 286

Racine, Jean, 64
Radio City Music Hall, 94
Randall, Dudley, 232
Rauch, Jonathan, 6
Redmond, Eugene, 271–72, 274, 276
Reed, Lou, 162
"Remembrance" (Brontë), 46
Ricchetti, Dr., 47
Rich, Adrienne, 14, 190, 281, 291
Richardson, Dorothy, 14, 301
Richardson, Joanna, 61
Richter, Sviatoslav, 105
Ringgold, Faith, 14, 285–86
Rios, Alberto, 245
Rivera, Chita, 14, 251
Rivera, Diego, 95
Robinson, Bill "Bojangles," 195, 251
Robinson, Jackie, 153
Robinson, Julie, 275
Robinson, Marilynne, 15
Robinson, Roxana, 103
Rodgers, Carolyn, 232
Roebling, John H., 157
Roebling, Washington, Mrs., 157
Roosevelt, Eleanor, 91
Rose, Barbara, 108

Rose, Phyllis, 33
Rothko, Mark, 109
Rothko Chapel (Houston, Tex.), 109
Rungstedlund, 121, 129
Rungstedlund Foundation, 136
Rupert (fictional character), 50–51

Saar, Betye, 15
Said, Edward, 289
St. Mawr (Lawrence), 98
St. Paul's Cathedral (Pittsburgh), 208
Salinas, Luis Omar, 245
Sanchez, Sonia, 232, 245
Sandburg, Carl, 231
Sarkozy, Nicolas, 187
Sarton, May, 7, 14
Savage, Augusta, 14, 190
Schulz, Kathryn, 301
Schumann, Clara, 14
Scott, Hazel, 197, 200, 219
Scruggs, Mary Elfrieda, *see* Williams, Mary Lou
Second Vatican Council, 204, 209
Seeger, Pete, 103
Segovia, Andrés, 154
Self-Portrait (Neel), 21, 279
Semmel, Joan, 15
Senegalese National Ballet, 262
Senghor, Léopold, 262
Seventeen magazine, 154
Sexton, Anne, 12
sexual abuse, 258–59
sexualities in old age, 17, 18, 28, 112, 291
Shakespeare, William, 130, 160, 277
Shor, Toots, 153
Silko, Leslie Marmon, 15
Sitwell, Edith, 153
Sitwell, Osbert, 153
Sitwell, Sacheverell, 153
Smith, Charlie, 28
Smith, Dinitia, 48–49
Smith, Kate, 163
Smith, Ozzie, 152
Smith, Patti, 15

Snow, Valida, 220
Sontag, Susan, 1, 244–45
Sorbonne University, 167
Souls of Black Folk, The (Du Bois), 232
Southern Illinois University, 270
Southern Illinois University Carbondale, 261–62
Southside Community Art Center (Chicago, Ill.), 223
Sovereignty of Good, The (Murdoch), 21
Soviet-American Writers' Conference, 243–44
Spirits in the Well (Morrison), 284
Sports Illustrated, 153
Stanford Center on Longevity, 24
Stanton, Elizabeth Cady, 11
Stark, Inez Cunningham, 223
State Department, 252, 260
Statue of Liberty, 156
Stein, Gertrude, 151
Steinem, Gloria, 10, 91, 96
Stern, Isaac, 155
Stettheimer, Florine, 87–88, 100
Stevens, Wallace, 160
Stieglitz, Alfred
 death, 101
 and Marianne Moore, 151
 My Faraway One, 96
 photographs of O'Keeffe, 85
 relationship with Dorothy Norman, 91–94, 100
 relationship with Georgia O'Keeffe, 84–87
Stone, Ruth, 14
Storr, Robert, 168, 177
Stovall, Jeanelle, 271
Stowe, Harriet Beecher, 23, 43
St. Paul's Chapel (Columbia University), 209
Strand, Paul, 91

Strand, Rebecca, 91–92, 106
Streisand, Barbra, 15
Stuart, Michelle, 15
Svendsen, Clara, 116, 136
Sweet Talk (Morrison), 284
Syncopators, 195

Tan, Amy, 15
Tar Beach (Ringgold), 285–86
Tarn, Pauline (Renée Vivien), 70
Tate Modern, 181, 183–84
Tatum, Art, 197, 201
Taylor, Cecil, 215–16
Teagarden, Norma, 220
Tempest, The (Shakespeare), 130
Tennyson, Alfred, 34
Terpsichorean Club, 256
Terrell, Ernie, 154
"Thank Heavens for Little Girls," 77
Tharp, Twyla, 15, 295
Their Eyes Were Watching God (Hurston), 13
Third World Press, 241
Thompson, Emma, 279
Those Pleasures (Colette), *see Pure and the Impure, The* (Colette)
Thurman, Judith, 56, 115, 136
Time magazine, 196, 206
Times (London), 287
Time Transfixed (Magritte), 98
Tomlin, Lily, 15
Toomer, Jean, 95–96
"Torching the Dusties" (Atwood), 287
Torff, Brian Q., 214
Torschlusspanik, as term, 24
Treemonisha (Joplin), 272–73
Trollope, Anthony, 10, 34
Truth, Sojourner, 190
Turgenev, Ivan, 34
Twelve Clouds of Joy, 195–96

Uchida, Mitsuko, 15
University of Chicago, 258–59

Van Gelder, Alex, 187–88
Van Vechten, Carl, 102
Varda, Agnès, 14
Varo, Remedios, 282
Vatican, 208
vaudun (voodoo), 263–66, 268
Vendler, Helen, 158
Venice Biennale, 181
Verdi, Giuseppe, 3, 209
Verine, Pauline, 74, 291
Vieillesse, La (Old Age) (Beauvoir), 7
Vieja Magdalene, La (Carrington), 283
Vietnam War, 163
Vivien, Renée (Pauline Tarn), 70
Vogue, 154
Vogue magazine, 166

Wagner, Richard, 34
Walker, Alice, 13, 15
Walker, Margaret, 190
Waller, Fats, 152, 195, 251
Wall of Respect, The (mural), 226
Warhol, Andy, 103
"Warning" (Joseph), 18
Washington, George, 160, 161
Waters, Ethel, 197, 250
Watson, Hildegarde, 161
Way of the World, The (Congreve), 17
Webster, Ben, 196
We Flew over the Bridge (Ringgold), 285–86
Weir, Fanny June, 255, 258
Welles, Orson, 123
Wells, Ida B., 190
Wescott, Glenway, 137
West, Rebecca, 14
Wharton, Edith, 14, 296
Wheeler, Monroe, 160
White House, 217, 272
Whitman, Walt, 7, 155, 157, 183
"Who Stole the Lock off the Henhouse Door," 215
Wilde, Oscar, 56
Wilder, Laura Ingalls, 15

Williams, John, 195–96
Williams, Mary Lou, 189–90, *193*, 193–220
"Act of Contrition," 210
"Amen," 211
"Anima Christi," 207
changing styles, 289
"Credos," 211
"Drag 'Em," 196
and Katherine Dunham, 197
early life, 194–95
"Elijah and the Juniper Tree," 206
"Embraced" (concert), 215
finances, 198–200
"A Fungus Amungus," 198
"Gloria," 210
health, 217, 219
History of Jazz (poster), 213–14
History of Jazz (recording), 215
"Holy, Holy, Holy," 211
"Hosannahs," 211
"In the Land of Oo-Bla-Dee," 196
"It Is Always Spring," 211
as jazz historian, 213–18
"Jesus Is the Best," 211
"Kyrie Eleison," 210
"Lamb of God," 211
"Lazarus," 210
Live at the Cookery, 214
"The Lord Says," 210
Mary Lou's Mass, 208–12, 219
Mary Lou Williams Foundation, 218–19
"Mary Lou Williams: My Life with the Kings of Jazz," 199
The Mary Lou Williams Piano Workshop, 197
Mary Lou Williams Presents Black Christ of the Andes, 205–6
Mass for Peace, 209
Mass for the Lenten Season, 208

Williams, Mary Lou
 (*continued*)
 "Medi I," 210
 "Medi II," 210
 mother, 195
 Music on My Mind (film), 218
 "Nightlife," 196
 "Old Time Spiritual," 210
 "One," 211
 "Praise the Lord (Come, Holy Spirit)," 207, 210–11
 on race and racism, 189–90, 198, 206–7, 218
 "Roll 'Em," 214
 "Scorpio," 197
 stepfather, 195
 "St. Martin de Porres" (jazz hymn), 204, 206
 teaching, 217–18
 "Tell Them Not to Talk Too Long," 207
 "Tisherome," 198
 touring, 195–200
 "Trumpets No End," 196
 The Zodiac Suite, 197
Williams, William Carlos, 141
Willy, Colette, *see* Colette
Wilson, Garland, 200
Wilson Junior College (Kennedy-King College), 222
Wind in the Willows (Grahame), 141
Winfrey, Oprah, 285
Witkowski, Deanna, 216
Wollstonecraft, Mary, 12
Women's Jazz Festival, 219
Women's Wear Daily, 162
Woods, Anthony, 202–4
Woodward, Kathleen, 8
Woolf, Virginia, 13, 280
World Festival of Negro Arts, 262
World War II, 74–75, 116, 144, 167, 172, 178, 224
World Zionist Organization, 41
Wretched of the Earth, The (Fanon), 232
Wright, Frank Lloyd, 3
Wye, Deborah, 166, 185, 187

Yeats, W. B., 151, 281
Yeats, William Butler, 112
Yevtushenko, Yevgeny, 160

Zionism, 41
"zombie music," 197, 216